Adobe Photoshop
Lightroom 2

Adobe Photoshop Lightroom 2

A Digital Photographer's Guide

Dave Huss

David Plotkin

ELSEVIER

AMSTERDAM • BOSTON • HEIDELBERG • LONDON • NEW YORK • OXFORD
PARIS • SAN DIEGO • SAN FRANCISCO • SINGAPORE • SYDNEY • TOKYO
Focal Press is an imprint of Elsevier

Focal Press is an imprint of Elsevier
30 Corporate Drive, Suite 400, Burlington, MA 01803, USA
Linacre House, Jordan Hill, Oxford OX2 8DP, UK

∞ Recognizing the importance of preserving what has been written, Elsevier prints its books on acid-free paper whenever possible.

Library of Congress Cataloging-in-Publication Data
Huss, Dave
 Adobe Photoshop lightroom 2 : a digital photographer's guide / Dave Huss, David Plotkin.
 p. cm.
 Includes index.
 ISBN 978-0-240-52133-6 (pbk. : alk. paper) 1. Adobe Photoshop lightroom. 2. Photography—Digital techniques—Computer programs–Handbooks, manuals, etc. I. Plotkin, David. II. Title.
 TR267.5.A355H873 2008
 006.6'96–dc22 2008035741

British Library Cataloguing-in-Publication Data
A catalogue record for this book is available from the British Library.

ISBN: 978-0-240-52133-6

For information on all Focal Press publications,
visit our website at www.books.elsevier.com

08 09 10 11 12 5 4 3 2 1
Printed in Canada

This book is dedicated to Chad Smith. Glad you're part of our family. —Dave

This book is dedicated to my father, Norman Plotkin, from whom I learned most of life's important lessons. Thanks, Dad! —David

Contents

Contents

Introduction

Welcome back. If you are like many of those that browse through the shelves in the bookstore, the first thing you did was flip through the pages of this book to see if it was the level of material that meets your wants or needs. If you are browsing, here is a brief summary of the book's focus. If you already own the book, congratulations on a brilliant choice, and thank you. Feel free to read the following paragraphs along with the browser.

The ultimate goal of this book is to provide you with the essential information necessary to incorporate Lightroom into your existing photographic workflow. If you are new to Lightroom, we cover the basics, but not at a painful level of detail. For example, we assume you have enough computer skills to open, close, and save a file, and therefore we do not need to waste three pages explaining how to do the obvious. If you have used one of the 1.x versions of Lightroom, we have tried to point out where the program has changed in version 2 as well. If you were one of the many beta testers of version 2, we have also identified names and functions that changed during the beta testing cycle. We did this primarily for the sake of those that attempt to use LR 2 beta tutorials that are still available on the Web. So when the tutorial refers to the Touch-up brush in the Localized Correction tools, you will understand that we are referring to what is now called the Adjustment brush in the Local Adjustment tools.

At what level of digital photographer is this book focused? In other words, can I use this book? To paraphrase Chief Gusteau in the exceptional Pixar film *Ratatouille*, anyone can cook—with this book. Whether you are a serious amateur or a seasoned professional, a majority of the material presented in this book is applicable for your needs. For example, the section that covers the library explains how best to sort and select through a large number of images. The family returning from a vacation and the wedding photographer both face the same challenge. Hundreds of photos and precious little time means you need an efficient workflow that doesn't require hours to understand and implement. In my chapters, the references to techniques to make photos that please clients apply equally well to making the photos on your personal Web page rock.

Why two authors? Lightroom is too broad an application for one person to get a complete grip on explaining it. David Plotkin is an expert in metadata and image management, so one of the several chapters he has written explains how to manage your images using the Library module. Listen, I look forward to reading what he has written about getting the most out of the Library

module because he knows it so well. My area of expertise is working as a professional photographer, mostly focusing on stock and fine art photography (www.davehuss.com). I love Lightroom because when I return from a shoot at a remote location, I expect to have several thousand shots. Before Lightroom, it took forever to process and manage all of the photos. With Lightroom, I can sort through a thousand photos and separate the keepers from the duds in a single evening—okay, maybe two. I have concentrated on the Quick Develop/ Develop and Print modules. The result of the collaboration is a book that is beyond the sum of our collective knowledge.

Regarding the format, we have attempted to cover the basic operation of Lightroom tools and then focus on the uses of those tools that are most important for a smooth photographic workflow. This book does not repeat or paraphrase what is in the online user guide. Why? To see what Adobe wrote, just open Help and you can read detailed instructions on what the tools do. David and I show you what you can do with the tools. Is every feature in Lightroom covered in this book? Almost, but the honest answer is no. Why not? Glad you asked. The answer is time and pages. To cover every tool and every possible technique using Lightroom would take so long that Adobe would be beta-testing Lightroom 5 by the time we were finished and the book would be several thousand pages long—which is great for a doorstop but not practical as a reference manual. There is something wrong about a book so thick it can also be used for upper-body strength training.

What about the topics that are not covered in the book? To this end, we are already hard at work developing additional material, which will be posted on the Focal Press Web page, www.focalpress.com/lightroom, that will include tutorials, advanced techniques, updates (if you used Lightroom 1.x, you know the program is going to change, possibly a lot), and, dare I say, corrections. Yes, it is possible a mistake slipped by us, but we won't admit it.

I hope that explains things well enough for you. I hate long introductions because I would rather use the pages for including more cool stuff about using Lightroom. One last point: if you haven't seen *Ratatouille*, rent the DVD, put you feet up, and be inspired. If a rat can become a five-star chief in Paris, think about what you can accomplish with Lightroom.

Dave Huss
July 2008

Key to Icons

 These are features that are brand new to Lightroom 2.

 This indicates a point that is so important we didn't want it to get lost in a paragraph.

 This is usually a suggestion on how to use something better or an introduction to some neat Lightroom feature that we have discovered.

Acknowledgments

This is my favorite part of the book. It is very much like a private club, because traditionally the only people who ever venture into this section are those readers who think they might find their names forever immortalized in print. Of course, given the short life of a technical book about a product that is updated on an annual basis, the *forever* part of that phrase might be slightly overstated.

To be fair, there are others who will read this acknowledgments section. Faced with the current rash of delayed and canceled flights, more than one stranded traveler faced with the choice of rereading the in-flight magazine for the fifth time has turned to the acknowledgments section of a book—any book. Then there are the insomniacs who don't respond to heavy medication, but I digress.

As the credits of a modern film attest, it takes a lot of people create and produce a work of art, and a book such as the one you are currently hefting is no exception. So, because it is just us, the travelers and insomniacs here, let's get comfy and begin mentioning names. What follows is an incomplete listing of those marvelous people who either directly or indirectly contributed to this work.

Some authors believe that the editor who oversaw the book gets mentioned first, and I would be one of those authors. Valerie Geary paid her dues on the first edition of this book and was foolhardy enough to sign up for a second edition. This alone warrants a top spot in the credits if not a consideration for a psych evaluation. Next on the hit parade is my co-author, David Plotkin, who is able to grasp concepts like how Lightroom handles metadata and make them understandable even to me. Our technical editor, Donna Powell, rocks. Take a bow Donna. Without her the names of many tools (which were changing faster than a stock on the NASDAQ) would, even at this late date, be incorrect. On faith I need to thank Kara Race-Moore for a job well done. She is, while I am typing this, trying to assemble the book. Never fear. If she does a bad job, I will hire 100 Nepalese scribes to remove her name from every copy of the book. That's all of the people who are directly responsible for the production of the book.

Now let's move on to those bleary-eyed individuals who spent way too many hours working on the program during the seemingly endless beta testing. Top on this list is Mark Hamburg, the genius behind Local Adjustments, and Tom Hogarty, the overall head honcho of Lightroom. Words are inadequate. Many thanks Tom both for the program and the excellent author support. Likewise for Adobe's Melissa Gaul's efforts on the beta user forum has been nothing short of heroic. Roma Dhall, thanks for the management of the beta program, which must, at times, seem something like herding cats—to water.

A few notables among the beta testers who unselfishly and patiently answered some of the dumbest questions (most asked by me) on the forum are Lee Jay Fingersh, Sean McCormack, and the Lightroom Queen herself, Victoria Bampton.

Lastly, 35 years of marriage has taught me many things and one of them is to make sure I include the name of my lovely wife Elizabeth in this section. She has endured the rear view of my head and the insistent muttering about things like "How could they change the name Localized Corrections at this late date?" for many months now. To her I can only say thank you and be comforted by the fact that if Lightroom 2.0 is finally shipping, Lightroom 3.0 beta can't be very far away.

A last word of advice for those of you reading this at this very moment; sit near the gate so when they call your flight you can get in line and nab some space in the overhead compartment.

—Dave Huss, July 2008

My partner on this book, Dave Huss, has acknowledged most of the heavy hitters, so I only have a few things to add. First of all, kudos to Dave, who must have gone cross-eyed trying to keep up with the multiple functionality and interface changes for "Localized Adjustments" (including a complete change what the tools were called in the 11th hour) and the Print module. But ever the consummate professional, he just shrugged off the changes (and multiple screen reshoots that came with it) as just being part of the job. Dave is also a great photographer; all the chapter-leading images and the cover image are from his extensive collection. Gives me something to aspire to! One last thing about Dave—this is not our first collaboration and probably won't be our last. So, like Valerie, we are probably candidates for a psych evaluation as well. But then, it takes a little bit of crazy to take on this job.

As Dave said, the Adobe folks and our co-conspirators on the forum were wonderful. Although, in one sense, some are competitors (many of them are writing books on Lightroom as well), there was a definite sense of camaraderie as we helped each other out. There is nothing like working with beta software—the most common question seemed to be "Is it *supposed* to work that way, or is it a bug?"

Finally, Marisa, my wife of 32 years, was endlessly patient during this time, as I answered most requests to get things done around the house with "I'm working on the Lightroom book." And she learned to ignore the screams of frustration that emanated from my office with each new beta release. I'm afraid she also learned to dread Fridays (most beta releases came out on Friday). But being an author herself (of children's books, with multiple awards to prove it), she at least understands the writing process, if not the insanity of writing about something that changes *every* week.

And here I thought it was just me who turned to the acknowledgments during long flights or the inevitable flight delays.

—David Plotkin, July 2008

Lightroom Fundamentals

This chapter focuses on the basics of Lightroom from navigation to configuration and most everything in between. If you are an experienced Lightroom user, you may be tempted to skip this chapter. I recommend instead that you skip to the information about setting up some of the new Lightroom 2.0 features toward the end of the chapter.

Introduction

Let's begin with a brief introduction about how Lightroom works and how to find your way around the Lightroom workspace. If you are already familiar with Lightroom, feel free to skip to the next topic; you won't hurt my feelings (sob).

One Program, Five Modules

The Lightroom workspace consists of five modules, as shown in **Figure 1.1**. They are Library, Develop, Slideshow, Print, and Web. Unlike other programs that

Library

Develop

Slideshow

Print

Web

FIG. 1.1 Lightroom is composed of five modules.

must open additional applications as you progress through the photographic workflow, Lightroom accomplishes the same tasks by switching between modules—a much faster solution. The following list briefly describes each module:

- **Library**. The Library module is the logical starting point in a typical photo workflow. This module is where you import, export, sort, and browse photos. It is in the Library that you can add images to collections, add or modify image metadata and keywords, and rank and sort images On top of all of that, you can apply quick image corrections in the Library as well.
- **Develop**. From this module, you can perform a wide variety of image enhancements or pass selected images to an external photo editor. This module is where a majority of the image processing and editing is preformed. New with version 2.0 in this module is the ability to make local adjustments to specific areas of an image.
- **Slideshow**. You can use the Slideshow module to create and export a slideshow of selected images. The tools in this module allow you to either quickly assemble a slideshow to show a client using Adobe built-in presets or create your own custom display of your work. The slideshow has become the standard method for both wedding and portrait photographers to showcase their work to clients and prospective customers.
- **Print**. Just as its name implies, the Print module gives you the ability to output high-quality prints. You can also print preset or custom-designed contact sheets, multiple copies of a single photo on a page, or multiple images on one page. The Print module provides all of the tools necessary to create high-quality prints without the need to go to an external editor like Photoshop.
- **Web**. The Web module provides you with a quick and easy way to display your work online in a Web page that was designed by professionals. From the Web module you can select one of the many HTML or Flash Web gallery presets. Using that preset as a starting point, you can customize it with your own copy, logo, and color schemes. You can also use the Web module to upload your work to a server without leaving Lightroom.

How Lightroom Works

Although not essential, knowing a little about how Lightroom works will help you get more out of Lightroom in the long run. It is especially important because the way that Lightroom operates on images is different from other image processing applications you may already be familiar with.

When you import an image into Lightroom, the program only imports information about the location of the image into its database (called a catalog). It doesn't load the actual file into the Lightroom catalog; instead, it stores a preview (thumbnail) of the image in the catalog. All image operations within

Lightroom—from image enhancement to adding titles, assigning keywords, or creating collections—are recorded and maintained in the Lightroom catalog file. This is why it is important to back up your catalog often. You will learn more about working with the Lightroom catalog in Chapter 4.

Non-destructive Editing

All the image modifications you make to an image in Lightroom are applied to the thumbnail and not to the actual image. For example, in the Develop module, if you open an image like the one shown in **Figure 1.2** and apply one of the Develop module presets like the Antique Grayscale, the change appears on the image as shown in **Figure 1.3**. Yet the original image remains unaltered. Only the thumbnail has been altered to reflect the change.

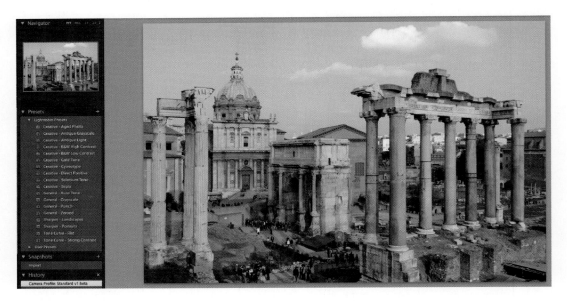

FIG. 1.2 Original image in the Develop module.

This is called non-destructive editing. It is the key to what makes Lightroom different from other image editors. Photoshop or Photoshop Elements modify the image file, whereas Lightroom shows you a preview of the effects of your work, but the original image file remains unchanged.

The Power of Non-destructive Editing

There are many advantages to non-destructive editing. Probably the most important is that it is possible to have multiple versions of an image displayed in the catalog but only one source file. Let's look at a real-world example.

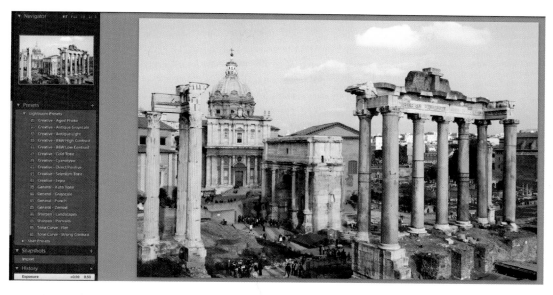

FIG. 1.3 Preview reflects the changes but the original file remains unaltered.

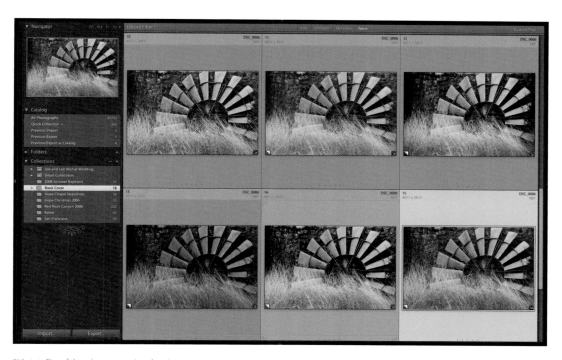

FIG. 1.4 Five of these images are virtual copies.

Figure 1.4 shows five variations of a photo being considered for the cover of this book. It appears there are six images, but if I open the folder containing the photo, I will only find the original photo—and it is unaltered. In this example, I have made five **virtual copies** of the original file. I can work on any of these copies, and although it appears I am making changes to the image, Lightroom is recording the changes I made to the copy in its catalog. Anytime these files are viewed in Lightroom, the thumbnail previews are displayed.

So when are the changes actually applied to the image? I knew you were going to ask that question. The answer is, when the image is output. Lightroom makes a copy of the original, applies all of the changes, and renders the copy in whatever format you need. The output can take many forms. The image can be exported, printed, made into a slide show, or made into a Web page. Lightroom can output any image into almost any format that you can imagine.

What's New in Lightroom 2.0

Adobe has made a lot of changes to Lightroom in this release. Some new features have been added, and others have been improved. Here are just a few of the new features:

Local Adjustment Tools

If this were the only feature added to version 2.0, the upgrade would be worth it. Local Adjustment tools give the user the ability to retouch an image without the need of an external photo editor. Here are a few things you can do with Local Adjustment tools:

- Paint masks, which are fully editable, and use the masks to adjust exposure, brightness, clarity, saturation, and even add color.
- The Auto Mask feature (when enabled) automatically creates masks based on the tool starting point. In other words, Auto Mask can figure out what you want included in the mask and almost always gets it right.
- Create multiple masks on an image, each with its own settings.

An example of a localized correction is shown in Figure 1.5. The original photo was taken under a bright afternoon sun. The sky looks washed out, the colors are flat, and part of the barn hidden in shadows. Using the new local correction tools, it was possible to selectively increase the exposure in the shadows on the barn, make the sky bluer while bringing out the clouds, and darken the grass a little to emphasize the barn—all in less than a minute and without the need to use an external editor (Figure 1.6).

Improved User Interface

Adobe rearranged the user interface (UI) making the Lightroom workflow even smoother than the previous version. So if you are a veteran of the first version and you can't find your favorite feature, look around; its location may have moved.

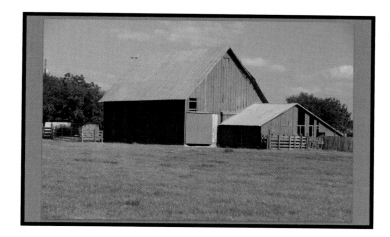

FIG. 1.5 Flat, uninteresting photo taken on bright afternoon.

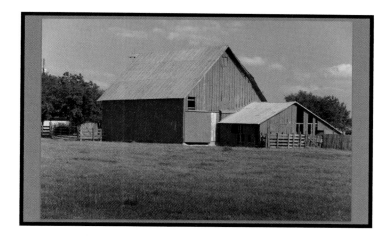

FIG. 1.6 Local Adjustment tools quickly correct problems and enhance images.

Photoshop CS3 Integration

There are several new features for those of you that use Lightroom with Photoshop CS3 and some improvements on existing ones. Here are some of the new 2.0 features:

- You can open files in Photoshop as Smart Objects. This means you can fiddle with your Lightroom adjustments from within Photoshop!
- In 2.0, you can select multiple images for a panorama and have them open in Photoshop already in the Photomerge dialog box. Speaking of panoramas, the old 10,000-pixel size limit of Lightroom has been raised to 65,000 pixels, so it is now possible to catalog those panoramas that were too large to be imported into the previous version (**Figure 1.7**).
- You can merge multiple exposures into a single Photoshop HDR image.

FIG. 1.7 Large panoramas now fit into Lightroom.

- It is possible to load multiple images into Photoshop with each photo being a separate layer in a single document.

Improved Organizational Tools

In the Library module, you will find a lot of improvements to help you find the images you need quickly and easily. Adobe has completely streamlined the interface, so it may take you a moment or two to find things; but once you do, you will love how it works and feels. Here are a few of the 2.0 improvements:

- The new Text filter replaces the old Find filter and metadata browser and it can be can be used to search almost every data field imaginable for almost anything.
- The Keyword Tags panel has moved and now has a Suggested Keyword feature that, when enabled, suggests keywords as you type. The suggestions are based on previous keyword usage and keywords assigned to other images that are close to the image you are working on.
- The Collections panel is now visible in all of the output modules—Slideshow, Print, and Web.
- Smart collections is new to version 2.0. With it you can set up a series of rules so that any image meeting that criteria will be added automatically the smart collection. For example, when writing this book, I use Lightroom to track all of the photos I use in the book. All of the photos or screen captures have the keyword LR2. Every image with this keyword automatically gets added to the Lightroom Images Smart folder.
- You can now export an image to the same folder it came from and also add images you export into the Lightroom catalog—a real time-saver.

Picture Package

Borrowed from Photoshop, this feature gives you the ability to print multiple sizes of a single photograph on a page (**Figure 1.8**). If you don't want to use one of the preset layouts that Adobe provides, you can create and save you own custom layouts.

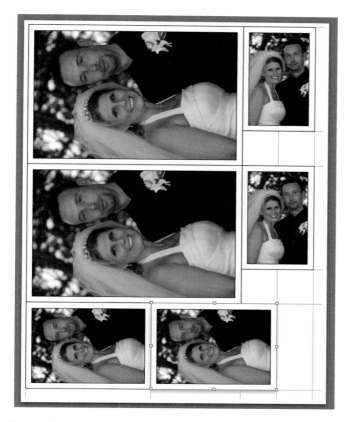

FIG. 1.8 Picture package.

Print to JPEG

A lot of people have been asking for this one. From the Print module, it is possible to print to a JPEG file. For those of us that send files to a lab to be printed, the ability to output the file to a JPEG using the Print module is critical.

16-Bit Printing

Lightroom can now print 16-bit images. Typical 24-bit RGB images use 8 bits per channel; 16-bit images (rarely called 48-bit) provide the increased dynamic range that some of the newer high-end printers can reproduce. Add to this, the print output sharpening algorithms in version 2.0 have been noticeably improved.

64-Bit Support

With most computers today sporting multiple core architectures, operating systems can now take advantage of the increased horsepower by operating

in 64-bit. Lightroom now offers full 64-bit support to improve both memory handling and overall performance.

Multiple Monitor Support

With the availability of inexpensive monitors, the ability to easily add and manage a second monitor with Lightroom is arguably one of the best new features (**Figure 1.9**). The use of multiple monitors can improve your

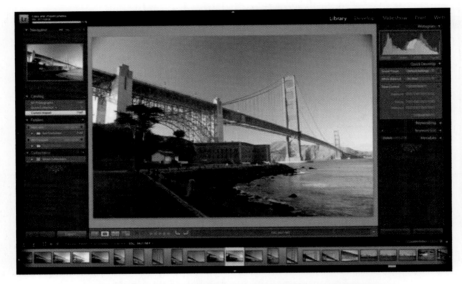

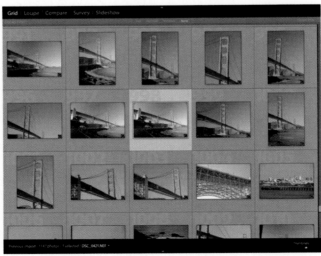

FIG. 1.9 Screen displays shown from two monitors using the improved multi-monitor feature.

photographic workflow, especially when sorting photos or when doing touch-ups. Later in this chapter, we will learn how to set up this feature and use it.

There are many more additions and improvements, but it is wiser to use the page space to explain how to use them instead of making a detailed laundry list of every item that has been added or changed. Let's move on to the Lightroom workspace.

The Lightroom Workspace

Lightroom is easy to navigate once you know how (**Figure 1.10**). First, let's learn the names of some of the major parts of the Lightroom interface. Figure 1.8 shows the major components of the user interface (UI). If this is your first exposure to Lightroom, the screen capture in Figure 1.10 makes it appear as though there is hardly any room left to work on images. Rest assured that the example shown in the figure has everything opened. In a real world workflow, there is a lot more room to work.

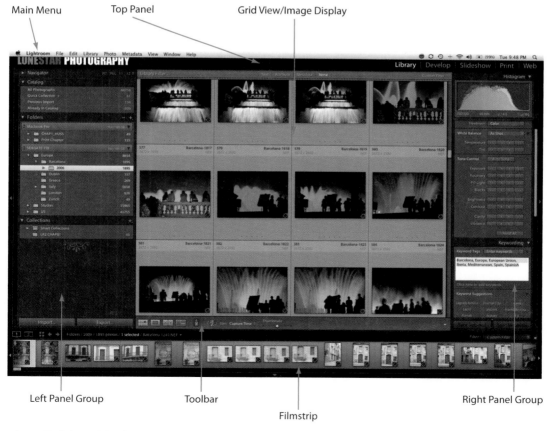

FIG. 1.10 The Lightroom 2.0 workspace.

Main Menu

The main menu commands are located in the Lightroom menu bar at the top of the screen. If you are in Full Screen mode, the menu bar is hidden, you can reveal it by pressing the F key or moving the mouse up to the top of the screen.

Top Panel

The top panel section in Lightroom contains the module picker, allowing you to move between the different Lightroom modules with the click of a mouse. The top-left section also contains the Identity Plate under which you can see the progress indicator when Lightroom is busy working on something. We will learn more about the Identity Plate later in this chapter.

Grid View or Image Display

This is the part of the interface where you view, select, sort, and work with the photos. How this area appears depends on the module you are in and what mode you are in as well. For example, in the Library module Grid mode (shown in **Figure 1.11**), the thumbnails are displayed like a traditional light table.

FIG. 1.11 Library module in Grid View.

The slider on the toolbar controls the size of the thumbnails. In the Library module Loupe mode (Figure 1.12) or in the Develop module, this area displays individual images at different zoom factors. In the other modules—Slideshow, Print, and Web—this area previews how images will appear when they are output from Lightroom.

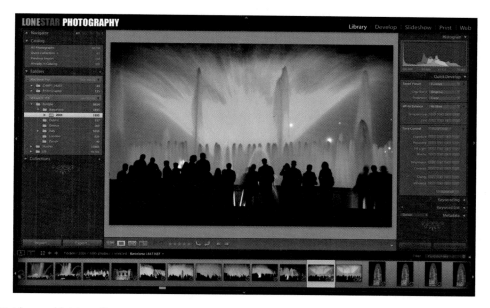

FIG. 1.12 Library module in Loupe View.

Toolbar

The toolbar (at the bottom of the screen) is toggled on and off by pressing the T key. It is common to all Lightroom modules. It contains different tool sets depending on the module currently selected.

Left and Right Panel Group

Each panel group contains multiple panels that are different in each of the five modules.

Filmstrip

The filmstrip at the bottom of the screen contains thumbnails of all the images currently being displayed in the Library module. These filmstrip thumbnails can be accessed in all of the modules. This is a handy way to

access the images or even a group of images without having to switch back to the Library module.

Working with Panels and Panel Group

Each part of the Lightroom interface (panels, toolbars, and so on) can be individually opened and closed to allow more room for the images. Press Shift + Tab to toggle the panels on or off.

Lightroom panels are shy. They will hide from view if they get a chance. If a panel is hiding, move the mouse pointer to the edge of the screen where the panel is and it will reappear. There is an icon that is on the screen edge side of the panel as shown in **Figure 1.13.** Click on it and it rotates so that the flat side of the icon is against the panel; now when you move the mouse away, the panel remains open. The only hiccup to this arrangement is that sometimes when you are moving a scroll bar on the edge of the screen, Lightroom interprets the mouse movement as a request to open a panel.

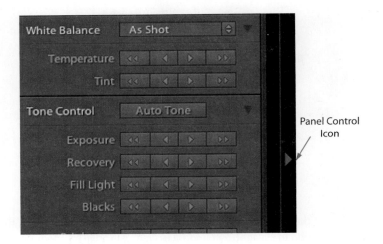

Panel Control Icon

FIG. 1.13 Icon to open panel.

There's a hiding panel option you'll want to know about. You already know that when you hide a panel, it will automatically pop back into view if you move your cursor over that edge of the screen. This feature is called Auto Hide, and although it is handy, at times it is seen as counterproductive because the panels pop open when Auto Hide smells the mouse closing on the edge. Never fear. You can turn Auto Show/Hide off by right-clicking (Cmd-click on the Mac) on any one of those Show/Hide icons. This brings up a contextual menu where you can choose your panel options. Because the option names

are less than clear, I thought a few words might clarify the operation. The options are as follows:

- **Auto Hide & Show.** This is the default setting; panels jump out of the screen edge when they sense a mouse nearby.
- **Auto Hide.** The only way to open a hidden panel is to click on its Show/Hide arrow, but when your cursor moves away from that panel, it automatically hides.
- **Manual.** The name says it all. You can use the arrows to show and hide every time.

When you open a panel using Auto Hide, the panel opens over the image being viewed, thereby covering part of the photo. When you open the panel using the icon, the image is resized to allow the panel to fit and permit you to still view the entire image.

Are some of your panels are missing? Right-click (Cmd-click on the Mac) the panel group and a list of the available panel options appears like the one shown in Figure 1.14; you will find that your panel isn't gone but just turned off.

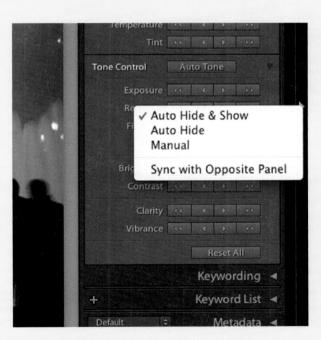

FIG. 1.14 Option menu for panel configuration and control.

Keyboard Shortcut Navigation

Each module (Library, Develop, Slideshow, Print, and Web) has a different set of panels and features. One way to make your workflow smoother is to take advantage of the many keyboard shortcuts in Lightroom 2.0. Each module can have its own unique set of keyboard shortcuts, which means there are too many shortcuts to remember. In this section, we will cover the important shortcuts to know. First, the keyboard shortcut made for all of us who can't remember shortcuts is Ctrl+/ (Win) Cmd+/ (Mac). Pressing this shortcut displays the overlay shown in Figure 1.15.

Develop Shortcuts

Edit Shortcuts

Command + U	Auto Tone
V	Convert to Grayscale
Command + Shift + U	Auto White Balance
Command + E	Edit in Photoshop
Command + N	New Snapshot
Command + '	Create Virtual Copy
Command + [Rotate left
Command +]	Rotate right
1-5	Set Ratings
Shift + 1-5	Set ratings and move to next photo
6-9	Set color labels
Shift + 6-9	Set color labels and move to next photo
Command + Shift + C	Copy Develop Settings
	A dialog will come up asking which settings to copy.
Command + Shift + V	Paste Develop Settings

Output Shortcuts

Command + Return	Enter Impromptu Slideshow mode
	Shows the current selected photos in a slideshow based on the current Slideshow module settings.
Command + P	Print selected photos
Command + Shift + P	Page Setup

Navigation Shortcuts

Command + Left Arrow	Previous Photo
Command + Right Arrow	Next Photo

View Shortcuts

Tab	Hide panels
Shift + Tab	Hide all panels
T	Hide/Show toolbar
F	Cycle screen modes
Command + Option + F	Go to normal screen mode
L	Cycle Lights Out modes
Command + Shift + L	Go to Lights Dim mode
Command + Option + Up Arrow	Go to previous module
Command + I	Show/Hide Info Overlay
I	Cycle Info Overlay
Command + J	Develop View Options

Mode Shortcuts

R	Enter Crop Mode
N	Enter Spot Removal Mode
M	Enter Graduated Filter Mode
K	Enter Adjustment Brush Mode
D	Loupe View
Y	View Before and After left and right
Option + Y	View Before and After up and down

Target Collection Shortcuts

B	Add to Target Collection
Command + B	Show Target Collection
Command + Shift + B	Clear Quick Collection

FIG. 1.15 Overlay displays shortcuts available in currently selected module.

Module Navigation

Most of the module switching you will encounter when working in Lightroom will be between the Library and the Develop module. The D key selects the Develop module, but there isn't a single key shortcut to switch to the Library module. However, pressing the G (Grid) key switches Lightroom to the Grid view of the Develop module. So the D and the G keys effectively switch between the Develop and the Library module.

If a keyboard shortcut doesn't work as expected, it might be because of where the cursor's location on the screen. For example, if the cursor is over a control panel when you press the G key, Lightroom will not interpret the keystroke as a shortcut.

I have included the following table of module navigation keyboard shortcuts because you can never seem to find these listed in one place.

Destination Module	Mac Keyboard Shortcuts	Win Keyboard Shortcuts
Go to Library module	Cmd + Opt + 1	Ctrl + Alt + 1
Go to Develop module	D or Cmd + Opt+ 2	D or Ctrl + Alt + 2
Go to Slideshow module	Cmd+ Opt + 3	Ctrl + Alt + 3
Go to Print module	Cmd + Opt + 4	Ctrl +Alt + 4
Go to Web module	Cmd + Opt + 5	Ctrl + Alt + 5
Return to last module	Cmd + Opt+ Up Arrow	Ctrl + Alt + Up Arrow

Popular Viewing Keyboard Shortcuts

Here are some other useful shortcuts you should know.

Screen Modes (F)

Lightroom has three screen modes. Normal displays Lightroom in its own window. Full-Screen with Menu fills the screen leaving only the menu bar showing. Full Screen fills the entire screen. The F key cycles through all three screen modes (Normal, Full Screen with Menu, and Full Screen). This is a global keyboard shortcut that works in all modules.

Because Full Screen mode fills the entire screen, if there comes a time when you can't find anything but Lightroom on your display, you are in Full Screen mode. Press the F key to see other applications on your display.

Lights Out Modes (L)

Lightroom has three Lights Out modes (Lights On, Lights Dim, and Lights Off) that control the lighting of everything on the screen except the selected photo(s). The Lights Out mode enables you to dim, black out, or brighten the Lightroom interface so that your photo stands out on screen. This global shortcut works in all of the Lightroom modules and not only controls the

lighting in Lightroom but also any other applications running at the same time. The Lights Off mode is good to use when you want to show your photos to someone without any other applications distracting the viewer. The percentage of dimming for the Lights Dim mode is controlled in the Interface tab of Preference (Cmd+, Ctrl+,).

When using Lights Out, remember that only the selected image remains at its original lighting level. So if you have one image selected in Grid mode, only the tiny thumbnail will be visible.

Hardware and Performance

This section of the chapter discusses hardware improvements to consider that will speed up your Lightroom experience without breaking your wallet. First of all, Lightroom is a cross platform application, meaning that it can be installed on either a Mac or a Windows platform. For the Mac users, Lightroom is written in Universal Binary, so it can go blazing fast on an Intel-based Mac and also work on a G4 or G5 PowerPC.

Minimum System Requirements

The following is an abbreviated list of Adobe's minimum hardware requirements for each platform. Using a computer with these minimum components will let you install and run Lightroom—not very fast, but it will run.

Windows
- Processor: Intel Pentium 4 or Intel Duo 2 Core
- OS: Microsoft Windows XP with SP2 or Windows Vista and Windows Vista (64-bit)
- RAM: 1 GB
- Hard Drive: 1 GB available
- Display: 1024 × 768 monitor resolution

Macintosh
- Processor: PowerPC (G4 or G5) or Intel-based Mac
- OS: Mac OS X 10.4 or Mac OS X 10.5
- RAM: 1 GB
- Hard Disk: 1 GB of available hard-disk space
- Display: 1024 × 768 monitor resolution

The Need for Speed

When it comes to processing a large amount of images in a photographic workflow, you want to have equipment that will give you the best

performance; but buying a computer with a faster processor is no guarantee that it will run Lightroom any faster than a similar model with slower CPU (Figure 1.16). Typically the cost difference between a computer with the fastest processor and a model with second fastest processor far outweighs any speed advantage gained by the faster CPU (processor). So whether you are buying a Mac or a PC, you are better off with a slightly slower CPU and spending the money saved on improving other system hardware.

FIG. 1.16 CPUs.

Which Is Faster, a Mac or a Windows PC?

This is probably one of the most frequently asked questions on the Lightroom forums. Lightroom on the Mac has a very slight performance edge over a PC running Windows XP. The difference is so small that as a user, you wouldn't notice it. When Lightroom under OS X 10.5 is benchmarked against Lightroom running under Windows Vista, the difference in performance is more noticeable. That's not as much because the Mac is faster, but more about Vista being slower. Of course, there is a way to speed up Windows Vista—run it on a Mac using one of the popular virtual machine applications like Apple's Boot Camp or Parallel's Desktop for the Mac.

New in Lightroom 2.0 is another way to improve the overall performance—using 64-bit operation.

64-Bit Operation

Lightroom 2.0 can run in 64-bit mode offering improved memory handling and improved overall performance. On a Windows platform, the operating system must be the 64-bit version of Windows Vista. Most Vista installations are now 64-bit versions of the operating system.

To get the 64-bit version of Vista, you must have hardware that supports it and in some cases you need to order the 64-bit version from Microsoft who will charge you a small fee for shipping you the disk. When you run Lightroom on a 64-bit version of Vista, it runs in 64-bit mode if you've installed the 64-bit version. You can also install the 32-bit version on Windows. By default on a 64-bit system, the 64-bit version of Lightroom will be installed.

A common misconception is that using the 64-bit version of Vista only allows you to run applications that support 64 bits. It's not true.

Mac OS X on an Intel-based system is a 64-bit OS. To get Lightroom to run in 64-bit mode requires that you set it up as shown next:

1. In Finder, locate Lightroom 2 in the Applications folder.

2. Ctrl + Click on Lightroom 2, and from the secondary list that opens choose Get Info.
3. In the Info box, uncheck Open in 32 Bit Mode as shown in Figure 1.17.

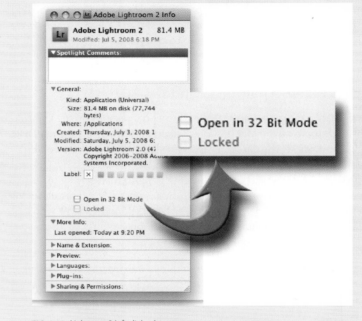

FIG. 1.17 Lightroom 2 Info dialog box.

The original i-Mac uses a version of the Intel duo chip that doesn't support 64-bit, so the Info box will not have the **Open in 32 Bit mode** check box.

4. Close Finder and launch Lightroom. The opening splash screen (Figure 1.18) shows that Lightroom is running in 64-bit mode.

FIG. 1.18 Splash screen at launch shows Lightroom is running in 64-bit mode.

Thanks for the Memory

Lightroom loves memory (called RAM or SDRAM). The truth is many computer applications can benefit from extra RAM. Fortunately, RAM prices have plummeted in the past few years. At the time I am writing this, 4 GB of RAM can be found online for less than $130 (Figure 1.19). There are limits to the amount of RAM you can stuff in your computer, like the number of memory slots in your computer. My Macbook Pro can hold 4 GB of RAM, but it can only address 3 GB. On older systems there was is limit as to how much RAM the operating system could effectively address or use, but with today's operating systems that is no longer an issue.

FIG. 1.19 RAM product shot.

So how much RAM do you need? As a general rule of thumb, 2 GB of RAM is a good amount of memory. If you are running Lightroom in 64-bit mode, you should consider increasing system RAM to 3 or 4 GB take real advantage of power of 64-bit operation.

Video Graphics Cards

The video graphics card, also called graphic accelerator, is a piece of hardware (often quite an expensive one) that seems like it should speed up all of your image editing. Actually, these cards are designed to speed up video games and editing movies. They do not provide noticeable improvement when used with Lightroom, Photoshop, or Photoshop Elements. I am not saying that you can't buy some hot graphics card to feed your videogame habit and say that it is for improving Lightroom. I am only saying you shouldn't expect to see any difference in performance—with Lightroom.

How about My Wacom Tablet?

With the addition of Localized Correction in Lightroom 2.0 comes support for pressure-sensitive tablets. The Adjustment brush reads the pressure date from the tablet and uses it to control the flow of the brush. If you will be doing a lot of retouching, you should invest in a tablet. Wacom has a new tablet called Bamboo (Figure 1.20) that sells for much less than $100. The Adjustment brush is much easier to use with a stylus than a mouse. For the record, there are other companies that make wireless pressure-sensitive tablets, but Wacom makes the best ones, so accept it.

FIG. 1.20 Bamboo tablet.

Color Calibration

I am sure you have read about the importance of calibrating your monitor, but this is the most important necessary step to develop a color-managed workflow. Although the colors on your monitor will never exactly match those on the printed page (reflective versus transmitted light), you can get it close enough so that the colors you see on the monitor will more closely match the colors you'll see in the final print.

The most effective way to calibrate and profile your monitor is to use a colorimeter. This is a device that, using the software that comes with it, automatically measures color samples on your monitor and builds a profile that will ultimately lead to creating more color-correct prints. These devices used to cost a lot of money but now can be purchased online for $60 to $80. I recommend you consider the Pantone huey Monitor Color Calibrator (**Figure 1.21**).

FIG. 1.21 Pantone huey Monitor Color Calibrator is an inexpensive tool that accurately corrects the color on your monitor.

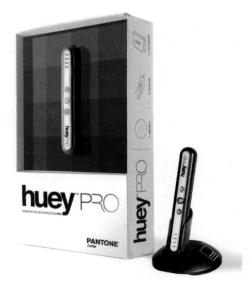

I have used one for several years, and it not only calibrates my LCD monitor but it also has a little stand that works as an ambient light monitor that adjusts the monitor in response to the lighting in the room. There is a Pro version of the huey that has the same sensor—only the software features are expanded.

The colors of your monitor change over time. If you are using a CRT monitor, it is generally accepted that you should calibrate it weekly. If you are using an LCD, no one agrees on how often it should be calibrated. The software with my huey reminds me to calibrate it once a month, which I do and am thankful for the reminder.

Using Multiple Monitors

Using more than one monitor allows you more display space to focus on the task at hand. There are several reasons people give for not using multiple monitors, but the one I hear the most is that they don't want to go through the hassle of setting it up. If that is your objection, I think I can help you. You only need to plug the second monitor into your computer Lightroom and your operating system does the rest.

A popular question for those setting up multiple monitors for the first time is, will my computer support two monitors or do I need to buy a special card? The first answer is usually yes; your computer, in most cases, supports two monitors. If it is a notebook, there is an external monitor port. If your Windows computer is a recent desktop, there are two outputs. One is DVI and the other analog RGB. So the second answer is if you don't have two monitor ports, you don't need a special dual-monitor graphics card; you will need to buy a second graphics card, which sell online for around $20.

Another question asked is, do the monitors have to be the same size or shape? No, any monitor will work.

Using multiple monitors is easier than describing it:

1. The filmstrip must be open to view the icons that control the settings. Clicking the icon for the primary (1) monitor in the lower-left corner opens a list of options for the primary display as shown in **Figure 1.22**.
2. Clicking the Monitor 2 icon toggles the second monitor on and off. Right-clicking (Cmd-clicking on the Mac) the icon opens the same options for the second display that appeared for the primary display. You can also just click and hold to see the options.
3. From the second display, you can choose one of Grid, Loupe, Compare, and Survey in the upper-left corner. See Chapter 2 for more information about these modes.
4. The upper-right corner has options that are unique to the second display. In Normal, the second monitor displays the currently selected image in the primary display. Live causes the monitor to show any image that you are hovering over with a mouse. To try it out, select Live and move the mouse

FIG. 1.22 Primary display options.

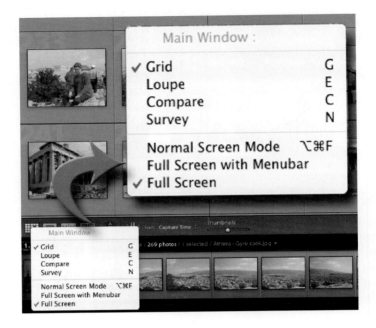

over the filmstrip; the images in the secondary monitor will change as you move the mouse along the strip. Locked keeps the image in it unchanged regardless of what you actions you take in the primary display

5. If you don't have a second monitor, this option still works. Huh? Clicking on the Monitor 2 icon when you don't have a second monitor attached causes the screen that would have appeared on the secondary monitor to appear on the primary, as shown in Figure 1.23.

FIG. 1.23 Multiple monitors with only one monitor.

After you plug in a second monitor and set it up, there are many ways to integrate it into your workflow. My favorite use for multiple monitors is for retouching photos. I set the second monitor for Loupe with Fit to Screen. This allows me to see the effect on the entire image while I am zoomed in on a photo to retouch with the Adjustment brush as shown in **Figure 1.24**. Whatever your personal preference, you will find working with Lightroom on multiple monitors to be very helpful.

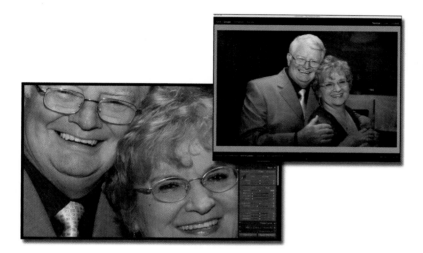

FIG. 1.24 Using second monitor to view an image involving close-up retouching to see the effect as I work.

Customizing Your Identity Plate

The main Identity Plate (IP) in the upper-left corner allows you to customize the look of Lightroom and make it your own. The default IP looks like the one shown in **Figure 1.25**. There is a second Identity Plate, which is only used in the Print module. The set-up of both Identity Plates is the same with few exceptions. See the Chapter 11 for details on Print IP exceptions and on using it:

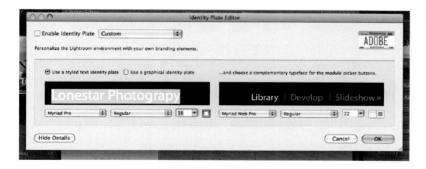

FIG. 1.25 The default Identity Plate.

1. From the Lightroom menu, select Identity Plate Setup shown in **Figure 1.26**. From here you can enable the Identity Plate, which then appears in the upper-left corner replacing the Adobe Default logo.

FIG. 1.26 Identity Plate Editor.

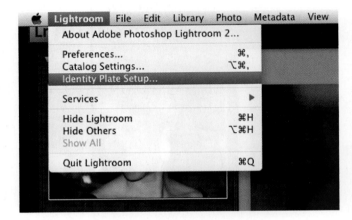

2. There are two choices for the Identity Plate: Styled Text or a graphical element. The default Styled Text option displays the name registered as the computer administer.
3. After highlighting the text in the box on the left side, you can change any of the font attributes (**Figure 1.27**). Change the font color by clicking on the color patch. The font attributes of the module names in the box on the right side can also be changed, but you cannot change the names.

FIG. 1.27 Identity Plate with changed font attributes.

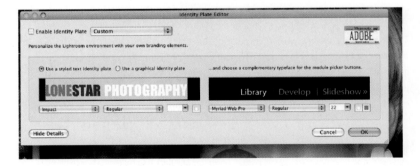

4. If you select the Use a graphical identity plate option, you can add a logo in the form of a graphic image by pasting or dragging an image into the Identity Plate area; most popular image formats can be used. The logo cannot be more the 60 pixels tall, but it does support transparent pixels. This size limitation makes the image too small to print, which is why the IP in the Print module doesn't have a size restriction.
5. Once you have the IP the way you want it, you can save it by selecting Save As from the drop-down list as shown in **Figure 1.28** and give your custom IP a name.

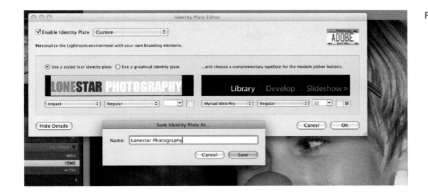

FIG. 1.28 Saving a custom IP name.

Customizing Essential Preferences

Lightroom, like most other applications, has a number of preference settings on six tabs in the Preferences dialog box. To open the Preferences dialog, use the keyboard shortcut Ctrl + , (Win) or Cmd + , (Mac). In most cases, the preinstalled default preferences will work fine. There are a few preferences that you should be aware of in order to optimize Lightroom for your photo workflow. The preferences are grouped into different sets that can be accessed by clicking the tabs at the top of the dialog window.

General Tab

Click the General tab to open general preferences, and in the Default Catalog section the default setting is Load most recent catalog. For most situations, this is perfect. If you use multiple catalogs in your work, click the pull-down menu and choose Prompt me when starting Lightroom (Figure 1.29). Each time you start Lightroom, it will ask you which catalog you want to use. You can also pick a catalog from the list shown, but if you just want to switch catalogs, it is much simpler to open another catalog from the File menu and not from preferences.

Presets Tab

From this tab you can control the Lightroom presets and specific settings that are applied to multiple images (Figure 1.30). There is an option that is unchecked by default (Apply auto tone adjustment) and I recommend leaving it unchecked. It is rarely wise to apply auto tone to all of the images. If you really feel the urge to do it, you can always select it as one of the Import options in the Library module. These preset settings can be used to speed up your workflow if you have a lot of custom settings and custom camera profiles you want to apply to images from a shoot. For example, if I have created a calibrated camera profile for my Nikon D-300 and it is possible to enable

27

FIG. 1.29 Lightroom catalog loading preference settings.

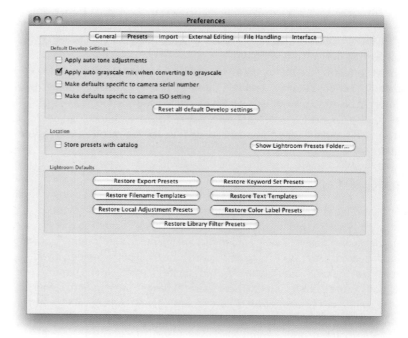

FIG. 1.30 Presets.

Make defaults specific to camera serial number, then anytime I import images made with that camera, Lightroom applies the specific settings I have created for the camera. In a like manner, the setting below that Make defaults specific to camera specific to camera ISO setting is a time-saver. I do a lot of low-light photography (some ministers officiating a wedding hate flash cameras with a passion), so I must set my camera to an insanely high ISO level (6400+) and take the photos. When I import these images, with this option set, Lightroom applies the multiple settings I have developed for these low-light photos automatically during import. Again, this is advanced Lightroom stuff that I mention only so that you will know that these features exist.

In the Location section of the Presets dialog is an option called Store presets with catalog. Lightroom presets are stored in a folder in Lightroom. To share the presets if you will be accessing the catalog on different computer, you can check this option. Before you get excited, this option doesn't allow one catalog to be shared by multiple users on a network. Lightroom 2.0 doesn't support that kind of sharing, regardless of any true stories you have heard in forums by users who claim to have done so. This option allows you to open a catalog on a different computer and have all of the presets from one computer be available on the other.

Import Tab

Several settings are of interest in this section (**Figure** 1.31). The default setting that is enabled is Show import dialog when a memory card is detected. It will also open the Import dialog if you plug a camera into the computer. The only time you may want to uncheck this setting is if it is causing a conflict with another program that also is trying to launch when you plug in a card reader. The Ignore camera-generated folder names when naming folders option is self-explanatory. Most cameras offer users the ability to customize their internal folder names, but if you choose the default camera settings, it produces a folder name made up of the date. You should consider checking this option and creating an appropriate name when importing (see Chapter

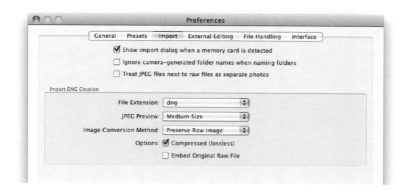

FIG. 1.31 Presets section of preferences.

2 for more details). The last option to consider only applies if your camera is set to shoot combination Raw + JPEG images. Checking Treat JPEG files next to raw files as separate photos does just that. Each image from the camera is saved as a raw file and a JPEG.

External Editing Tab

The External Editing tab controls the image settings for photos that are edited in Photoshop CS3. The Additional External Editor section is where you set up the other editor that will be accessed from within Lightroom. The dialog box shown in Figure 1.32 shows Adobe Photoshop Elements, but you can select several other applications by pressing the Choose button and locating the application. There are several points to note with this preference tab. First, the top application must be Photoshop CS3 or later. Lightroom cannot work with earlier versions because they do not support the features that version 2.0 of Lightroom needs to do its magic. The default setting for Bit Depth is 16 bits/component (16 bits per channel), which means huge files—not virtual copies, these are large files. When I am working on images that are not fine art, I back this down to 8 bits per component. For example, I did some photography at a company picnic, and I was convinced that none of the shots would end up in an art gallery, so I changed the External Editing settings to 8 bit. This way if I wanted to open up one of the images in Photoshop, it would become a reasonably sized image file.

FIG. 1.32 External Editing tab of preferences.

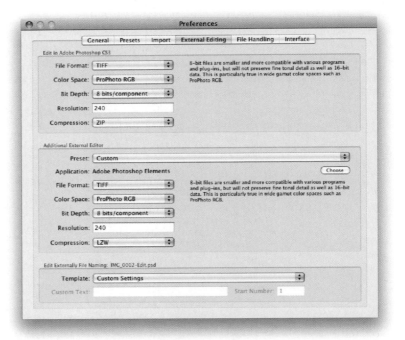

Even though Photoshop Elements has Photomerge for making fantastic panoramas and it is just like the one in Photoshop, Lightroom cannot directly upload images into the Elements version of Photomerge as it does with CS3.

File Handling Tab

Most of the items in this tab are self-explanatory, but there is one that might puzzle you. I am referring to the Camera Raw Cache Settings section. Every time you open a raw image in Lightroom, you are using the Adobe Camera Raw (ACR) software. When the raw image is opened, the full resolution of the image must be loaded into the ACR, an operation that uses significant processor power. The Camera Raw cache caches recently opened images to make reopening them faster. The Maximum Size setting determines the maximum size of the image. When more images are opened, the cache size remains constant because Lightroom removes older cache files as newer raw images are loaded into Lightroom.

In the Camera Raw preferences, you can control how large of a cache to allow and where it is stored; there is even a Purge Cache button that will purge the cache while in Preferences. The default setting is 1 GB. This setting is a trade-off. If you have limited space on your hard drive, you may want to keep the size of the cache small. Otherwise if you have plenty of space and you are opening a lot of raw files, kick up the setting to several gigabytes for improved performance.

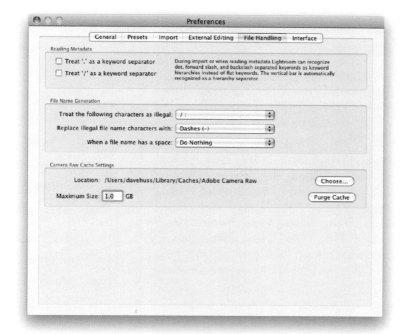

FIG. 1.33 File Handling tab.

One final thought about Camera Raw Cache Settings is that the cache is a shared resource. This means that if you have Adobe Bridge, Photoshop CS3, or any Adobe application that uses ACR; each one of those applications has control over the size of the Cache Settings. So if the maximum size of the Cache setting in Bridge is 3 GB but Lightroom on the same computer is set for 1 GB, when Bridge is operating it will allow the cache expand up to 3 GB. As soon as Lightroom begins to use it, the cache size will be reduced to 1 GB.

Help and Other Resources

Lightroom is user-friendly and relatively easy to learn. Even with that, you should familiarize yourself with some of the great online Lightroom resources. The best built-in help tool is the Adobe Help viewer. To launch the help viewer, choose Lightroom Help from the Help menu. You can browse by topic or enter a request in the search field.

Another invaluable resource is the free Adobe Online resource center. To access these resources, choose Help > Help Resources Online (**Figure 1.34**).

FIG. 1.34 Adobe Help Online resource.

If you are interested in learning more about Lightroom, there's more information than you can image available for free on the Web. You can go to the sites I list in this discussion or use Google to search for Lightroom 2.0. Just make sure that the article you are looking at is describing Lightroom 2.0 and not 1.x.

The following sites are some of my favorites:

Lightroom News

This site is run by Martin Evening & Jeff Schewe. These guys are a great resource for detailed Lightroom information and news (**Figure 1.35**); http://lightroom-news.com).

FIG. 1.35 Lightroom News.

Adobe Exchange

This is a great site for sharing and learning about everything Adobe. There are plug-ins and free downloads of presets and templates. You name it and you can probably find it there (**Figure 1.36**; www.adobe.com/cfusion/exchange).

33

FIG. 1.36 Adobe Exchange.

Lightroom Galleries

Described as a home for Lightroom Web Gallery templates, this site is discusses everything you need to know, have, and share to make your Lightroom Web pages rock (Figure 1.37; www.lightroomgalleries.com/index.php).

Lightroom Queen

Victoria Bampton (the Lightroom Queen) is currently building this site, which will include an eBook based on all of the questions that are posted in the Adobe forums. What is there now is an excellent PDF that lists all of the keyboard shortcuts in Lightroom version 1.x and version 2 (for both the Mac and the PC), so in all there are four PDFs (Figure 1.38; www.lightroomqueen.com).

Lightroom-Blog.Com

Run by Sean McCormick who is one of the most knowledgeable Lightroom users I know, this site offers a wealth of information about Lightroom (Figure 1.39; www.seanmcfoto.com/lightroom).

FIG. 1.37 Lightroom Galleries.

FIG. 1.38 Lightroom Queen.

FIG. 1.39 Lightroom-Blog.com.

Getting to Know the Library Module

The Library module is used to bring your images into Lightroom, which you'll need to do before making adjustments (in the Library and Develop modules), creating slideshows (in the Slideshow module), printing (yep, in the Print module), and building Web presentations (in the Web module). This chapter and the next introduce you to the Library module and provide details on how to import, label, and tag your images. And in Chapter 5, we'll show you how to use the Quick Develop panel to make easy adjustments to your images right from the Library module.

Understanding the Parts of the Library Module

As with all the other modules, the Library module is split into several basic sections (Figure 2.1). In addition to the menu bar at the top of the screen, the module contains the following parts:

Grid (or Image) Display

Search for photographs using the Library Filter Tools

Identity Plate

Top Panel

Left Panel Group

Right Panel Group

Toolbar
Filmstrip

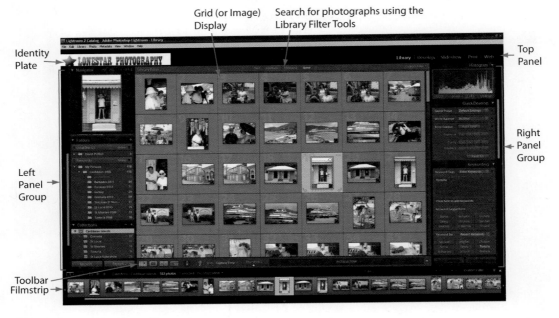

FIG 2.1 The Library module with everything turned on.

- **Top panel**. The top panel section contains the module picker, allowing you to move between different Lightroom modules. The top-left section also contains the Identity Plate.
- **Left panel group**. The left panel group is where you manage catalogs, folders, and collections (discussed in Chapter 4).
- **Right panel group**. The right panel group contains controls for adjusting images (Quick Develop), working with keywords, and viewing or changing metadata.
- **Library Filter Bar**. Just under the top panel is the Library Filter Bar, which enables you to locate images by various characteristics, including the date taken, the camera used, location, keywords, and even text associated with various picture fields.
- **Toolbar**. The toolbar contains tools for changing the view of the photos, sorting your images, setting the rating and labels for photos, and much more. You can toggle the toolbar on and off with the T key.
- **Filmstrip**. The filmstrip at the bottom of the screen contains the thumbnails of all the images currently displayed in the library. The filmstrip is available in all modules, providing a convenient way to choose a picture without switching back to the Library module.
- **Grid view or image display**. The central section in the middle of the screen is the part of the interface where you view, select, sort, and work with the photos. You can display multiple image thumbnails (and control the size of those thumbnails), a single picture, or multiple pictures for comparison.

Setting the View Options in the Library Module

Although the default image view in the Library module displays a set of thumbnails, you can choose other views, as described later in this chapter. You can also configure the thumbnails to customize the amount of information displayed, essentially trading screen space for information. That is, you can choose to display minimal information about each thumbnail (Figure 2.2) and see a lot of thumbnails or display a lot of information about each thumbnail (Figure 2.3) and see fewer thumbnails.

FIG 2.2 With the bare minimum of information, you can fit many thumbnails on your screen.

Thumbnail size slider

FIG 2.3 Or you can add information directly into the thumbnail, but this makes each thumbnail cell larger.

If you hover your mouse pointer over a thumbnail, most of the information available in the larger cells appears in a tooltip.

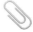

Understanding the Views

The Library module provides four different views of your image: Grid, Loupe, Compare, and Survey. You can switch between the views using the icons at the left end of the toolbar (see Figure 2.4), by selecting the view you want from the center section of the View menu, or by using the keyboard shortcuts, as noted in the callouts for Figure 2.4.

FIG 2.4 Use these tools on the toolbar to switch views in the Library module.

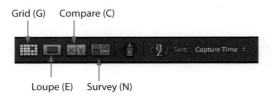

Grid (G) Compare (C)

Loupe (E) Survey (N)

Use the Grid View

The Grid view (shown previously in Figure 2.2) shows thumbnails in the central grid area. You can select a thumbnail by clicking it, or you can select multiple thumbnails by clicking the first one then Ctrl-clicking the remaining thumbnails. Additionally, you can select a range of thumbnails by clicking the first one, then Shift-clicking the last one in the sequence. You can even combine Shift-click and Ctrl-click; for example, you can select a range of thumbnails using the Shift-click technique, then exclude individual thumbnails from the selection by Ctrl-clicking those thumbnails.

> If you want to include certain photos in a slideshow, print layout, or Web gallery, select them in the Library grid before switching to the Slideshow, Print, or Web modules. The selected images remain selected when you switch to the Slideshow, Print layout, or Web gallery, enabling you to choose Content > Use Selected Photos from the Play menu (Slideshow module), Print menu (Print module), or Web menu (Web module).

Lightroom uses the color of the thumbnail cell to clue you into which images are selected. The first image you select has a very light gray border, whereas the subsequently selected images are a shade of gray that is darker than the originally selected image but lighter than the unselected images (Figure 2.5).

FIG 2.5 The cell border colors tell which images are selected.

First image selected Additional selected images Unselected image

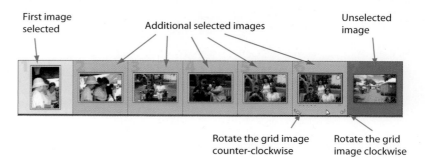

Rotate the grid image counter-clockwise Rotate the grid image clockwise

You can control the size of the displayed thumbnails using the Thumbnails Zoom slider in the toolbar below the grid area. Dragging the slider to the right increases the thumbnail size and reduces the number of visible thumbnails, whereas dragging it to the left shrinks the thumbnail size.

You can rotate the thumbnails in the Grid view. This is handy if the image in the thumbnail is lying on its side in the grid. This can happen if, for example, you shot an image by turning the camera on its side (portrait mode). The easiest way to rotate the thumbnail is to use the arrow controls in the bottom border of the grid cells. These controls are turned on by default and become visible when you move the mouse over the thumbnail (see Setting the View Options, later in this chapter, for instructions on how to turn these controls on and off).

You can also change the size of the thumbnails using the + and − keys. Actually, you use the = key (which has the + sign on it) to enlarge the thumbnails.

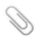

Using the Loupe View

The Loupe view uses the entire center section of the screen to display a single image (Figure 2.6).

Zoom slider in the toolbar

FIG 2.6 View a single image in Loupe view.

To toggle back and forth between the Loupe view and the Grid view, you can use View > Toggle Loupe View in the menu. You can also use the keyboard shortcuts E (to switch to Loupe view) and G (to switch to Grid view).

By default, the entire image is visible in the Loupe view, but you can zoom in and out to focus on specific areas of the image. In addition to various zoom levels, there are two special zoom settings called Fit and Fill. The Fit setting fits the entire picture into the central image viewing area. If the image does not have the same aspect ratio (the ratio of the length to the width) as the viewing area, there will be blank area either at the top and bottom borders or at the left and right borders. The Fill setting expands the image to fill the image viewing area, so that either the top and bottom border or the left and right borders extend all the way to the edges of the viewing area. If the image does not have the same aspect ratio as the viewing area, either the left and right borders will be cropped off (to fit the image into the top to bottom distance) or the top and bottom borders will be cropped off (to fit the image into the left to right distance).

You have quite a few options for adjusting the zoom:

- **Drag the toolbar Zoom slider**. Drag the zoom slider to the left to shrink the image or to the right to zoom in on the image. If you drag the slider all the way to the left, you'll see the Fit setting just above the slider. As you begin to drag the zoom slider toward the right, you'll see the Fill setting. As you continue to drag the zoom slider to the right, you'll see the various zoom ratios (1:4, 1:3, 1:2, 1:1, 2:1, and so on).

If you don't see the Zoom slider in the toolbar, click on the arrowhead at the right end of the toolbar and choose Thumbnail size from the pop-up menu.

- **Use the Navigator zoom controls**. The Navigator shows a large thumbnail of the image in the upper left corner of the Library module (Figure 2.7). Click on the Fit, Fill, or 1:1 (shows the image at 100% magnification) buttons above the thumbnail to set those zoom levels. You can also click the ratio control above the right corner to open a drop list and set a zoom ratio. The ratio is measured as two numbers—such as 1:4. When the left number is less than the right number, the image is shown at *less* than 100% (zoomed out). When the left number is *greater* than the right number (such as 3:1), the image is shown at greater than 100%, or zoomed in.
- **Use the View menu zoom controls**. The View menu contains two controls that change the zoom: Zoom In (Ctrl + =) and Zoom Out (Ctrl + −). Oddly, these controls don't always do what they say. Choosing Zoom In cycles first through the values Fit and Fill. Continuing to use this control then chooses either 1:1 and then the far right Navigator zoom level (if its 2:1 or higher) or the far right Navigator zoom level (if its 1:2 or lower) and then 1:1. After that, the control is unavailable. Choosing Zoom Out cycles through these same values in the reverse order. If you use the Zoom Out control again after Fit, it returns you to the Grid view.

FIG 2.7 Use the Zoom controls in the Navigator to control the image view.

- **Use the Z key or View > Toggle Zoom View**. Pressing the Z key (or using the menu option) in Loupe view jumps between the last two Zoom settings you used from the Navigator panel. That is, if you set the far right zoom control to 2:1, then click the Fill control (both in the Navigator), pressing the Z key jumps between 2:1 and Fill. If you press the Z key in Grid view, it switches to the Loupe view; pressing the Z key again switches back to Grid view.

Need an easy way to remember the keyboard shortcut for Zoom In? The equals symbol (=) is on the same key as the plus (+) symbol.

When the image in the Loupe view is zoomed in to the point where the entire image is not visible in the viewing area, you can click and drag the image to move it inside the visible area. The visible area is displayed as white rectangle in the Navigator (Figure 2.8). You can move the white rectangle in the following ways:

- Click on the outline of the white rectangle and drag it to a new area to view that area.
- Click somewhere else in the image and the white rectangle relocates to that area.
- Click inside the white rectangle and drag it to a new location.

Click and drag this
white rectangle

To show that part of the image here

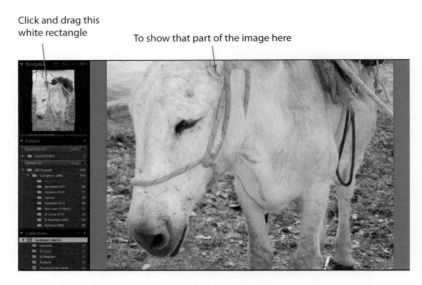

FIG 2.8 Click and drag the border of the white rectangle to display a different part of the picture.

If you are in Grid view and want to temporarily see the thumbnail in the Navigator in the Loupe view, click and hold the mouse pointer in the Navigator. Releasing the mouse button returns to Grid view.

Using the Compare View

As you might expect from the name, the Compare view enables you to compare two photos side by side. This is much easier than trying to compare photos by jumping back and forth between them in Loupe view.

To compare two photos, select them (click on the first, then Ctrl-click on the second) and click the Compare view tool in the toolbar or use the C key (Figure 2.9). The two images are normally linked so that changing the zoom level (using the Zoom slider) or clicking and dragging to show a different part of one image changes the other one as well. To unlink the zoom and position, click the padlock in the toolbar to unlock it (click it again to relock it).

You can select either of the two images by clicking on the image. To change the selected image, simply click on a different thumbnail in the filmstrip. There are a variety of other ways to change the images shown:

- **Sync the two frames**. If you unlocked the zoom/position so that the images are no longer aligned, you can force the unselected frame to match the zoom level and position of the selected frame by clicking the Sync button.
- **Swap the two images**. Click the Swap control near the right end of the toolbar to switch the frames of the two images.

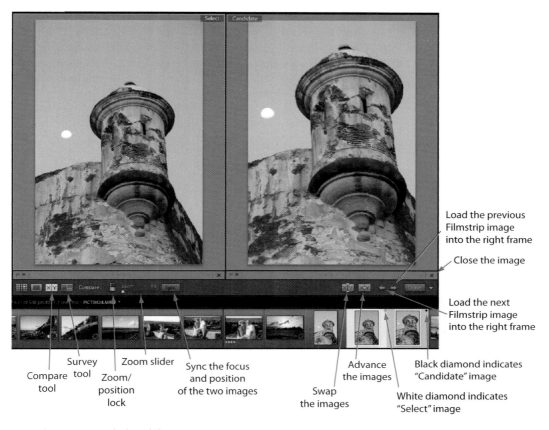

Load the previous Filmstrip image into the right frame

Close the image

Load the next Filmstrip image into the right frame

Compare tool

Survey tool

Zoom slider

Zoom/position lock

Sync the focus and position of the two images

Advance the images

Swap the images

Black diamond indicates "Candidate" image

White diamond indicates "Select" image

FIG 2.9 Comparing two nearly identical photos.

- **Advance the images**. Click the Make Select control (alongside the Swap control) to move the image in the right frame to the left frame and load the next image (to the right in the filmstrip) into the right-hand frame.
- **Select Previous Photo**. Click the left-facing arrow to load the previous filmstrip image into the right frame. The right frame is the only one affected, even if you have the left frame selected.
- **Select Next Photo**. Click the right-facing arrow to load the next filmstrip image into the right frame.
- **Done**. Click the Done button to switch to the Loupe view, displaying only the left-hand image.

Use the Survey View

The Survey view is useful for viewing multiple images at once. You can switch to the Survey view using the keyboard (press the N key), the Survey tool in the

toolbar, or choose View > Survey from the menu. The Survey view displays all the selected images (Figure 2.10). To add more images to the Survey view (and shrink the existing ones to make everything fit), simply select images from the filmstrip. As you pass the cursor over an image, a small black and white "x" appears in the lower right corner. Clicking on the "x" (or Ctrl-clicking on the image) removes the photo from the Survey view, but not from Lightroom. When the photo is removed, all the other photos are resized and redisplayed.

Select the previous photo in the Survey view

Select the next photo in the Survey view

Selected photo

Click here to remove this photo from the Survey view

FIG 2.10 Display multiple images in the Survey view.

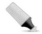

Do not press the "x" key on the keyboard instead of clicking on the "x" in the image. Doing so simply flags the image as "rejected," as we will discuss in Chapter 3.

The toolbar arrows select the next image (right arrow) or previous image (left arrows) of those in the Survey view. The selected image shows a white boundary around it.

Setting the View Options

You can control what information you see on the screen in both the Grid view and the Loupe view by selecting View > View Options (or pressing Ctrl + J) to open the Library View Options dialog box (Figure 2.11).

FIG 2.11 Specify what you want to see with the Library View Options dialog box.

Specifying the Grid View Options

The Grid tab in the Library View Options dialog box (seen previously in Figure 2.11) enables you to set what is visible in the thumbnail cells when viewing the grid. To configure what you can see in the grid, use the following steps:

1. To show any of the items in the various sections of the dialog box (Options, Cell Icons, Compact Cell Extras, and Expanded Cell Extras), select the Show Grid Extras check box. Leaving this check box empty grays out (makes unavailable) the rest of the options in the Grid View tab.
2. Choose whether you want to see the Compact Cells or the Expanded Cells by making a selection from the drop-down list at the top of the dialog box.

The Compact Cells view shows you the items listed in the Compact Cell Extras section of the dialog box, whereas the Expanded Cells view displays the larger cells containing the selected items in the Expanded Cell Extras section.

3. Set the options in the Options section. These include the following:

 a. Show clickable items on mouse over only. If you select this check box, certain items (such as the rotation arrows, star ratings, and Quick Collection button) are visible only when you hover the mouse over the cell. Otherwise, they are always visible.

 b. Tint grid cells with label colors. As you'll find out in Chapter 3, you can rate your photos with color labels. Selecting this check box tints the cell borders with the label color.

 c. Show image info tooltips. Selecting this check box displays a short text description flag (a "tooltip") when you hover the mouse over a control (such as a rotation flag) in the cell (Figure 2.12).

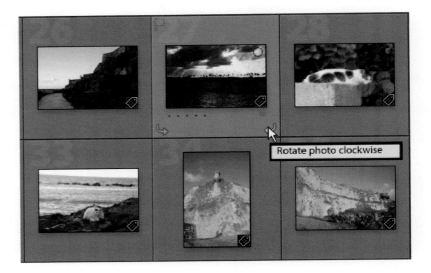

FIG 2.12 A tooltip is visible when you move the mouse over a grid cell control.

Rotate photo clockwise

4. Set the cell icons you want to see. These include the following:

 a. Flags. When the Flags check box is selected, items such as the "rejected" flag (see Chapter 3) are displayed in the cell.

 b. Thumbnail badges. These include the keyword flag (see Chapter 3) and the stacking indicator (see Chapter 4).

 c. Quick Collection markers. If this check box is selected, you can add a photo to a "Quick Collection" (see Chapter 4) by clicking the tiny circular button that appears when you move the mouse over a thumbnail (Figure 2.13). You can also remove it from the Quick Collection by clicking the marker again. If you do add the image to a Quick Collection this way and the Quick Collection Markers check box is selected, the marker stays lit even after you move the mouse away from that cell.

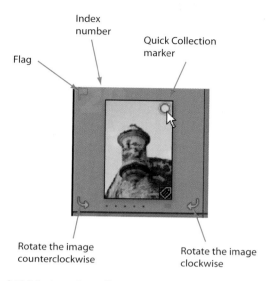

Index
number

Quick Collection
marker

Flag

Rotate the image
counterclockwise

Rotate the image
clockwise

FIG 2.13 Click the Quick Collection marker to add or remove an image from a Quick Collection.

5. Choose the Compact Cell Extras, which are visible when the drop-down list at the top of the dialog box is set to Compact Cells. In addition to the index number and rotation buttons (see Figure 2.13, shown previously), you can choose to display a top label and a bottom label, and select what to show using the appropriate drop-down list alongside each check box label. The two drop-down lists are identical and contain an extensive list of data you can display (Figure 2.14).

6. Choose the Expanded Cells extras, which are visible when the drop-down list at the top of the dialog box is set to Expanded Cells. You can add up to four pieces of information (from the four drop-down lists) to the cell. The list of available information is identical to the list shown in Figure 2.14, except that there is an additional option (None) to turn off the display of information in that list.

7. If you wish, you can select the Show Rating Footer check box to display colors labels and rotation buttons at the bottom of the cell.

You can choose a field to display in either the top label or the bottom label directly from the Grid view. Simply right-click a thumbnail in the spot where the Top Label or the Bottom Label is located (just above or just below the thumbnail image) and pick the field from the shortcut menu.

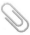

Specifying the Loupe View Options

It can be handy to display photo information in the Loupe view, as shown in Figure 2.15.

FIG 2.14 Pick what you want to see in the top or bottom labels with this list.

You can specify what information is visible in the Loupe view by clicking on the Loupe View tab of the Library View Options dialog box (Figure 2.16).

To turn on the overlay (and display any information), click the Show Info Overlay check box. You can then select from one of two overlays—Info 1 or

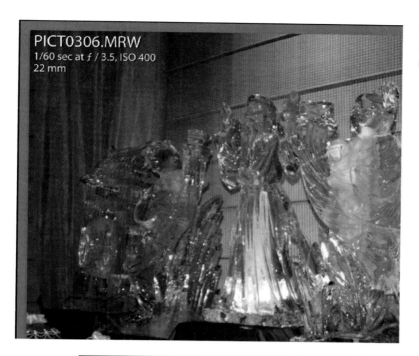

PICT0306.MRW
1/60 sec at *f* / 3.5, ISO 400
22 mm

FIG 2.15 It is helpful to see basic photo information right on the photo.

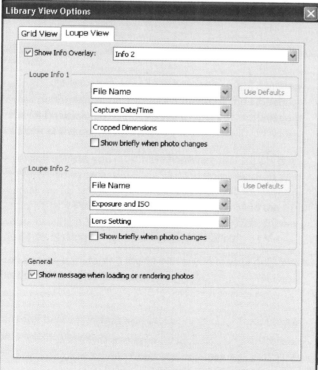

FIG 2.16 Pick the information you want to see from the Loupe View tab.

Info 2—by picking the option from the drop-down list. To pick the three fields visible in the selected overlay, choose the fields from the three drop-down lists in the Loupe Info 1 and Loupe Info 2 sections of the dialog box. The available options are the same as shown in Figure 2.14, shown previously.

If you don't wish to see the information overlay on the image all the time, you can choose to see it briefly when you select a new image in the Loupe view. Just select the Show briefly when photo changes check box.

To set the color of the area around the image in Loupe view, right-click and pick a color (such as black, white, and several shades of gray) and a texture (either None or Pinstripes) from the shortcut menu.

Setting the Grid View Style

Once you've specified the Grid view options in the Library View Options dialog box, you can use the View menu to specify what you'll actually see on the screen—that is, what options to use. Choose View > Grid View Style and make a choice from the menu items listed there:

- **Show Extras**. Toggling this option on (or pressing Ctrl + Shift + H) shows the extra information you specified in the last time you used this option.
- **Show Badges**. Toggling this option on (or pressing Ctrl + Shift + Alt + H) shows the thumbnail badges (such as the stacking notification and keyword icon).
- **Compact Cells/Expanded Cells**. Pick one of these options to set which view to show in the grid. Choosing one option deselects the other.
- **Cycle View Styles**. Choose this option (or press J) to cycle through the available view styles: Compact Cells, Expanded Cells, and all extras turned off.

Setting the Loupe Info

You can use the View menu to specify what you'll actually see in the Loupe view—that is, what options to use. Choose View > Loupe Info and make a choice from the menu items listed there:

- **Show Info Overlay**. Toggling this option on (or pressing Ctrl + I) shows the info overlay you specified in the last time you viewed Loupe info overlays.
- **Info 1/Info 2**. Pick one of these options to set which overlay to show in the Loupe. Choosing one option deselects the other.
- **Cycle Info Display**. Choose this option (or press I) to cycle through the Loupe views: Info 1, Info 2, and no overlay.

Controlling the Tools in the Bottom Toolbar

You have complete control over what tools appear in the bottom toolbar in the Grid, Loupe, and Survey views (but not the Compare view). To change the selection of available tools, click the down arrow at the right end of the toolbar (Figure 2.17) to drop down a list of available tools. Click a tool to turn it on (a checkmark shows) or turn it off (no checkmark).

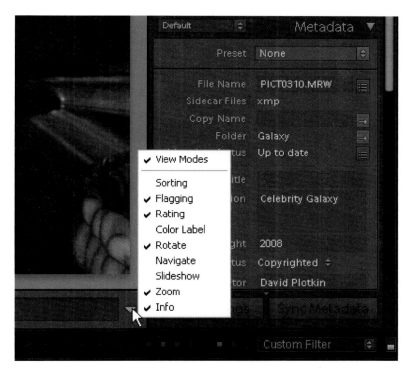

FIG 2.17 Control what tools you have using the toolbar drop-down list of tools.

You can select the available tools exactly this way in the Develop module as well.

Configuring the Filmstrip

You can configure what you see in the filmstrip thumbnails by choosing Edit > Preferences to open the Preferences dialog box and then clicking on

the Interface tab (Figure 2.18). The options in the Filmstrip section of the dialog box enable you to do the following:

- **Show ratings and picks in filmstrip**. Selecting this check box shows the flags, star ratings, and color rating (the color of the image border).
- **Show photos in the Navigator on mouse-over**. If you select this check box, the filmstrip thumbnail under the mouse is displayed in the Navigator section in the upper left corner.
- **Show badges in filmstrip**. Selecting this check box shows the badges (such as keyword flag and stacking indicator) in the filmstrip thumbnails. Note that these won't show up if the filmstrip images are too small.
- **Show image info tooltips in filmstrip**. Select this check box to show the tooltips when you hover the mouse over ratings, picks, or badges in the filmstrip.

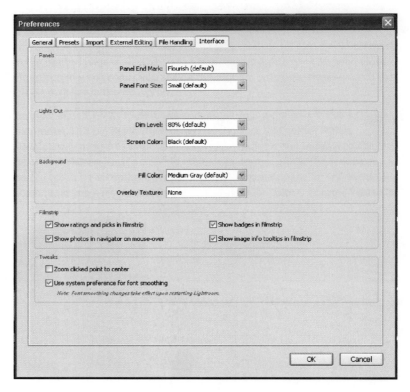

FIG 2.18 Configure what you see in the filmstrip using the Preferences dialog box.

To increase the size of the thumbnail images in the filmstrip, click and drag the upper border of the filmstrip (just below the toolbar) upward.

Customizing the Identity Plate

The Identity Plate lives in the upper-left corner of the various modules (as shown previously in Figure 2.1). You can tailor the Identity Plate to customize your copy of Lightroom. The Identity Plate also plays a special role with slide shows, printing, and Web presentations, covered later in the book.

To create a custom Identity Plate, choose Edit > Identity Plate Setup to open the Identity Plate Editor dialog box (Figure 2.19).

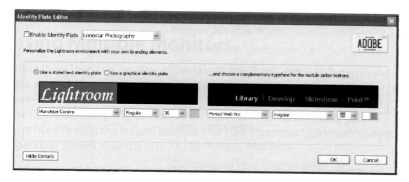

FIG 2.19 Create a custom version of the Identity Plate in this editor dialog box.

To create and save a custom graphic Identity Plate, use the following steps:

1. Click the Use a graphical identity plate radio button. The dialog box changes to show the graphical version of the Identity Plate Editor (Figure 2.20).

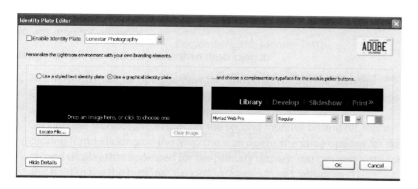

FIG 2.20 The graphical version of the Identity Plate dialog box.

2. If you want to clear an existing image and start over, click the Clear Image button.
3. Either click and drag an image onto the graphical area in the dialog box or click the graphical area and pick an image from the Open dialog box.

You can also click the Locate File button to navigate to a folder and choose a file.

4. Click the drop-down list in the upper left corner and choose Save As.
5. Fill in the name of the Identity Plate in the Save Identity Plate As dialog box, and click Save.

The maximum size of a graphical identity plate is 50 pixels high by 400 pixels wide. If you choose an image that is larger than that, it will be cut off. Note also that although the template does not show the full width of 400 pixels, the actual identity plate (in Lightroom) will show the full width.

To create and save a text identity plate, use the following steps:

1. Click the Use a styled text identity plate radio button.
2. Select and edit the text in the identity plate.
3. Select the portion of the text to which you want to apply the changes to the font, style, and size. Use the three drop-down lists to change the font (left), style (middle), and size (right).
4. Select the portion of the text to which you want to apply the changes to the color. Click the color box to the right of the size drop-down box, and pick a color from the Color dialog box.
5. Click the drop-down list in the upper left corner, and choose Save As.
6. Fill in the name of the Identity Plate in the Save Identity Plate As dialog box, and click Save.

Getting Your Photos into Lightroom

Before you can do anything with Lightroom, you have to get the photos into your computer. Lightroom can bring photos in from cameras (via card readers or direct connection) or it can import images that are already on the computer. During the import, you can choose to copy the files to another location, set up the metadata and keywords associated with the imported files, and even apply Develop module settings (which adjust the exposure, white balance, and other attributes of the image; see Chapters 5 and 6).

> Take the extra time to set up your import correctly before you begin. This will save you a lot of time later!

Setting Up Import Settings

To get ready to import images, you'll need to configure the Import settings for Lightroom. These are located on the Import tab of the Preferences dialog box

(Figure 3.1). To open the dialog box, choose Edit > Preferences in Windows or Lightroom > Preferences on the Mac and then click on the Import tab.

FIG. 3.1 Use the Preferences dialog box to configure your Import settings.

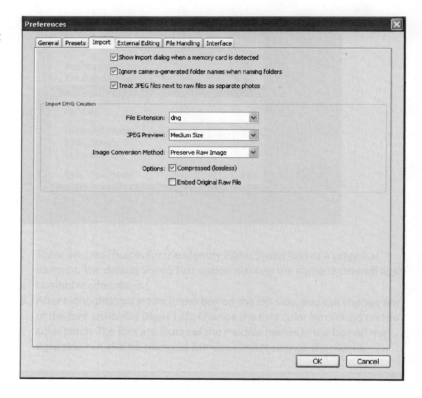

Right now, we are only interested in the settings near the top of the dialog box, which control the following:

- **Whether the import dialog box appears when you insert a memory card**. Select the first check box to have the Import dialog box (discussed later in this chapter) open automatically to begin the import process.
- **Ignore camera-generated folder names when naming folders**. Your camera puts some strange folder names on the memory card—like "DCIM." Select this check box to ignore those folder names when performing the import.
- **Treat JPEG files next to raw files as separate photos**. Some cameras have the ability to save both a raw file and a JPEG file from the same photo. If you set your camera to do this, you'll actually have two picture files for each photo. Select this check box to import and handle both image files separately. If you leave this check box unselected, only the raw file will be imported.

It is better to set up a system of folders to hold your image files. In theory, using Lightroom's image management capabilities, you could put all your images into a single folder, but this is not a good idea. By separating your pictures into folders—perhaps by location or event or trip—it will be easier to find them outside of Lightroom as well as view related pictures before you have implemented metadata and keywords to effectively group the images. For example, let's say you wanted to copy all of your photographs of the Lulling Texas 2008 Watermelon Seed Spitting Contest (yes, there really is one—you gotta love Texas). It is a simple matter to drag the folder to a CD icon to burn a copy—and you don't need Lightroom to do it. One more thing—it is better to set up the folders *before* you import the images, as that makes the whole process easier.

Importing Photos

You can import photos from a whole host of sources—photos you already have on your disk, photos from a camera card (device) and even photos from another Lightroom catalog. We'll leave importing from a Lightroom catalog for Chapter 4.

The basics of performing an import are the same, regardless of the source of the images. We'll discuss importing photos from disk first, then we'll point out the small differences when using other sources.

Importing Photos from Disk

Begin the process of importing photos from disk by selecting File > Import Photos from Disk (Ctrl + Shift + I) or clicking the Import button in the lower-left corner of the Library module. This opens the Import Photos or Lightroom Catalog dialog box (Figure 3.2).

If you've enabled the Import dialog box to open when you insert a camera card (from the Preferences dialog box), you can also begin the import process by inserting a camera card or connecting your camera to the computer.

Pick the folder(s) containing the images you want to import. If you want to select multiple folders, you can select the first folder, and then Ctrl-click additional folders. Click the Import All Photos in Selected Folder button, which opens the Import Photos dialog box (Figure 3.3). If you accidentally (I assume it would be accidental) include images that are already in your catalog, you'll get a dialog box (Figure 3.4) warning you that the images are already in the catalog and will not be imported.

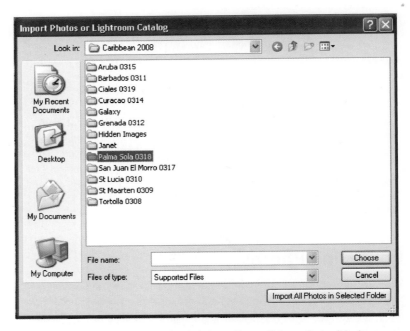

FIG. 3.2 Pick the source of the files on the disk with the Import Photos or Lightroom Catalog dialog box.

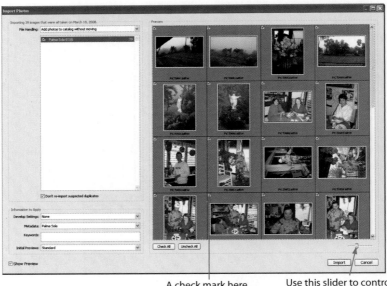

A check mark here
means the image will be
imported

Use this slider to control
the size of the preview
thumbnails

FIG. 3.3 Pick the folder(s) containing the images you want to import.

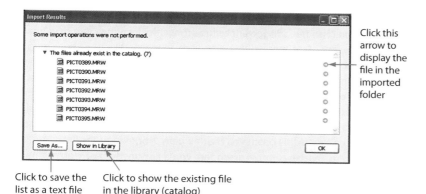

Click this
arrow to
display the
file in the
imported
folder

Click to save the
list as a text file

Click to show the existing file
in the library (catalog)

FIG. 3.4 A list of images already in your catalog—images cannot be imported twice.

If *all* of the images in the selected folder are duplicates (e.g., you've imported this folder before), Lightroom just displays a warning to that effect and lists all the duplicate files.

Once the import is completed, the Catalog panel shows a count of both the newly imported images (Previous Import) and those that were considered duplicates (Already in Catalog), as shown in Figure 3.5.

FIG. 3.5 Check out the duplicates that are already in your library.

Setting the File Destination

Use the File Handling drop-down list at the top of the Import Photos dialog box to pick how you want to import the images:

- **Add photos to catalog without moving**. This does just what it says— references the images right where they are on the disk. This is handy for images you already have on the drive where you like to store your photos.

- **Copy photos to a new location and add to catalog**. This option copies the photos to a new location and proceeds with the import (just as you might suspect!). It is handy if the images are currently stored on an external hard drive or on a camera memory card. In fact, this option and the DNG option (discussed in a bit) are the only ones available if your source is a camera memory card.
- **Move photos to a new location and add to catalog**. This option works just like the previous option, except that it erases the images after the import is complete. Proceed with caution on this one—I never use it, preferring to ensure that the images are copied correctly before manually erasing the originals.
- **Copy photos as Digital Negative (DNG) and add to catalog**. You also have the option to convert an image to a "digital negative" (DNG), while copying and importing it. DNG is an Adobe format that is rapidly becoming a standard for raw images, which differ from camera manufacturer to camera manufacturer—and sometimes, even from camera model to camera model. This option is best to use if you have decided to go exclusively with DNG format, as Lightroom will convert your files for you during the import. To configure how the DNG conversion is accomplished, use the Import tab of the Lightroom Preferences dialog box (Edit > Preferences).

If you don't see the preview thumbnails in your Import Photos dialog box (they are visible in Figure 3.3, shown previously), select the Show Preview check box in the lower-left corner of the dialog box. Unless you show the previews, you don't have the opportunity to pick the individual photos to import by selecting the tiny check box in the upper-left corner of each thumbnail. Oh, and by the way, the size of the preview thumbnails is controlled by the unmarked slider in the lower-right corner of the dialog box.

If you chose to either copy or move your files during the import, the Import dialog box changes to provide additional controls so you can specify where the files will be copied or moved to (Figure 3.6).

Any subfolders of the selected folder are displayed in the list below the Organize drop-down list. You can select (to include photos in that folder) or deselect (to exclude photos in that folder) the check box next to each folder.

Use the Copy to field to specify the top-level folder where the images will be stored. Your first option is to click the Choose button to open the Browse For Folder dialog box (Figure 3.7), where you can select or create a folder and then click OK to specify the new destination. If you want to pick a top level folder

FIG. 3.6 A new version of the Import Photos dialog box provides you with a way to specify the file destination during a copy or move.

FIG. 3.7 Use the Browse For Folder dialog box to pick a destination folder or create a new one.

that you've used before (such as C:\Documents and Settings\Username\My Pictures), click the tiny down arrow alongside the current Copy to destination and pick the destination from the list. This list also has the option to clear list, in case it is getting too long or includes invalid destinations (such as an external hard drive that is no longer connected).

The Organize drop-down list appears to have a lot of choices but there are actually only three. The choices are to put the photos into a set of folders with same name and structure as the source (By original folders), put them all into the same folders (Into one folder), or to tuck them into one of the long list of folders that use different date formats for the folder name (Figure 3.8). If you select Into One Folder, another choice appears (Put in subfolder), which gives you the option to put all of the images into the named subfolder you specify in the adjacent field. The subfolder is located beneath the folder specified in the Copy to field. If you select this choice, don't forget to enter a name or Lightroom will name the folder "Untitled Import."

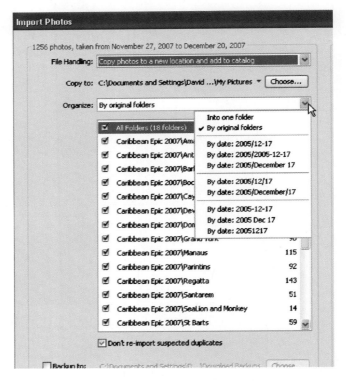

FIG. 3.8 Pick from one of the options for folders in the Organize drop-down list.

If you choose one of the By Date options, a list of the dates on which the photos were taken appears in the area beneath the Organize drop-down list (Figure 3.9). You can select (to include photos taken on that date) or deselect (to exclude photos taken on that date) the check box next to each date.

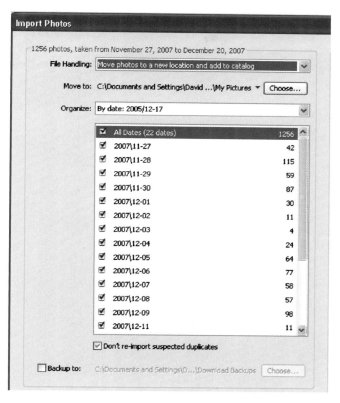

FIG. 3.9 Pick the dates you want to include in the import.

Handling Duplicates and Backups

There are two more options in the File Handling section of the Import dialog box. Don't reimport suspected duplicates, if selected, compares files being imported with those already in the catalog. Files with matching names *and* EXIF capture dates *and* file size are considered duplicates and are not reimported.

The other option (Backup to) produces a duplicate copy of all the imported files at a different location on a hard drive. It is a nice safety net that I like to use (especially for location shooting) to put the imported images on an external hard drive (you can't put them directly on a CD/DVD, as Lightroom won't burn these media).

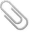

Back up the images to a hard drive other than the one where you are storing the imported images, especially when importing from a camera card, which you will then erase. Putting the photos and the back-up on the same hard drive is not much protection if the hard drive fails or someone steals your computer.

Naming Your Imported Files

The File Naming section of the dialog box enables you to choose a template (Figure 3.10) for either leaving the filename alone (choose Filename in the Template drop-down list) picking a template to rename the file, or choosing Edit to build your own template.

FIG. 3.10 Pick a template to rename (or not) your imported image files.

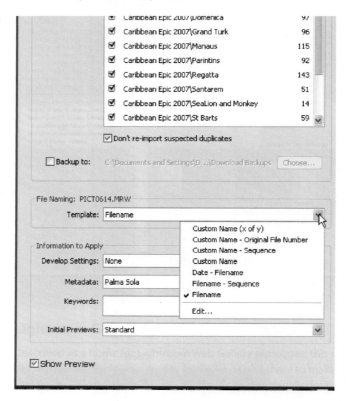

If you choose a template that contains the words "Custom name," you'll get a new field into which you can enter the custom text. If you choose a template that includes either *Sequence* or *x of y*, you'll also get a field to put in the start number (Figure 3.11).

If you choose Edit from the Template drop-down list, Lightroom displays the Filename Template Editor (Figure 3.12). Using this dialog box, you can build a custom text string that includes custom text as well as information numbering, date, and information about the image (metadata).

Here is how you can build your custom text string:

- **Start with a preset**. Choose a preset from the Preset drop-down list at the top of the dialog box. This populates the text box at the top of the dialog box with the contents of that preset. For example, the Date-Filename preset places the date field and filename field into the text string.

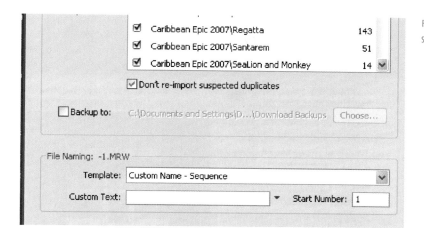

FIG. 3.11 Enter the custom text or sequence number in the new fields.

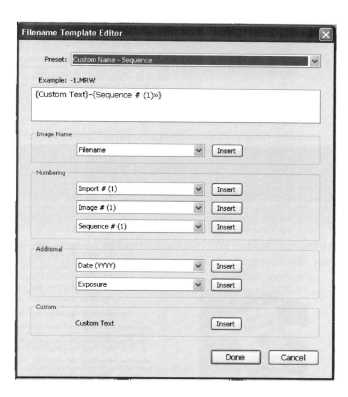

FIG. 3.12 Create your own custom filename templates.

The Example line above the text box displays an example of what the text string will look like.

- **Add a field from the various drop-down lists**. To add a field to the example text, choose the field from one of the six drop-down lists in the

dialog box. These lists are grouped by the type of data available in the drop-down list, such as the Image Name, Numbering, and Additional (which includes a list of metadata). Selecting an item from the drop-down list places it into the text string at the location of the text cursor.

If you want to add a field that is already visible in the drop-down list, click the Insert button.

To reposition the text cursor in the text string, click between the fields, which are denoted by braces ({}).

- **Remove a field from the text string**. To remove a field, click it to highlight the entire field—the text between the braces ({}) and then press the Delete key.
- **Change an existing field**. If you want to replace a field in the text string with another field from the original drop-down list, click the field, pause, then click again to display a shortcut menu with the options from the original drop-down list (Figure 3.13), and choose a different option.

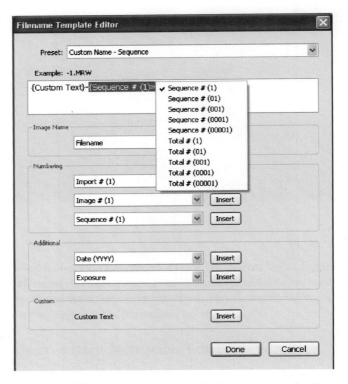

FIG. 3.13 Click an existing field twice to change the contents of that field with the choices from the original drop-down list.

- **Add custom text**. You can include custom text in the template, but the template doesn't actually contain the custom text; that must be entered in the Custom Text field back in the Import dialog box. Using custom text is a good way to add identifying labels.

If you just want to type characters (or spaces) between the fields, simply click between the fields and type the characters you want to add.

- **Save the settings to reuse them**. To save the contents of the Filename Template Editor so you can reuse them, click the Preset drop-down list and choose Save Current Settings as New Preset. Provide the name in the New Preset dialog box, and click Create.
- **Update an existing preset**. To update the preset you are currently working with, click the Preset drop-down list and choose Update Preset.
- **Delete a preset**. To delete a preset you are currently working with, choose Delete Preset (followed by the name) from the drop-down list. This option is not available for presets (such as Filename-Sequence) that are built into Lightroom.

You'll know that you've modified the existing preset (and thus might want to save the changes) because the name of the preset is followed by "(edited)" in the Preset drop-down list.

Choosing the Develop Settings

Develop Settings gives you the option of applying any of the settings from the Develop module. If you don't want to use one of the default presets, you'll need to have used the Develop module previously (see Chapter 6) and saved the image adjustments (such as exposure, white balance, contrast, and so on) as a preset so that the preset appears in the Develop Settings drop-down list. Be cautious while using this feature. It is rare that any one set of changes is appropriate for all of the imported images. That said, remember that, like all settings in Lightroom, the settings applied during import can be removed at any time.

Specifying the Metadata

The Metadata drop-down list is used to associate a set of information (metadata) with the imported image by picking a collection of metadata called a "metadata preset." You can specify a rating and label, copyright information, creator information, location information, keywords, and more. If you've built metadata presets (see Chapter 4 for more information on metadata), you can simply pick one of them from the Metadata drop-down list. Selecting New from the list enables you to build a new metadata preset (see Figure 3.13). If you want to pattern the new preset on an existing preset, simply pick the existing preset from the Preset drop-down list. Then, type in a name in the Preset Name field, fill in the various values in the dialog box, and click Create.

To edit an existing metadata preset, choose Edit Presets from the Metadata drop-down list. The resulting dialog box looks just like the one in Figure 3.14, except that the Preset Name field is missing. Just select the preset you want to change from the Preset drop-down list, make your changes, and click Done (which appears in the lower-right instead of the Create and Cancel buttons).

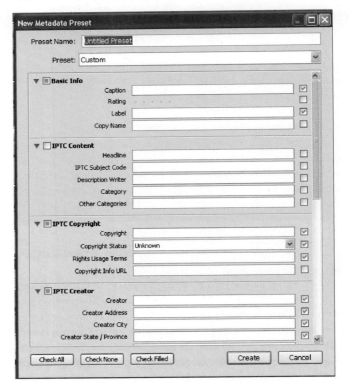

FIG. 3.14 Use the New Metadata Preset dialog box to build new collections of metadata you can associate with a group of photos.

Once you have created a metadata preset, you cannot rename it. About all you can do is create a new preset based on the misnamed one. Also, when editing a preset, the title will be followed by the word "(edited)" once you make any changes. Because there is no Cancel button in the Edit Metadata Preset dialog box (unlike the New Metadata Preset dialog box), the only way to cancel the changes you have made is to click on the red "x" in the upper-right corner.

One last thing about metadata: The color labels (discussed later in this chapter) actually write a value into the metadata Label field (in the Basic Info section). Thus, if you have information you don't want to inadvertently write over, *do not* put it in the Label field. You have been warned.

Specifying the Keywords

Understanding keywords are a crucial part of managing your images, especially if you shoot stock photos. But even if you don't, keywords are great for identifying people who appear in photos or the location of the photo. To add keywords to the Import Photos dialog box, just type them into the Keywords text box, separating them with commas. Lightroom tries to autocomplete the keyword, so you can just either press Enter (if there is just one keyword in the list) or arrow-down to pick the keyword you want and then press Enter. Just be careful—this feature can be intrusive as you type in a word while Lightroom keeps trying to help.

If you are running Lightroom on a Mac, you can run a spell check of the keyword field because the spell checker is part of the operating system. That won't work on Windows, though you can copy the contents of the Keyword field and paste them into a Word document. Spell check it there, make any corrections, and then copy and paste the list back into the Keyword field. Sure is easier on a Mac!

Did you notice that keywords are included in both the Import dialog box and the Metadata preset? If you import images using a Metadata preset that contains keywords, those keywords will be applied to the image and the new keywords created in the library (see Chapter 4). Thus, there is an advantage to putting the keywords in the Metadata preset as they become reusable. Any images you apply the preset to also get the keywords—unless that's not what you want.

Render the Previews

When you import the images into Lightroom, you need preview thumbnails to see the images in the grid. You can choose which previews to render from the Initial Preview drop-down list at the bottom of the Import dialog box. The Minimal setting just renders small thumbnails, suitable for viewing in the grid. The problem here is that any time you want to see the thumbnail any larger, Lightroom has to take the time to render it. The Embedded and Sidecar option is the fastest of all—it simply uses previews that are embedded in file types that allow for that (like JPEG) or stored in the "sidecar" files for raw format files. However, this option has the same issues as the Minimal setting. Choosing the Standard setting isn't much better, especially if you view the images at a large size in the Loupe view (or at full-screen on a second monitor). Thus, it is best to choose 1:1 as the value. For one thing, Lightroom is much faster at rendering the 1:1 previews during import than it is "on demand." The only downside is that the size of the collection of 1:1 previews can grow quite large, so if you're running short of disk space, you may need to clean out the collection of 1:1 previews by choosing Library > Previews > Discard 1:1 Previews.

Lightroom gives you complete control over both the size and the quality of generated previews. To control those settings, select Edit > Catalog Settings to open the Catalog Settings dialog box and click the File Handling tab, as shown in Figure 3.15.

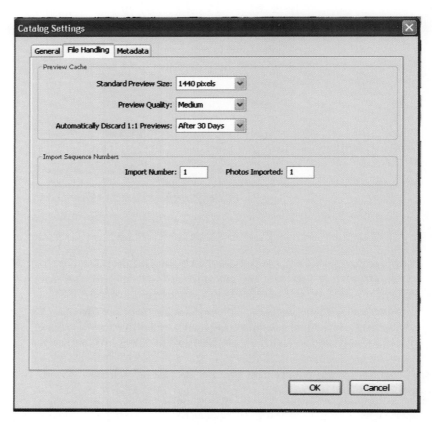

FIG. 3.15 Use the Catalog Settings dialog box to configure previews.

From this dialog box, you can set the following:

- **Standard Preview Size**. Select the larger dimension (either height or width) for the standard preview from the Standard Preview Size drop-down list. Values from 1024 to 2048 pixels are available.
- **Preview Quality**. Pick the quality (high, medium, or low) from the Preview Quality drop-down list. Higher-quality previews take longer to generate and are larger, but they give you a better idea of what your image looks like.
- **Automatically Discard 1:1 Previews**. As mentioned earlier, 1:1 previews can take up a lot of space. If you'd like Lightroom to automatically delete them after a certain time period, select that period from the drop-down list. You can also choose "Never," and the previews will not be automatically deleted.

Finishing Up

Once you've configured everything, click the Import button and the process begins. At first it may appear that nothing is happening. However, watch the upper-left corner and you will see a small progress bar replacing the Identity Plate indicating that the import is occurring (Figure 3.16). After a number of images have been imported, their preview thumbnails will begin appearing several at a time. If you want to see what percentage has been completed, minimize the Lightroom window (which will speed things up slightly) and the percentage completed will appear in the Lightroom entry in the taskbar (in Windows). When the progress bar disappears, the import has completed.

FIG. 3.16 Progress indicator displays what Lightroom is doing.

Before you import images in Lightroom, check *all* of your settings. Lightroom uses the last import settings. If you do not change them, your last settings will be applied to the current imports. Many settings applied during import are time consuming to correct.

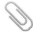

Configuring and Using Auto Import

You can have Lightroom watch a folder and automatically import images that appear in that folder. To perform this particular bit of magic, you'll need to set up the Auto Import Settings. Choose File > Auto Import > Auto Import Settings to open the dialog box (Figure 3.17).

The first parameter to set is the Watched folder. Simply click the Choose button, and navigate to the folder you want Lightroom to watch for new files. This should be a folder that contains all of your picture folders, as any image added to a subfolder is noticed as well.

The folder you specify in the Destination section specifies where you want the images moved to when Lightroom does the import. If you want the images imported into a subfolder of the selected folder, fill in the name of the subfolder in the Subfolder Name field.

The rest of the settings (such as File Naming, Develop Settings, and so on) work the same as previously described in the Import dialog box.

FIG. 3.17 Specify the settings to automatically import any new images found on your drive.

Just setting the auto import settings doesn't actually turn on auto import. To do that, you'll need to select File > Auto Import > Enable Auto Import. Note that this menu item is unavailable until you specify the Auto Import settings.

Importing Images via Drag and Drop

Another way to import images into Lightroom is to simply drag and drop files from a camera card or folder into the Library module. It does not matter which folder (if any) is selected, because this method of import also opens the Import Photos dialog box. From this point on, the Import operation continues as previously described.

Sorting Your Photos

You can control the order in which your photos are displayed in the Grid view and the filmstrip. To adjust the sort order, click the pop-up list alongside the Sort label in the toolbar (Figure 3.18).

The default sort order—capture time—works well most of the time, showing you the photos in the order in which you took them. But other options can be useful as well. For example, you might want to sort by rating (all of your five-star pictures together) or by Edit time (so you can see the photos you've worked on most recently). You can change the sort order at any time and the sort order has no effect on the images themselves or the catalog—it just changes the display order.

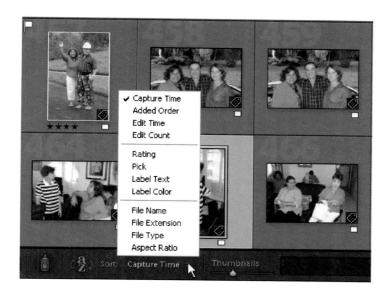

FIG. 3.18 Control the sort order of the images with this pop-up list.

Rating Your Photos

Lightroom provides quite a few ways to rate your photos, but the first step is to discard the photos that are so bad they aren't worth rescuing. To discard a photo, simply select it in the Grid view or view it in the Loupe view and press the Delete key. Lightroom presents you with the choice of deleting the image from disk (click the Delete from Disk button) or simply removing it from the Lightroom catalog (click the Remove button) (Figure 3.19).

FIG. 3.19 Choose whether to remove the image from Lightroom or the hard drive.

Rating Your Photos: So Many Ways

Lightroom developers went a little overboard when they came up with the rating systems (plural) that they designed into Lightroom. Here is a list of the ways that you can rate photos:

- **Stars**. Rate your images from zero to five stars—just like the movies!
- **Flags**. A more simplistic approach in which choices are flagged as picked, rejected, or not flagged at all.

- **Colors**. If you are not into stars or flags, you can use color labels. Color labels can also be used as an excellent process control tool because you can define the meaning for the colors, as we'll see shortly.

Working with the Star Ratings

Stars are simple to work with and you have a whole host of ways to set the star rating if an image. To change the number of stars, simply select the image(s) and do the following:

- **Press a number key between 1 and 5**. This method is the simplest—pressing 1 awards the image one star, pressing 2 awards it two stars, and so on. Press 0 to remove all stars. This method works in the Loupe view and even when viewing images in all the other modules. In fact, you can even press one of these keys during a slideshow and rate the pictures as they're displayed.
- **Click the star symbols in the grid thumbnail**. These symbols show up as either stars (if the image has already been rated) or as small dots just below the left corner of the thumbnail (Figure 3.20). To clear the stars (set the rating back to 0), click on the rightmost star present. That is, if the image has three stars, click on the third star to turn them all off.

FIG. 3.20 Hover the mouse over the thumbnail to see the star symbols when no stars have been selected.

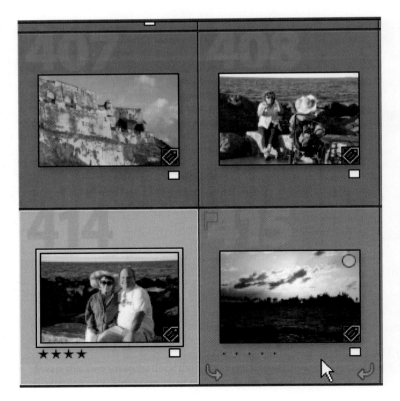

- **Click the stars in the toolbar**. If you've enabled the stars to show in the toolbar (click the arrow at the right end of the toolbar and pick Rating from the drop-down menu), click the stars in the toolbar. As with the Grid view, clicking on the highest-number star resets the rating to zero stars.
- **Use the menu**. Choose Photo > Set Rating and then pick the number of stars from the fly-out menu. You can also increase the rating by one star (choose Photo > Set Rating > Increase Rating or press the] key) or decrease the rating by one star (choose Photo > Set Rating > Decrease Rating or press the [key).

> If you can't see the stars in Grid mode, press the J key to change the view until the stars appear.

Flags: Simple and Effective

This is my tool of choice for sorting images. When the shoot is done, you can flag the best shots and tag (and delete if you wish) the flops. The flag is visible in both the Grid and the Filmstrip thumbnails if you have the appropriate options enabled. As you can see in Figure 3.21, the flags show up in the

Reject flag in the grid (image is dimmed)
Pick flag in the grid

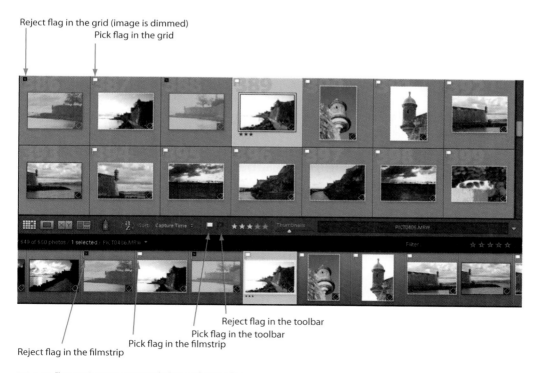

Reject flag in the toolbar
Pick flag in the toolbar
Pick flag in the filmstrip
Reject flag in the filmstrip

FIG. 3.21 Flag your images to separate the keepers from the flops.

upper-left corner of the thumbnail as well as in the toolbar (if you have
configured the toolbar to show the flags).

As Figure 3.21 shows, an image that has the "rejected" flag is dimmed in
the Grid view.

As with the star ratings, there are bunches of ways to set the flag for selected
images. The simplest way is to use the keyboard, pressing the following keys:

- P key to add the Pick flag.
- U key to remove a flag.
- X key to add a Reject flag.
- ` key to toggle the flag. This cycles the flag between Pick and Unflagged.
- Ctrl + Up Arrow. This sets an Unflagged photo to Pick.
- Ctrl + Down Arrow. This sets a Pick photo to Unflagged.

You can also use the Photo > Set Flag menu items, or click the flags in the
toolbar in either the Grid or Loupe view. Finally, you can right-click the flag
symbol in the upper-left corner and pick a flag rating from the tiny drop-down
menu that appears.

As with the star ratings, you can set the flag while viewing the images in
the other modules as well.

If you go to all the trouble of setting the Pick flag on all the images you want to
keep, you can "refine" the images in the catalog by choosing Library > Refine
Photos. This operation sets all the unmarked photos to Reject and sets the rest
of the photos to unmarked. You can then easily delete the rejected photos by
selecting Photo > Delete Rejected Photos (Ctrl + Backspace).

Working with Color Labels

Like star ratings, you can assign color labels to images. However, unlike
star ratings, you can assign values to the five color ratings and use them for
purposes other than just ranking photographs. For example, you can assign
values to the color labels that indicate where they are in the workflow—such
as unprocessed, processed, sent to Photoshop Elements, posted to the Web,
and so on.

To apply or change a color label, you can use the following methods:

- **Type in a number**. To set one of the first four flags (red, yellow, green, and
 blue), you can type in the corresponding number (6, 7, 8, or 9). Oddly, there
 is no number you can type for the last color (purple)—you'll have to use
 some other method of choosing that color. There is also no number you
 can pick to remove the color label from an image.

- **Use the Photo > Set Color Label menu**. All the colors are available from this menu. There is also a menu item for None, which removes the color label from the selected images.
- **Use the toolbar**. Click one of the colors in the toolbar to assign that color to the selected images.

Once you've assigned a color label to an image, it is easy to see which label is assigned in the Grid view (Figure 3.22). If the cell is selected, the border around the image is the same color as the color label for that image. If the cell is not selected, the entire cell background around the image reflects the color of the color label.

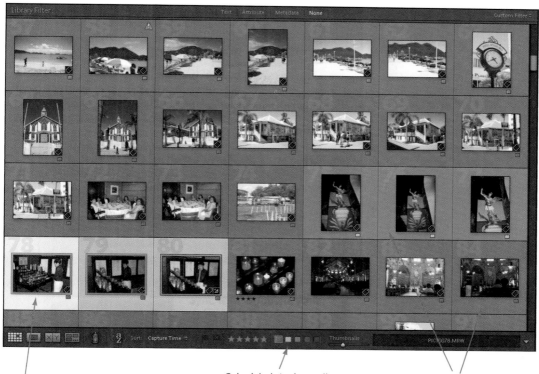

Selected cell shows the border color here

Color labels in the toolbar

Unselected cell shows the background color here

FIG. 3.22 The Grid view tells you which color label is assigned to the image.

If you don't see the color tinting described here, open the Library View Options dialog box (View > View Options), click the Grid View tab, and select the Tint grid cells with label colors check box.

What really makes the color labels useful is that you can assign values to each color then change the color label assigned to an image as you move through the workflow. For example, when I initially return from a shoot, I select all the images from that day and set them to "unprocessed" (the red label). After I add metadata, set the keywords, and make corrections in the Develop module, I set the color label to "Corrected" (the yellow label). I then convert the images to high-quality JPEGs and export them to Photoshop Elements to make adjustments I can't do in Lightroom. At that point, I set the color label to "Exported to Photoshop Elements" (the green label). And so on. You can see the full range of values I use in Figure 3.23.

FIG. 3.23 Customize your own preset for the Color Label set.

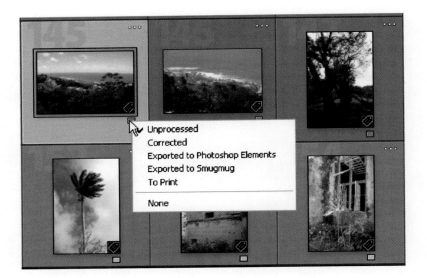

To create your own values for the color labels, use the following steps:

1. Choose Metadata > Color Label Set > Edit to open the Edit Color Label Set dialog box (Figure 3.24).
2. Select the text alongside each color label and type in the value you want for that color.
3. Click the Preset drop-down list and choose Save Current Settings as new preset.
4. Fill in the name of the preset in the New Preset dialog box and click Create.

You can switch between color label sets by picking a new preset from the Metadata > Color Label Set fly-out menu (Figure 3.25). You can also choose a new preset from the Edit Color Label Set dialog box Preset drop-down list, and then click the Change button.

If you can't remember what the different color labels are, there is help—just hover your mouse over the color label in the toolbar and the resulting tooltip shows you the value for that label.

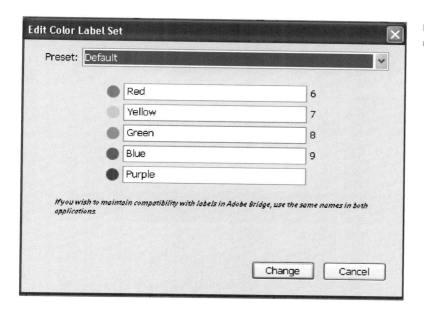

FIG. 3.24 Customize your own set of color labels.

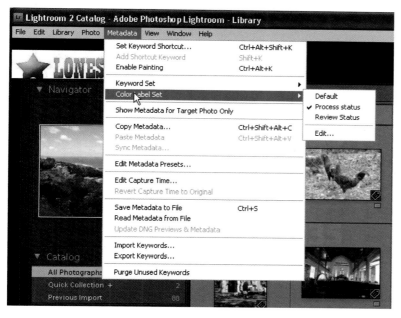

FIG. 3.25 Pick the color label set you want to use from the Metadata menu.

If you assign a bunch of color labels to images, then switch color label sets, the assigned colors disappear from the images. However, switching back to the original color label set reestablishes the assigned color labels unless you reassign a color label to an image while you're using the alternate color label set.

Filtering the Results

Now that you have all the stars, flags, and color labels in place, it is time to make some use of them. The quickest way to filter the current images by stars, flags, color labels, and type (master photo or copy) is to open the filters in the Library Filter bar at the top of the screen (Figure 3.26) by clicking the Attribute button (between Text and Metadata). This is a toggle—clicking Attribute again (or clicking None) turns off the filters.

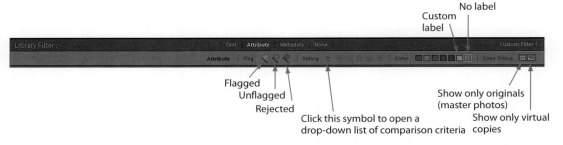

FIG. 3.26 The filters in the Attribute selection of the Filter bar make it easy to find images tagged with flags, stars, and color labels.

The rest of the options in the Library Filter bar are discussed in Chapter 4.

You can also turn the filters on and off by choosing Library > Enable Filters (Ctrl + L) to display a checkmark when filters are enabled.

If you're used to using the filters in the filmstrip in earlier versions of Lightroom, they are still there (Figure 3.27), though they may be a little hidden. If you don't see the full Filter strip shown in Figure 3.27, click the word "Filter" to display it. You can choose filters just as you would from the Attribute selection of the Library Filter bar. The advantage to having this Filter strip is that it available in any module, whereas the Library Filter bar at the top of the grid is available only in the Library module.

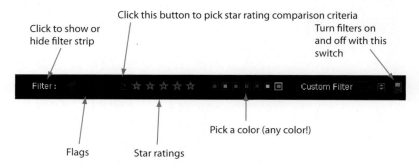

FIG. 3.27 The Filter strip can be used to pick stars and color labels.

If you filter on multiple criteria (such as images that have three stars and a red color label), only images that meet all the filter criteria will appear.

The behavior of the Attribute filters in the Library Filter bar (and those that appear in the Filter strip) is a bit tricky to understand, so we'll walk through it.

If you want to quickly disable all your filters and return to viewing the entire catalog, turn the filters off by using the Filter bar Attribute or None buttons by selecting Library > Enable Filters to remove the checkmark, or by clicking the tiny switch at the far right end of the Filter strip. To reenable the filters, simply use one of these toggles again.

Filtering by Flag

Click on one of the flag symbols to filter based on that flag status (as detailed in Figure 3.26, shown previously). You can click on multiple flag symbols to display images that meet either of the filter criteria. For example, if you click on the leftmost flag symbol and the center flag symbol, the images shown are those that are either flagged (the leftmost symbol) or unflagged (the center symbol). To remove the filter, simply click on the symbol again. Thus, if you click on the center symbol again to turn it off, the remaining images are only those that are flagged. To help you keep track of this, the Grid view displays a reminder of the filter criteria for a few seconds (Figure 3.28).

FIG. 3.28 This reminder appears for only a few seconds, but it helps you understand what filter criteria you have chosen.

You can also filter by flag using the Library > Filter by Flag menu items (Figure 3.29). As you can see, there are a large number of options, corresponding to all the ways you can combine the various Flag filtering criteria. The last option (Reset this Filter) is available in all the filter menu options. It turns off that filter (in this case, the Flag filter) without affecting any of the other filters.

83

FIG. 3.29 Pick the combination of Flag filters you want from the menu.

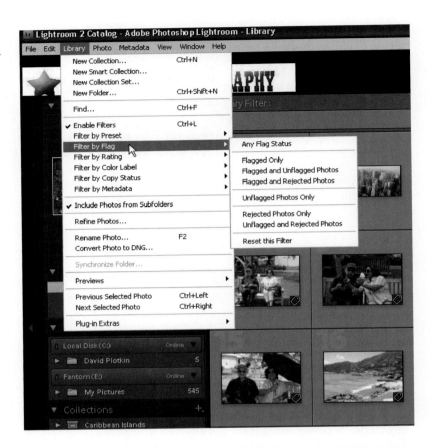

 All of the filtering options in the Library menu are also available in the File > Library Filters menu as well. So many choices, so little time.

Filtering by Stars

Clicking on a particular star (such as the third star from the left) returns images that match the rating criteria. The "greater than or equal to" button to the right of the row of stars in the Attribute Filter bar enables you to use the drop-down list (Figure 3.30) to set the criteria to Rating is equal to, Rating is greater than or equal to, or Rating is less than or equal to. If you click on a star rating that is less than the current setting or greater than the current setting, the filter resets to that rating. For example, if you currently have three stars selected and click on the second star (from the left), the filter rating resets to two stars. However, if you click on the current rating (the three star rating in this example), the star filter turns off and Lightroom stops filtering by star rating.

 The comparison options in the Filter strip (above the filmstrip) work identically.

FIG. 3.30 This drop-down list lets you set the comparison criteria for stars.

You can also filter by Stars using the Library > Filter by Rating menu items. Again, the menu items (Figure 3.31) include options for all the star ratings as well as comparison criteria and the Reset this filter option. However, the comparison criteria are stated differently—they are "and higher" (Rating is greater than or equal to), "and lower" (Rating is less than or equal to), and "only" (Rating is equal to).

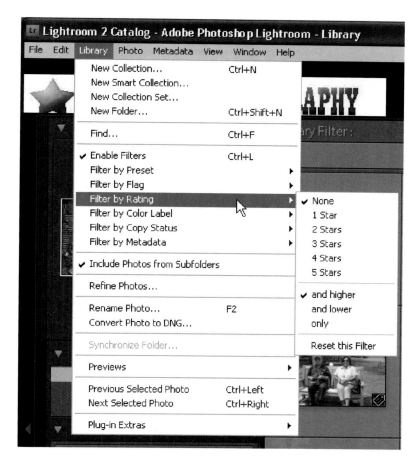

FIG. 3.31 Pick the rating and comparison criteria you want from the menu.

The Filter strip and the Attribute Library Filter bar automatically synchronize—changing the values in one also changes the values in the other.

Filtering by Color Label

Clicking on a particular color label displays the images that have that color label. As with flags, you can select multiple color labels and the filter will return images that have *any* of the selected labels. For example, if you click the red, yellow, and green labels, the displayed images are all those that have either a red, yellow, or green color label. To remove images from the filtered result that have a selected color label, simply click that label again to turn it off.

In addition to filtering on one or more of the five color labels, you can filter using one of the two icons at the right end of the color labels (in both the Attribute Filter bar and the Filter strip). The first icon (Show photos with "custom label" label) locates any photo that has a label assigned to it that isn't one of the current color labels. If you're scratching your head about that one, let me explain. When you choose a color label, what you're actually doing is placing the value associated with that color (in the currently selected color label set) into the Label field in the metadata, as Figure 3.32 shows. Thus, filtering on the Show photos with "custom label" label icon chooses any photo that has a value in the Label field that is not one of those associated with the current color label set. How can you get a different value in the Label field? There are at least two ways. You could simply type a value into the field in the Metadata panel (visible in Figure 3.32). You may also have assigned a value to this field during the import by using a Metadata preset that contains a value in the Label field.

The other icon (Show photos with "no label" label) does just what you'd expect—it returns any photo that does not have a value in the metadata Label field. It can be confusing if you're expecting any image without a color label assigned to be returned by this filter—because that is not what you'll get if you assigned a value to the metadata Label field during the import or by typing a value into the field.

The Library > Filter by Color Label menu items provide options for each of the colors, No Label, and Other Label (which corresponds to the "custom label" icon), as well as the Reset this filter option. Note, however, that the menu items don't change to reflect the assigned names in the current color label set. That is, the Library > Filter by Color Label menu items simply display the names of the colors (red, yellow, green, etc.).

Filtering by Copy Status

Clicking on the Master Photo icon displays all the photos that *are not* virtual copies, whereas clicking on the Virtual Copy icon displays all photos which *are* virtual copies. And, of course, clicking both icons displays all photos. You have these same options in the Library > Filter by Copy Status menu.

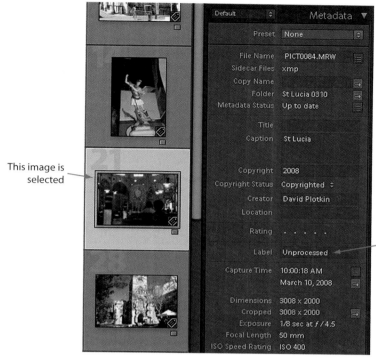

This image is selected

The label field contains the value associated with the color label assigned to the image

FIG. 3.32 The Label field holds the value from the color label.

A *virtual copy* is an independent version of the master photo. The image information actually exists just once, but the information that describes how the original was modified in Lightroom exists twice—once for the master photo and once for the virtual copy. You can have multiple virtual copies of an image. To create a virtual copy, select an image and choose Create Virtual Copy from either the shortcut menu or the Photo menu.

Inverting Your Filter

It can be useful to find images that don't meet your selection criteria. For example, let's say you want to select all images that are not unprocessed (have a color label other than red). To do that, use the following steps:

1. Turn on the filters and choose the red label to show just those images that are unprocessed.
2. Press Ctrl + A to select those images.
3. Turn off the color label filter and the rest of the images will appear.
4. Select Edit > Invert selection and any images that don't have the red label will be selected.

Selecting by the Results

In addition to filtering your images by flag, star rating, or color, you can also select your images by these quantities. Unlike filtering, which shows you only the images that meet the filter criteria, the Select By function simply selects the images that meet the criteria—you can still see the other images, but they are not selected.

There are three main Select By menu items in the Edit menu: Select By Flag, Select By Rating, and Select by Color Label. Each of these provides selection criteria as well as tools to build a custom selection. For example, the Select By Flag menu item (Figure 3.33) provides selection criteria for Flagged, Unflagged, and Rejected. The Add to, Subtract from, and Intersect with menu items each have the same three options (Flagged, Unflagged, and Rejected).

FIG. 3.33 Build a custom selection for just the photos you want.

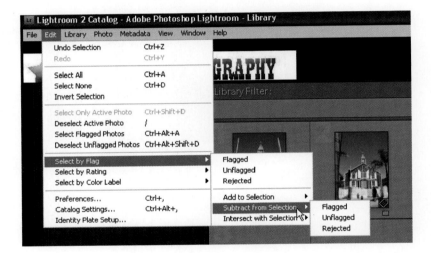

To build up a custom selection, start by making a selection from the Edit menu for the item you want. For example, you could choose Edit > Select by Color Label > Red. To further customize your selection, use the submenus provided in each Select by menu:

- **Add to Selection**. Making a selection from this submenu adds images with the chosen flag, rating (stars), or color to the selected images.
- **Subtract from Selection**. Making a selection from this submenu removes images with the chosen flag, rating (stars), or color label from the selected images.
- **Intersect with Selection**. Making a selection from this submenu starts with the currently selected images and removes any images that do not have the chosen flag, rating (stars), or color label. For example, if you selected all images with a red color label, then intersected that selection with a three-star rating, you'll only get those images that have both a red color label and a three-star rating.

Exporting Images from Lightroom

Although Lightroom has the ability to build slideshows, print, and create Web sites, it is often a good idea to export your images to other applications, typically those that have more robust output options. For example, Photoshop Elements has the ability to create a slideshow and burn it to a video CD, as well as make adjustments not possible in Lightroom (though not as many as in previous versions of Lightroom). Other applications can create slideshows and burn them directly to DVD. Website building software can directly use photos to create robust Web sites, even generating the thumbnails automatically and making it easy to add hyperlinks, text, and image maps.

To begin the export process, select the images you want to export and choose File > Export (Ctrl + Shift + E) to open the Export dialog box (Figure 3.34). Many of the settings in the dialog box should look familiar. The File Naming section works identically to importing photos (discussed earlier in this chapter in the section Importing Photos). The other sections provide a high degree of control over exactly what you export.

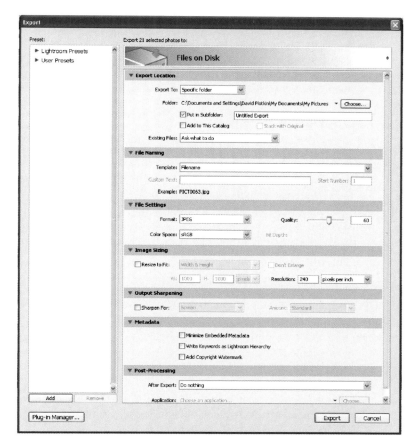

FIG. 3.34 Export your photos to a specific destination in the format you want.

 When you are all done setting up the export parameters, click the Export button and wait while Lightroom converts the files and exports them. Like other long-running tasks, you can view the progress of the export in the progress bar in the upper-left corner of the window.

Setting Up the Export Location

The Export Location section enables you to pick where the exported files will be located. You can choose to put the photos in the same folder as the original (choose Same folder as original photo from the Export To drop-down list) or in a different folder (choose Specific folder from the Export To drop-down list). If you decide to pick a specific folder, click the Choose button to pick the folder from the Browse for Folder dialog box. You can also put the images into a specific subfolder by selecting the Put in Subfolder check box and entering the name of the subfolder in the adjacent field.

If you'd like to add the exported images to the current catalog, select the Add to This Catalog check box. If you decide to do that, you can also stack the exported images with the originals (see Chapter 4 for more on stacking) by selecting the Stack with Original check box. Finally, if the exported files have the same name as an existing file in the destination folder, you can decide what to do about that by selecting one of the options from the Existing Files drop-down list. Your options include Ask what to do, Choose a new name for the exported file, Overwrite Without Warning, and Skip (don't write the exported file).

Setting Up the File Settings

The File Settings section enables you to pick the type of image file you want to export and (where appropriate) set parameters to control the file format. For example, the default format of JPEG enables you to set the quality using the slider or associated text field (type in a value between 0 and 100). Lower quality (smaller numbers) create smaller files but may show "artifacting" and other quality degradations. Given that disk space is so cheap, I tend to use very high quality exports and reduce the quality later if I have a need for a small file (such as for uploading to the Web).

Here are some pointers for using the File Settings:

- **TIFF**. Tagged Image File Format preserves the full quality of the image (unlike JPEGs) and also enables you to set compression. However it does not permit the more "normal" compression schemes (such as LZW) that most image programs can read. Instead, it provides only ZIP format, which most image programs cannot handle. My recommendation—don't compress these files. You can also set the following options:
 - **Color Space**. Set the color space you want from the Color Space drop-down list. You are allowed include three main options: sRGB, Adobe RGB (1998), and ProPhoto RGB. This feature also tags the exported file with

the chosen color space, so that applications you use to open the photo can (if they recognize color space information) detect the appropriate color space and use it.

> The subject of what color space to use is well beyond the scope of this book, but suffice it to say that sRGB works wells for viewing the image on screen (and on the Web), whereas Adobe RGB works better for modern printers that can support its wide color gamut (Adobe RGB (1998) supports more colors than sRGB). And ProPhoto RGB supports an even wider color gamut, suitable for professional work.

- **Bit Depth**. The options in the Bit Depth drop-down list support 8 bits/component and 16 bits/component; 16-bit color depth supports preserving more colors, but the files are bigger and not all imaging applications can recognize and use 16 bits/component color depth. Except for professional use, 8 bits/component is sufficient.
- **PSD**. Photoshop/Photoshop Elements. This is a lossless conversion to the native file format for Photoshop and Photoshop Elements. Just remember that if you then need to send the photos out for printing or upload to the Web, you'll have to convert again to JPEG. You can set the bit depth and color space for this option as well.
- **DNG**. Digital negative—an Adobe sponsored alternative to raw file formats. The advantage is that, like Adobe Acrobat, this format is becoming a standard and has at least the potential to replace the multitude of proprietary raw formats. For this option, you can set the following:
 - **The size of the JPEG preview**. This specifies whether or not a JPEG preview is created, and what size (none, medium, or full size). Creating a preview enables other programs to display the preview more quickly because it doesn't have to generate a preview.
 - **Image conversion method**. You have to option to match the default settings of the raw image or convert the image to a linear format. The advantage to converting is that other programs can interpret the resulting file even if they don't have the information (called a "profile") for the particular raw file format used by the camera that shot the image.
 - **Options**. You can choose to compress the image to make it smaller by selecting the Compressed (lossless) check box. There is really no reason not to do this, as no information is lost during the compression. You can also embed the original raw file in the DNG file, though I'm not sure why you'd want to do that, as it makes the resulting file considerably larger.
- **Original**. This simply exports the images in their original raw formats, along with the "sidecar" files (ending in .xmp) that contain the metadata, keywords, and Develop module corrections. You could simply drag and drop the files to a new location using Windows Explorer if you wished, although using the Export function does ensure that you get all the files you want and will not miss any ancillary files that you need.

Setting Up the Image Size

You can set the size (and resolution) of the exported images in the Image Sizing section of the dialog box by selecting the Resize to Fit check box. You can specify the size in pixels, inches (in), or centimeters (cm) by selecting the unit of measure from the drop-down list. You can also select the Don't Enlarge check box to ensure that if you specify a size that is larger than the original image, Lightroom doesn't "scale up" the result, usually resulting in a poor-quality image. The Resize to Fit drop-down list provides the following options:

- **Width & Height**. Type the width into the W field and the height into the H field. The result actually constrains the image to the smallest size without changing the aspect ratio (ratio of the width to the height). Say, for example, the original image aspect ratio is 3:2 (a common ratio for digital landscape images) and the actual image is 3000 pixels wide by 2000 pixels high. If you set the width to 1500 pixels and the height to 100 pixels, the resulting image will be 100 pixels high (and 150 pixels wide). If, instead, you set the width to 100 pixels and the height to 1500 pixels, the resulting image would have a width of 100 pixels (and be 67 pixels high).

- **Dimensions**. The Dimensions choice provides two unlabeled fields into which you can type dimensions (Figure 3.35). The smaller number is used for the longer dimension of the image and the result has the identical aspect ratio as the original. Thus, typing 1500 (pixels) into the first field and 100 (pixels) into the second field produces exactly the same result as reversing the numbers.

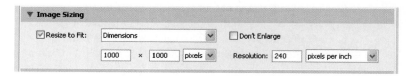

FIG. 3.35 Using Dimensions lets you type the numbers into either field with the same result.

- **Long edge**. This option provides a single field into which you can type the dimension corresponding to the longer edge of the image. This is the width for a landscape image and the height for a portrait image.
- **Short edge**. This option provides a single field into which you can type the dimension corresponding to the shorter edge of the image.

You can set the resolution in either pixels per inch or pixels per cm (choose from the Resolution drop-down list). To specify the resolution, type the number into the Resolution number field.

Setting Output Sharpening

You can specify that the output images are "sharpened" during the export process. Sharpening increases the contrast along the edges in a photo, making the photo appear, well, sharper. This is especially true for images that you are

The "right" number to use for resolution depends on what you intend to use the image for. For viewing onscreen (or from a Web page), a resolution of between 72 and 96 pixels/inch is sufficient, as that corresponds to the resolution of a computer monitor. Thus, you could set the width or height to a particular size (in inches or centimeters) and that is the size the image will appear on a monitor. For printing, however, you should use a much higher resolution—between 240 and 300 pixels/inch. Lower resolutions won't print well and higher resolutions just increase the file size without making a better print.

going to print—even images that look fine on the screen can often benefit from being sharpened before printing. Of course, you can sharpen the image in the Print module before printing!

To set the type of sharpening to add during the export, use the controls in the Output Sharpening section of the dialog box. Select the Sharpen For check box and pick Screen, Matte Paper, or Glossy Paper, depending on whether you are going to view the images or the type of printer paper you use. You can set the amount (Low, Standard, or High) from the Amount drop-down list.

Setting the Metadata check boxes

There are three check boxes to control what metadata is written to the exported file. Minimize Embedded Metadata is available for JPEG, PSD, and TIFF formats. This setting instructs Lightroom to write only the copyright metadata into the resulting file, leaving everything else out.

You'll learn all about keywords in Chapter 4, but in essence, you can "nest" keywords, for example, making the keyword "Rome" a subkeyword of "Italy." The other check box (Write Keywords as Lightroom Hierarchy) instructs Lightroom to preserve any hierarchy of keywords when writing them to the exported file with the pipe character (|) between the keywords.

Selecting the Add Copyright Watermark check box displays a copyright watermark on the image when it is displayed. However, this only occurs if there is copyright information in the IPTC section of the metadata (see Chapter 4 for more on metadata) when the file is exported.

Setting Up Postprocessing

You can specify what happens after the files have been exported by making a selection from the After Export drop-down list. In addition the Do Nothing option, your options include the following options:

- **Show in Explorer**. Opens Windows Explorer and shows you the folder into which the images were exported.
- **Open in…**. This selection opens the exported files in the specified application (which really ought to be able to handle displaying images). If you have Adobe Photoshop or Adobe Photoshop Elements installed on your computer, you'll actually have two options: open the files in Photoshop or Photoshop Elements or open the files in another application. If you choose to open the files in another application, you can click the Choose button to display a list a dialog box where you can select the application you want to use.
- **Go to Export Actions Folder Now**. This opens a dialog box that displays the Lightroom folder, which contains the Export Actions folder as well as a lot of other folders that Lightroom uses to store information. Choose the action you want to execute from the folder.

Export actions are actually quite a lot of fun. You can create them in a number of ways. For example, you can drag an alias (Mac) or a shortcut (Windows) to the folder. If you drag an alias or a shortcut for your browser into the Export Actions folder, you can then view the exported images in your browser as part of postprocessing. You can also drag an alias or shortcut of your email application into the folder—and it will open with the images in the body of the email.

Another way to create an action is to export a Photoshop action as a droplet and place it in this folder. When you're done exporting from Lightroom, the image will open in Photoshop and the action will be performed automatically on the image. This enables you to continue processing in Photoshop with actions that are not available in Lightroom.

Burning Your Images to a CD or DVD

Well-hidden in the top area of the Export dialog box is an option to burn the exported files to a disk. This copies the images to a CD or DVD. To switch between exporting to a hard drive (Files on Disk) and exporting to both a hard drive and burning a CD/DVD, select the option from the menu that appears when you click on the tiny up/down arrow button at the right side of the Export dialog box header (Figure 3.36).

FIG. 3.36 Choose to burn your exported files to a CD/DVD too.

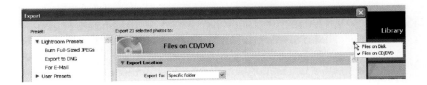

You can also pick a Lightroom preset that automatically sets the destination to a CD/DVD. You can pick the preset (Burn Full-Sized JPEGs) from either Lightroom presets in the left pane of the Export dialog box or pick the preset directly from the File > Export with Preset menu.

When the export is complete, Lightroom will either start the burn if you have a single writable drive (so make sure to have a writable disk in the burner) or prompt you for the drive to use (if you have more than one). If you are prompted for the drive (Figure 3.37), pick it from the Burn Disc In: drop-down list. Once Lightroom is able to confirm that a writable disk in the in the burner, it will enable the Burn button so you can complete the operation. If you change your mind, click the Cancel Burn button.

FIG. 3.37 Fill in the identity of the drive you want to use to burn your disk, then click the Burn button.

If you are using the 64-bit version of Lightroom, the option to burn your images to a CD or DVD is not available.

Exporting Using Plug-Ins

If you've installed some export plug-ins in Lightroom, you can use the plug-in to export the image. To export using a plug-in, select the plug-in from the menu that appears when you click on the tiny up/down arrow button at the right side of the Export dialog box header.

If you would like to obtain some plug-ins, click the Plug-in Exchange button in the Lightroom Plug-in Manager dialog box. This opens the Web page where you can download or purchase plug-ins. To get to the Lightroom Plug-in Manager dialog box, you can click the Plug-in Manager button in the lower-left corner of the Export dialog box or select File > Plug-in Manager (Ctrl + Alt + Shift + ,).

Building and Using Export Presets

After you've gone to the trouble of specifying the export settings as described previously in this chapter, you can save them as a Preset. To do so, click the Add button in the lower-left corner of the Export dialog box, fill in the Preset Name in the New Preset dialog box, and click the Create button. The new preset appears in the left border of the Export dialog box (Figure 3.38) along

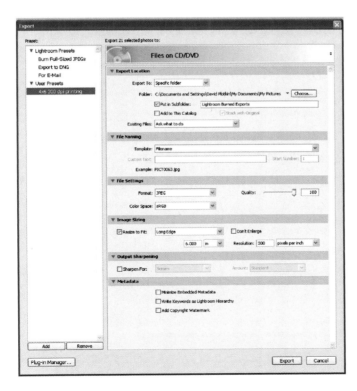

FIG. 3.38 Use common or saved presets as the starting point for your exports.

with the Lightroom Presets provided with the product. Clicking on a preset places its settings in the right side of the Export dialog box. You can change these settings (and save the results as a new preset if you wish).

I build presets to export specific size images, such as 4 × 6-inch images at 300 dpi suitable for printing. To do this, I start with Lightroom's Burn Full-Sized JPEGs preset, select the Resize to Fit check box, and set the Resolution (in the Image Sizing section) to 300 pixels per inch. From there, I pick the Long Edge option from the drop-down list and set the size to 6 inches. Because the preset burns the exported file to a disk by default, I end up with a disk ready to take to the drugstore and have printed.

Using the Rest of the File Menu Export Options

The File menu has several other options for exporting images. For example, you can choose File > Export with Previous (Ctrl + Alt + Shift + E) to export the selected images with exactly the same export settings you used the previous time you exported images. Alternatively, if you have a set of presets you like, you can choose File > Export with Preset and choose the preset you want from the fly-out menu (Figure. 3.39).

FIG. 3.39 Pick a preset from the menu to export images.

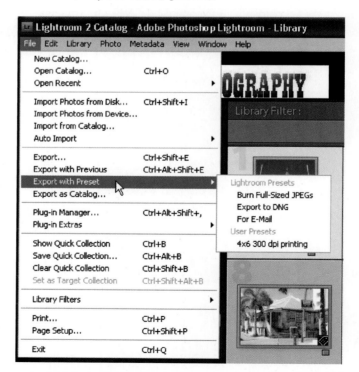

Exporting as a catalog is covered in Chapter 4.

Organizing Your Photos

Now that your photos are safely tucked into Lightroom, our goal is to find the best way for you to organize them so that can find them at a later date. Organizing your photos is a crucial undertaking in this era of digital images, cheap memory cards, and huge hard drives. The fact of it is that people are shooting far more pictures than when the cost of film (and processing) tended to limit the number of photos taken. Further, remember that Lightroom is a workflow management tool. It's impossible to manage your workflow if you don't manage (or can't find) your images.

Lightroom Image Management Concepts

In Chapter 3, we learned that images could be imported into folders on the hard drive. The folders serve as a rudimentary way to divide a large collection up into manageable chunks. But folders provide only a physical way to

organize image files and are not especially helpful for locating specific images in a large collection. Besides that, folders are no help if you want to include images in multiple sets; doing this with folders would mean having duplicate copies of the images in multiple folders.

Stacking Photos

Although folders help organize images on the hard drive, with a collection of thousands of images, the display of the images can become extremely cluttered. One feature that is specifically designed to reduce this clutter is called stacks. Stacks are great for collecting similar photos into a single displayed image, because you can view the contents of the stack any time you want. To see stacks in action, take a look at Figure 4.1, which shows a collection of very similar photos.

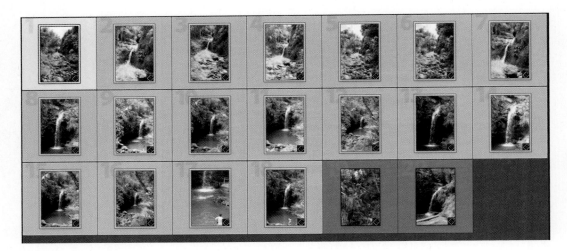

FIG 4.1 This many nearly identical photos clutter up the Grid view.

Stacks let us stack all the identical or similar images one on top of the other. As you can see from Figure 4.2, the stacked images take up only a single thumbnail now, allowing the grid to show more varied images. There are two indications that the images are stacked. The first is the tiny icon in the upper-left corner with a number indicating how many images are in the stack. The other indication is the "handle" on the top image (the vertical lines that enable you to expand the stack).

Building Stacks

To stack photos into a group, use the following steps:

1. Open the Grid mode in the Library module (G).
2. Select the photo that you want to be at the top of the stack.

This is the number
of images in the stack

Click here (vertical
line) to expand the stack

FIG 4.2 Much better! The images are stacked now.

3. Using the Shift or Ctrl key, select the other photos to be included in the stack.
4. Choose Stacking > Group into Stack from either the shortcut menu or the Photo menu (Ctrl + G). All of the images except the top one will disappear from view and a tiny icon appears in the upper-left corner indicating how many images are in the stack.

To unstack the photos and return them to the Grid view, select the stack and choose Photo > Stacking > Unstack (Ctrl + Shift + G). You can also choose this option from the thumbnail shortcut menu.

Working with Stacks

To view the contents of a stack, select the top image and press the S key, choose Photo > Stacking > Expand Stack (or pick Stacking > Expand Stack from the shortcut menu). All of the stacked images will appear on the grid. These images are still part of the stack group as indicated by the tiny *x of y* icon in the upper-left corner as your mouse moves over the thumbnail (Figure 4.3). Pressing the S key again (or choosing Photo > Stacking > Collapse Stack) collapses them back into the normal stack view where they are hidden.

> If you add a stacked image to either a Quick Collection or Collection (discussed later in this chapter), only the top image joins either collection.

There are other useful commands (in the Stacking shortcut menu or the Photo > Stacking menu) you can use to manage stacks:

- **Expand all stacks**. Expands all the stacks you have created to show the individual images, as described previously.
- **Collapse all stacks**. Collapses all the expanded stacks back into their normal stack view.

This tooltip indicates how many images there are in the stack

This is the number of the image in the stack order

Click here (vertical line) to collapse the stack

FIG 4.3 Use the S key to quickly expand and collapse stacks.

- **Remove from stack**. Once you have expanded a stack, you can select images from that stack and choose Remove from stack to remove those images from the stack. When you collapse the stack, those images will no longer be part of it.
- **Move to top of stack (Shift + S)**. If you pick an image that is not at the top of the stack and choose this item, the selected image moves to the top of the stack. Remember that the image at the top of the stack is the only one you can see in the normal stacked view. This menu item is not available if the image is already at the top of the stack.
- **Move up in stack (Shift + [)**. Moves the image up one in the stack, changing the stacking order and the order in which you see the images when you expand a stack. This menu item is not available if the image is at the top of the stack.
- **Move down in stack (Shift +])**. Moves the image down one in the stack, changing the stacking order and the order in which you see the images when you expand a stack. This menu item is available if the image is at the bottom of the stack, though clicking it doesn't actually do anything.
- **Split Stack**. If you pick an image that is not at the top of the stack and choose this item, the stack is split into two separate stacks. The images between the original top of stack and the image before the currently selected image form the first stack. The images from the currently selected image to the end of the original stack form the second stack.

If you expand a stack, then select images that are part of a stack and choose Photos > Stacking > Group into Stack, nothing happens.

Automatically Creating Stacks

Lightroom can automatically stack contiguous photos based on their capture time. The process is pretty simple—you specify a time interval from 0 to 1 hour. Photos that were taken closer together than the specified interval are stacked together. As you can imagine, specifying shorter durations creates more stacks (with fewer pictures in each stack) and specifying longer durations creates fewer stacks (with more pictures in each stack).

To get started, choose Photo > Stacking > Auto Stack by Capture time. This opens the Auto Stack by Capture time dialog box (Figure 4.4). Drag the slider to the left to decrease the time between stacks, or drag it to the right to increase the time. The time (in hours:minutes:seconds format) is shown in the upper-right corner and the number of stacks is shown in the lower-left corner. When you have the stacking set the way you want, click the Stack button.

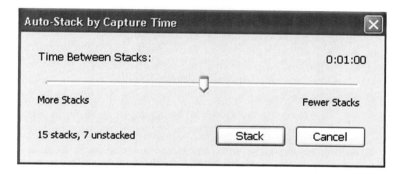

FIG 4.4 Let Lightroom stack your photos based on capture time.

Working with Folders

At the most basic level, pictures are image files stored on your hard drive. And, although Lightroom never actually modifies the picture information in those files, it has to know where the files are located. Thus, when you (for example) see a thumbnail in Grid mode, behind the scenes Lightroom is maintaining a pointer to where the file is located in a folder on a hard drive attached to your system. As you can probably guess from this explanation, it would be a problem if you use Windows Explorer or Mac Finder to move the image files from their current location to some other location—in a different folder or even on a different hard drive. But you can perform these actions through Lightroom, which keeps everything connected.

Viewing Folders and Images

The left pane of the Library module contains a Folders panel (Figure 4.5) that displays any folders containing images you have imported into Lightroom, as

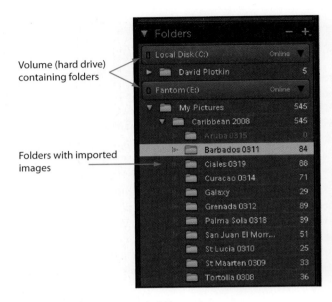

Volume (hard drive) containing folders

Folders with imported images

FIG 4.5 View the folders that contain images in the Folders panel.

well as the volume (hard drive) that contains the imported folders. The tiny rectangle at the left end of the volume name bar uses color to display the status of the drive. A drive with plenty of room displays a green rectangle. As available space decreases, the rectangle changes color to yellow, then orange, then red. If the volume is unavailable (offline)—such as those on an external hard drive that are not currently attached—the rectangle is transparent.

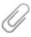

If the folder names are too long to be fully displayed in the Folders panel, hover your mouse over the folder name to see a tooltip containing the full path to the folder and the folder name.

You can expand the volume or folder list by clicking on the arrows alongside the volume or folder names to display any contained folders. Each folder displays the number of images in that folder alongside the folder name. To see just the images in a particular folder, click on the folder name.

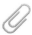

Alt-click on a volume to select all the folders in that volume.

You can pick what information you want to show in the volume bar (along with the volume name). To do so, right-click in the volume bar and make your choice from the shortcut menu (Figure 4.6).

The Disk Space information in the volume bar is displayed as Available space/total space. Hovering your mouse over the information reveals a tooltip that shows the used space, free space, and total space.

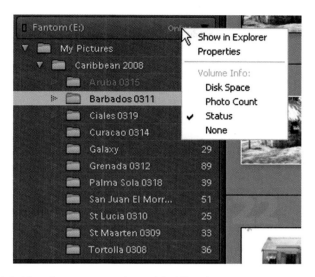

FIG 4.6 Pick the information you want to see about each hard drive volume.

You can also choose how you want to display the folder name by clicking on the + sign in the Folders panel:

- **Folder Name Only**. Displays (as you might guess) just the name of the folder.
- **Path From Volume**. Displays the full path from the volume (hard drive). In other words, it displays the current folder name, preceded by a list of the parent folders for that folder, going all the way back to the hard drive letter. This option only adjusts the displayed name for the topmost folder in a structure, and if you've included all the parent folders in the Folders panel, choosing this option doesn't actually change anything.
- **Folder and Path**. Displays the name of the folder, followed by a dash and then the path from volume, as described in the previous bullet.

You won't be able to see the entire path in the left panel group, even if you set it to its widest setting, so these options aren't especially useful. However, as mentioned previously, you can hover the mouse over any folder and view a tooltip containing the full path to the folder.

Show and Hide Parent Folders

One commonly used workflow in Lightroom is to import the contents of individual folders into Lightroom one at a time. If you're like me, you group your images into folders when you first transfer them to your computer. For example, when I'm shooting exotic locations, I group the images by location. By importing images this way, you can create metadata presets that include specific labels, captions, locations, and keywords consistent with those

locations (or however you group your images) and apply the metadata during the import.

However, this may leave you with something of a problem—all the image folders are imported, but the "parent" folder—the one that contains these folders and provides a convenient grouping—is missing. It used to be that you had to use some convoluted workarounds to add the parent folder, but no more. To add the parent folder to the Folders panel, simple right-click on one of the folders and choose Show Parent Folder from the shortcut menu. This menu option is not available if the parent folder is already present.

To remove the parent folder, right-click it and select Remove from the shortcut menu. What happens next depends on whether the parent folder is also the top folder in the structure of Lightroom folders. If the parent folder *is* the top folder, you can choose from the following options in the Confirm dialog box:

- **Promote Subfolders**. This button removes the top folder (and any images it contains) from the catalog, although they are not deleted from the hard drive. It leaves the subfolders and their images in the catalog. The subfolders are promoted one level and are still visible in the Folders panel.
- **Remove Entire Folder**. This button removes the top folder and all the subfolders (and all the images) from the Lightroom catalog, though it does not delete them from the hard drive.

If the parent folder is *not* the top folder, the Confirm dialog box simply asks you to confirm that you are going to remove the folder and all its subfolders from the Lightroom catalog.

Moving Images to Different Folders

To move images to a different folder and still have Lightroom know where the images are, you need to perform this task from within Lightroom. If you need to create the folder first, use the following steps:

1. Click the + sign in the Folders panel and choose Add Folder from the drop-down menu to open the Browse For Folder dialog box (Figure 4.7). You can also get to this dialog box if you select Library > New Folder (Ctrl + Shift + N) *if no folders are selected* (you can click on a Collection to achieve that).
2. Navigate to the drive and folder where you want to create the new folder, and then click the Make New Folder button. A new folder is created called New Folder.
3. Right-click the new folder and choose rename, or click the new folder, pause, then click again. Either technique makes the folder name editable.
4. Type in the new folder name, and press Enter. Then click OK.

While you have the Browse For Folders dialog box open, you can rename an existing folder by using steps 3 and 4 on the folder.

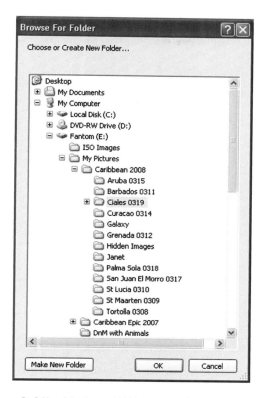

FIG 4.7 Use the Browse For Folders dialog box to add folders or rename folders.

Regardless of where you create the new folder this way, it becomes visible in the Folder panel. To move pictures, you can either click and drag an existing folder into the new folder or select pictures in the Grid view or filmstrip and drag those pictures into the folder (Figure 4.8).

> You will get a warning that the move can't be undone—just click the Move button to proceed in the dialog box. Of course, you *can* undo it. Simply click and drag the images back to their original folder!

The individual folder shortcut (right-click) menu provides some other options for creating and renaming folders:

- **Create a nested folder**. To create a folder inside (that is, as a subfolder) an existing folder, choose Create Folder inside "folder name." This displays the Create Folder dialog box (Figure 4.9). Type the name of the folder in the Folder field. Then click Create. The new folder shows up in the Folder panel as a subfolder of the originally selected folder (Figure 4.10). If you want to include any selected images, select the Include selected photos check box.

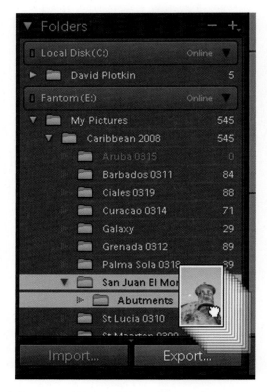

FIG 4.8 Drag a stack of images into a folder in the Folder panel to relocate the pictures.

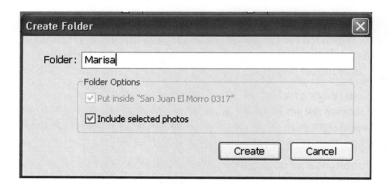

FIG 4.9 Create a subfolder to further physically divide up your photos.

You can also create a nested folder by selecting the folder, clicking on the + sign in the Folders panel, and choosing Add Subfolder. Or you can select a folder and then choose Library > New Folder (Ctrl + Shift + N). In the resulting dialog box, fill in the Folder name and click Create.

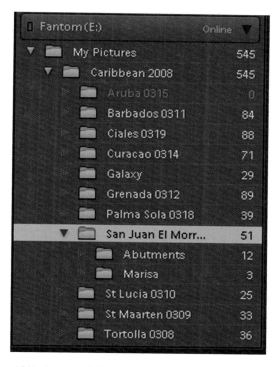

FIG 4.10 The new subfolder shows up in the Folder panel.

How do you know a folder has available subfolders? The little arrowhead just to the left of the folder name shows as a solid shape! Click the arrowhead to display the subfolders; click it again to collapse (hide) the subfolders.

- **Rename a folder**. To rename the folder, choose Rename from the shortcut menu to open the Rename Folder dialog box. Simply type in the new name of the folder and click Save.
- **Remove a folder**. To remove a folder and all its contents from the Catalog, choose Remove from the shortcut menu. You can also remove a folder by clicking the minus sign in the Folders panel. Click OK in the Confirm dialog box to complete the removal.
- **Move photos to a folder**. To move selected photos to a folder, choose Move selected photo to this folder. The images are moved to the target folder and removed from the folder in which they currently reside. However, Lightroom continues to "know" where they are, so the images are still available in the catalog. This menu option only appears if you have selected at least one image and then right-click on a different folder.
- **Update the folder's location**. If you want to move an entire folder to a new location on your hard drive (or on a different hard drive), choose Update Folder Location from the folder's shortcut menu. This opens the

Browse for Files or Folders dialog box, where you can select the destination folder or create a new folder (click the Make New Folder button) to use as the destination folder. After you click OK, the folder is moved to its new destination—but Lightroom remembers where the images are located.

- **Save metadata**. If you aren't saving your metadata automatically (an option you can set in the Metadata tab of the Catalog Settings dialog box), you can save all the metadata changes you have made to the images in a folder by choosing Save Metadata from the shortcut menu.
- **Show in Explorer/Finder**. Select this option to open Windows Explorer (in Windows) or the Finder (on a Mac) and show the folder—along with all the other folders in the same parent folder.
- **Synchronize folder**. This option synchronizes the catalog with the contents of the folder using a dialog box to capture the options you want (Figure 4.11). You can choose to do the following:
 - Add new images you may have put in the folder from outside of Lightroom and which are therefore not currently shown in the catalog. If you wish, you can specify whether to show the import dialog box when performing the addition. As you'll recall, the Import dialog box gives you the opportunity to specify metadata and keywords.
 - Remove any photos from the catalog that you deleted from the folder outside of Lightroom. If Lightroom detects missing photos, you can click the Show Missing Photos button to display the previews of the photos that are missing.
 - Scan for metadata changes.

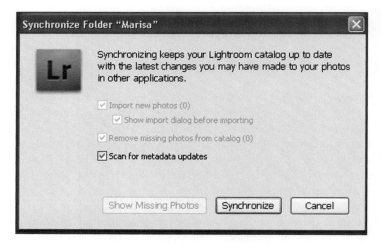

FIG 4.11 Synchronize the Catalog with the Folder.

Lightroom only provides those options needed in the Synchronize dialog box. For example, because there are no new photos or missing photos in the folder, those options are unavailable in Figure 4.11.

- **Delete a folder**. To delete a folder, select it and press the Delete key. A dialog box appears giving you the option of removing the folder and images from the catalog (click the Remove button) or deleting the folder entirely (click the Delete from Disk button).

Grouping Photos into Collections

Lightroom lets you create a "virtual" set of pictures called a collection. A collection is set of grouped photos within a catalog. The set is virtual because the collection simply points at the pictures you specify. These pictures can span the entire Lightroom catalog and you don't have to create duplicates or copies of the pictures (thus wasting hard drive space) in order to group them into various collections. A single picture can be in multiple collections regardless of where it is physically stored. Make as many collections as you want—they take up virtually no space.

There are two types of collections you can create—collections and Smart Collections. Each behaves differently and each is useful for different things. You can also create collection sets, a mechanism for grouping collections. Collection sets do not hold images themselves—they just create a bucket for related collections.

Creating and Working with Collections

Those who have used previous versions of Lightroom are familiar with collections, as they have been in the product since the beginning. To create a collection, use the following steps:

1. Select the photos you want to be included in the collection.
2. In the left panel group, click the + in the Collections panel and pick Create Collection from the drop-down menu to open the Create Collection dialog box (Figure 4.12). You can also right-click any item in the Collection section and choose Create Collection from the shortcut menu. Or you can select Library > New Collection (Ctrl + N).

FIG 4.12 Build a new collection in the Create Collection dialog box.

3. If you want to include the new collection into a collection set, choose the collection set from the Set drop-down list (see Creating and Working with Collection Sets, later in this chapter). If you want the collection to be a "root" collection (not included in a collection set), choose None from the Set drop-down list.

4. Select the Include selected photos check box to include the selected photos in the collection when you create it. To populate the collection with all new virtual copies (so you can edit the images independently of the master photo), select the Make new virtual copies check box.

5. Click the Create button. The collection is created and becomes visible in the Collections panel. If the Collection is associated (is a child of) a collection set, it appears indented under the parent collection set (Figure 4.13).

FIG 4.13 The new collection appears in the Collections panel and is displayed hierarchically.

Collections are useful because there are all sorts of things you can do with the contents of a collection that can't do with photos in a folder. For one thing, images in a collection have order—and you can change the order by clicking and dragging thumbnails to a new location. As you drag a thumbnail or a set of thumbnails, the new location is highlighted in the grid by a heavy black line (Figure 4.14). Rearranging the images this way makes it easy to get the images in the right order for a slideshow (see Chapter 8) or a Web gallery (see Chapter 9).

FIG 4.14 Rearranging the images in a collection is handy for setting up a slideshow or Web gallery.

If the images in the collection don't appear in the order that you specified, make sure the Sort drop-down list (in the toolbar just above the filmstrip) is set to User Order. Any other setting (such as Capture Time) will not show the images in the order you specified.

You can add photos to a collection at any time by selecting the images and dragging them to the collection in the Collections panel. These new images appear as the first images in the collection, but again, you can rearrange them. You can also easily add images to a collection that has been designated as a "Target Collection," as described later in this chapter.

Removing an image from a collection is even easier—just select the image(s) and press the Delete key or choose Remove from Collection from the shortcut menu. You can also select Photo > Remove from Collection (Backspace) from the menus.

If you want to know what collections an image belongs to, right-click on the image and choose Show in Collection from the shortcut menu. The fly-out menu lists all the collections that the image belongs to (Figure 4.15).

FIG 4.15 It's easy to find out what collections an image belongs to!

Creating a Quick Collection

A Quick Collection is a temporary collection. You can use a Quick Collection to assemble a temporary group of photos to work with from within any module. To add photos to a Quick Collection, just move the mouse over a thumbnail

and click the circle in the upper-right corner of the thumbnail, turning the circle dark (Figure 4.16). Alternatively, you can click the thumbnail and press the B key or select Photo > Add to Quick Collection. The keyboard shortcut is handy because it works in any module—for example, if you are editing an image in the Develop module, simply press the B key to add that image to the Quick Collection. By the way, clicking on the dark circle or pressing the B key again removes the image from the Quick Collection.

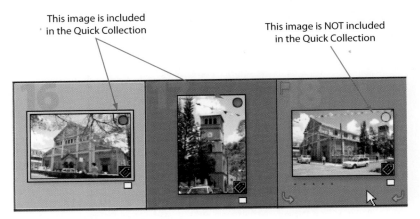

This image is included in the Quick Collection

This image is NOT included in the Quick Collection

FIG 4.16 Click the circle or press the B key to add an image to a Quick Collection.

To view the contents of a Quick Collection, click the Quick Collection line in the Catalog panel.

Are the photos in your Quick Collection missing? If you click on the Quick Collection line in the Catalog panel and discover you are facing a blank screen that says No photos selected, press Ctrl + L to disable all of the filters and the photos will appear.

You can only have one Quick Collection, so it could come in handy to save the contents of a Quick Collection to a named collection. Fortunately, this is easy to do:

1. Choose File > Save Quick Collection, choose Save Quick Collection from the Quick Collection shortcut menu, or press Ctrl + Alt + B.
2. In the Save Quick Collection dialog box (Figure 4.17), type a name into the Collection Name text box.
3. If you select the Clear Quick Collection After Saving check box, it clears the Quick Collection after it has been saved as a Collection. If you don't, the contents of the Quick Collection remain.
4. Click Save.

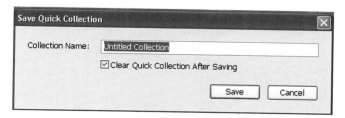

FIG 4.17 Save a Quick Collection with a name.

To clear a Quick Collection, right-click Quick Collection in the Catalog panel and choose Clear Quick Collection or select File > Clear Quick Collection (Ctrl + Shift + B).

Save Images Easily to a Target Collection

If you were reading the last section on Quick Collections and thought to yourself, "Wouldn't this be great to do with any collection?" you aren't alone. You can add images to *any* collection just as you would with a Quick Collection by first designating that collection as a "Target Collection." Once you do that, clicking the circle, pressing the B key, or any of the other techniques for adding images to a Quick Collection now adds the images to the Target Collection. Images in the Target Collection display the dark circle in the upper-right corner.

To designate a collection as the Target Collection, right click the collection in the Collections panel and choose Set as Target Collection. The Collections panel displays a tiny plus sign alongside the image count (Figure 4.18), as did the Quick Collection when it was the default Target Collection. The Set as Target Collection item in the shortcut menu also displays a checkmark. In addition, when you move the mouse over the circle on the image thumbnail, the tooltip reads, "Add Photo to Target Collection" instead of "Add Photo to Quick Collection." This tooltip only appears if the image is not already a member of the Target Collection (in which case, the tooltip does not appear).

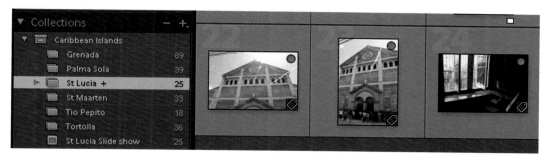

FIG 4.18 The Target Collection is displayed with a plus sign.

If you select a collection and then choose File > Set as Target Collection (Ctrl + Shift + Alt + B), the Target Collection reverts back to the Quick Collection. You get this same result if you reselect the Set as Target Collection option in a Collection shortcut menu to remove the checkmark.

Creating and Working with Smart Collections

A Smart Collection is a collection of photos that meet the criteria you set. But unlike a "standard" collection (discussed previously), you don't pick out specific photos and add them to a Smart Collection. Instead, you build a set of conditions for inclusion in the Smart Collection, Lightroom sifts through your images, and adds those that match the specified conditions. One very neat thing about Smart Collections is that they are dynamic—as you add more images to your catalog, any that meet the Smart Collection criteria are added automatically.

To create a Smart Collection, use the following steps:

1. Click the + symbol in the Collections panel and pick Create Smart Collection from the drop-down menu to open the Create Smart Collection dialog box (Figure 4.19). You can also choose Create Smart Collection from any Collections section shortcut menu or choose Library > New Smart Collection.

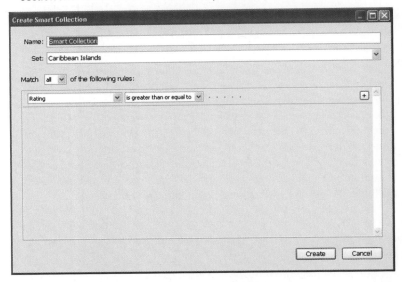

FIG 4.19 Build up the matching criteria for including images in a Smart Collection.

2. Decide whether you want the criteria to match all of the specified rules or any of the specified rules by picking all or any from the Match drop-down list.
3. Pick the field upon which you want to base the first criteria from the leftmost drop-down list. Options include Rating (stars), flags, colors, keywords, and many other criteria (Figure 4.20).

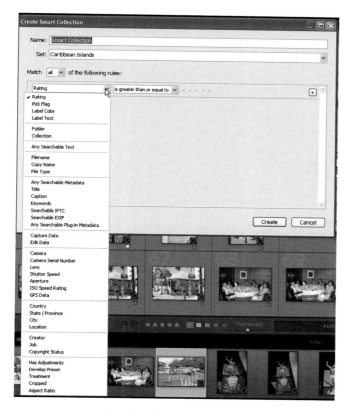

FIG 4.20 Pick the criteria you want from this drop-down list.

4. Pick the comparison criteria from the next drop-down list to the right. The values in this drop-down list vary depending on the criteria you picked in step 3. For example, if you chose Rating, the comparison criteria include greater than, less than, range, is, is not, and other numeric comparisons. However, if you chose Pick Flag, the comparison criteria are limited to is and is not.

5. Pick the comparison value from the list on the right, or, alternatively, type values into this field (Figure 4.21). For certain criteria (such as Rating, Pick Flag, and Label Color), the rightmost field is a list containing the valid values for the criteria (e.g., flagged, unflagged, and rejected for the Pick Flag criteria). For the rest of the criteria in the list (except for Aspect Ratio at the bottom), the rightmost field is simply a text box into which you can type the values you want to match (or not match) in some way.

6. To add another criteria to combine with the first, click the small plus sign at the right edge of the dialog box. This adds another row to the dialog box, which you can fill as described in steps 3 through 5.

7. Continue adding criteria until finished and then click the Create button. If you need to remove one of the criteria, click the minus sign alongside any of the criteria. The minus sign doesn't appear until you have more than one criterion.

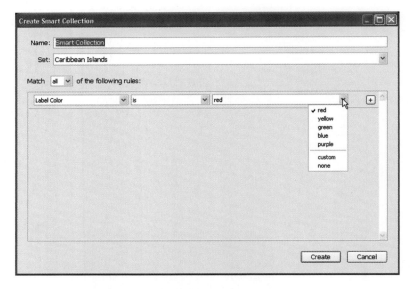

FIG 4.21 For Label Color, pick a label color from the rightmost field.

8. To associate a Smart Collection with a collection set, choose the collection set from the Set drop-down list in the dialog box. Choose None to leave the Smart Collection in the root of the Collections section.

In addition to adding criteria as described, you can also expand a single criterion into multiple criteria with their own comparison rules. An example would probably be helpful here. Take a look at Figure 4.22. This shows a Smart Collection with the following rules:

1. The pictures are in the "Barbados" folder.
2. None of the following are true:
 - The Label Color is red.
 - Camera contains "Sanyo."
3. All of the following are true:
 - The Rating is greater than or equal to 3 stars.
 - The Keywords contains "Galaxy."

Each of highest-level criteria (Folder, None of the following are true, and All of the following are true) is combined using the Match drop-down list setting ("all," in this example). To build a complex Smart Collection like this one, use the following steps:

1. Alt-click the + button (which turns into a # button). This action adds the nested criterion line (this is visible in Figure 4.22).
2. Choose the comparison rule from the drop-down list. The options are None of the following are true, All of the following are true, and Any of the following are true.

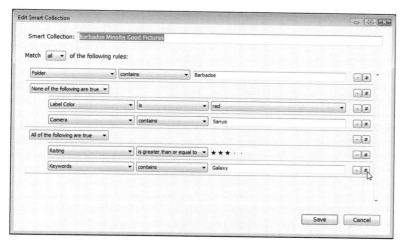

FIG 4.22 Nest criteria in a Smart Collection to build complex matching rules.

3. Continue adding criteria to each line and nesting/expanding the lines as needed.

> Although Lightroom provides a ready-built Collection Group called "Smart Collections," you don't actually have to put your Smart Collections in that group. You can choose any Collection Group or none at all. But it is handy to have all your Smart Collections grouped together (experience is talking here).

You can adjust the criteria for Smart Collections by choosing Edit from the shortcut menu to open the Edit Smart Collection dialog box. This dialog box looks exactly like the Create Smart Collection dialog box except that it doesn't include the Set drop-down list—you can't change the collection set for a Smart Collection when you edit it.

To rename a Smart Collection, choose Rename from the shortcut menu. Type the new name into the Rename Smart Collection dialog box and click OK.

If you've gone to a lot of trouble to build a Smart Collection, you can export those settings as a file to share with others or even to import into another of your catalogs. To do so, select the Smart Collection and choose Export Smart Collection Settings from the shortcut menu. Type the filename into the Save dialog box, and click Save to save the settings as a file. To import Smart Collection settings, use the following steps:

1. Select either the Smart Collections collection set or one of the Smart Collections.
2. Right-click and choose Import Smart Collection Settings.
3. Choose the file that contains the settings (the file you saved using Export Smart Collection Settings) and click Import.

4. The file is imported and a new Smart Collection created. If you already have a Smart Collection with that name, Lightroom automatically renames the Smart Collection by adding a sequence number to the name. Of course, you can always rename it.

Creating and Working with Collection Sets

A "collection set" is a mechanism for grouping collections together. For example, my wife and I went to churches in each of the cities in Mexico that we visited on our Easter cruise. I wanted to create individual collections for the set of pictures I took in each city, but I also wanted to group the collections together so I could see just the church pictures all at once.

> Clicking on a collection set enables you to view all the images contained in collections that belong to that collection set.

To create the collection set, click the + symbol in the Collections header and choose Create Collection Set from the menu, or choose Create Collection Set from any Collections section shortcut menu (or the Library menu). This opens the Create Collection Set dialog box (Figure 4.23). Simply fill in the name and click Create to create the collection set in the Collections panel. If you want the new collection set to belong to (next within) an existing collection set, pick the name of the collection set from the Set drop-down list.

FIG 4.23 Create a collection set to group collections with this dialog box.

As mentioned earlier in this chapter (Creating and Working with Collections), you can add a collection to a collection set when you create the collection by selecting the collection set from the Set drop-down list in the Create Collection dialog box. You can also add a collection to a collection set by clicking and dragging the collection to the collection set in the Collections panel. At any time, you can rearrange the hierarchy of the collections by clicking and dragging a collection to a different collection set. When the collection is properly positioned to become the child of a new collection set, the icon turns into a small rectangle (Figure 4.24). If you'd like to change a collection back into a "root" collection (not associated with a collection set), you can do that as well. Simply click and drag the collection into an area of the

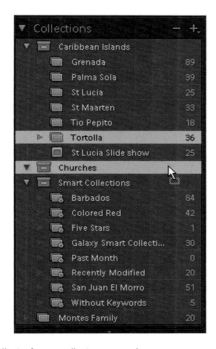

FIG 4.24 Relocating a collection from one collection set to another.

Collections panel that is not within a collection set. A horizontal line shows you where the collection will be located once you release the mouse button.

Renaming and Deleting Collections

You can delete a collection or collection set by selecting it and then clicking the − symbol in the Collections panel. However, if you delete a collection set that has collections associated with it, those collections will be deleted as well. You do get a warning dialog box to that effect if you try and delete a collection set. You can also delete a collection, Smart Collection, or collection set by right-clicking the collection and choosing Delete from the shortcut menu.

To rename a collection (or collection set), right-click the Collection and choose Rename Collection from the shortcut menu. Fill in the new name in the Rename Collection dialog box (Figure 4.25) and click Rename.

FIG 4.25 Rename a collection or collection set any time you want.

119

Importing and Exporting Collections as Catalogs

Once you've gone to the trouble of defining a collection, you can export that collection as a catalog so it can be imported into another copy of Lightroom, as described later in this chapter. To do so, select the collection you want to export and choose Export this Collection as a Catalog from the shortcut menu. Then follow the instructions for exporting catalogs, as discussed later in this chapter.

The Power of Keywords

Folders, collections, and the other tools work well, but when it comes to managing a library of thousands of photos you will discover that being able to quickly find the exact photo (or photos) when you need it is a challenge. The key to quickly locating specific images is applying keywords (called keyword tags in Lightroom) to your photos. You should have applied some basic keywords when you first imported these photos into Lightroom. For example, when I imported the photos from my Caribbean cruise, I imported the photos taken on each island separately and I included the name of the island in the keywords. To be able to search the catalog effectively, you need to take a few minutes to assign more specific keywords. Investing the time now will save you hours of searching later.

Keywords are words that describe the important contents of a photo. They help you identify, search for, and find photos in the catalog. Keywords are stored with the image, either in the XMP sidecar files (for raw photos) or in the file itself. The best news is that after investing the time entering all of your keyword information, other Adobe applications, such as Bridge, Photoshop, or Photoshop Elements, can read this keyword data. There are image viewers and other applications that support XMP metadata that can also read the keywords added by Lightroom, but the only way to be sure is to try them out on your favorite application to see if they read the keywords.

You'll do most of the heavy lifting (creating keywords, associating photos with them, and so on) from two panels in the right panel group the Keywording panel and the Keyword List panel (Figure 4.26).

Creating and Editing New Keyword Tags

The most straightforward way to create a new keyword tag is to click the + symbol in the Keyword List panel in the right panel group. This opens the Create Keyword Tag dialog box (Figure 4.27). Fill in the name in the Keyword Tag field and add any synonyms if you wish. Synonyms (words related to the keyword) are not useful within Lightroom, but can be useful when submitting images for stock photography.

To set the options for the keyword tag, select from the following check boxes:

- **Add to selected photos**. Adds any photos you selected to the keyword—that is, those photos will be associated with the newly created keyword.

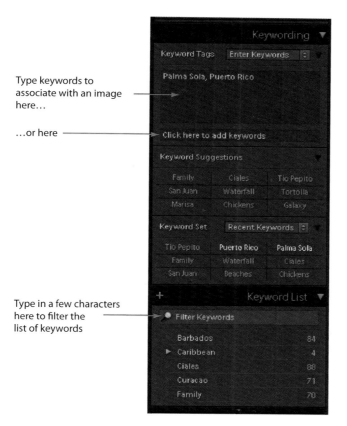

Type keywords to associate with an image here…

…or here

Type in a few characters here to filter the list of keywords

FIG 4.26 The Keywording and Keyword List panels provide the tools to create and associate image with keywords.

FIG 4.27 Create a new keyword tag with the Create Keyword Tag dialog box.

- **Put inside "keyword name"**. Keywords can be nested—one keyword can be a child of another keyword. If you select a keyword before creating a new one, you can make the new keyword a child (subkeyword) of the selected keyword. Otherwise, this check box is not visible.
- **Include on export**. The keyword will be exported along with the image when export the image from Lightroom—for example, when you create a JPEG for Photoshop Elements.
- **Export containing keywords**. If this keyword has a parent keyword, selecting this check box exports those keywords with the images associated with the newly created keyword.
- **Export synonyms**. The synonyms of the keyword will be exported along with the image.

You can also create a keyword tag by right-clicking on an existing keyword tag and picking either Create Keyword Tag or Create Keyword Tag inside "keyword name." This second option creates the new keyword tag as a child (subkeyword) of the selected keyword. This "nesting" can be handy for organizing keywords by family, geography, and so on.

If you are going to be adding a whole set of keywords inside of a keyword, choose Put New Keywords Inside this Keyword from the shortcut menu. Until you turn this feature off (by reselecting the option or choosing this option for a different keyword), all new keywords you create *in the Keywording panel* (as described later in this chapter) are placed inside the selected keyword. This "target keyword" is indicated by a small dot to the right of keyword name.

Keywords you create using the Keyword List are *not* affected by the Put New Keywords Inside his Keyword option. In order to nest keywords you create in the Keywording list, you must use the "Create Keyword Tag Inside…" option.

To change the name of a keyword tag, right-click the keyword tag and select Edit Keyword Tag from the shortcut menu or double-click the keyword. Either way, the Edit Keyword Tag dialog box (Figure 4.28) opens, and you can change the name, synonyms, and adjust the check boxes.

To just rename the keyword, choose Rename from the shortcut menu. This makes the keyword name editable in the Keyword List panel, so you can type in the new name and press Enter.

Renaming a keyword does *not* detach it from any images it is attached to.

To delete a keyword, select it and click the — sign in the Keyword Tag panel or choose Delete from the shortcut menu.

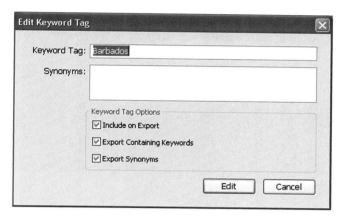

FIG 4.28 Edit an existing keyword tag using the Edit Keyword Tag dialog box.

Adding Keywords to a Photo

Of course, the main purpose to even *have* keyword tags is to associate images with the keywords so you can locate them later. You can associate photos with keywords using either the Keyword Tags or the Keywording panel and there are quite a few methods to associate the keywords with a photo.

Adding Photos to Keywords with Keyword List

There are three ways to add photos to a keyword using the Keyword List panel. The first way involves using click and drag. Just select the photos you want from the grid or the filmstrip, then click and drag them to the keyword tag (in the Keyword List panel) you want to associate them with.

However, although this technique works, it can quickly become tiresome to add a lot of keywords to a set of images because of all the clicking and dragging. Instead, you can select the images ahead of time, right-click on a keyword in the Keyword List, and choose Add this Keyword to Selected Photo.

> To remove the keyword from the selected photos, choose Remove this Keyword from Selected Photo from the keyword shortcut list.

An even easier way to add keywords to selected images is to hover the mouse over the keyword, which shows a check box near the left margin (Figure 4.29). Simply select the check box and that keyword is associated with the selected images. De-select the check box to remove the keywords from the images.

Adding Photos to Keywords with the Keywording Panel

Another method involves using the top section of the Keywording panel. There are actually two ways to add keywords (and create new

If you're really serious about keeping track of your photos, you are going to create a lot of keywords. Once the list gets to be 30 or more, it can be hard to remember whether you already have created a particular keyword or (perhaps) exactly how you spelled it. To help with that problem, Lightroom provides the Filter Keywords text line just below the top of the Keyword List panel (shown previously in Figure 4.26). Simply type a few characters into that line and the Keyword list is filtered to show just those keywords that match what you typed. For example, if you can't remember how you spelled "Caribbean" (and who can?), simply type Car into the text line and you'll see all the different ways you might have done that. Once you're done with the filter, click the "x" button at the right end to return to the complete list of keywords.

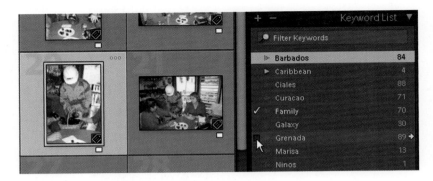

FIG 4.29 Select this check box to associate a keyword with an image.

ones) using this panel. The first is to type the keywords into the line labeled "Click here to add keywords" (shown previously in Figure 4.26). Once you click on this text line, it becomes editable, and you can type in the new keywords. They are added to the image (and to the Keyword tag text box just above the line) when you press Enter.

If you type in a new keyword (one that didn't exist before), Lightroom creates the keyword, adds it to the image, and places it in the Keyword List panel.

The second technique for associating keywords with an image is to select the images and use the following steps:

1. Open the Keywording panel in the right panel group and ensure that Keyword Tags is set to Enter Keywords.
2. Click the cursor inside the text box, changing it from dark to white.
3. Type in the new keyword. If adding more than one keyword, separate each word with a comma.
4. When you are finished, press the Enter key. The keywords will be rearranged alphabetically and the box will become dark again.

As with the "Click here to add keywords" line, typing new keywords into the box will add them to Lightroom.

Viewing the Association between Photos and Keywords

When a photo has keywords associated with it, it displays a small badge in the lower-right corner of the thumbnail in Grid view. However, this badge isn't very useful—it doesn't tell you what the keywords are and clicking it just makes the Keyword Tags text box editable. However, if you look in the Keyword List panel (Figure 4.30), you'll see a set of marks next to the keywords associated with the selected photos. If the mark is a checkmark, the keyword is associated with all the selected photos. If the mark is a dash (—), it means that

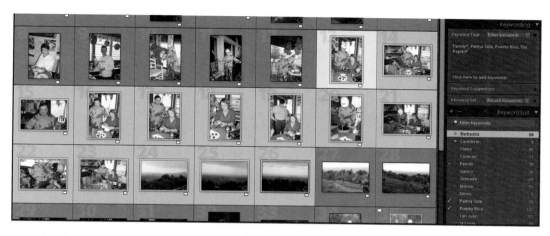

FIG 4.30 Both the Keywording panel and the Keyword List panel show the keywords associated with the selected photos.

the keyword is associated with only some of the selected photos. Another way to tell is to look at the text box in the Keywording panel. The keyword tags are listed there, but keywords with an asterisk (*) are associated with only some of the selected photos.

> If you edit the text in the Keywording panel and remove the asterisk, that keyword will become associated with all the selected photos when you press Enter.

Keep in mind that when you add keyword tags to photos (as well as change metadata and many other things), the keywords are stored in the Lightroom catalog, but not written to the images unless the Automatically Write Changes into XMP option is selected in the Catalog Settings dialog box. I leave this option set so that the metadata is always saved with the image; however, if you choose not to do that, you can manually save the keywords (and metadata) to the photo files by selecting the photos and choosing Metadata > Save Metadata to Files or pressing Ctrl + S. You can write the metadata for all the files in a folder by right-clicking on the folder in the Folders panel and choosing Save Metadata from the shortcut menu.

Auto Completion of Keywords

As the size of your keyword collection increases, you will discover that Lightroom attempts to anticipate (based on your existing keywords) what you are entering for a new keyword. As you begin to type in the field at the bottom of the Keywording panel, Lightroom either completes the keyword or displays a list of possible keywords if what you have typed so far matches more than one keyword (Figure 4.31). You can keep typing if you need to create a new

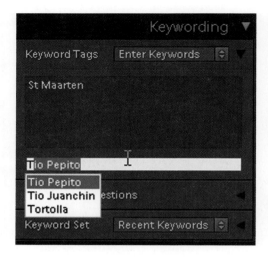

FIG 4.31 Auto completion of keywords helps you type existing keywords.

keyword. Auto completion speeds up the process of adding keywords to an image or a set of images; it also ensures that your keywords are all spelled (or misspelled) the same way.

Using Keyword Sets

Keyword sets provide a set of keywords that allow you to quickly grab and assign the keywords to photos. Figure 4.32 shows an example of one of the

FIG 4.32 The Edit Keyword Set dialog box enables you to edit the contents of a keyword set or create a new one.

preset keyword sets that ships with Lightroom 2.0. The limitation of the keyword set is the restriction to only nine keywords. Still, it's better than nothing. To use the keyword set, select the photo from any view and click a keyword tag from the keyword set in the Keywording panel (Figure 4.33).

To switch between keyword sets, pick the set you want to use from the Keyword Set drop-down list (in the Keywording panel) or choose the set from the Metadata > Keyword Set menu.

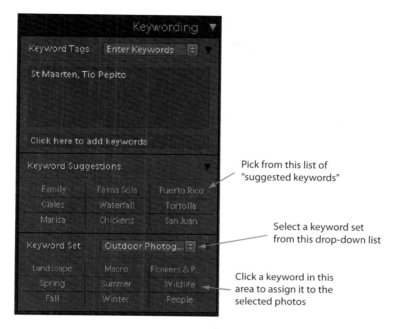

Pick from this list of "suggested keywords"

Select a keyword set from this drop-down list

Click a keyword in this area to assign it to the selected photos

FIG 4.33 Choose a keyword from the Keyword Set section of the Keywording panel.

In addition to the static keyword sets provided (such as Outdoor Photography), Lightroom provides several dynamic keyword sets. You can pick either a static or a dynamic keyword set from the drop-down list in the Keywording panel. The dynamic keyword sets change (hence the name "dynamic") as you work. The Recent Keywords set is available in the Keyword Set drop-down list, while the Keyword Suggestions set has its own area in the Keywording panel. The Recent Keywords set presents you the nine most recent keywords you have used. The Suggested Keywords set attempts to guess (based on the current keywords of an image) what other keywords you might want to assign to that image.

To create your own keyword set, choose Metadata > Keyword Set > Edit, or choose Edit Set from the Keyword Set drop-down list. Either option opens the Edit Keyword Set drop-down list, seen previously in Figure 4.27. The currently selected keyword set will open. You can then modify it by typing new values into the individual cells, and choose Save Current Settings as new preset from the Preset drop-down list. This opens a new dialog box and you can give the set a new name.

If you click the Change button instead, it saves the current set with the new values.

The Keyword Set drop-down list and the Preset drop-down list in the Edit Keyword Set dialog box have several other useful options:

- **Save current settings as a new preset**. If the set of keywords you can see currently might be useful to you later, you can save them as a new preset by selecting this option. Type in a preset name in the New Preset dialog box and click Create. You can then choose this preset from the Keyword Set drop-down list.
- **Delete preset "preset name"**. If you are using a named preset (rather than a dynamic preset such as **Recent Keywords**), you can delete the preset by selecting this menu option.
- **Rename preset "preset name"**. If you are using a named preset, you can rename it by selecting this menu option. Simply type the new name into the Preset Name field in the Rename Preset dialog box and click Rename.

Cleaning Up Your Keyword Lists

There are two reasons why you might want to clean up your list of keywords. First, you may discover that you have keywords that you created but never used. These are easy to spot, as the number of photos associated with the keyword tag (visible in the Keyword List panel) is 0 and these keywords are shown dimmed. You can either right-click on the unused keyword tag and select Delete from the menu or choose Metadata > Purge Unused Keywords.

The other reason to clean up keywords is if you misspelled or misused a keyword in some other way. For example, I realized that some of the pictures of me were associated with a keyword **David P**, whereas others were associated with a keyword **David**. To clean up an error of this type, use the following steps:

1. Click on the arrow to the right of the keyword (in the Keyword List panel) you want to get rid of to display all the photos that are associated with this keyword. This arrow is only visible if you hover the mouse over the image count in the Keyword List.
2. Click in the list of keywords in the Keywording panel to make the list editable.
3. Type in the keyword that you'll want to keep and press Enter, thus associating the keyword with all the images that are also associated with the keyword you are discarding.
4. Right-click on the keyword you want to discard, and select Delete from the menu or click the − symbol in the Keyword Tags panel.
5. Click Delete in the resulting Confirm dialog box.

If you just want to disassociate all the images associated with a keyword, use the following steps:

1. Click the keyword to display all the images associated with the keyword.
2. Press Ctrl + A to select all the images.
3. Right-click the keyword and choose Remove this keyword from Selected photo from the menu.

Hovering the mouse over a keyword highlights (turns the border white) all the thumbnails (in Grid view) that have that keyword.

The Power of Metadata

"Metadata" (at least, in the context of imaging software) refers to the information stored about the image. Your camera will fill in many of the fields for you, such as the time the picture was taken, camera name, exposure (f-stop and shutter speed), ISO, metering mode, whether the flash fired, and so on. Other fields are filled in when you import the image into Lightroom using a Metadata preset, as detailed in Chapter 3.

You can view the metadata in the Metadata panel in the right panel group (Figure 4.34). To display different sets of metadata, make a choice from the drop-down list at the top of the Metadata panel. Various values in the list show All the metadata, the EXIF metadata, the IPTC metadata, and so on.

Click here and pick a value (Default, All, EXIF, IPTC, etc.) to choose a set of metadata to view

Click this list and pick a value to apply a Metadata preset to the selected images

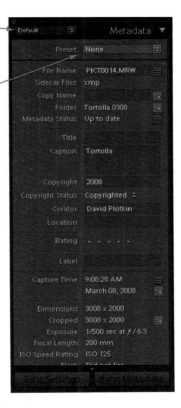

FIG 4.34 View the photo metadata in the Metadata panel.

129

Adjusting Metadata in the Metadata Panel

You can change some of the metadata for selected images using the Metadata panel. To apply a metadata preset, pick the photos and select the preset from the Preset drop-down list. If you need to build a preset first, choose Edit Presets from the list to open the Edit Metadata Presets dialog box (Figure 4.35). From here, fill in the values and choose Save current settings as new preset from the Preset drop-down list. Fill in the name of the preset in the New Preset dialog box and click the Create button to create the new preset. From then on, the metadata preset will appear in the Preset drop-down list in the Metadata panel.

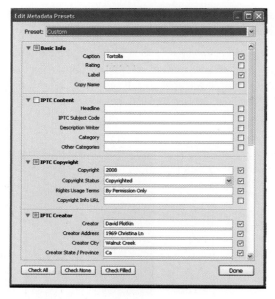

FIG 4.35 Build a new metadata preset for future use when importing images or adjusting metadata.

Metadata presets built this way are also available for use when importing images into Lightroom.

The fields in the Metadata panel break down into three types: editable, searchable, and informational. Fields such as the File Name, Rating, Label, Title, and Caption are directly editable—just click in the field and type in a value. This is also true of the fields in the Contact, IPTC, Image, Workflow, and Copyright sections (Figure 4.36).

The EXIF section is not editable, as your camera fills it in.

Some of the fields (such as the Folder field) display a button alongside the field. Clicking this button displays a set of pictures that have the same

metadata value as the selected image. For example, clicking the Folder field button displays a list of images that reside in the same folder, while clicking the Date Time Original field displays all photos with the same value of date and time. On the other hand, the button alongside the Cropped field button (in the EXIF section) opens the Cropping tool in the Develop module. Other fields (such as the E-mail or Website fields) have buttons that launch an action—in these cases, sending an email or opening your browser and navigating to the Web site.

Finally, some fields just "are"— they are informational only. The fields in the EXIF section (Figure 4.37) are all informational—you can't change their values. If you think about it, that makes sense—the ISO speed rating that was used isn't something that can (or should) be changed.

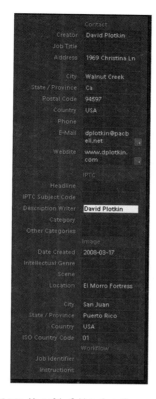

FIG 4.36 Most of the fields in the in the Metadata panel are editable to adjust the metadata associated with an image.

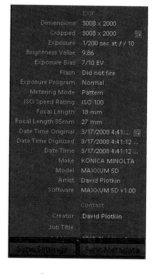

FIG 4.37 Some metadata fields simply record information and cannot be changed.

Editing the Capture Time

As I travel around the world, I often forget to reset the clock in my camera. Thus, the pictures that I took in London (which is eight hours ahead of my U.S. West Coast home) appear to have been taken at 3 o'clock in the morning! Lightroom provides a way to adjust the capture time of the images. To do so, select the image or images for which you need to make a change, and choose Metadata > Edit Capture Time to open the Edit Capture Time dialog box (Figure 4.38).

There are three options for adjusting the time. Select the one you want to use from the Type of Adjustment section of the dialog box. The fields in the New Time section of the dialog box show you both times: the Original Time (the current capture time) and the Corrected Time (what the time will be if you make the correction). The three options are as follows:

- **Adjust to a specified date and time**. To specify the exact date and time, select each item in the Corrected Time field/drop-down list and type in the

131

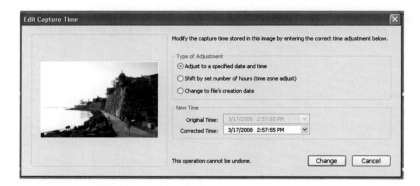

FIG 4.38 Adjust the capture time of an image using the Edit Capture Time dialog box.

value. For example, to adjust the month, click the month (first two digits) in the field and type in the number of month (January is 01, February is 02, and so on). If you click the down arrow, you can pick the date from a calendar.

- **Shift by set number of hours (time zone adjust)**. To adjust the date and time by a set number of hours, choose this option. The dialog box provides an additional field to pick the number of hours to adjust either forward ($+$) or back ($-$) (Figure 4.39). For example, to adjust my London pictures, I would choose $+8$ from the list.

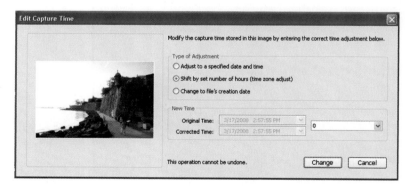

FIG 4.39 Pick the time zone adjustment from the pop-up list.

- **Change to file's creation date**. This option adjusts the date and time to when the file was created on the computer. This usually isn't a good option, as you most likely will transfer the file to the computer many hours (or even days) after the image was shot.

If you change your mind later about the adjustment, select the image and choose Metadata > Revert Capture Time to Original.

Synchronizing Metadata between Images

You may need to copy the metadata from one image to another. For example, you might have taken the trouble to set up the IPTC Copyright and IPTC Creator information correctly on one image and now you want to copy that information to a whole set of images. Lightroom provides several ways to do transfer metadata from one image to another.

The first way to copy metadata is to use the metadata copy and paste functions:

1. Select the image that has the metadata you want to copy to another image.
2. Choose Metadata > Copy Metadata (Ctrl + Shift + Alt + C). This opens the Copy Metadata dialog box (Figure 4.40).

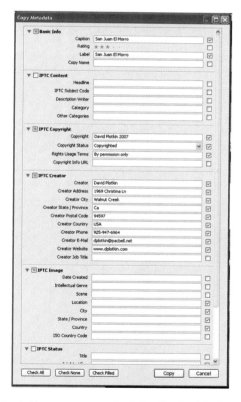

FIG 4.40 Specify which metadata you want to copy using the Copy Metadata dialog box.

3. Select the portions of the metadata you want to copy by selecting a "header" check box (such as IPTC Copyright) or by selecting the individual check boxes alongside each field.

In case you haven't figured it out yet, you can type values into empty fields and change the contents of existing fields. In other words, the Copy function really just starts you out with the metadata associated with a given image—and you can then adjust that metadata any way you'd like.

Notice that the EXIF metadata (which is captured by the camera) is not available for Copy and Paste. Again, this makes sense—information about the exposure, ISO, flash, and so on just is what it is.

4. Select the Copy button to place the metadata on the clipboard.
5. Select the images for which you want to change the metadata.
6. Choose Metadata > Paste Metadata (Ctrl + Shift + Alt + V).

The other way to copy metadata from one image to another is to use the Sync Metadata function. Use the following steps:

1. Choose all the images you want to work with, including the source image (the one containing the metadata you want to add to other images).
2. Switch to Survey View (N).
3. Select the source image—it appears with a highlighted border around it (Figure 4.41).
4. Click the Sync Metadata button at the bottom of the right panel group. This opens the Synchronize Metadata dialog box, which looks just like the Copy Metadata dialog box.

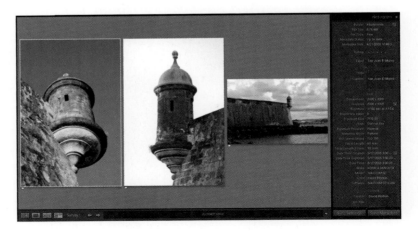

FIG 4.41 Display all the images (including the source image) in Survey view.

5. Select the content you want to synchronize and adjust the contents of any of the fields, as described previously for the Copy Metadata dialog box.
6. Click the Synchronize button to adjust the metadata of all the other images in the Survey view.

If you are only working with two images—the source and the target—you can select them both and use Compare view (C). The Select image is used as the source for the metadata, the Candidate image is used for the target.

Applying Settings with the Painter Tool That Doesn't Paint

The Painter tool resides in the toolbar below the grid and looks like a can of spray paint. If you can't see this tool, click the down arrow at the far right end of the toolbar and choose Painter from the list. Oddly enough, the Painter tool doesn't actually paint the image the way you'd think—instead, this tool enables you to "paint" settings (such as keywords and Metadata presets) onto images.

The first step in using this tool is to activate it by either clicking on the tool in the toolbar or choosing Metadata > Enable Painting. When active, the mouse pointer turns into the spray paint can and the toolbar shows an empty circle where the paint can used to be (Figure 4.42).

The spray paint can used to be here

Click here to pick what settings you want to add to an image

Configure the settings here

FIG 4.42 Activate and configure the Painter tool from the toolbar.

To use the Painter tool, pick the type of tool you want to use from the left pop-up list (called out in Figure 4.42) and then choose the configuration settings from the right pop-up list or type values into the right field (depending on the settings). Table 4.1 details what you can do with Painter tool.

TABLE 4.1 Choose and configure the Painter tool with these options.

Painter Tool	How to Configure the Tool
Keywords	Type the keywords you want to add to an image into the right field. Autocompletion of the keywords will help you fill in existing keywords, but you can also type in new keywords.
Label	Pick the color of the label from the color blocks or type a custom value into the field just to the right of color blocks.
Flag	Pick a value (Flagged, Unflagged, Rejected) from the right pop-up list.
Rating	Pick a star rating. This works just like choosing a rating in the toolbar.
Metadata	Pick the name of a Metadata preset from the pop-up list. You can't create a new preset using that list; for that, you'll have to use the techniques described previously in this chapter.
Settings	These are Develop module settings for adjusting white balance, exposure, lighting, and so on, as described in Chapters 5 and 6. Pick the name of the Develop preset that you want to use from the pop-up list.
Rotation	Rotates the image. Pick the direction of rotation or flip (flip horizontal or flip vertical) from the pop-up list.
Target Collection	Adds the image to the Target Collection.

Finding Your Images

Of course, the main reason to go to all the trouble of adding keywords, adjusting metadata, editing the capture time, flagging and rating your images, and so on is so that you can easily find the images you are looking for later. Lightroom provides powerful tools for using this information to do just that.

As discussed in Chapter 3, you can filter the images by rating, color label, and more by clicking the Attribute button in the Library Filter bar at the top of the screen or the Filter strip above the filmstrip.

Keyword Searching

The quickest and easiest way to find images with a certain keyword is to click the tiny right-facing arrow for that keyword in the Keyword List panel. This opens the Metadata filter (discussed in the next section), selects the appropriate keyword in the Keyword column, and displays all the images associated with that keyword.

Using the Metadata Browser

Lightroom contains a browser that enables you to construct sophisticated search criteria to find just the images you want using the metadata attached to the images. To activate the browser, click the Metadata button in the Filter bar at the top of the screen. A four-column search engine appears (Figure 4.43). The default height is useful, but if you need to adjust the height, move the mouse over the bottom border until it turns into a two-headed arrow, then click and drag the border up and down.

Click Custom Filter to display a list of saved filters or save a new filter

FIG 4.43 Use the search engine to find the photos by up to four different criteria.

Setting Up the Column Contents

Each column can contain any of the fields (Figure 4.44) that you'll see when you click on the small two-headed arrow button alongside each column heading. To change the search criteria for that column, simply pick the quantity you want to search on from the pop-up list.

The two-headed arrow is not visible in Figure 4.44 because it disappears when you click to display the fields.

Although Lightroom won't stop you from doing so, it really makes little sense to select the same criteria for two or more columns.

FIG 4.44 Pick search criteria from the pop-up list at the top of each column.

Three of the fields are "hierarchical." That is, there is a structure to the values contained in the field. For example, the date hierarchy is year, month, date. The other two fields are Keywords (which can be nested) and Location. If you pick one of these fields, the drop-down list that appears when you click the List icon in the upper-right corner includes the options "Flat" and "Hierarchical." "Flat" displays all the valid values for that field. For example, if you pick Keyword, the column will display a list of all available keywords (as shown previously in Figure 4.44). If you pick "Hierarchical," you will see the structure of the field and you can click on a hierarchy level, expanding the hierarchy by one level. For example, if you pick Date, it enables you to pick a year or month or day, expanding the hierarchy as you go (Figure 4.45). Clicking on a year, month, or day shows the images shot during that time period, which is especially useful for large collections of images that have been built up over time. As with other filter criteria, you can Ctrl + click multiple years, months, or days to show those images.

FIG 4.45 Expand the Date (Hierarchical) filter criteria to pinpoint images shot during the specified year, month, or day.

For "normal" (nonhierarchical) fields, the Flat/Hierarchical options are not available, and the column shows all the available values for that field.

Picking the Values to Search For

Now comes the fun part. You work with the search engine from left to right. That is, when you pick a matching value from the leftmost column, the other

three columns change to show just the valid values within the image set that matches the first column. In our example, if the first column contains Date and you pick a date from that column, the other three columns adjust to show the camera, country, and keywords for the images taken on that date. If you then pick a value from the second column, the two rightmost columns adjust to show the values that correspond to the images that match both the criteria in the first column (Date, in our example) *and* the criteria in the second column (Camera, in our example). You can work through all four columns this way; at the end, the visible photos match the criteria in all four of the columns.

You can choose multiple criteria within a given column by choosing the first value, then Ctrl-clicking additional values. This technique chooses photos that match the first value in the column or the second value in the column (or the third value, etc.). You can also click the first value in the column, then Shift-click the next value, selecting the entire range of values. So, for example, you could pick photos taken over a range of dates by clicking on the first date then Shift-clicking on the end date for the range (Figure 4.46).

FIG 4.46 Pick a range of dates in the search engine.

Adding and Removing Columns in the Metadata Browser

If you find that the default four columns aren't enough to filter your images, you can add columns by clicking the list symbol in the upper-right corner of any existing column and selecting the Add column option from the drop-down menu. This adds a new column to the right of the column you clicked on. You can remove a column by clicking the Remove this column option in the list for the column.

You can also save a set of columns and the search criteria selected within the columns. Once you've configured the filter criteria (columns and values), click Custom Filter in the upper-right corner of the Metadata Browser and pick Save current settings as New Preset. Fill in the name of the new preset and click Create. The new preset is added to the list so you can pick it later.

The Custom Filter list contains presets for all of the Library filters (Text, Attribute, and Metadata). Picking a preset that applies to a filter that is not the currently selected filter automatically opens that filter. You may want to build the name of the filter into the preset name to give yourself a hint as to which filter the preset applies to.

Filter Using a Text Search

The text field that appears when you click the Text button in the Filter bar enables you to search for your photos based on almost any text field including

keywords and various flavors of metadata. To execute a text search, use the following steps:

1. Click the leftmost field in the Text search strip to display the list of text-searchable fields (Figure 4.47). The metadata categories Searchable EXIF and Searchable IPTC search through any of the fields in those sections of the Metadata panel. The Searchable Metadata entry searches through all the text fields in the metadata.

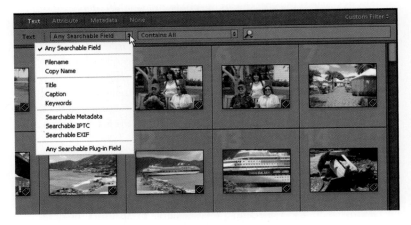

FIG 4.47 Pick a field to search on from the Text search tool.

2. Click on the center (comparison) field and choose the comparison term from the list.
3. Except for the comparison criteria that contain "Empty" (Is Empty, Are Empty, Isn't Empty, Aren't Empty), type the comparison text into the rightmost field. As you type the text, Lightroom dynamically chooses the images that match what you have typed. For example, if you select *Keywords* and *Contains any*, and type *Puerto* into the field, Lightroom finds all the images from Puerto Vallarte and Puerto Rico (and any other keywords that contain *Puerto*). *Note:* The above assumes that you, like me, create Keyword tags containing the city or state name.
4. When you are done viewing the images, click the Text button to turn off the text filter and return to viewing all the image.

Locating Wayward Images

I warned you earlier in this chapter about deleting or moving images using Explorer (Windows) or Finder (Mac). The problem is that Lightroom won't know where the images are and thus won't allow you to work with them. If you ignore my advice (either accidentally or on purpose), Lightroom will warn you that it can't find the images by placing a badge in the upper-right corner (Figure 4.48).

One very handy use of the Text search tool is to find images that are missing important information—such as images that have no keywords. To detect images like that, select the field you are interested in and choose the comparison *Are Empty* or *Is Empty*. Only images missing that information are shown, and you can use the right panel group panels to add the information you need. As you do, the image will disappear from the Grid until they are all gone—and you're done.

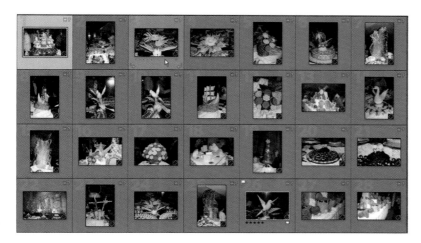

FIG 4.48 Oops. File not found!

To correct this situation, click the badge to open the Confirm dialog box (Figure 4.49). The dialog box enables you to locate the file by clicking on the Locate button. When you do, the Locate dialog box opens. This is a standard file dialog box, which you can use to navigate to the folder holding the image and select it. Then click Select.

FIG 4.49 Click the Locate button to point Lightroom to the image it can't find.

If multiple images are missing, you'll want to select the Find Nearby Missing Photo check box. When you locate the first missing photo, Lightroom will check to see if the rest of the missing photos are in the same directory. If they are, the catalog will be updated for the location of all of them—saving you the trouble of performing this job manually.

Of course, if you actually deleted the image, you'll simply have to remove the thumbnail from Lightroom by right-clicking the image and choosing Delete Photo from the shortcut menu. And don't forget that you can synchronize an entire folder to get rid of missing images.

Although some settings—like stacks and collections—are stored in the catalog, most of what I do on the road is stored either in the file itself (for files like JPEG) or in the sidecar file (the .xmp file that goes along with raw-format photos). These changes include all the Develop module adjustments, including cropping, adjusting white balance, exposure, lighting, clarity, and vibrance. In addition, the keywords and metadata are also stored with the photos. Thus, if what you want to preserve is just the adjustments, keywords, and metadata that you applied on the other computer, you don't actually need to go to the trouble of exporting a catalog and then reimporting it on another machine. Instead, just copy the files (and sidecar files, if any) from one computer to the other. Then, open Lightroom on the target computer and simply reimport the files themselves (File > Import Photos from Disk). All your changes, keywords, and metadata will be intact!

Exporting and Importing Catalogs

If you're like me, you have a master Lightroom catalog of images (backed up, of course) on your home computer. But when you're out on the road, taking photos of exotic locales, you may be creating catalogs in Lightroom, tagging, flagging, rating your photos, and perhaps making adjustments at the end of the day on your laptop computer. When you return home, you don't want to lose all that work you've done and fortunately you don't have to. You can export a catalog (with all its images and changes) from one computer and import them into a catalog on another—and never lose any of your hard work. Here is how you go about that.

Exporting a Catalog

To export a catalog, the first step is to filter the photos to show only those you want to export. You can do this by choosing a folder or collection or applying criteria from the Library filter. Choose File > Export as Catalog to open the (you guessed it) Export as Catalog dialog box (Figure 4.50).

FIG 4.50 Specify the name of the exported catalog in the Export as Catalog dialog box.

Fill in the name of the exported catalog in the File name field. This name is used as the name of the folder where all the contents of the catalog are stored.

If you are going to move the catalog (and images) to another computer, leave both the Export negative files check box and Include available previews check box selected.

> If you are going to import the catalog into an existing catalog on the same machine, you don't need to select these two check boxes.

If you only want to export the selected photos, select the Export selected photos only check box. If you leave it unselected, all the visible files will be exported. Finally, click Save to start the export process.

You can also export the following items as new catalogs:

- **Collections**. Select the collection (either a regular collection or a Smart Collection) and choose Export this Collection as a Catalog from the shortcut menu.
- **Folders**. Select the folder and choose Export this Folder as a Catalog from the shortcut menu.
- **Keywords**. To export all photos associated with a keyword, right-click the keyword in the Keyword list panel and choose Export these Photos as a Catalog from the shortcut menu.

Importing a Catalog

To import a catalog and merge it with an existing catalog, open the catalog you want to merge the photos into in Lightroom. Then use the following steps:

1. Choose File > Import from Catalog to open the Import from Lightroom Catalog dialog box (Figure 4.51).

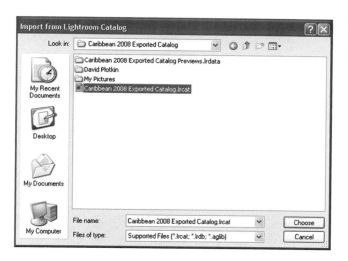

FIG 4.51 Find the catalog that you want to import in the Import from Lightroom Catalog dialog box.

2. Navigate to the catalog you want to import (ending in .lrcat) and click Choose. This opens the Import from Catalog "catalog name" dialog box (Figure 4.52).

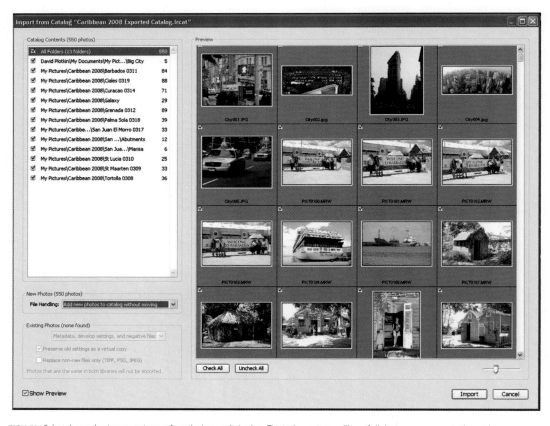

FIG 4.52 Select the catalog images to import from the Import dialog box. This is the version you'll see if all the images are new to the catalog.

3. Select the images you want to import. If you don't see the previews, select the Show Preview check box.
4. Adjust the settings in the Import dialog box as described in the next section, and click Import to add the photos to the current catalog.

Don't get upset if you only see your new photos in the catalog. The default setting for Lightroom is to show you only the results of your previous import—exactly the images you just imported. To see all the images in the catalog, click All Photographs in the Catalog panel on the left side of the screen.

Adjusting Import Settings for New Images

You can set the file handling controls for new photos in the New Photos section of the Import from Catalog dialog box. Choose whether to import the images at their current location or to copy them to a new location. If you choose to copy them to a new location, the Copy to control appears (Figure 4.53). Click the Choose button to specify the target folder to copy the photos to.

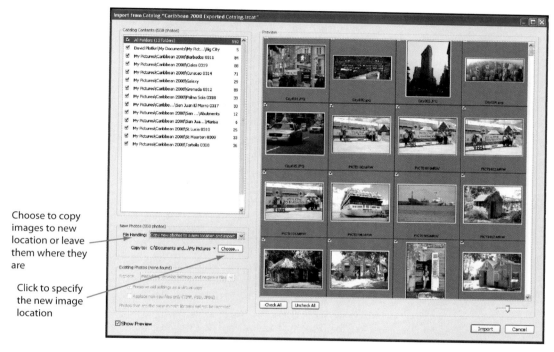

Choose to copy images to new location or leave them where they are

Click to specify the new image location

FIG 4.53 Use the new controls to copy images to a new location.

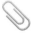

Of course, if the photos are on a USB drive or CD/DVD, you'll definitely want to copy them to a new location on your hard drive—and that is the only option you are offered.

Adjusting Import Settings for Existing Images

You can adjust what will be imported for images that already exist in the target catalog using the controls in the Existing Photos section of the Import from Catalog "Catalog Name" dialog box (Figure 4.54). These options are only available if duplicates are detected.

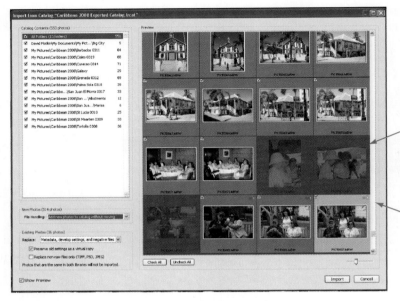

Indicates that the re-imported image is identical to the version in the Lightroom catalog and will not be imported (dimmed)

Indicates that this image exists in the current catalog, but is different from the catalog you'll be importing (badge)

FIG 4.54 Adjust the parameters for what Lightroom will do with existing images.

The first thing you need to decide is what to replace in the target catalog. You can select from a combination of choices in the Replace drop-down list:

- **Metadata, develop settings, and negative files**. Replaces metadata values, Develop module settings and the image files from the source (imported) catalog. If the source catalog settings are different from the target catalog settings, the target values will be overwritten unless you choose to preserve those settings as a virtual copy (discussed later).
- **Metadata and develop settings only**. Replaces metadata values and Develop module settings only. This option does not replace the image file itself. In truth, because Lightroom doesn't make any changes to the negative (image) file, this is the best setting to use if you're just working with files that have been modified in Lightroom.
- **Nothing**. Nothing is replaced. The import proceeds, but only new photos are imported. Photos that are different in the source catalog are not imported into the target catalog.

If you have made changes in the original catalog and are reimporting images with new Develop settings or metadata, you have the option to preserve those settings as a "virtual copy." To do so, select the Preserve old settings as a virtual copy check box. Essentially, this means that you'll appear to have two copies of the image in your Lightroom catalog (Figure 4.55). What you actually have is one copy of the negative file itself and two sets of non-destructive changes. You can then proceed to modify each virtual copy independently, changing the metadata and Develop settings, as well as the keywords and everything else.

This number indicates
how many copies of the
image are in the catalog

Lines indicate
the last
thumbnail
in the set

This is a "matched pair" of
the original and the copy

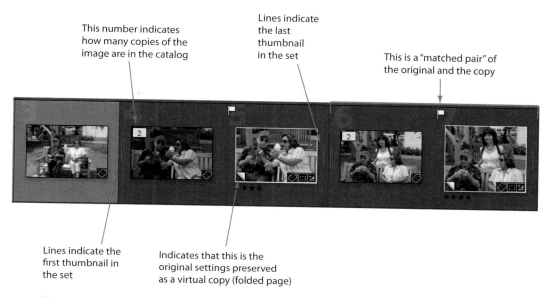

Lines indicate the
first thumbnail in
the set

Indicates that this is the
original settings preserved
as a virtual copy (folded page)

FIG 4.55 When you preserve your original settings as a copy, you'll see two versions of your image.

The multiple-version images have dark gray borders, compared to the light gray borders of "normal" (nonmultiple) images.

Lightroom provides some additional information to help you sort out the imported results:

- **Indicator of a virtual copy.** The virtual copy displays a "folded page" icon in the lower-left corner to let you know that it was the original, preserved when you imported a new version.
- **Number of copies**. If there is more than one copy of the image in the catalog, a number appears in the upper-left corner of the most current version to tell you how many copies there are.

If you hover your mouse pointer over either a virtual copy or the most recent version, you'll see a counter (Figure 4.56). The counter numbers are from 1 (the most recent version) to n, where n is the number of copies. The sets of thumbnails are displayed in a dark gray with a small set of lines in either the left margin (the first thumbnail) or the right margin (the last thumbnail).

FIG 4.56 Hover your mouse pointer
over a thumbnail to see a counter
of the number of versions of an
imported image.

If you chose to replace the negative files in the target catalog, you can limit this option to replacing just the nonraw files. To do so, select the Replace nonraw files only (TIFF, PSD, JPEG). As stated earlier, you only need to replace the negative files if you made changes to the original in an external editor. This is really only possible with nonraw files, so it makes sense to select this option and speed up the import by replacing only those files.

Performing Catalog Maintenance

Specific photo information (metadata, keywords, and Develop module adjustments) is stored with the photo itself (either in the file or as a sidecar file). However, a great deal of the information that makes Lightroom so powerful is stored in a catalog file and is therefore quite important. For example, this file contains information about how photos are grouped into collections; definitions of Smart Collections, Slideshow, Web, and Print module settings; user-defined presets and templates; preferences; and much more.

On occasion, the catalog file can become corrupted, resulting in strange behavior (such as not being able to find images that you *know* exist). You can often recover the information from a corrupted file and rebuild it using the tools in Lightroom. And it is obviously important to back up the file from time to time.

Creating New Catalogs

Lightroom would obviously be limited if you could have only a single catalog. Fortunately, however, you can create new catalogs and work with them— though only one at a time. To create a new catalog, use the following steps:

1. Choose File > New Catalog to open the Create Folder with New Catalog dialog box (Figure 4.57).

FIG 4.57 Specify the folder that will contain the new catalog in the dialog box.

2. Type the name of the folder that will contain the new catalog and all its support files into the File name field in the dialog box.
3. Click Save.
4. Lightroom closes and then relaunches using the New Catalog. This is because Lightroom must shut down and relaunch each time you change catalogs.

Opening a New Catalog

Of course, if you have multiple catalogs, you need a way to switch between them. Lightroom provides two menu options in the File menu to perform this task. The simplest is to choose File > Open Recent and then pick a catalog from the fly-out menu.

To pick a catalog that doesn't appear in the File > Open Recent menu, choose File > Open Catalog to open the File Open Catalog dialog box. Use the standard controls to navigate to the location of the catalog you want to open, and select it (catalog files end in .lrcat). Then click Open. Lightroom presents the Open Catalog dialog box (Figure 4.58), which warns you that it will relaunch to open the selected catalog. Click Relaunch to relaunch Lightroom and switch to the selected catalog.

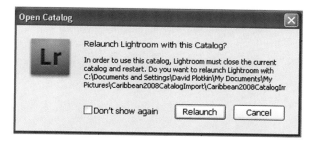

FIG 4.58 Relaunch Lightroom to open a new catalog.

Backing Up and Testing the Integrity of a Catalog File

As mentioned earlier, catalog files contain considerable useful information and are worth backing up. To back up and (optionally) test the integrity of a catalog file, you must use the Back Up Catalog dialog box (Figure 4.59), which appears periodically when you launch Lightroom.

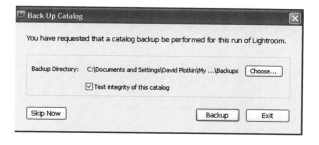

FIG 4.59 Back up and test the integrity of your catalog when you launch Lightroom.

The dialog box provides the following options:

- **Choose the location of the back-up file**. You can put the back-up file anywhere you want by clicking the Choose button and navigating to the folder using the resulting Browse For Folder dialog box. However, the default location (in My Pictures\Catalog Name\Backups) is as good a place as any.
- **Test integrity of this catalog**. Select this check box if you want Lightroom to ensure that the file has not gotten corrupted. This takes longer but is advisable to do at least occasionally as the files do become corrupted and it does you no good to back up a corrupted file! Just be aware that this can take a while.
- **Skip now**. If you don't want to back up the file when the dialog box appears, just click the Skip Now button.
- **Back up**. Writes out the back-up file to the chosen location, testing its integrity if you selected the appropriate check box.
- **Exit**. Aborts opening Lightroom altogether and does not back up anything.

One of the most asked questions about backing up is what controls when the Back Up Catalog dialog box appears. As it turns out, the frequency of its appearance is under your control, but this is not immediately obvious. To adjust the frequency, you need to use the Catalog Settings dialog box, which you can access by choosing Edit > Catalog Settings (or Ctrl + Alt + ,) and switching to the General tab (Figure 4.60).

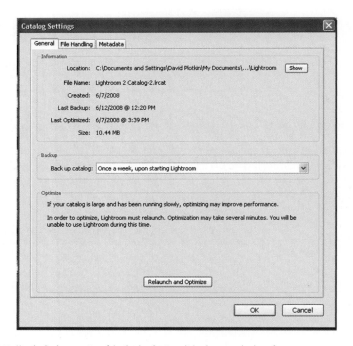

FIG 4.60 Use the Back-up section of the Catalog Settings dialog box to set back-up frequency.

Set the frequency by choosing the value you want from the Back up Catalog drop-down list. There are a variety of frequency values, such as once a week or upon starting Lightroom (which happens to be the default). One value is worthy of special mention—Next time Lightroom starts only. Pick this value if you feel the need to back up your catalog without waiting for the next time the Back Up Catalog dialog box appears. After choosing this value, shut Lightroom down and restart it, and the dialog box is presented during start-up so you can do the back-up. After that one-time launch, the value becomes Never, so don't forget to go in and adjust it if you want to be reminded to back up your catalog periodically.

So what do you do with a back-up? If you manage to corrupt your main catalog and can no longer use it (something I've never actually had happen with the released product but that has happened with the beta), you can use the back-up catalog file. Simply close Lightroom, find the back-up file (.lrcat) you made, and copy it over the corrupted original. If the file still won't open in Lightroom, you may have to delete the "Catalog name" Previews.lrdata folder. Opening the catalog should then work, but Lightroom will have to rebuild all the previews, which can take a while. Still, it's better than having to build your catalog from scratch.

Optimizing a Catalog

As you make changes to your Lightroom catalog—adding and removing collections, building and discarding presets, and so on, the catalog file can grow large and inefficient. You can "optimize" the catalog file, which removes unneeded portions and shrinks the overall size, making it faster to load and use. To optimize the catalog, return once again to the General tab of the Catalog Settings dialog box and click the Relaunch and Optimize button. Lightroom closes and begins the process of optimizing the catalog. Once it is done, Lightroom reopens. Opening the optimized catalog the first time takes a little longer than usual because it has to reload the entire catalog and rebuild various files.

Fixing Photos Fast Using Quick Develop

After you have imported your photos and sorted out the good from the bad and the ugly, your next step is to enhance the selected images that you will deliver to your client or display on your Web page. Ideally, all of the photos you shot were perfect. Your flash always fired, none of the people in the photos had red-eye, and the bride didn't break out with a bright red rash minutes before the ceremony. Unfortunately, we shoot photos in the real world and all of the aforementioned imperfections can and do happen.

Discovering the Power of Quick Develop

Photoshop Lightroom has a lot of tools designed to clean up the real-world problems photographers deal with on a daily basis. With the addition of Local Adjustment tools to the Develop module, you now can enhance or even salvage photos that would have required an external photo editor in the previous version. The only drawback with using the tools in the Develop module is that it slows down the overall workflow to jump back and forth

between the Library and the Develop modules. If you are working on a single photo, then you can justify the extra time it takes to make it perfect. If you are faced with several hundred photos from a wedding or your last vacation, you want to enhance them in the shortest amount of time. To accomplish this goal, Adobe provides the Quick Develop tools in the Library module, as shown in Figure 5.1, which allow you to do quick clean-ups in the same module in which you are sorting the photos.

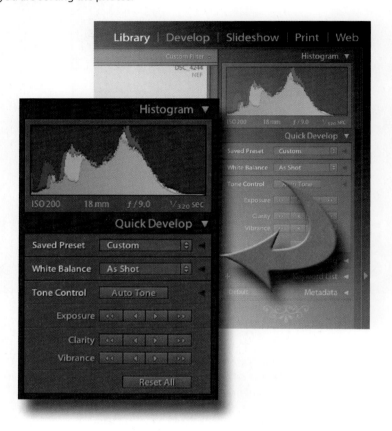

FIG 5.1 Quick Develop tools.

What Is Quick Develop?

The Quick Develop panel in the Library module contains a set of controls that allow you to apply tone and color adjustments to images with a few clicks of a mouse. The adjustments can be applied to a single photo or multiple images that have been selected from the grid or filmstrip. The Quick Develop tools allow quick adjustments to images from within the Library module and are same as those tools found in the Develop module. The primary difference between the tools is the Quick Develop tools use a simplified interface (buttons or selecting

presets), whereas the tools in the Develop module are managed using sliders and other methods that offer a finer degree of control. Not all of the tools in the Develop module have an abbreviated counterpart in Quick Develop.

What Can Be Done Using Quick Develop?

The Quick Develop panel, as shown in Figure 5.2, presents all three sections or panes fully expanded. The sections are named Saved Presets, White Balance, and Tone Control. The display located on top of Quick Develop tools called the histogram. What follows is a summary of the Quick Develop tools and what you can do with them.

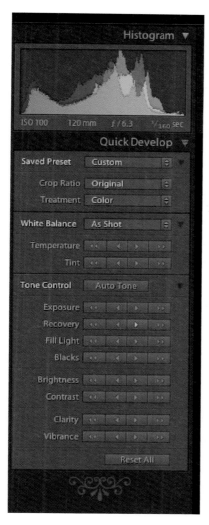

FIG 5.2 The Quick Develop Sections (expanded) and the histogram.

Saved Presets Pane

The name "Saved Presets" doesn't give you a clue as to what can be done with the controls in this pane. From the Saved Presets pane, you can apply one of the many built-in Develop effects, crop an image, as well as convert an image from color to grayscale.

Developing Presets

The Preset menu shown in **Figure 5.3** allows you to select and apply Develop module presets while in the Library module. You can learn more about Develop presets in the next chapter. For now, know that a preset provides a way to save a group of Lightroom tool settings and apply them to other photos.

FIG 5.3 Preset menu and a modern color photo.

Lightroom comes with a collection of presets. The presets available in Quick Develop can be modified in Quick Develop, but to save a modified preset, you must switch to the Develop module. The example shown in Figure 5.4 is a photo taken of a Civil War reenactor. The Antique Grayscale preset was applied to make it look more like a photo taken in the 1860s (**Figure 5.4**).

FIG 5.4 Photo with Antique Grayscale Effect applied.

Important Presets You Should Know

Presets are not limited to producing cool effects. There are several important presets that you should use as part of your photographic workflow. Make a special note of the presets (Figure 5.3) categorized as Sharpen and Tone Curve.

There are two Sharpen presets: Landscape and Portrait: These presets contain some well thought out settings for the Sharpen tool (located in the Develop module). Use the Portrait preset for close-up photos of people and the Landscape preset for every thing else. You can also develop you own favorite sharpening setting in the Develop module, save it, and it will be available in Quick Develop. I know you know this, but always apply sharpening after you have made any other enhancements.

The Tone Curve preset has two-tone curve settings and it gives you the ability to apply Tone Curve settings (another Develop Module tool) from within the Quick Develop module.

Applying a Preset

To apply one of the presets to an image:

1. Click on the down arrow to the right of the Saved Presets and a drop-down list appears as shown in **Figure 5.5**. The list is alphabetical and each of

FIG 5.5 Presets list in the Saved Presets pane.

the built-in presets includes general category names: Creative, General, Sharpen, and Tone Curve.

2. Select a preset and click on its name. The preset is immediately applied. In the Develop module, you can preview the effect of the preset before you apply it. Not so in Quick Develop, so if you don't like the preset after it is applied, use Undo Ctrl + Z or Cmd + Z (Mac) to remove it.

Modifying the Presets

It has been my experience that the application of any of the Creative preset requires some tweaking after it is applied. The most common occurrence is that the preset settings make the photo too dark or too light. A before and after example of this effect is shown in Figure 5.6. If this happens, it doesn't mean you cannot use the preset; it just needs to be adjusted to fix your photo using the Tone Control tools described later in the chapter.

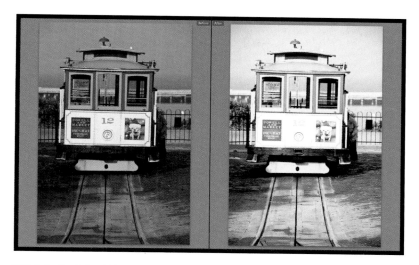

FIG 5.6 Creative-Antique Light preset overexposes the image.

Pressing the Reset All button at the bottom of the Quick Develop pane or selecting the Default Settings preset will reset to the Lightroom default import settings

Regardless of what preset you select in the Saved Presets pane, its name automatically changes to custom whenever you change any setting in the Quick Develop panel. The White Balance setting also changes to custom.

Cropping a Photo

The **Crop Ratio** menu option lets you apply a preset crop setting. You can only use the choices that appear on the drop-down list shown in Figure 5.7. There is a custom setting where you can enter crop dimensions, but Lightroom centers the new crop dimensions on the image. For cropping that can't be done using the preset sizes, a full featured Crop tool (called Crop Overlay) is found in the Develop module.

Sensor Aspect Ratios and Photo Sizes

The crop dimension choices listed on the drop-down list are standard photo or paper sizes. The aspect ratio (ratio of width to height) sensor on most digital cameras is 3:2. If the aspect ratio of the photo paper is different from the ratio of the sensor, then part of the image may be cut off. Figure 5.8 shows the entire photo as shot by the camera. Figure 5.9 shows the same photo if it is cropped to 8 × 10. Notice how much of the left and right sides of the photo would be cut off if this photo were to be printed on an 8 × 10. It is something to keep in mind when shooting a photo that a customer might request as an 8 × 10.

FIG 5.7 Corp preset sizes.

FIG 5.8 Original photo viewed with the original crop ratio.

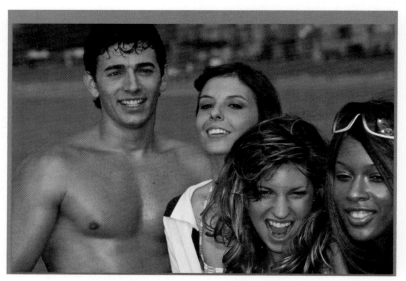

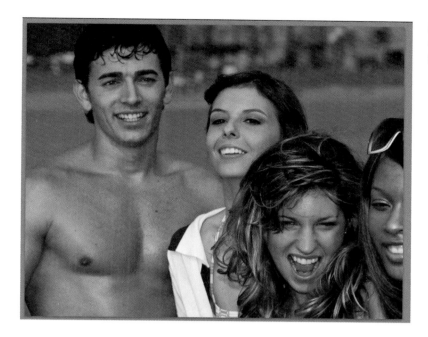

FIG 5.9 Using an 8 × 10 crop can result is part of the subject being lost.

Quick Black-and-White Conversion

The **Treatment** option allows you to switch a color image and make it appear as grayscale as shown in Figure 5.10. This feature is great way to preview what an image may look like as a grayscale. When you select it, Lightroom evaluates the colors in the image and does a respectable job of making it into a grayscale. Still, for critical fine art black-and-white work, there are advanced

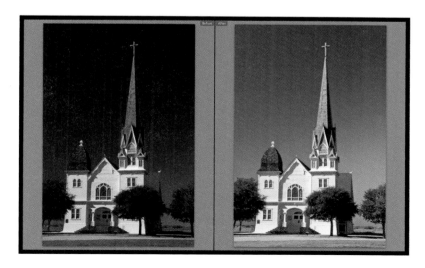

FIG 5.10 The Treatment option redisplays a color image as a grayscale.

tools in the Develop module that provide a great amount of control over how the colors in the image are converted to grayscale.

Reading Image Histograms

If you are unfamiliar with using histograms, it is time to correct that problem, because the histogram is an essential tool of both digital photography and Lightroom. Let's start at the beginning.

A histogram displays the relative levels of darker to brighter tones in an image. There are two histograms in Lightroom. The histogram in the Library module (shown in Figure 5.11) is a traditional passive display, meaning in that it shows the light distribution of the selected image. The histogram in the Develop module is an interactive tool that can be used to adjust the tonal distribution in an image.

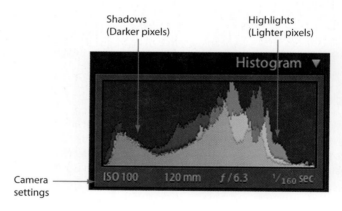

Shadows (Darker pixels)

Highlights (Lighter pixels)

Camera settings

FIG 5.11 Library module histogram.

Figure 5.11 shows the histogram that appears in the Library module. When an image is selected, the display is briefly blanked while Lightroom calculates the histogram. The left third of the display represents the darker pixels or shadow region; the right third represents the brightest pixels or the highlights. The middle pixels are called midtones. A histogram with spikes pushed up against either end indicates a photo with shadow or highlight clipping. Clipping can result in the loss of image detail.

How to Use a Histogram

Using the histogram to evaluate changes made with the Quick Develop tools is simple. Figure 5.12 is a photo of a bicycle race shown with its histogram. Its bell-shaped distribution curve is considered by some to be ideal. Don't become a slave to the idea of trying to achieve that shape of curve; it is only

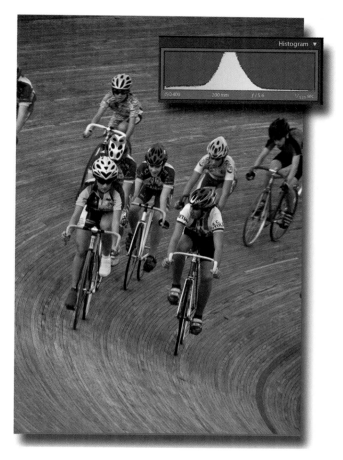

FIG 5.12 Bell-shaped histogram distribution is considered by many as ideal.

a guideline. In Chapter 6, you will see some excellent photographs whose histograms have curves that look like the stock market on a bad day.

Avoiding Clipping and Loss of Detail

Any time you make any changes to a photo, you want to monitor the histogram, making sure that you avoid clipping in either the highlight or shadow region. Figure 5.13 shows the histogram that resulted when a preset was applied (refer to Figure 5.6).

Notice how the distribution of pixels in the histogram is slammed against the right side. This means that the highlights in the photo are blown out. If the file was exported or printed at this point, all of the details in the highlights would be lost.

If clipping occurs at the time a photo is taken, any details in the clipped area is lost and cannot be recovered, which is why you should also be looking at the

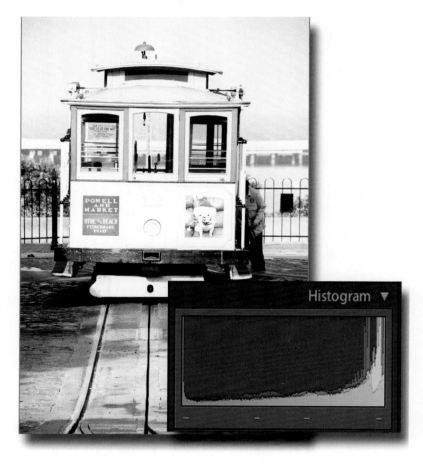

FIG 5.13 Histogram shows highlight clipping.

histogram display on your digital camera after taking photos to make sure the photo you just took doesn't have clipping.

A common cause of loss of detail as a result of highlight clipping occurs when photographing a white wedding dress in bright sunlight. Monitor your camera's histogram and reduce your camera's Exposure Value (EV) setting to prevent blowouts.

White Balance (WB)

White balance is used to remove unwanted color casts and produce accurate colors in your photos. The concept of white balance comes from video photography and works on the principle that adjusting the image color

remove any color casts on a neutral subject (white card) will ensure accurate color, which is why is it called white balance. Today, the ideal color target is not white but 18% gray. We will cover white balance in greater detail in Chapter 6. Correcting the white balance in the Quick Develop module can be accomplished in two ways. Using one of the predefined white balance settings from the drop-down list or adjusting the Temperature and Tint settings.

Correcting White Balance

The photo shown in Figure 5.14 opens with the As Shot white balance settings selected. This means that Lightroom is using the white balance setting that the camera used. In this case, the camera's WB setting didn't get it correct, and the white façade of this old Venetian building on the Grand Canal appears slightly blue.

FIG 5.14 Camera auto-white balance produced a bluish color cast.

Try these procedures to correct the white balance:

1. In Quick Develop, first try the Auto setting. This is almost always a good place to begin. The Auto setting in this case improved the color, but you should try one or more of the presets to see if the color improves.
2. In this example, several other presets were tried before settling with the Daylight setting, as shown in Figure 5.15.

FIG 5.15 The Daylight WB preset corrects the color so it looks like it did the day the photo was taken.

3. If Auto or any of the presets fail to give you a color correction that you want, you can adjust the Temperature and Tint buttons to tweak the color correction. Use the single-headed arrow buttons because the double-headed buttons will, in most cases, add or subtract too much color shift.

Critical Color Adjustments

If you need to make critical adjustments to the color temperature or tint settings, it is best accomplished in the Develop module. All of the WB settings like daylight, tungsten, and flash, represent a generalized correction and you should not assume if a photo was taken using a flash that you must use the flash preset. You may open a WB list and only see As Shot, Auto, and Custom. This happens with photos saved as JPGs or TIFF format.

The Tone Controls and What They Do

Some of the controls in the Tone Control portion of the Quick Develop pane may be familiar to you; others may be new. The operation of the buttons is the same on all of the controls. Click the single-headed arrow button for small incremental changes and the double-headed arrow button for larger changes. When you work with the sliders in the Develop module, you will discover that the settings

represent values in a range. For example, moving the Saturation slider to the extreme left applies a setting of −100% saturation to the image, making it appear as a grayscale. Clicking the buttons in Tone Control applies changes to the selected setting relative to its current setting. When you use the Saturation example, each time you press the double-headed arrow button it changes the saturation by 20%, but there is nothing in the Tone Controls section that reports the setting. The only feedback you have is the preview image.

What follows is a brief summary of what each control does.

Auto Tone

Pressing Auto Tone causes Lightroom improve the overall appearance of the image without clipping. In the previous version of Lightroom, applying Auto Tone almost always made the photo too bright. In version 2.0, Auto Tone has been greatly improved and you should make it one of your first steps when correcting an image in Quick Develop. Figure 5.16 shows a before and after example of a quick photo fix made using Auto Tone.

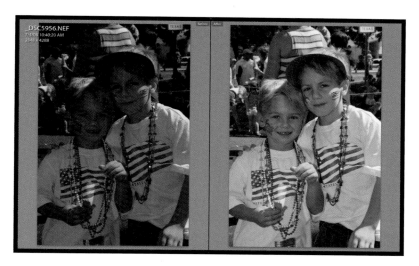

FIG 5.16 Auto Tone often corrects the image with a single click.

In Figure 5.17, the flash fired but it didn't have a full charge. The model is still visible, and the histogram says there is some detail that can be recovered from the image. Figure 5.18 shows the image after applying Auto Tone.

Automatic Tools in Lightroom

There is a general belief among a few photo professionals that any automatic tools in photo editing applications are strictly for use by nonprofessionals and should be eschewed by the true professionals. You will do yourself a

FIG 5.17 Underexposed image caused by the flash not being ready.

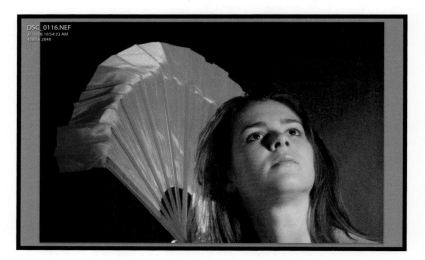

FIG 5.18 Auto Tone recovered the photo.

disservice if you don't at least try them and make up your own mind. I would hate to think that you would miss out on the benefits of this integral part of the Lightroom workflow. Don't let others deter you from using the automatic tools. I'll quit preaching now.

Exposure

With all of the sophisticated metering systems built into today's digital cameras, exposure remains one of the most common problems with

photos—they're frequently too dark or too bright. The Exposure control lets you monitor the overall brightness of the image and it has a greater effect in the highlight region than on the part of the image in the shadows. If an image is badly underexposed, be cautious when increasing the exposure as too much exposure may introduce noise (graininess) in the shadow details. Figure 5.19 is a close-up of the image recovered by Auto Tone (see Figure 5.18) and the noise that occurs when the pixels in the shadows are pushed make the details visible.

FIG 5.19 Noise (graininess) often occurs when making dark areas lighter.

The Exposure control mimics the f-stop settings on your camera. The single-headed arrow buttons are approximately 0.3 of a stop and each click of the double-headed arrow button is the equivalent of an f-stop.

Fine-Tuning with Exposure

Here is one of the best ways to use the Exposure settings. You can download this photo (Dog.JPG) and do this yourself.

1. The original photo (Figure 5.20) of the dog (his name is Rabies) is a little too dark, so click the Auto Tone button.
2. The application of Auto Tone made the dog a little too bright (Figure 5.21).

FIG 5.20 Original dog photo.

3. Click the left single-headed arrow Exposure button one time to slightly decrease the exposure and you are done (Figure 5.22).

A question you may have at this point is, couldn't increasing exposure do the same thing that Auto Tone did? In some cases it does, but Auto Tone adjusts all of the tonal settings, unlike the Exposure button, which only controls exposure. Figure 5.18 was recovered using Auto Tone; Figure 5.23 shows the same image, only the Exposure button was used instead of Auto Tone.

Is one of your Quick Develop sliders missing? To the right of Tone Control and White Balance is a tiny triangle. Clicking the triangle reveals all of the sliders.

FIG 5.21 Auto Tone makes the photo a little too bright.

Recovery

The Recovery control is really great. It literally recovers detail in areas that would normally be lost because of overexposure (blowouts). It does its magic by looking at all three color channels and if it finds detail information in one of the channels, it redistributes it to the channels in which the detail was lost. Recovery works best with raw files where detail is still available in at least one channel. Lightroom can interpolate for JPEG and TIFF, but not as effectively. Recovery cannot remove or reduce glare from a flash or the sun. If an area is completely blown out, no amount of adjustment to the Recovery setting can restore the lost details. Also be careful that you don't apply too high of a Recovery setting, as this can turn a soft glare into a bright well-defined blob.

171

FIG 5.22 A little negative exposure does the trick.

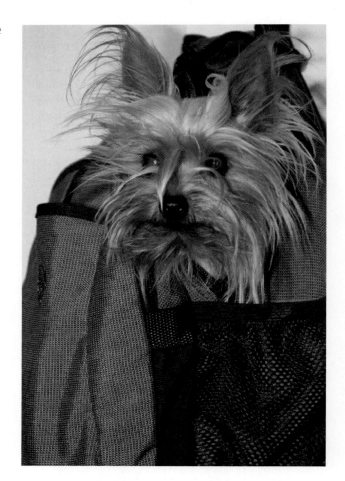

FIG 5.23 Using Exposure alone does not do as much as Auto Tone.

Fill Light

Like its namesake, the Fill Light setting lightens the shadow regions of a photo to reveal more detail without brightening the darkest blacks. It is best to make small adjustments with this slider, as over applying it can reveal image noise and add an unnatural look to the image. In Figure 5.24, the Fill Light setting was used to bring the subject on the left out of the shadows and the Recovery setting was used to prevent the bright background from getting any brighter.

FIG 5.24 Fill light improves images with cast shadows.

Blacks

This setting control defines which image values are mapped to black. Using the buttons on the right increases the areas that become black. Although it darkens the image somewhat, pushing the darker shadows to black adds depth to the photo and a much harder edge. The Blacks control's greatest effect is in the shadow region; it makes very little change to the midtones or highlights.

Brightness

This control adjusts image brightness, mainly affecting midtones much like the gamma on Photoshop levels. In other words, the Brightness control allows you to brighten or darken an image without blowing out the highlights or making the shadow region go pure black. The control doesn't protect either the highlights or the shadows; it has a reduced effect, lessening the chance of clipping on either end.

The recommended procedure is to establish the overall tonal scale by setting the Exposure, Recovery, and Blacks controls. After that, set the overall image brightness. Large brightness adjustments can affect shadow or highlight clipping, so you may want to readjust the Exposure, Recovery, or Blacks slider after adjusting brightness. In some situations, using the Brightness adjustment

in combination with the Fill Light control is more effective than using the Exposure control alone. In the example shown, the nighttime shot of the U.S. Capitol that was made lighter by using the Exposure control alone resulted in highlight clipping, as indicated by the red in the image on the left. The same image on the right was enhanced by using the Brightness and Fill Light controls to lighten the darken porch of the building. As you can see, the result is that there isn't any highlight clipping.

FIG 5.25 When the image is lightened by the Exposure control alone, clipping (red) occurs. Using a combination of the Brightness and Fill Light controls prevents clipping.

Contrast

This control increases or decreases image contrast, mainly affecting midtones. Unlike the contrast controls in previous Adobe products, you can apply contrast without fear of dragging your photo into darkness. When you increase contrast, the middle-to-dark image areas become darker, and the middle-to-light image areas become lighter.

Clarity

This is a control that is often described as adding "punch" to an image. In fact, the Clarity control enhances the feeling of depth to an image by increasing local contrast with a touch of Unmask filter thrown in for good measure. When using this setting, it is best to zoom in to 100% or greater to accurately evaluate its effects. To maximize the effect, increase the setting until you see halos near the edge details of the image (i.e., the USM making its presence known), and then reduce the setting slightly. As good as this control is, it is not recommended for portraits unless the subject wants his or her wrinkles emphasized. New in Lightroom 2.0 is Negative Clarity, which is a great skin smoother. You will learn about this feature in the Chapter 6.

Vibrance

This control is essentially saturation with an internal limit to prevent it from over saturating the image. It does this by adjusting the saturation so that clipping is minimized as colors approach full saturation, changing the saturation of all lower-saturated colors with less effect than on the higher-saturated colors. Vibrance also prevents skin tones from becoming oversaturated. There are some really great things you can do with the Vibrance control, which is covered in greater detail in Chapter 6.

Sharpening and Saturation

These two controls use the same buttons as Clarity and Vibrance. Holding down the Alt key (the Option key on the Mac) changes the buttons to Sharpening and Saturation. This is not a toggle, so you must continue to hold the button down when applying the adjustments.

The **Saturation** buttons adjusts the saturation of all image colors equally from −100 (monochrome) to 1100 (double the saturation).

All digital images need to be sharpened at some time. There are two places in Lightroom where an image is sharpened. You can sharpen an image for viewing on the screen, which is what is done with the Sharpen tool both here and in the Develop module. The other time an image is sharpened is when printing or exporting the images; however, the sharpening is not applied to the viewed image but to the file as it is exported or printed. See the Print chapter for more details print sharpening. The Sharpening buttons add or reduce sharpening. Although Quick Develop employs the same software used for sharpening in the Develop module, it lacks the level of control. As noted earlier in this chapter, consider using the presets to add sharpening to a photo, or do the sharpening in the Develop module.

> Double-clicking the name of any of the adjustment controls resets the value of the adjustment to zero.

Quick Develop Workflow

Now that you have an idea how the Tone Controls work, the following is a suggested workflow that I and several other photographers use for processing event and vacation photos that should work for most of your photos.

Photo Selection

1. Begin by picking the photos you want to use by adding them to the Quick Collection (B). I recommend several passes. Include similar shots and even questionable photos in the first pass.

2. Open the Quick Collection folder and go through these photos with a more critical eye. This time use the Survey view (N) to pick the best photo out of a set of similar photos.
3. Make the Quick Collection into a collection. Now go through this collection a third time, but this time you are looking for photos that need some extra attention either in tonal or color correction. Be selective, most of the photos will not need any attention at all. If you have lots of such images, you may need to reevaluate your photo skills.

Photo Enhancement
4. In the Library module, select a photo that you think needs enhancement.
5. Does the photo have exposure issues? In the Quick Develop panel, click the Auto Tone button to apply automatic Lightroom settings for exposure, blacks, brightness, and contrast. Look at the histogram and see if Auto Tone produced any clipping.
6. If the photo is too bright or not bright enough, use the Exposure control to correct it.
7. Apply a white balance preset by choosing it from the White Balance pop-up menu. Begin with Auto, and if the result isn't satisfactory try one of the presets. You can fine-tune the white balance by adjusting the Temperature and Tint settings.
8. If all of the photos were taken under similar lighting conditions—for example, flash lighting at an indoor event—you can spend some extra time fine-tuning the white balance and then use **Sync settings** to apply that white balance setting to the rest of the photos. See the next section for information about Sync settings and how to use them.
9. Apply the Sharpen preset as needed.

Applying Settings to Many Photos

The Sync Settings button is found at the bottom of the right panel group in the Library module. It is simple to use and a great tool for applying the same setting to multiple photos. Here is how it works:

1. In the Grid view, select the first photo and apply the settings you plan on applying to all of the photos. Open the photo and apply the changes.
2. Back in Grid mode or from the filmstrip, select the other photos that will receive the settings using either Shift select or Ctrl-Select (Cmd-Select Mac) to add individual photos.
3. The example in Figure 5.26 is shown in Survey view so that you can see it more clearly, but I recommend remaining in Grid view, especially if you have a lot of photos. In this example white balance, color and tonal changes were made to the image in the upper-left corner.
4. Click the Sync Settings button at the bottom of the right panel group. A large dialog box will appear on the display. Use the Check None button to clear it or the Check All button to select everything. In this example, I cleared all of the settings and checked the settings shown in Figure 5.27.

FIG 5.26 The photo with the changed settings appears in the upper-left corner.

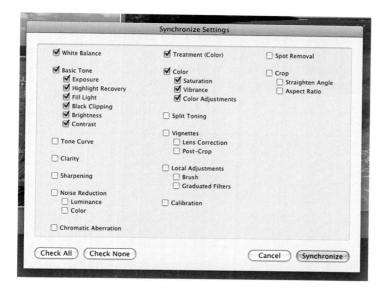

FIG 5.27 Sync Settings dialog box.

5. Click the Synchronize button and Lightroom will begin applying the settings from the first photo to all of the other selected photos. The result is shown in **Figure 5.28**.

If you look closely at the Sync Settings dialog box, you will discover that with this feature you can synchronize almost anything you have applied to one

177

FIG 5.28 The settings applied to the first photo have been applied to all of the selected photos.

photo to any other photo. This includes cropping, tonal, and color corrections. Just remember that you only want to sync settings that you want applied globally. For example, if one of the photos was shot at an angle and you straightened it, applying that to other photos will just make them crooked—unless they were all shot at a crooked angle.

Removing Spot Sensors Automatically

Probably one of the biggest time-savers that the Sync Settings feature offers is the ability to apply Spot Removal to multiple images. The Spot Removal tool is in the Develop module, but with it, you can remove a sensor spot on an image. I am referring to the debris that always seems to find its way onto your camera sensor when you change lenses. The location of a sensor spot is fixed in relation to the camera frame, so if you use the Spot Removal tool to remove it on the first image, you can sync it to all of the other images and Lightroom will remove the spot from all of your images in a single action. Even if some of the photos are in landscape orientation and the others are in portrait, Lightroom figures it out. You can find a lot of information about using the Spot Removal tool in the next chapter.

That's it for Quick Develop. I just want to emphasize the importance of using this tool for the purpose it was designed—that is, quick fixes. Don't spend a lot of time working on an image in Quick Develop. If you cannot get the look you want after a few clicks, press the D key to open the Develop module, which, coincidently, just happens to be the subject of the next chapter. See you there.

Precision Correction and Enhancement Using Develop Module

With the addition of local adjustments in version 2.0, the Develop module can now do many of the tasks that required an external photo editor in version 1.4. In Figure 6.1, a before and after photo taken on an overcast day, the sky and grass were enhanced using the new Graduated filter.

The Adjustment brush is used to isolate the color of the flower in the bridal shot while making the bride appear in grayscale as shown in Figure 6.2.

Exploring the Develop Module

The Develop module uses two sets of panels and a toolbar for viewing and editing your images. The left panel group contains the Navigator, Presets,

FIG 6.1 Use Local Adjustment tools to enhance a photo.

FIG 6.2 The Adjustment brush was used to isolate the color in this bridal image.

Snapshots, and History panel for previewing, applying preset Develop settings, saving custom settings, capturing different stages of an image during editing, and selectively undoing changes you've made to a photo. The right panel group contains the tools and panels for making global and localized adjustments to a photo. The toolbar at the bottom contains controls for tasks such as changing between before and after views, playing an impromptu slideshow, and zooming. Many of the tools in the Develop module were introduced in Chapter 5. Figure 6.3 shows the major parts of the Develop module.

Navigator

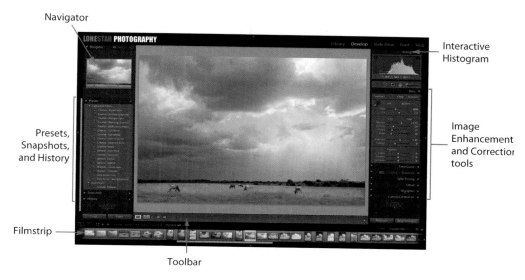

Interactive
Histogram

Presets,
Snapshots,
and History

Image
Enhancement
and Correction
tools

Filmstrip

Toolbar

FIG 6.3 The Develop module.

In case you are thinking that the Adjustment brush in this section looks a
little different than the one on your system—it does. The panel in
Figure 6.3 was expanded to its maximum width by clicking and dragging
the left side to make it easier to see in the book.

Using the Develop module tools, you can do the following:

- Crop or straighten an image
- Remove red-eye
- Remove blemishes or sensor spots
- Perform touch-up using Local Adjustment tools (new in version 2.0)
- Enhance or correct color or tonal issues
- Create effects like split-toning
- Convert a color photo to black and white
- Sharpen, reduce noise, or reduce chromatic aberration (purple fringe) in a
 photo
- Apply post-crop vignettes (new in version 2.0)
- Load and apply camera profiles

What's amazing is that this list isn't exhaustive by any means. You can do a lot
more in the Develop module than what is shown on the bulleted list.

Learning the Develop Tools

All of the image enhancement and correction tools are located in the right
panel. At the top of the panel is the histogram. Unlike the passive histogram

introduced in the Quick Develop module, this one is interactively tied to the controls in the Basic panel immediately below it. The Basic panel provides the same controls as the buttons did in the Quick Develop module except that sliders are used for more precise adjustments (Figure 6.4).

FIG 6.4 The interactive histogram and sliders provide precision enhancement and correction control.

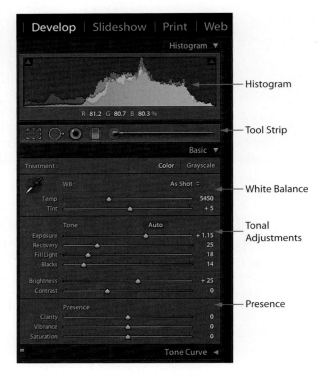

New in Lightroom 2.0 is the Tool Strip (not to be confused with the toolbar at the bottom of the work area) that contains the Crop Overlay, Spot Removal, and Red Eye Correction tools that used to be located in the toolbar in the previous version. It also contains the new Graduated filter and Adjustment brush. Rather than go through the tools in the order that they appear, in this chapter they will be grouped by their common functionality. The first tool to be considered is the histogram.

The names of both of the Local Adjustment tools—the Graduated filter and the Adjustment brush—changed during beta testing. Even their collective name changed (they were called Localized Correction tools). So if you are reading an article or are working through a tutorial made during beta testing, you may find references to these tools by the names Gradient filter and the Touch-up brush. Nothing has changed except the name, and to quote the Bard, "What's in a name?"

Interactive Histogram

A histogram graphically displays the number of pixels in a photo at each level of brightness. To be technically correct, the display is based on percentage of luminance, but the idea is the same. The histogram in the Develop module visually indicates when changes you are making cause clipping. Clipping can result in the loss of image detail. What is unique about the Develop module histogram is that you tonally correct an image interactively using the histogram.

If you are not a Lightroom user, the odds are that you have never adjusted an image using a histogram. The upper corners of the Histogram panel are clipping indicators. The black (shadow) clipping indicator is on the left, and the white (highlight) indicator is on the right. You turn each of them on independently by clicking on them. When they are on, the shadow and highlight clipping appears in the image as blue (shadow) and red (highlight), as shown in Figure 6.5. Clicking and dragging the shadow portion of the histogram and dragging it to the right moves the Blacks slider, and the Shadows clipping indicator (blue) changes. As you drag the highlights portion of the Exposure or Recovery sliders, watch the highlights (red) clipping indicator. Either a red or a blue clipping indicator in the preview image indicates that one or more of the color channels are clipped, which means detail may be lost. The setting of the clipping indicator has no effect on the histogram display when you are working in Quick Develop. We'll learn more about using the histogram throughout this chapter.

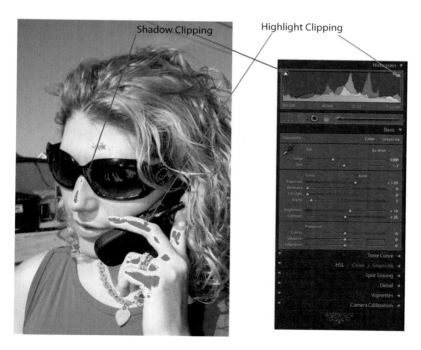

Shadow Clipping Highlight Clipping

FIG 6.5 In this histogram, the Highlight and Shadow clipping indicators are enabled.

Before and After Views

Although it's not part not of the Basic panel, an important feature that you need to be aware of when working in the Develop module is the Before/After view. This mode is only available in the Develop module.

The Before/After view is selected by clicking its icon in the toolbar (Figure 6.6), and it changes the image displayed to before and after previews so you can see how your adjustments compare with the original. The fastest way to switch to the Before/After view is by pressing the Y key. This toggles between the currently selected Before/After view and the Loupe view.

The Before/After Left/Right view displays two whole versions of your photo in two views, side by side on the screen as shown in Figure 6.6. You can change

Loupe View Before and After Views Switch Before and After Settings

FIG 6.6 Before and after split compare.

the format of the Before/After displays by clicking the down arrow to the right of the Before/After view icon. A list of choices (lower-left corner of Figure 6.7) appears when the triangle icon to the right of the icon is clicked. The Before/After Top/Bottom split displays two halves of the photo split into two views, one on top of the other as shown in Figure 6.7. The dividing line of the split view cannot be moved.

The default Before/After view is to have the Before view on the left. The toolbar buttons shown in Figure 6.6 allow you to copy settings from the Before photo to the After photo button, copy settings from the After photo to the Before photo button, or even swap the Before and After settings.

FIG 6.7 Before/After Top/Bottom split.

Basic Tools

The tools in the Basic section can be used to adjust white balance, color correction, tonal enhancement, and correction. Clicking Grayscale at the top of the panel coverts the photo to a grayscale image.

White Balance

The White Balance (WB) section provides controls that allow you to adjust the white balance of a photo to correct for the effects of the lighting conditions under which it was taken. For example, the photo on the left of Figure 6.8 is the Villa of Mysteries in Pompeii, and it is illuminated by incandescent lamps. Flash photography is not allowed, so the resulting photo was shot using available light and therefore reveals an orange color cast. I applied the Tungsten WB preset to the photo on the right, and as a result the colors appear to be very close to those that I saw when I took the photo.

Generally speaking, any white balance correction should come first in the workflow, but it isn't critical. It's sometimes difficult to evaluate the color in an underexposed photo, so in those cases you should use the Auto feature and brighten up the image before doing any color correction.

There are three ways to correct the color balance of a photo in the Develop module. You can use one of the White Balance preset options (as shown in Figure 6.9), use the Temperature and Tint sliders (trickier), or use the White Balance selector (Eyedropper icon) to click an area in the photo containing a neutral color. Regardless of the method you use, you can always fine-tune the colors using the Temperature and Tint sliders.

The Zen of Color Balance

The ultimate goal of adjusting the white balance in a photo is to achieve a pleasing balance of the colors in an image. In most cases, you will choose to remove unwanted color casts, but not always. Would you want to remove the reddish glow of a sunset from a romantic photo of a couple on the beach? I doubt it. When color-correcting an image, your goal is not necessarily to make the colors accurate; it should be more focused on making the colors in the photo look the way you want them to look. Painters can choose the colors used in their creations to interpret a scene they have painted. Before digital photography came along, photographers worked hard to achieve accurate colors. With Lightroom, you can control the colors and the mood of the finished work. So when working with color correction in Lightroom, spend some time and explore all that you can do with color.

"It's entirely an artist's eye, patience and skill that makes an image."

Ken Rockwell, *Your Camera Does Not Matter*, 2005

FIG 6.8 The White Balance preset removes the color cast produced by the incandescent lamps that were illuminating this room in Pompeii.

White Balance Presets

The White Balance (WB) presets in the Develop module are the same ones used in the Quick Develop module. By default, the WB preset that is selected is As Shot. This setting represents the WB information recorded by the camera at the time the photo was taken. Digital cameras today are getting quite accurate in determining the white balance of a scene at the time the photo is taken, which is why most of the time you can use this setting.

To change the WB preset from As Shot, click on the double-headed arrow in the White Balance box to open a list of presets. If you open a raw format image, you will see a list of presets that looks like the one in Figure 6.9 (left).

FIG 6.9 The white balance presets for raw (left) and nonraw (right).

The presets available for images in JPEG, TIFF, or any other camera format are shown in Figure 6.9 (right). The number of choices for nonraw images is limited by the fact that the image has already been processed and the white balance setting has been applied.

With the exception of Auto, the WB presets are approximations of the Temperature and Tint settings needed to correct the color cast produced by the light source. These provide a good starting point for color correcting an image. The Auto setting analyzes and attempts to create an accurate color balance, but how well it works is determined by the availability of neutral colors that are in the photo.

The Temp and Tint Sliders

The Temp and Tint sliders are interactive controls. The Temp slider controls the overall color temperature of the photo, and the Tint slider fine-tunes it by adjusting the green-magenta tint. Color temperature, measured in degrees Kelvin, is an established unit of measure used by photographers and physicists to describe how warm or cool colors appear. Moving the Temp slider to the left increases the overall color temperature and makes the image appear cooler (bluer). Moving it to the right decreases the color temperature and makes colors in the photo appear warmer (more yellow).

The Tint slider adjusts the green or magenta tint in an image. Moving the slider to the left (negative) adds green to the image; moving it to the right (positive) adds magenta.

The scale used by the Temp slider is dependent on whether you are adjusting a raw or JPEG image. One of the benefits of working on raw files in Lightroom is that you can adjust the color temperature as if you were changing the camera setting at the time you were taking the photo. This is why many professionals prefer using the raw format and the broad range of settings it provides. When working with JPEG, TIFF, and PSD files, the Temp slider uses a scale of −100 to 100 rather than the Kelvin scale. Nonraw files such as JPEG or TIFF include the temperate setting in the file, so the temperate scale is more limited.

The Temp and Tint sliders control the color correction for each image. There is another set of sliders that provides a more global adjustment based on the camera being used; it is called camera calibration. These controls allow specific color calibration for specific models of cameras and also allow you to calibrate your camera. Designed for professional SLR cameras, this feature allows you to assign a camera profile to a model of camera so it will be automatically applied. The operation of camera calibration is covered in more detail later in this chapter.

Color Correction Using Mixed Light Sources

Another situation that you will encounter is when several different types of light sources illuminate the subject. To illustrate, look at Figure 6.10, which was

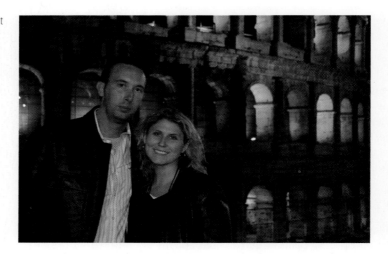

FIG 6.10 Couple lit by different light sources (streetlamp and flash).

taken using an external flash in slow sync mode. This means when you press the shutter button, the flash does not immediately fire, allowing enough time for the darker background to be exposed before the flash fires and the camera shutter closes. As a result, both the modern streetlamp the couple is standing under and the flash illuminate the couple, producing an orange color cast on them. It can be argued that the warm color cast is acceptable in this type of shot. As the photographer, I think the warm cast is too much like a tanning bed accident. How to correct it is the next question. In the WB presets, the Daylight, Cloudy, Shade, and Flash presets cannot be used as they all add warm colors to reduce expected cooler colors. The Fluorescent preset removes a green cast, so it is out. The Tungsten preset is designed to remove reddish orange casts, so it can be used, but with this photo it cooled off the orange colors in the background. Ultimately, Auto provided the best initial correction, as shown in Figure 6.11.

FIG 6.11 Using Auto White Balance correction removes much of the color cast.

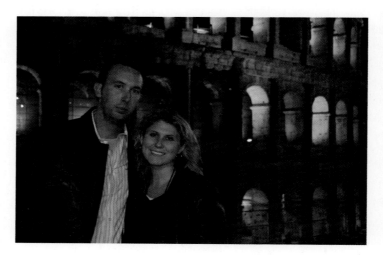

Using the White Balance Selector

Using the Auto setting or one of the WB presets usually produces results that are close enough for most jobs. Because the couple in the photo is my daughter and son-in-law, I want the color balance to be perfect. There are two other ways to correct the color balance: by using either the Temperature and Tint sliders or the White Balance selector. Either method can work, but adjusting the sliders is a little difficult until you have experience using them because of the interactive nature of the sliders. Therefore, we'll use the White Balance selector, which gives a reason to demonstrate its proper use:

1. Clicking on the White Balance selector (or pressing the W key) turns the cursor into an eyedropper with the Show Loupe in close proximity. You need to find a neutral color to use the tool. Even though it is called white balance, the preferred color is 18% gray.
2. When you think you have found a neutral color, hold the eyedropper over it. As you move the cursor around, the Show Loupe continually displays a close-up view of the pixels the cursor is hovering over and RGB values of the pixel under the White Balance selector. Neutral colors will have the same numbers in all three channels—in theory. The values shown in this example are Red: 59.6%, Green: 53.7%, and Blue: 42.4%. It doesn't seem to be equal, but that is often as close as you will get. In this photo, some of the stones of the coliseum are perfect. Figure 6.12 shows the Eyedropper cursor used to pick a neutral color and the loupe with the RGB values at the bottom.

FIG 6.12 Use the White Balance selector to pick a neutral color, and view the color correction in real time in the Navigator window.

When selecting a neutral color, avoid spectral highlights (blowouts) or areas that are 100% white. If you cannot find a light neutral color, find a darker one.

3. With the Navigator open in the right panel group, the color correction for the color you selected is updated in real time. Don't move the cursor around too quickly so as to give the Navigator window time to generate the preview. Clicking on the chosen neutral spot corrects the color, and the eyedropper cursor disappears. The final correction appears in Figure 6.13.

FIG 6.13 The White Balance selector provides color correction without losing the warm tones of the photo.

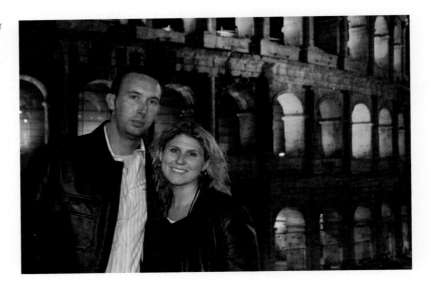

4. One last point about the White Balance selector concerns the options that appear in the toolbar (if the toolbar is open) as shown in Figure 6.14. Auto Dismiss causes the WB selector to close after a neutral point is selected. Selected by default, if not checked the WB selector remains open, allowing you to use multiple points to determine what is neutral in the image. Show Loupe is on by default, and the Scale slider defines the grid inside of it. The Show Loupe provides a pixel-level magnification so you can find the exact pixel that you want, whereas Scale determines how many pixels are included.

FIG 6.14 The options for the White Balance selector appear if the toolbar is open.

By default, the Auto Dismiss is enabled. Don't change it. This setting prevents Lightroom from combining all of the samples that you make and forces the White Balance selector to flush out the last sample automatically after you have clicked on the photo and the WB selector has changed into the Hand or Zoom tool.

For best results, have one of the subjects hold a calibrated color card (such as the one shown in Figure 6.15) or 18% gray card while you take the photo for later use as a reference for white balance adjustments. These cards are available at most photo stores.

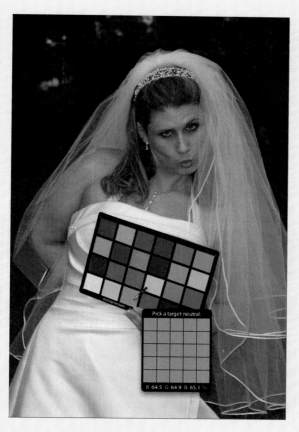

FIG 6.15 The subject is holding a calibrated color card, and the eyedropper for the White Balance selector is on one of the neutral gray squares.

Camera Calibration

Another factor that controls the color balance of a raw image is the Camera Calibration setting. Located at the bottom of the panel.

Tone Controls

The Tone controls allow you to adjust the overall tonal settings of the image. In other words, using the tone controls you can recover detail in shadows, reduce

highlights, and provide an overall improvement to the tonal qualities of the image. As good as these controls are, they have limits. For example, the details in an image that has been grossly underexposed by a flash failing to fire most often cannot be recovered, just as parts of an image that are *blown out* (so overexposed that the pixels have gone white) cannot be recovered because there is no detail to recover.

Using Auto

If you click the Auto button in the Tone section, Lightroom attempts to expand the tonal range of the image without creating either highlight or shadow clipping. This is the same Auto tone feature that is in Quick Develop. If you used the Auto feature in the previous release of Lightroom, you are aware it had a strong tendency to overexpose the image. In version 2.0, the folks at Adobe have improved the Auto feature's algorithms so it can routinely produce an impressive tonal correction like the one shown in Figure 6.16. Auto is now a recommended first step when performing tonal correction on an image. As good as the improved Auto now works, you will often need to use the other sliders in the Basic pane to fine-tune the image.

FIG 6.16 The improved Auto can produce excellent results like the one shown here.

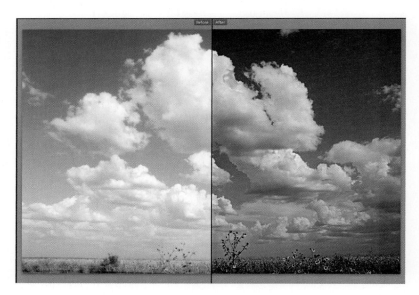

When you apply Auto, Lightroom moves the tonal adjustment sliders to the new calculated settings, and the Auto button becomes grayed out, indicating that the image is at the tonal settings made using Auto. If any tonal adjustment is applied to the image using the sliders, the Auto button is visible again.

Exposure

This slider controls the overall brightness of the image. It adjusts all of the pixels in the image. If you move the slider to the right, you will make the

image brighter by bringing out details hidden in shadow. The same action may blow out pixels in the highlight region. Conversely, moving the slider to the left darkens the image, and detail in the shadow region can be lost when the darker pixels are pushed to black. Exposure values are in increments equivalent to f-stops. An adjustment of +1.00 is the approximate equivalent of increasing the aperture by one f-stop. Likewise, an adjustment of −1.00 is similar to reducing the aperture one stop. You can type the exposure values directly into the numerical field. The slider is zero centered, meaning that when it is reset to zero, the slider is in the center. Double-clicking the word *Exposure* resets the slider to zero.

Recovery and Fill Light

These two sliders control the tonal extremes of an image. The Recovery slider darkens the extreme highlight pixels in a photo and is useful for recovering highlight detail caused by overexposure when the image was shot or after changes have been made. Lightroom can recover detail in raw image files when one or two of the color channels are clipped. It recovers the detail by extracting it from a third channel and applying it to the channels in which the detail is absent. The Fill Light slider lightens darker pixels in the shadow region to reveal more detail while maintaining blacks. Figure 6.17 was shot on a bright day during the July 4th parade in Centerville, Texas. The sun produced harsh shadows that hide the faces of the riders and other details. Applying the Fill Light feature at a high setting (79) revealed the faces and other details hidden in the shadows.

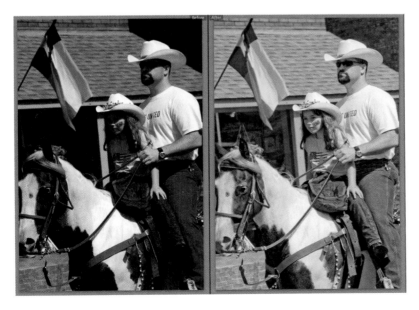

FIG 6.17 The Fill Light slider can recover details hidden in the shadows.

On the surface, it appears that these two controls could fix any image, but as noted earlier, if an area of a photo is blown out, Recovery cannot fix it because there is no detail there to recover. Likewise, applying Fill Light at a high setting to reveal detail in the shadows can often produce an unacceptable amount of image noise.

Blacks Slider

This slider controls which pixels in the image are mapped to black. Moving the slider to the right increases the areas that become black. As more of the pixels move to black, it often creates the appearance of increased image contrast. The slider has its greatest influence on darker pixels in the shadows. Increasing the Blacks slider has little effect on the midtones or highlights.

Brightness Slider

In the early days of digital photo editing, many articles and books discouraged the use of Brightness and Contrast functions, but that just isn't true anymore. The Brightness slider adjusts image brightness, but its effect is primarily on the midtones and it leaves the existing black points and white points unchanged. This makes the Brightness slider a good choice when you want to increase the overall brightness of an image whose tonal range is already close enough to maximum that increasing it using the Exposure slider might produce blowouts.

The Contrast slider increases or decreases the overall image contrast, mainly affecting midtones. As you increase contrast, the midtones and shadows of an image become darker, and even though the midtones through highlights portions become lighter, the overall effect is to make most images darker, so you may lose the detail in the shadows you just recovered by adding brightness.

You can reset the Tone and Presence controls (but not the other Basic controls) by holding down the Alt key or Option key (on the Mac), and the Tone label becomes Reset Tone.

Presence Controls

The sliders in the Presence section of the Basic panel contain controls for adjusting color saturation of all colors in the image using the Clarity, Vibrance, and Saturation sliders. The HSL/Color/Grayscale panel can be used to adjust a specific range of colors, as described later in this chapter.

Clarity

This slider can add an extra edge to a photo that appears to be flat by increasing both contrast and sharpening. In fact, the Clarity slider does its magic by increasing local contrast. It really does an excellent job, but you

must be cautious when applying it because it can produce halos near edges of high contrast. If you then save the image as a JPEG, these halos can appear to be JPEG artifacts. The best way to avoid this is to view a part of the image containing the highest contrast at a zoom level of 100% or greater. Increase the Clarity setting until you see halos near the edge details of the image, and then reduce the setting slightly. Be aware that depending on the composition of the photo, these halos may not appear, even at a maximum Clarity setting.

A new feature of the Clarity slider in version 2.0 is the addition of negative clarity, which sounds like a contradiction in terms. Quite simply, negative clarity softens the area of high contrast, making it a great tool for improving less-than-perfect skin or for softening the background in a portrait.
Figure 6.18 shows a close-up (100% zoom) of a photo (left) taken on a bright, sunny day. The combination of the sun and the fill flash bring out every detail in the subject's face. The application of negative clarity to the entire image softens the skin. When the zoom level is changed to Fit to Screen, it is apparent that all of the detail in the photo has been softened (Figure 6.19), turning the photo into a glamour shot. You can use the Adjustment brush (K) to limit the application of negative clarity only to the face, allowing the detail in the rest of the photo to remain.

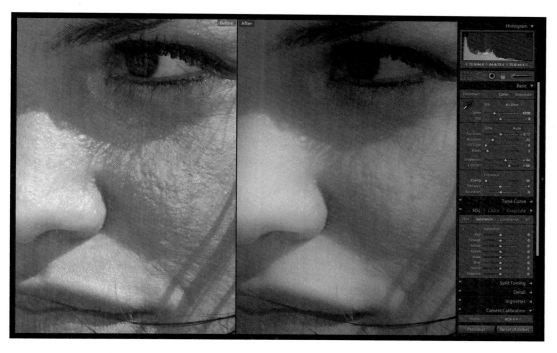

FIG 6.18 Negative clarity softens the model's skin, reducing the effect produced by the harsh lighting.

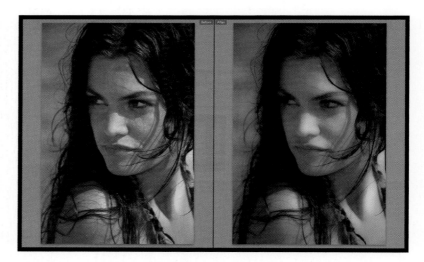

FIG 6.19 The application of negative clarity softens all of the details and converts the photo into a glamour shot.

Saturation

The Saturation slider adjusts the saturation of all colors in the image. Its range is −100 (grayscale) to +100 (doubles the saturation). Be careful when increasing the saturation settings, as it is easy to oversaturate your images and this can lead to clipping in one or more of the color channels and loss of detail can result. Figure 6.20 shows the loss of detail in the close-up of a hat worn by a model. In this case, the loss of detail resulted from overexposure at the time the photo was taken. Notice that all of the colors have turned a solid red on the before side. By decreasing the saturation, the detail was restored.

FIG 6.20 Oversaturation of the red channel causes clipping and loss of detail.

When shooting photos with vivid colors, reduce the exposure value (EV) a little to prevent possible channel clipping.

Vibrance Slider

This control allows you to add or remove saturation, but in a unique way. The Saturation slider affects all of the colors uniformly. Vibrance affects the lower-saturated colors and has less of an effect on the higher-saturated colors. In addition, the Vibrance slider protects color associated with skin tones.

The following examples will give you a better idea of how well the Vibrance slider works. The original shown in Figure 6.21 appears a little washed out. In Figure 6.22, the saturation slider is set to +79 and the model becomes too

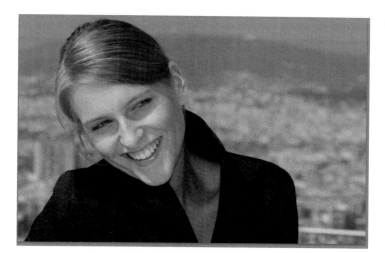

FIG 6.21 The original photo.

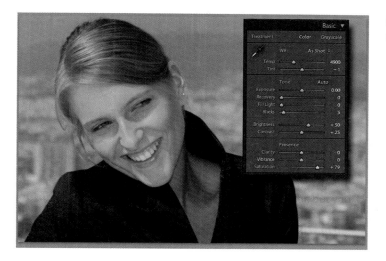

FIG 6.22 Saturation set to +79 makes the model appear orange.

orange. The third image (Figure 6.23) was made using a Vibrance setting of +79. As a result, the model's skin tones are protected while the increased saturation deepens her pale skin color.

FIG 6.23 The Vibrance slider set to +79 increases the saturation while protecting the skin colors.

Unleashing the Tool Strip

The Tool Strip located below the histogram (Figure 6.24) is new to version 2.0 (most of the tools are not new). In this section, we will discover what tools are available and how to use them as part of your photographic workflow.

FIG 6.24 The Tool Strip is an addition to version 2.0.

Crop Overlay Spot Removal Red Eye Correction Graduated Filter Adjustment Brush

Cropping and Straightening Photos

Open the Crop Overlay (Figure 6.25) pane by clicking the Crop Overlay button in the Tool Strip. It contains tools for cropping and straightening photos. The crop and straighten controls work by first setting a crop boundary and then moving and rotating the image in relation to the crop boundary. Or you can use more traditional Crop and Straighten tools and drag directly in the photo.

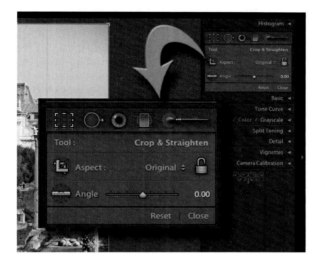

FIG 6.25 The Crop Overlay pane.

Crop, Straighten, or Both

You can crop or straighten images in the Develop module from the Crop Overlay mode. Unlike the Crop tool in Quick Develop, the Crop tool in the Crop Overlay mode can perform any kind of crop to a photo that you can image.

To switch to the Crop Overlay mode from any module in Lightroom, press R and Lightroom takes you directly to the Develop module in the Crop Overlay mode as shown in Figure 6.26.

If you are in Develop module, clicking the Crop Overlay mode button on the Tool Strip causes a crop bounding box to appear with the entire image selected. The bounding box has a grid that divides the image into nine zones to assist with the composition of the crop for those of us who grew up using the rule of thirds.

Move the Crop Frame cursor over the photograph to then click and drag to make a freeform crop (as you would with the Crop tool in Photoshop). When you have finished defining the crop, the Crop Frame tool reappears in the Crop Overlay pane. You can then proceed to modify the crop in various ways. As you drag a corner or side handle of the crop bounding box, a crop is applied to

FIG 6.26 Crop Overlay mode.

Crop Frame Tool Cursor Grid

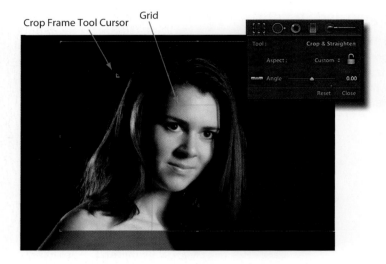

the photograph, shading the areas that fall outside the crop. To reset the crop, click the Clear button in the lower-right corner or press Command + Shift + R (Mac) or Ctrl + Shift + R (Windows).

As you drag the crop handles, the image and crop edges will move relative to the center of the crop, whereas dragging the cursor inside the crop bounding box will scroll the image relative to the crop. To rotate and crop an image at the same time, move the cursor outside of the crop bounding box and click (Figure 6.27). The image will rotate relative to the crop, which will always

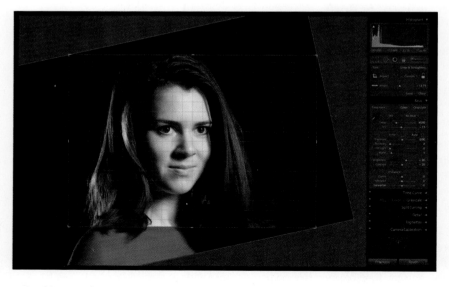

FIG 6.27 Free rotation of the image when cropping.

remain level. At any time you can evoke the Straighten tool using Shift + Ctrl (Shift + Command on the Mac) and align elements of the image to either the vertical or the horizontal. This tool is handy when you are working on photos with a clear horizon or architectural subjects, but it is not needed in the photo shown in the example.

The Crop Overlay grid shown in Figure 6.26 is by default shown only in Auto mode whenever you click in the image area. You can manually set the Crop Grid Overlay modes from the menu bar by selecting View > Crop Grid Overlay and selecting from the submenu or by pressing O to cycle through the Crop Grid Overlay options shown in Figure 6.28. Lightroom provides an excellent selection of classic compositional grids.

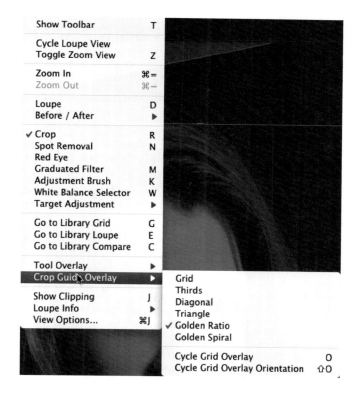

FIG 6.28 Lightroom offers a selection of photographic compositional grids.

Both the crop and straighten controls require that you first set a crop boundary and then move or rotate the image in relation to the crop boundary.

As you adjust the crop overlay or move the image, Lightroom displays the selected grid within the outline to help you compose your final image. As you rotate an image, a finer grid appears to help you align to the straight lines in the image.

Cropping an Image

1. On the Tool Strip, click Crop Overlay button or press the R key from any module in Lightroom.
2. An outline with adjustment handles appears around the photo (Figure 6.29).

FIG 6.29 Photo ready to be cropped.

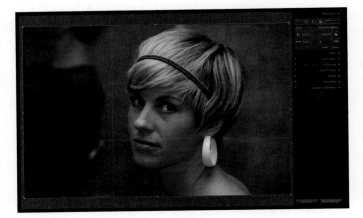

3. The immediate goal in this example is to crop the out-of-focus person on the left out of the image. To do this, I drag in the edges of the crop boundary by clicking on the edges and dragging them as shown in Figure 6.30. Corner handles can be used to adjust both the image width and height. In this example, the original aspect ratio is being changed so the padlock in the far right must be unlocked. Click the icon to toggle the lock status.

FIG 6.30 Crop boundaries are dragged to create the cropped area.

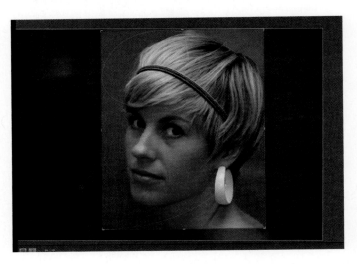

4. Reposition the photo within the crop frame by dragging the photo until you get the desired composition. Several grid overlay options are available.

Press the O key to cycle through different grid overlays in the crop area. If the grid pattern orientation is wrong, use Shift + O to cycle it in 90-degree increments. The grid used in this example (Figure 6.31) is Golden Spiral.

FIG 6.31 Reposition the photo inside the new crop boundaries.

5. Click the Crop tool or press Enter when you have finished cropping and straightening. The finished image is no longer in landscape orientation and the distracting out-of-focus person in the background is removed, as shown in Figure 6.32.

FIG 6.32 The finished crop.

To limit the display of the grid to cropping, choose View > Tool Overlay > Auto Show. To turn off the grid, choose View > Tool Overlay > Never Show.

Straightening an Image

It has happened to all of us at one time or another—we captured a great shot, but the camera wasn't level. Straightening an image with Lightroom is a snap. If you want to do this exercise, download the file Crooked ship.JPG. Here is how to straighten the image:

1. Open the image to be straightened (Crooked ship.JPG), and then press the R key to launch the Crop Overlay mode. In this example we will be using a photo of a cruise ship whose stern appears lower than the bow (Figure 6.33). There are two ways to straighten out the photo. Use the Straighten tool and drag a line across a visible horizontal or vertical element in the photo. Or use the Scale slider and drag it until the image in the photo appears straight.

FIG 6.33 The cruise ship appears to be leaning a little—or the photographer was.

2. Select the Straighten tool, and then drag in the photo along a line that you want to be horizontal or vertical. The choice of the straightening line can be deceptive. In this example, it appears that you would need to drag a line along the portholes or the stateroom balconies. When you release the mouse button, the image straightens as shown in Figure 6.34. Egad, now the ship is going down by the bow. What happened? The Straighten tool worked perfectly. The grid horizontal and the portholes are aligned.

FIG 6.34 Oops. It appears the portholes weren't on the level.

So what went wrong? From this angle, the ship's hull is raked and the horizontal lines should not be level.

3. What part of the image is on the horizontal? The horizon. It is small and behind the ship, but it is adequate for the job. Select the Straighten tool again, and this time drag a horizontal line along the ocean horizon behind the ship. Now the ship is on the level—except part of the stern is cut off (Figure 6.35).

FIG 6.35 Level ship missing part of its stern.

4. To recover what was autocropped from the stern, we need to push up the bottom crop boundary and push down the top crop boundary as shown in Figure 6.36.

FIG 6.36 By changing the height of the crop, we recover the missing part of the stern.

5. When your ship is level, press Enter. The resulting photo is shown in Figure 6.37. If you just don't like the crop and want to start over, right-click (Ctrl-click on the Mac) and select Reset Crop. To Undo a crop, use Ctrl + Z (Cmd + Z on the Mac). Do not use the ESC key to undo a straighten action or a crop.

FIG 6.37 The ship is level albeit with a little less ocean and sky.

Holding down Alt (Windows) or Option (Mac OS) with the Straighten tool selected displays an overlapping grid that may help you straighten an image. This is especially good with architectural subjects.

There are some traps you need to avoid when using the Straighten tool. Vertical lines in a building that are near the edge will be disfigured by barrel distortion, which is common with most wide-angle lenses, so pick a vertical line nearer to the center. You will have the best success with this tool if you are less concerned with whether something is truly vertical or horizontal. Look at the entire image. Does it *look* like it is straight? Some photos can align perfectly with the grid and still look crooked. Your goal is to make the photo look straight, not align it with a nonprintable grid.

The Spot Remover

"Out, damn'd spot! out, I say!" *Macbeth Act 5, Scene 1*. It seems Lady Macbeth didn't like spots either, and whether it is a piece of debris on your camera sensor or, in the case of Ms. Macbeth, a blood spot on the hands, the spots have to go. The spots in digital photography take many shapes, from a single piece of debris to a lot of tiny ones on your camera sensor (called sensor spots) in the same location. An important feature in Lightroom is its ability to remove sensor spots on multiple images automatically. Sensor spots are most noticeable when they are in the sky or on a solid backdrop. The spots are usually the result of debris that got into the camera body when you were changing lenses—outside, during a sandstorm. Figure 6.38 shows a recent example of a camera with four sensor spots (indicated by the red arrows).

FIG 6.38 An example of sensor spots (the spots are indicated by the arrows).

The **Spot Removal tool** (N) is used to remove a spot whether it is a sensor spot or a pimple on a groom's face. The Spot Removal tool gets rid of spots and leaves little, if any, evidence that the spots were ever there. This tool has continued to improve since it made its first appearance in version 1.

The Spot Removal tool has two modes of operation: **Clone** and **Heal**. In Clone mode it pastes a copy of the pixels from the source area of the image over the target area and then blends the edges to make the clone appear as seamless as possible. Heal works like the Spot Healing tool in Photoshop. When working in automatic, it finds nearby pixels that match the pixels surrounding the spot and blends the source and the target pixel area.

Removing Sensor Spots with the Heal Mode

When removing spots in either mode, you click on the spot and two connected circles appear: the **Target** circle indicates which area will change, and the **Source** circle determines which area of the photo is being used to clone or heal the spot.

1. Open the image with the spots, and switch to the Develop module (D); select the Remove Spots tool from the Tool Strip by pressing the N key.
2. The default mode when the Remove Spots tool opens is **Heal**. The cursor becomes a circle that looks like a gun sight. Place it over the first spot.

When removing camera sensor spots, it is highly recommended that you zoom in to 1:1 on the image. Sensor spots tend to be soft gray circles that are hard to see when you are zoomed out.

3. If the spot you are attempting to remove is larger than size of the circle cursor of the Remove Spots tool, use the mouse scroll wheel to make the brush slightly larger than the spot you're removing. The circle doesn't need to be the exact size of the sensor spot; it just needs to be a little bit larger. When you click on the spot, Lightroom will find an area to use as a source and another circle will appear, indicating the location of the source as shown in Figure 6.39.

FIG 6.39 Spot Removal Source and Target circles.

4. Continue clicking on the other spots until each one has been removed. At any time you can press the N key and the circles will disappear. You can also press the H key to hide them, but keep the Remove Spot tool active. A close-up of the spot-free finished photo is shown in Figure 6.40.

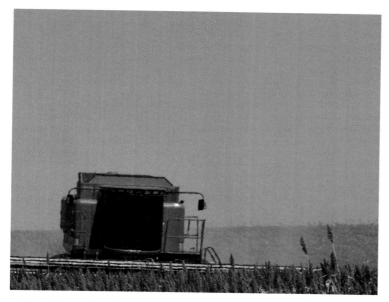

FIG 6.40 Sensor spots are quickly removed.

There will be times when the spot is near a dark or high contrast area. If the Remove Spots tool is set to Heal, it will try to blend in the darker colors, making something akin to dark smoke. In situations like the one described, use the Clone setting, which applies the sampled area of the photo to the selected area—without blending.

Up to this point we have talked about sensor spots. Blemishes and imperfections are removed the same way. An example is shown in Figure 6.41.

FIG 6.41 Minor facial blemishes are a snap to remove with the Spot Removal tool.

Using Spot Removal in Clone Mode

The Heal mode of the Spot Removal tool is great when the defect is on a smooth surface. If applied to an area with a pattern, it will blur it out, which is probably why Adobe included the Clone mode of this tool.

The marble bench shown in Figure 6.42 (left) has a crack that runs through the pattern on the edge of the bench. By applying the Spot Removal tool in Clone mode, it is possible to completely remove the crack from the bench. The procedure is a little different when using the Clone mode:

1. Open the image that needs repair (Figure 6.42). Go to the Develop module, and press the N key. Resize the tool large enough to cover about half of the crack, and click on it.

FIG 6.42 Crack in an ancient Roman bench.

2. Lightroom will automatically attempt to find a source for cloning. A second circle will appear, showing the connection between the target and source. The result was close (Figure 6.43), but it didn't match the pattern.
3. Click and drag the source circle until the pattern matches, as shown in Figure 6.44.
4. Double-click on the image to complete the work (Figure 6.45).

FIG 6.43 Automatic Clone mode does not quite match the pattern.

FIG 6.44 Manually moving the source circle produces a good match.

FIG 6.45 The cracked bench is repaired.

Additional Spot Removal Facts

To remove a Spot Removal circle, select it by clicking on it and press the Delete key. The selected circle is brighter than any other circles on the image. An animated puff of smoke will appear and the circle and the smoke will be gone. At anytime you can select and drag either the Source or the Target circles.

Automating Sensor Spot Removal

One of the advantages of a sensor spot is that its location in reference to the image frame is constant. Using the Sync Settings feature, it is possible to remove all of the sensor spots in one image and then automatically remove the same spots in all of the other photos you took until you got your camera cleaned. There are some limitations, but as a rule it works great. Here is how it is done:

1. In the Develop module, use the Spot Removal tool to remove all of the sensor spots.
2. Press the G key to switch to the Library module. The cleaned-up photo will still be selected. Use the Alt/Option key to select the additional photos that you want cleaned up.

If you are selecting a lot of photos, use Shift + Click to select the entire series and then you can use the Alt/Option key to remove any unwanted photos.

3. At the bottom of the right panel group, click the Sync Settings button to open the Sync Settings dialog box. Click the Check None button to clear all of the current settings, and check Spot Removal as shown in Figure 6.46.

FIG 6.46 Using the Spot Removal tool with the Sync Settings feature can remove sensor spots from multiple images with a single mouse click.

4. Click the Synchronize button and wait while Lightroom processes the images—depending on the number and size of the images, it may take a few moments. When Lightroom is finished, the sensor spots will have been removed from all of the selected images.

Here are a few things I have discovered about cleaning up images using this method:

• The orientation of the image (portrait or landscape) does not interfere with the operation.
• Be selective about which images to sync. Sensor spots in a blue or overcast sky really stand out. The same sensor spot in a complex background can rarely, if ever, be seen. It works better to only select images that have large areas of the same color. The next point explains why.

- The Spot Removal tool does an excellent job of finding a good source replacement, but it is wise to make sure that one of the sensor spots wasn't on someone's face and now the subject has a strange blur where his or her nose used to be. So after the Sync Settings action is complete, proof all of the photos with subjects in the area of the sensor spots.

Getting the Red Out

Removing red-eye using Lightroom's **Red Eye Correction tool** works great. It works perfectly most of the time, and the best part is that it works automatically. Figure 6.47 shows a lovely young lady with impressive red-eye. Here is how to use the tool to remove the red-eye:

FIG 6.47 Red-eye like this is easy to remove with the Remove Red Eye tool.

1. After opening an image with red-eye, zoom in (Z) to at least 1:1 (100%) to get a better view.
2. In the Develop module, click the **Remove Red Eye tool** in the Tool Strip. The cursor becomes a crosshair as shown in Figure 6.48.
3. Click the center of the eye. The tool will resize to fit the eye, and the red-eye disappears on the first eye as shown in Figure 6.49.
4. Click on the next eye, and Lightroom removes the remaining red-eye.
5. If you can still see the red-eye around the edges, drag the Darken slider to the right to darken the pupil area within the selection and the iris area outside the selection.

214

FIG 6.48 Put the crosshair cursor on the center of the eye.

FIG 6.49 The Remove Red Eye cursor removes the red-eye in a single click.

6. Press the H key to hide or show the red-eye circle. To remove the red-eye change, select the red-eye circle and press Enter or Delete.
7. Click Reset to clear the Remove Red Eye tool changes and to turn off the selection. Click the tool again to make further corrections.

FIG 6.50 Red-eye removed from both eyes in less than a minute.

You can almost eliminate red-eye by using an external flash mounted away from the axis of the lens. Other tips to prevent red-eye while shooting are to avoid taking people's photos in a darkened area and to avoid photographing subjects who have been drinking alcohol. No kidding.

Local Adjustment Tools

New to Lightroom version 2.0 are two tools called the Graduated filter and the Adjustment brush. With them you can make exposure, brightness, clarity, and other adjustments on specific areas of a photo. All of the controls in the Quick Develop and the Develop module apply color and tonal corrections to the entire image. Before version 2.0, you needed to open your photo in an external photo editor to make adjustments to a specific area of a photo. Here are a few examples of what you can do. Figure 6.51 shows

FIG 6.51 Before and after photos corrected using Local Adjustment tools.

the original photo of a dark street in Pompeii on the left with an overexposed sky. The Graduated filter was applied to bring out the blue of the sky, and it was applied again to lighten the parts of the street in shadow. The Adjustment brush was used to knock down the bright portions of the wall. The entire project took less than 5 minutes. These tools are so good that a portion of the next chapter is dedicated to how they work and how to use them.

The Adjustment Brush

The Adjustment Brush tool lets you selectively apply the familiar settings of exposure, clarity, color, and more to select areas of a photo with a brush. If it was a normal brush, then the application of the Adjustment brush could take a lot of time to ensure that the new effect is only applied to the area that needs it and not spill over to adjacent pixels that don't need it. No problem. The Adjustment brush has an Auto Mask option that uses the color and tonal information of your starting point to limit the pixels affected by the adjustment. Figure 6.52 shows the original photo. A fill flash was not used, so the

FIG 6.52 The subject's face in the original photo is in the shadow.

subject's face is in the shade. Figure 6.53 shows the Auto Mask that is created as the brush is painted on the subject's face to limit the Adjustment brush changes. The display of the mask is an optional feature that can be turned on and off. The finished photo is shown in Figure 6.54. The entire operation took less than 2 minutes.

FIG 6.53 The Auto Mask (shown in red) quickly establishes a boundary to isolate the changes of the Adjustment brush.

FIG 6.54 The finished photograph, with only the face made brighter.

The Graduated Filter Tool

Whereas the Adjustment brush allows you to paint the Basic Develop settings with a brush, the Graduated filter applies the same settings gradually across a part of the image in the form of a gradient. You can make the region as wide or as narrow as you like. Figure 6.55 shows a before and after view of a photo of an abandoned pier in western Florida that has been enhanced with multiple Graduated filter applications.

FIG 6.55 Multiple Graduated filter applications made an otherwise flat photo into a much better one.

You can apply both types of local adjustments to the same photo. As with all other adjustments in the Develop module, local adjustments are non-destructive and are not permanently applied to the original image. The next chapter offers detailed instructions on how to use these tools.

Split Toning

If you have ever worked the Hue/Saturation controls in Photoshop, you may be familiar with the Colorize option and how it can change a color image into a grayscale tinted with a single color. The result looks a lot like a duotone. **Split toning** in Lightroom is different in that it adds two colors, one to the highlights and another to the shadows of a photo. Many people think of split toning as being restricted to black-and-white images, but with Lightroom it can be used on both grayscale and color images.

Creating a Split Tone

To convert an image into a split tone, use the following steps:

1. Select an image (color or grayscale).
2. Switch to the Develop module, and open the Split Toning panel. The panel is divided into highlights and shadows. The goal is to assign a color and a saturation amount to the highlights and the shadows.
3. Select a color by clicking on the color chip to open the associated Split Tone Hue and Saturation palette (Figure 6.56). To select a color, just click in the color sample area. To see the effect of the color in real time, click and drag the cursor through the colors on the palette. When you have the desired colors, click the X in the upper-left corner to close the color palette.

FIG 6.56 Pick and Preview Split Tone colors.

When the color selection palette is open (either for shadows or for highlights) you can press Ctrl + or Cmd + (Mac) to select a color for the opposite tonal range.

4. Dragging the Hue sliders changes the color, whereas moving the Saturation slider controls the color's intensity. Typically, when the saturation amount is low, it is difficult to choose a specific color with the Hue slider. In this case, hold down Alt (Windows) or Option (Mac) and click and drag the Hue slider to preview the hue at 100% saturation.

Figure 6.57 shows an example of applying split toning to an image of a wheat field to create a pseudo tritone effect. Several of the Develop presets use a Split Tone setting to create their effects. I recommend that you open the Split Tone pane and choose one of the following Creative presets—**Cyanotype**, **Selenium Tone**, or **Sepia**—as a starting point. Then experiment by changing the Hue and Saturation sliders for shadows and highlights and see how they interact. If you find a combination that you really like, save the preset by clicking the + on the Preset pane and give your preset a custom name.

FIG 6.57 Color photo with split toning applied.

The Detail Panel

The Detail panel (Figure 6.58) contains controls for **sharpening**, **noise reduction**, and **chromatic aberration**.

Resetting and Customizing the Detail Panel

Holding down the Alt key (the Option key on the Mac) changes the section titles to reset sharpening, reset noise reduction, and reset chromatic aberration. This allows you to reset each section of the Detail panel individually. To reset all of the sections in the Detail panel, press the Reset button at the bottom of the right panel group. If you want to change the default settings of the Detail panel, make the changes and hold down the Alt key (Option key on the Mac) (the Reset key becomes the Set Default … key), and press it. You can restore the factory default settings in the Preset tab in **Preferences**.

Sharpening

As described in Chapter 5, sharpening should be the last correction applied in your photographic workflow. All digital images need to have some sharpening

FIG 6.58 The Detail panel.

applied. The trick is how much to apply. Apply too little and the image can appear soft. Add too much and the edges of higher contrast begin to blow out. Although no one would ever apply this much sharpening, Figure 6.59 shows what happens when maximum sharpening is applied to an image—it's not a pretty picture.

There are two places where sharpening can be applied in Lightroom: in the Develop module and in the Print module. The major difference between the two sharpen functions is that the sharpening applied in the Develop module is applied and can be seen on the image. The editing is still non-destructive, but you can see the effects of the sharpening when applied in the Develop module. The sharpening applied in the Print module is limited to three presets and you cannot preview the amount of sharpening on the screen. When the photo is printed, the sharpening preset selected is applied to the rendered file being sent to the printer. For details about this procedure, refer to the sharpen section of the Print chapter. The controls for sharpening in the Details panel are robust.

FIG 6.59 Too much sharpening can ruin an image.

The Sharpen controls work the same as they do in Photoshop and in Photoshop Elements. There are four adjustment sliders: **Amount**, **Radius**, **Detail**, and **Masking**.

Technically, the **Amount slider** controls the edge definition—in other words, the amount of sharpening. Increasing the Amount slider increases sharpening. By default, Lightroom always applies a small amount of sharpening. This is why the default setting for the Amount slider is 25. You can turn off sharpening completely by dragging the slider all the way to the left so that the value is zero.

How much sharpening you need to apply is determined primarily by the content of the image. If the image already has high contrast, keep the Amount setting to a lower value. Be aware that sharpening not only increases the sharpness of the image, but it also increases visibility of noise.

How Much Sharpening Is Enough?

A major factor in determining how much sharpening to apply is based on the subject and the purpose for which the photo will be used. Figure 6.60 is a close-up of a male model with the sharpening settings shown. The sharpening in this photo is excessive. It brings out his beard stubble and minor skin imperfections. If the model needed to look rugged in this photo, this level is acceptable. Applying the same level of sharpening to the portrait of an older person could make the subject look like the crypt keeper and would not be acceptable.

Another factor to consider is what will be done with the photo. If it will be printed in Lightroom, it can receive additional sharpening when printed, which is necessary. One of the advantages of the way Lightroom applies sharpening in the printing process is that you don't see a preview of the

FIG 6.60 Large sharpening settings bring out details that may be correct depending on the purpose for which the photo is being used.

sharpening being applied. That is because the correct amount of sharpening for printing is excessive for a photo being viewed on a display. A photo that looks edgy on the screen will look great when printed.

Before you apply any sharpening, change the zoom to 1:1 by pressing the Z key, or use the Detail panel of the Develop module (new in Lightroom 2.0) to see the area you are sharpening. Although the Detail panel is helpful for determining if an edge is being blown out by the sharpening setting, using a before/after split provides the best tool to evaluate the level of sharpening. Whichever way you use it, viewing at 1:1 (100% zoom) is critical because the amount of sharpening on a screen image can only be correctly evaluated at a 1:1 zoom setting.

The Radius slider controls the size threshold to which sharpening is applied. In other words, if an image contains very fine details, applying a larger radius will make the sharpening effects too large for the comparative size of the details being sharpened. So for images with fine lines and details, use a lower radius setting. If a smaller radius setting is applied to photos containing larger details, the effect of the sharpening may not be apparent. Using too large a radius generally gives unnatural-looking results.

The Detail slider controls how much high-frequency information is sharpened in your photo. In other words, it controls how much the sharpening being applied enhances the edge details. Use a lower setting (20) to sharpen edges just enough to remove blurring. Using a higher value (50+) gives your photo an Ansel Adams look, but be careful. Too high a setting will blow out the highlights on edges, which is not an Ansel Adams look.

The Masking slider defines how much of the image content is sharpened. It is called a Masking slider because internally the slider controls an edge mask that defines what amount of edge contrast will be sharpened. With the slider set to zero, everything in the image receives the same amount of sharpening that is defined by the previous three sliders. A maximum setting (100) restricts the sharpening to areas containing the strongest edges. To see a display of the areas controlled by the Mask slider, press Alt/Option (Mac) while dragging the Masking slider. In the Detail Preview window, you can see the areas to be affected (white) versus the areas masked out (black).

Noise Reduction

One of the challenges of digital photography is noise. Noise is the digital equivalent of film grain. I like this analogy and will continue to use it until someone says to me, "What's film?" Although the amount of noise produced by today's digital cameras is far less than that produced by earlier models, the fact is that noise is one of the issues we all face on a daily basis.

One of the most common sources of noise is found in photos taken either under low-light levels, high ISO settings, or usually both. Figure 6.61 was taken at

FIG 6.61 High noise occurred in this photo, which was shot under low-light conditions.

a concert using available light. The singer had several spotlights on her, but as far as the camera was concerned there wasn't enough light—hence, the noise.

Noise is apparent by the presence of color speckles where there should be none. For example, you will notice faint pink, purple, and other color speckles within an otherwise blue sky. Noise comes in two flavors: color and luminance. Color noise appears as random rainbow color specks in a photo. Luminance noise is less random, there is no color, and it may make the blue sky portion of a photo appear blotchy.

To begin the noise reduction process, zoom the image in to 1:1. This is a critical requirement because when the display is zoomed out to fit the screen, the zooming process hides almost all but the worst noise.

Look at the noise. Is it color noise or is it luminance noise? Drag the appropriate Luminance or Color slider slowly (giving the real-time preview time to show the changes). A general rule of thumb is that noise in a blue sky is luminance noise and noise in a low-light photo tends to be color noise.

Chromatic Aberration

Chromatic aberration refers to the color fringing in a photo located on hard contrast edges that usually have a bright light source behind them. It is often called purple fringing because the fringe is most often purple in color. Chromatic aberration is a common defect caused by the failure of the lens to focus different colors to the same spot. There are actually several types of chromatic aberration. In one type, the image produced by each color of light is in focus, but each image is a different size. The size differential is very, very small, but it is there. This type of aberration shows up as a fringing that is a complementary color of the pulling away from the center of the image.

Two Solutions

You don't see this problem often, as it is a subtle issue that isn't noticeable to the causal observer. If you come across this problem, there are several approaches to fixing it, one involving Lightroom and the other using third-party software. We will begin with the third-party solution. As you may be aware, the manufacturers of professional digital cameras also provide software to convert their raw files into standard graphic formatted images. This used to be the reason that many photographers did not initially accept the raw format, because the workflow was so complicated, but I digress. An example of one third-party solution is the software application Nikon Capture NX2. It can read the proprietary information embedded in the raw image by the Nikon camera and automatically remove any chromatic aberration. I am sure other manufacturers offer similar software.

For most of us, the controls for chromatic aberration located in the Detail panel can fix chromatic aberration in a photo in a few simple steps. Figure 6.62 is a photograph of a skylight in the Vatican that exhibits chromatic aberration.

FIG 6.62 Skylight 4:1 zoom exhibits chromatic aberration.

1. Zoom in on the area of chromatic aberration (**Figure 6.63**).
2. Most users at this point want to begin dragging the sliders around—don't. There are two automatic defringe controls: **Highlight Edges** and **All Edges**. Select Highlight Edges. Check the fringing and see if it is still there.
3. Now use the sliders to remove any remaining fringe color. The Red/Cyan and Blue/Yellow slider allows you to fix the fringing.
4. If you cannot remove the fringing, select All Edges to apply the color fringing correction to all edges (**Figure 6.64**). Be aware that All Edges may produce undesirable effects along the edges that exhibited the fringing.

FIG 6.63 Chromatic aberration fringing options.

FIG 6.64 Using the All Edges defringe option removes all of the chromatic aberration.

The Tone Curve

The Tone Curve is a tool familiar to Photoshop users. The Tone Curve controls allow you to make precision adjustments on specific tonal ranges of the photo, providing a greater degree of control over tonal adjustments than possible using the sliders in the Basic panel.

Unlike the Tone Curve in Photoshop, the Lightroom version of the Tone Curve has something akin to a built-in safety net that limits the degree of changes that can be made. When you click anywhere on the curve, a darker gray area appears behind the curve (Figure 6.65) to show you the limits that you can use to modify the curve. This gives you the freedom to make remarkable changes without concern that you may make the image unusable. Of course, with non-destructive editing even the worst change can be quickly reversed.

FIG 6.65 The Tone Curve.

The Tone Curve is an industry standard with the horizontal axis representing the original tonal values of the photo image (input values); there is a shadow region on the left and progressively lighter values toward the right. The two extremes are black and white. The vertical axis represents the changed tone values (output values), with black on the bottom and lighter values progressing to white at the top. If all of the tonal values of the input are

mapped to the same values on the output, a vertical line results, as shown in Figure 6.66. A lot of Photoshop users believe that the Tone Curve is the ultimate tool for tonal correction. With the introduction of the Tonal Adjustment tools in Lightroom and Adobe Camera Raw (ACR), the need for the Tone Curve has diminished somewhat.

FIG 6.66 An unchanged image is represented by a straight line.

The Tone Curve is unique in that gives you the ability to modify the tonal values of your image in a distinct way. If you have made Curves adjustments in Photoshop, you will discover that curves in Lightroom are quite a bit different. The Lightroom Tone Curves are controlled by sliders, and the adjustments are more limited in comparison to curves in Photoshop. Yet the end result is a set of powerful controls that are effective and easy to use.

Let's examine the elements of the Tone Curve panel (Figure 6.67). The graph represents the tonal scale with the darker tones on the left and the brighter tones on the right. The Split Point controls expand or restrict the tonal range affected by the different sliders. The sliders consist of Highlights, Lights, Darks, and Shadows, as their respective names allow you to adjust specific areas of the image. The Point Curve menu allows you to select a predefined contrast

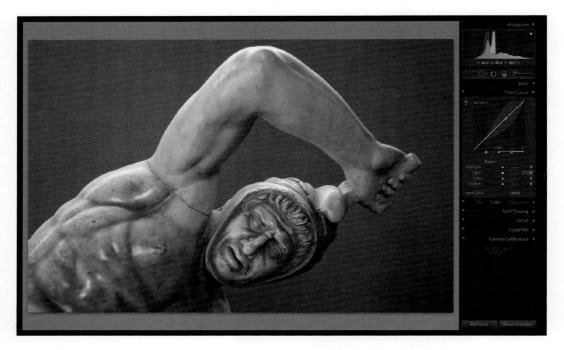

FIG 6.67 Initial photo with no Tone Curve adjustments.

level. The Target Adjustment tool can be used to hover over the image and make adjustments to that particular area.

Here is a quick look as some basic Tone Curve adjustments. Figure 6.67 is a photo of a statue at the Vatican Museum. I have no idea what the subject of the statue is doing, but it sure looks interesting. The Tone Curve is linear, so this means that the Tone Curve tool is not applying any correction.

In Figure 6.68, the Point Curve was changed to Strong Contrast. The displayed curve and the photo reflect the change.

The Target Adjustment tool (TAT) in the upper-right corner of the Tone Curve panel was selected, and the TAT cursor was placed over several points of the image and dragged (Figure 6.69). When it's dragged down, the pixels within that tonal range become darker. When it is dragged up, the pixels become lighter. Clicking the TAT icon in the Tone Curve panel completes the action. The changes made are reflected in the curve and in the image.

I hope it is apparent that the Tone Curve can be used for precision critical tonal corrections beyond what this brief description has demonstrated. The only service the Tone Curve was not able to render is to explain what the man in the statue was doing. Maybe it has something to do with an ancient Greek cure for a headache.

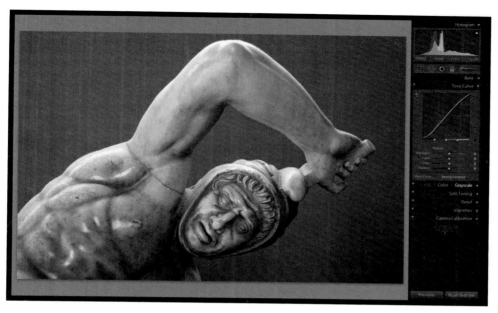

FIG 6.68 Strong contrast Point Curve setting.

TAT Cursor

Target Adjustment Tool (TAT)

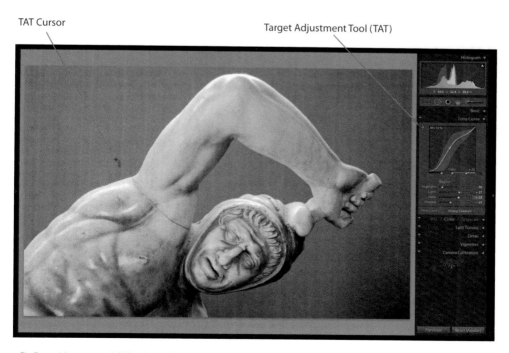

FIG 6.69 The Target Adjustment tool (TAT) selects and adjusts several tonal regions of the photo.

Lens Vignetting Correction

This is the same lens vignetting correction that was in the original Lightroom, and it is used to remove vignetting, which is a phenomenon produced by the camera lens. Most photographic lenses exhibit optical vignetting to some degree or another. The effect is strongest when the lens being used is set to a very low aperture (wide open). The effect will often disappear when the lens aperture is increased by a few stops. This optical vignetting produces a gradual transition from a brighter image center to darker corners. Figure 6.70 shows the before and after correction of the optical vignetting in the photograph of a Maine lighthouse.

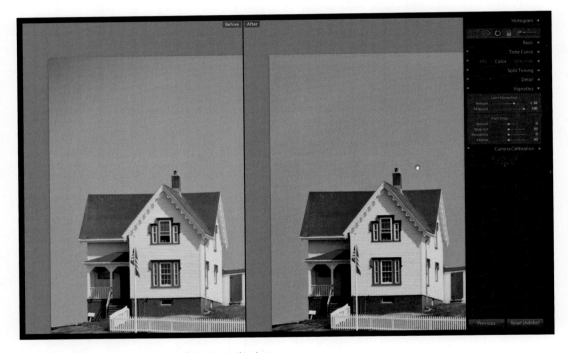

FIG 6.70 Optical lens vignetting corrects optical vignetting in this photo.

1. In the Lens Correction area of the Vignettes panel, move the Amount slider to the right to lighten the corners of the photo, or move the slider to the left to darken the corners of the photo.
2. Move the Midpoint slider to control the distance of the adjustment from the corners.

The lens vignette correction adjustment is a quick and easy way to resolve this problem. The sole limitation is that it only works on original, uncropped images. So what if the image is cropped? That is why Adobe added post-crop vignettes in version 2.0 of Lightroom.

Post-Crop Vignettes

In the first version of Lightroom, many users were more interested in lens vignette corrections for artistic work than for lens correction; but because the correction only worked with original photo edges, that meant that any cropping prevented its use. The reason that this feature is so important is because the vignette and post-crop vignette radiate out from the center of the image. This meant that the subject needed to be in the center of the photo. Adobe changed that by adding post-crop vignettes to version 2.0. Now you can crop the image in such a way as to put the subject in the center and apply the post-crop vignette.

The Amount and the Midpoint sliders in the Post-crop Vignette tool work the same way as the Lens Vignette correction tool. The Post-crop Vignette tool adds two new sliders: Roundness and Oval. Their operation is, I hope, self-explanatory.

The Roundness slider makes the vignette effect more oval or more circular. The Feather reduces softening between the vignette and its surrounding pixels or increases softening.

In Figure 6.71, a white vignette was applied to an image to which a Sepia preset had already been applied to give it an old-fashioned appearance. The child in

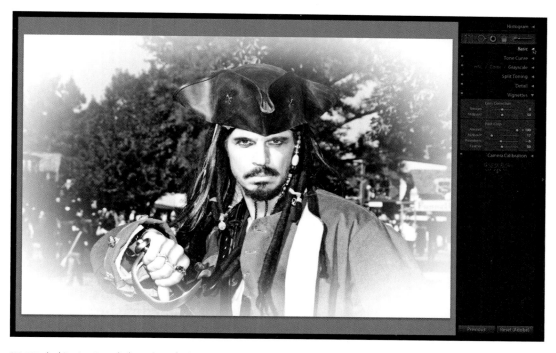

FIG 6.71 A white vignette applied to a photo of a pirate.

Figure 6.72 is darling, but the other objects in the photo are distracting, so a dark post-crop vignette was applied, making her appear to be standing in the light of a spotlight. show examples made using the Post-crop Vignette correction.

FIG 6.72 A dark vignette removes distracting clutter in a photo.

Camera Calibration Panel

In spite of the name, the Camera Calibration panel (Figure 6.73) in Lightroom is not limited to calibrating the camera to get the most accurate color. Probably most users employ it to select different digital camera profiles. You can also use the sliders of the Camera Calibration panel to create some interesting color effects.

Lightroom uses Adobe Camera Raw (ACR) or camera profiles to open raw format images. Adobe provides the camera profiles for most major digital cameras, and more are being added all the time. Camera profiles are available for download from Adobe. From the Camera Calibration panel, you can select one of several ACRs to process the image. You can also choose between different camera-specific presets. Figure 6.74 shows the list of profiles available for my Nikon D300. The panel will only let you open files that match the camera used to make the photo. When opening a nonraw file, the profile area displays the word *embedded,* and no selection options are available.

Figures 6.75, 6.76, and 6.77 show the effects the different profiles make.

FIG 6.73 Lightroom's Camera Calibration panel.

FIG 6.74 Digital camera profiles available in the Camera Calibration panel.

FIG 6.75 The ACR 4.4 is the default setting in the Camera Calibration panel.

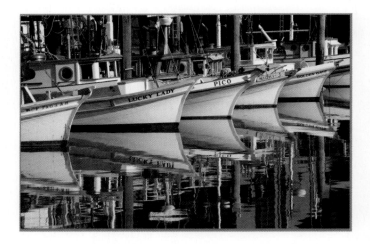

FIG 6.76 The Vivid camera profile increases the saturation of the colors.

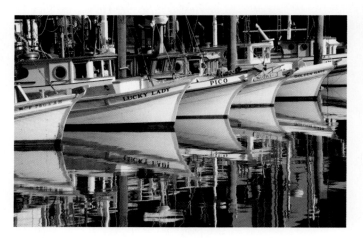

FIG 6.77 The neutral camera profile.

Presets, Snapshots, and History

The left panel group contains the Navigator, Presets, Snapshots, and History panels. Most of these features can be aptly described as laborsaving devices (Figure 6.78). The Navigator, Presets, Snapshots, and History panels can be used for previewing, saving, and selecting changes you've made to a photo.

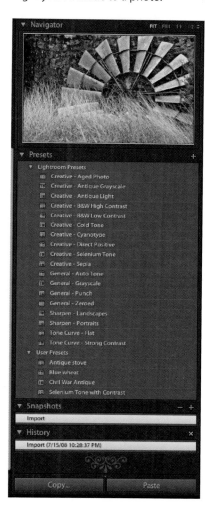

FIG 6.78 The left panel group is a collection of important tools for working on images in Lightroom.

Navigator

The Navigator is like a little GPS in the upper-left corner (Figure 6.79). The Navigator is found in both the Library module and in the Develop module. It can be used to set the level of magnification for an image in Loupe view. Lightroom saves the last level you used and lets you switch between that level and the current level when you click in the photo with the pointer. You can also toggle between four levels using the Zoom In and Zoom Out commands.

FIG 6.79 The Navigator panel.

In the Develop module, the Navigator also works as a preview monitor. It previews the effect of the Develop presets, Snapshots, and History as the cursor hovers over each one as shown in Figure 6.80.

Preview →

History Step
Being Previewed →

FIG 6.80 The Navigator works as a preview monitor.

Develop Presets

In the Develop module, you can make your own presets by customizing existing ones and saving them, creating your own from scratch, or

downloading and installing them from the Internet. See the description of the presets in Chapter 5 (Quick Develop). There are two differences between these Develop presets and those in Quick Develop. First, you can preview the effect produced by the preset in the Navigator window. Second, if and when you modify a preset, you can save it with a custom name.

The History Panel

The History panel keeps a record of the date and time that a photo was imported into Lightroom, including any preset that was applied at the time. Afterward, whenever you make an adjustment to the photo, Lightroom makes a record of that adjustment as a state and lists it with all the other states chronologically in the History panel. You can change the names of the states, but, unlike its counterpart in Photoshop, you cannot change the order in which they are listed. You can see what the image looks like at any state in the History panel by hovering the cursor over that state and looking at the preview in the Navigator.

Snapshots

At any time during the editing process, you save the current state of your image as a snapshot by clicking on the + button on the top of the Snapshot panel. A new untitled snapshot appears (as shown in Figure 6.81), which you should give a name that you will be able to associate with what it is. Each snapshot you create is listed alphabetically in the Snapshot panel.

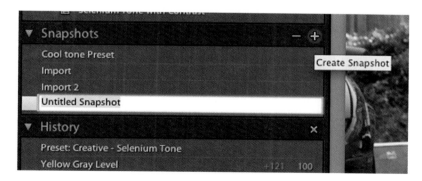

FIG 6.81 Snapshot panel.

Making Local Adjustments

Using the Adjustment Brush Tool

The Adjustment Brush tool (K) is used to selectively apply one or all of seven different Develop settings and a color tint to the part of an image defined by a mask. Wow, that one sentence covers a lot of pasture, so let's break it down into smaller parts.

Up until Lightroom 2, the Exposure, Brightness, Contrast, Clarity, and Sharpness settings could only be applied to the entire image. Now you can selectively paint all or any of these settings to the part of the photo that needs it using the Adjustment brush. **Figure 7.1** is an example of a creative treatment made using the Adjustment brush to selectively remove the color (−100% saturation) from everything in the photo except the leaf and the color in the stream.

Before we get into the operation of this fantastic tool, you first need to understand the principle on which it works. Trust me, it will make using the tool a lot easier.

FIG 7.1 The Adjustment Brush tool selectively removed color from this image.

Understanding Adjustment Brush Masks

When the Adjustment brush paints an image, it lays down a mask that limits its effects to the edge of the mask. For those of you familiar with Photoshop, the Adjustment Tool mask resembles the Quick Mask overlay. In other words, the mask produced by the Adjustment brush controls which areas of the image are affected and which areas are not affected by the brush settings.

When an Adjustment Brush stroke is painted on a photo, a mask is created where the brushstroke is applied. By default, the mask is not visible. Pressing the O key makes the mask visible. Clicking it a second time toggles it off. The default color of the mask is a ruby red.

If the content of the photograph is a similar color to the mask, use the SHIFT 0 key to toggle between red, green, and black mask colors.

Figure 7.2 shows a photo of a Dublin flower stall to which a brush stroke was applied and the O key pressed to make it visible.

FIG 7.2 Adjustment brush applied with mask visible.

When creating a mask, you may find it easier to see and define the edges of the mask when it is visible. The downside is that when the mask is visible, you cannot see any effects produced by the mask—only the mask.

In **Figure 7.3**, the O key was toggled, and the settings of the Saturation Adjustment brush (−100%) removed all of the color from the area defined by the mask. Once an Adjustment Brush mask is on an image, the effects applied to the area defined by that mask can be changed using the tools in the Adjustment Brush tool drawer as shown in **Figure 7.4**. Let's take a closer look at that tool drawer and see what's there.

FIG 7.3 The mask has been toggled off and the effect of the Adjustment brush is visible.

Local Adjustment Brush (K)

FIG 7.4 The Adjustment Brush tool drawer.

Controlling the Adjustment Brush Tool

Clicking the Adjustment Brush tool icon in the Tool Strip of the Develop module or pressing the K key opens the Adjustment Brush tool drawer (as shown in Figure 7.4), and the **Mask mode** is set to New.

The Adjustment brush has two modes of operation for defining a mask: Auto Mask and Freehand mode. When the Auto Mask option is checked, the brushstroke reads the pixels below it as it is dragged across the image. The resulting mask is confined to areas of similar color. The colors are those that were sampled the first time the brush was applied. When Auto Mask is not selected, the brush paints a mask over the pixels in an image without regard to the colors of the pixels being added to the mask. **Figure 7.5** shows a mask applied to the flower. The mask is semitransparent. Notice how the red mask goes right up to the edge of the flower. This mask was made in less than a minute because the Auto Mask is really good at detecting edges.

Masked Area Mask Adjustment Pin

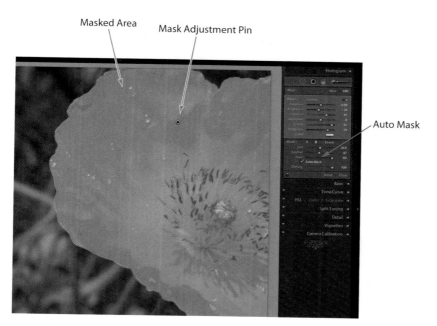

Auto Mask

FIG 7.5 Adjustment Brush mask.

Adjustment Brush Effects

When you open the Adjustment Brush feature the first time, the default view is **Effect Button** mode. This mode allows you to quickly select the last used Adjustment Brush setting using buttons and is handy for repetitive work that constantly uses the same settings. Most of the work using the Adjustment Brush tool shown in this chapter involves using the **Effect Slider** mode, so click the button located below the Mask New/Edit setting to toggle to the Effect Slider mode.

The Adjustment Brush Mask

As the mask is being defined, the Adjustment Brush tool applies changes to the image pixels. You can see the changes in real time if the mask is not visible. You can choose the type of adjustment you want to make either from the Effect pop-up menu shown in **Figure 7.6** or by dragging the individual sliders. The sliders are, for the most part, identical to the sliders in the Develop module. All of the sliders have a zero center point, meaning that when they are at midpoint, they have produced no effect. You can apply multiple types of adjustments to a single mask.

The following is a brief summary of each slider:

Exposure. Controls the image brightness. It affects all of the pixels in an image although it appears to have a greater effect in the highlight region than in the shadow region.

FIG 7.6 The Effects pop-up.

Brightness. Unlike the Exposure slider, the Brightness slider controls the midtones, leaving the black and white points relatively unchanged. Contrast adjusts image contrast, mainly affecting midtones.

Saturation. Controls how vivid the colors are. At the extreme ends of the slider are −100%, which removes all color giving a grayscale look, and +100%, which doubles the saturation and, unless your goal is an unusual artistic effect, usually results in loss of detail in the color channels.

Clarity. Adds depth to an image by increasing contrast in areas of the image that already contain well-defined edges. In Lightroom 2.0, a new feature was added to the Clarity function: Negative Clarity (which sounds like an oxymoron). As you will discover in the next few pages, this feature offers a great way to smooth skin and blur backgrounds.

Sharpness. Enhances edge definition to bring out details in the photo. A negative value blurs details.

Color. This is the one tool that isn't a slider. The Color function applies a tint to the selected area. You can select any hue (color) by double-clicking the tiny Color box located to the right of the name.

All of the Effects shown are presets that were defined by Adobe. In most cases, selecting one of the effects in the Effects pop-up zeros out all of the sliders except the one for the selected effect. For example, selecting Saturation will zero out all of the other sliders and will change the Saturation slider to −100%. That is because selective desaturation is very popular with professional photographers, as you will see later in this chapter. You can also save your own custom Local Adjustment tool settings by selecting Save Current Settings as New Preset… at the bottom of the list. Figure 7.6 shows two custom settings of my own that I apply to overcast skies.

Portrait Touch-up

We now know enough to demonstrate what will become the favorite use of most wedding and portrait photographers. Here is how to use Lightroom to soften the face on a portrait without making the entire photo into a glamour shot—by that I refer to a school of portrait photography where the entire image is slightly out of focus. Here is how it is done.

To demonstrate the technique, we will be using a close-up of a model that was shot on a bright, sandy beach in Barcelona (Figure 7.7). Even though she is not old, the flash and the sun (even though she is mostly in the shade) bring out every unflattering detail in her face.

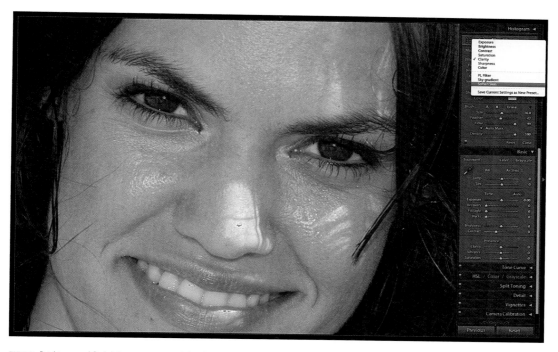

FIG 7.7 Bright sun and flash brings out unwanted details.

You can download the file Barcelona_Model.JPG from the Focal Press website if you want to try it out yourself.

1. After clicking the Adjustment Brush icon, open the Effects menu and set the Adjustment brush to **Soften Skin**. The Soften Skin setting is a combination of Clarity and Sharpness adjustments to make skin tones appear softer and more pleasing to the eye.

2. Apply the Adjustment brush to areas on the face to be smoothed. Click and drag in the photo to apply an Adjustment Brush tool stroke to the areas that you want to correct. Because the brush isn't going to be near any edges, Auto Mask should be turned off.

3. When you release the mouse, an adjustment pin appears at the initial application point of the adjustment. At the same time, the Mask mode changes from New to Edit, and the Effect sliders (if you are in Effect Slider mode) become available to refine the adjustment. In this example, the first brushstroke is applied to the forehead. See the box for more information on using the mask adjustment pin.

4. The painting continues on the cheeks, as shown in Figure 7.8. Even though it looks like there are three masks, there is only one mask. Lightroom allows multiple masks to be placed on an image; more on that later. The mask shown in the figure is visible, so you can see where it has been applied. In real use, you can't see changes being made with the Adjustment mask visible, so toggle it off (O).

FIG 7.8 Paint over the areas of the face to be smoothed.

5. Figure 7.9 shows that the Adjustment brush has smoothed the skin, but the model still needs a few more corrections. She has a flash reflection on her cheeks, and both her eyes and teeth could use some brightening.

6. The Spot Removal tool (Clone) is used to remove the flash reflections.

7. Brightening the eyes and teeth is next. Obviously the Smooth Skin effect won't brighten eyes. Selecting New from the Mask menu begins a second mask. From the Effect menu, choose Brightness and use a small value (50). This is enough to brighten without making her eyes and teeth look like landing lights on a plane.

FIG 7.9 The Adjustment brush smoothed the skin.

8. To select the whites of the eyes but not the pupils requires a smaller brush size. There is a Size slider, but the quickest way to change the size is to use the mouse scroll wheel. Check Auto Mask.
9. Click, don't drag, on the whites of the eyes. The Auto Mask will fill it in. Drag the brush on the teeth. **Figure 7.10** shows the finished image.

FIG 7.10 Lightroom provides a one-stop clean-up without using an external editor.

Adjustment Brush Controls

Here is a summary of the other controls in the Adjustment Brush tool drawer. The previous sliders controlled the effects that are defined by the Adjustment

THE MASK ADJUSTMENT PIN

The Mask adjustment pin is a multifunction device. In addition to using the O key to make it visible, you can also see the mask by positioning the cursor over the adjustment pin. Placing the cursor over the adjustment pin and dragging the double arrow to the right increases the selected effect; dragging to the left decreases it. Pressing the H key toggles the adjustment pin off and on.

Undoing and Resetting the Adjustment Mask

Even with Auto Mask enabled, you will sometimes paint outside of the lines. When this happens, select the **Erase tool** by holding down the Alt key (Option key on the Mac) and paint over the part of the mask you want to remove. While in Erase mode, the circle cursor, which normally has a plus (+) icon in its center, is replaced with a minus (−) icon in its center. If you need to do a lot of erasing, you can also select the Erase tool in the tool drawer.

To completely remove a mask, click on the adjustment pin to select it. The white

circle has a black dot in it to indicate that it is selected. Pressing the Delete key makes the mask vanish. If you use a Mac, it disappears in an animated puff of smoke.

Clicking the **Reset** button at the bottom of the Adjustment Brush tool drawer resets all of the Adjustment Brush tool adjustments and sets the Mask mode to New. It doesn't just remove the current mask. If you have multiple masks, it removes them all. If you have a mask and a Graduated filter layer, it only resets the mask.

Brush mask. These tools control the application of the mask. The effects sliders can be changed at any time. The following brush tools control the application of the mask and don't have any effect after the mask is in place.

There are two preset Adjustment brushes (A and B). This arrangement allows you to set each one to a specific size and switch between two preset sizes. Brush A is selected by default.

You can quickly toggle between the A and B brushes by pressing the / key.

The Size slider controls the diameter of the brush tip in pixels. You can also use the brace keys [] to control the size which is good for small incremental changes. The mouse scroll wheel is still the quickest way to go. The Feather slider controls the size of the soft-edged transition between the edge of the brush and the surrounding pixels.

The Flow slider determines the rate at which the adjustment is applied. At its maximum setting (100), it creates the mask immediately at full strength, and if it is set at a lower value, it applies the mask effect more slowly. If you use a pressure-sensitive stylus with the Adjustment brush, the pressure information from the stylus controls the flow setting. The harder you press, the greater the Flow rate. The Density slider controls the transparency of the mask. At its maximum setting, 100% of the effect is applied.

Fine-Tuning a Landscape

In an earlier example, you saw how to use the Adjustment brush to touch up a portrait. Here are a few other ways to use the Adjustment brush. The first one is a photograph of the Golden Gate Bridge (**Figure 7.11**) taken about an hour

FIG 7.11 Dark shadows and a washed-out background lessen the quality of this photo.

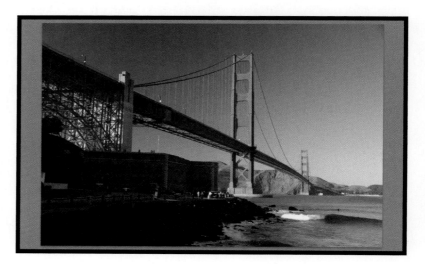

before sunset. The warm light really enhances the bridge but leaves Fort Point in the shadows. Because the camera's metering system is trying to get the details in the shadows and in the highlight region, the hills in the background are a little washed out.

To correct the image, the Adjustment brush (Brightness) was applied to the areas in the shadow. After that was adjusted, a second mask was selected by clicking New, and this time it was applied to the hills in the background. This mask had a multiple setting of −Brightness, +Clarity, and +Saturation. Using Auto Mask, it was easy to select only the hills. The finished photo is shown in Figure 7.12 and took me less than 5 minutes, most of which was spent wondering if I should or should not add a different color to the hills.

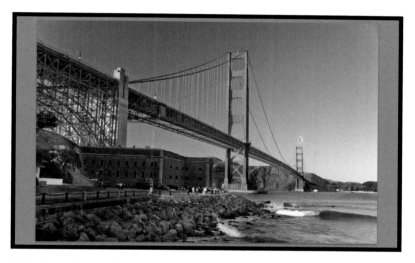

FIG 7.12 The shadows were lightened and the background was darkened in just a few minutes.

Cleaning Up after a Volcano

Figure 7.13 is a backlit photo of a bronze statue in Pompeii. I couldn't move the sun and didn't have a flash, but I hoped I could undo the damage in Lightroom—and I was correct. The first step was to apply Auto Tone. It made the entire scene even darker.

With Auto Mask enabled, the backlit statue was quickly selected (Figure 7.14).

The Auto Mask feature works best on backlit images if the brush has a moderate amount of feathering (50 to 60). Make sure the mask is visible when applying the mask.

FIG 7.13 Backlit photo of Pompeii bronze.

FIG 7.14 Auto Mask allowed a quick creation of an Adjustment mask.

It took a while (approximately 10 minutes) to come up with a combination of exposure, clarity, contrast, and saturation that worked, but the result (**Figure 7.15**) was what I wanted. In case you were wondering, I didn't remove the bronze defect on the statue's face (I was tempted), but it did appear as a bright spot when everything else on the statue was lit up. So I made another very small mask and used −Brightness to tone it down a notch.

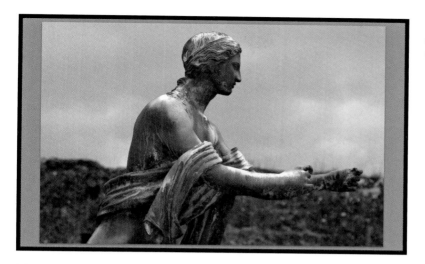

FIG 7.15 Looking pretty good after an eruption and being buried longer than 1800 years.

From Rehearsal to the Stage

The photo shown in **Figure 7.16** is of a flamenco dancer at a photo shoot in Barcelona. I loved the action (she was really a great dancer) but not the background.

FIG 7.16 Great action shot of a dancer, lousy background.

The first step is to use the Vignette control to darken as much of the background as possible, as shown in **Figure 7.17.** Then using the Exposure Adjustment brush (remember that Exposure darkens all of the pixels) at the lowest setting (−4.0), I painted out the rest of the background except for the dancer and part of the stage so it appears that she is in a spotlight (**Figure 7.18**).

FIG 7.17 Use the Vignette controls to darken as much of the background as possible before starting.

FIG 7.18 The Exposure Adjustment brush darkens the remainder of the background.

Working with Large or Complex Adjustment Masks

The flamenco dancer required a large mask because the original photo is 4000 × 3000 pixels and a large part of the photo required darkening. Here are a few tips about working with such masks. First, don't outrun your mask. By that I mean that Lightroom is working your computer into a sweat trying to create this deceptively simple mask. In fact, it is a very complex object. It is for this reason that you shouldn't try to see just how fast you can apply the Adjustment strokes. Stop now and again to make sure that Lightroom is keeping up with you. Second, apply short brushstrokes. The reason for this is if you have a very long brushstroke and need to undo it, you will lose a lot more than if you had used several shorter brushstrokes. Last point. If part of

a complicated brushstroke goes where it shouldn't, don't undo it; rather, hold down the Ctrl/Option key to temporarily switch to the Eraser tool, correct the booboo, and releasing the key return to the original brush.

Selective Color Removal

This technique has become popular with wedding photographers, and now that Lightroom makes this so easy to do, I expect we will be seeing even more of it—until we are tired of it. It is simple to create. Select the Saturation adjustment brush (which by default is set to −100), ensure that Auto Mask is selected, and paint the colors you want changed to grayscale as shown in Figure 7.19.

FIG 7.19 Two examples of selective color removal.

Turn off Auto Mask when painting over large areas that need to be affected (like the background). This is because colors in the background that differ greatly from the colors of the starting point won't be included and you will have to go back and individually select them. When Auto Mask is switched off, the Adjustment brush invites all of the pixels it meets to the party. Another reason to switch it off when you don't need it is that the mask creation runs a little faster without Lightroom having to go through the decision-making process for every pixel it meets.

Now let's look at the other Local Adjustment tool—the Graduated filter.

The Graduated Filter Tool (M)

During beta testing, this filter was at one point called the Gradient Filter tool, which describes its behavior pretty well. In short, every effect that can be accomplished with the Adjustment brush can also be applied with the Graduated Filter tool. The major difference between the two being that the Adjustment brush allows you to apply effects to a freeform area that you create with the brush tool. The Graduated Filter tool applies the same effects using a linear gradient mask. "A picture is worth a thousand words" is not an old Chinese proverb but describes a truth that we will use to explain how the Graduated Filter tool applies its effects.

Figure 7.20 shows an uninteresting photo taken in the Texas hill country. On the right of the image is the Graduated Filter Tool panel.

Graduated Filter Tool

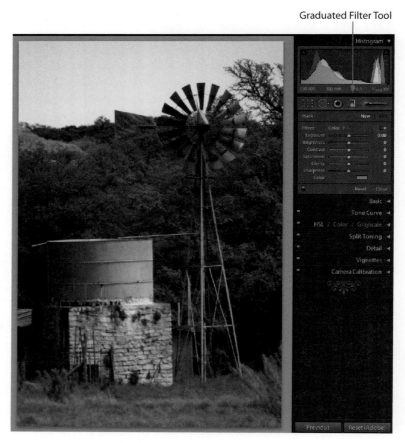

FIG 7.20 The Graduated Filter Tool panel.

To fix this photo, we will do the following:

1. Open the Graduated Filter Tool panel by either clicking the icon or pressing the M key.
2. The overcast sky is too bright and lacks color. We will correct that first. Change the settings as follows: Exposure: −.15, Contrast: +35, and Clarity: +20. This is my personal recipe for a **sky gradient**, and I have saved it in my system using that name. The choice of color depends on the color of the original sky, but in most cases the dark blue preset in the color box works fine.
3. Click and drag in the photo to apply a graduated filter across a region of the photo. As you drag, a **graduated filter pin** appears at the center of the effect. Three white guides also appear that represent the center, low, and high ranges of the filter effect.

Graduated Filter Pin

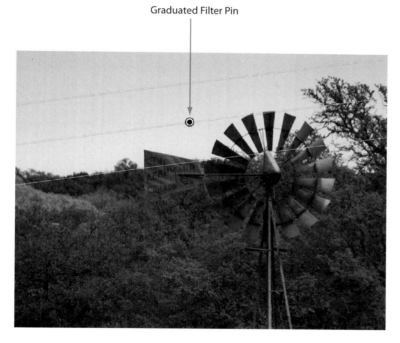

FIG 7.21 Graduated filter enhances an overcast sky.

4. The filter pin controls the position of the gradient map (graduated filter) on the image. The sliders control the effects produced by the gradient. See the sidebar for information on how to control the position of the graduated filter. In this example, the Graduated Filter tool was rotated to prevent it from turning the branches of the tree blue.
5. Click New to create a second Graduated Filter effect. This time, Color was chosen to add a little yellow (very little) to compensate for the cooler color cast produced by the overcast sky. Clarity, sharpness, and contrast were bumped up to give this soft portion of the photo some edge, as shown in, Figure 7.22. A before and after shot is shown in Figure 7.23.

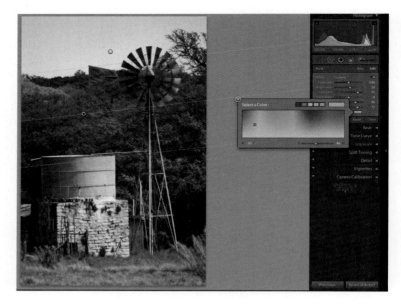

FIG 7.22 A second graduated filter is added.

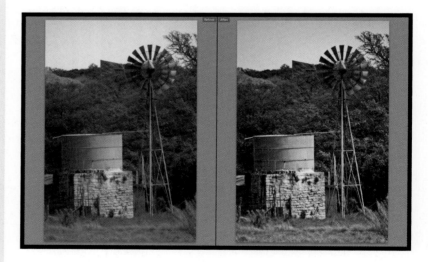

FIG 7.23 The original and the completed photo.

Controlling the Graduated Filter Tool Position

Dragging the graduated filter pin moves the center point of the effect. If you hover the cursor over any point of the center white line, the cursor becomes a curved, double-headed arrow. When it does, drag it to rotate the entire gradient map. The distance between either of the outer white lines and the center determines how smooth and spread out the transition is. Dragging one of the outer white lines toward the filter pin narrows the distance and decreases the transition. When you drag one line, they both move symmetrically either away from or to the center. All of the rules about deleting and resetting the Adjustment brushes described earlier in this chapter apply to the Graduated Filter tool.

Using Graduated and Adjustment Tools Together

A final example of what can be done with the Local Adjustment tools will use both tools together to correct a photo of a really great lobster shack in Maine, as shown in **Figure 7.24**.

FIG 7.24 A great lobster shack appears flat and colorless.

What's wrong with this photo? The sky is bright and hazy. The trees near the cove have a color cast that is a result of the hazy sky. The lobster trap floats (the main subject of the photo) are half hidden in the shadows.

The Adjustment brush was used to increase the saturation of the colors on the floats, and another mask was applied to lighten up the area around the wall of the shack. A third mask was used to darken the trees near the cove and make them a little greener. Two separate adjustment layers were used—one to add

FIG 7.25 The enhanced photo.

a blue gradient to the sky and another to darken all of the junk in the lower-right corner of the photo.

A Last Example

I think I could write an entire book about using the Local Adjustment tools. The truth is, I am running out of pages, so here is my last example. **Figure 7.26** is a fall photo taken in Texas (not New England).

FIG 7.26 A colorful fall photo of a leaf in a stream.

Using the Graduated Filter tool, I applied a Saturation layer to remove the color from the background (**Figure 7.27**). Next, I used the Adjustment brush to desaturate everything on the rock but the red leaf. The final result is shown in **Figure 7.28**.

FIG 7.27 The Adjustment brush removes the color from the rock.

FIG 7.28 The final figure.

Showtime: Making Slideshows

Y ou don't go to all the trouble of importing, cataloging, tagging, and cleaning up your photos just so you can increase the size of your digital picture collection! You want to *use* your pictures—tell a story, print them, and share them on the Web. And one of the easiest ways to share your pictures is to build a slideshow that you can show on your computer or share with friends. Adobe Photoshop Lightroom makes this easy and fun. You can even add music to your slideshow.

Understanding the Slideshow Module

Like the other modules that have been discussed in this book, the Slideshow module is broken up into several sections (Figure 8.1). The main section in the center of the screen shows the slide with all the text, shadows, border, and other items you have added. Other controls enable you to configure these items, add color and background, apply a soundtrack, and preview or play the slideshow. You can even save your configurations as a reusable template.

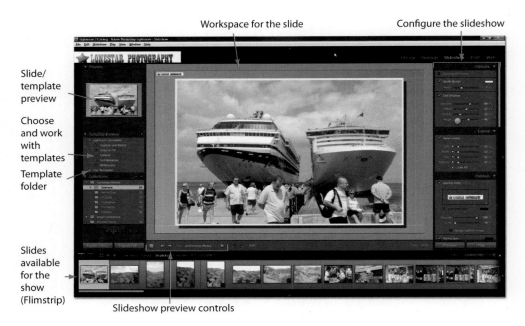

Workspace for the slide

Configure the slideshow

Slide/
template
preview

Choose
and work
with
templates

Template
folder

Slides
available
for the
show
(Flimstrip)

Slideshow preview controls

FIG 8.1 Use the controls in the Slideshow module to choose slides, configure, and (of course), perform the show.

You can use one of the available templates in the Template Browser as the starting point for your slideshow. Simply select a template before you begin, or choose a different template at any time. If you really make a mess of the slideshow, you can start over from the template settings by clicking the template you want to use. This resets everything (background, text overlays, Identity Plate, shadow, etc.) to the template default values.

Selecting and Setting Up for Slideshows

Before you can play your slideshow, you have to set it up. This includes picking the photos to include, configuring how the background will look, adding any informative text you want, and specifying the duration of each slide in the show.

Selecting Photos for the Show

The best way to select the available photos for your slideshow is to create a collection (as discussed in Chapter 4), then choose the collection in the Library module before switching to the Slideshow module. This will make only those slides available in the filmstrip at the bottom of the screen, in the order that you specified when you created the collection. This technique makes it easy for you to reproduce the slideshow by simply picking the collection and template. It also allows you to easily rearrange the slides by clicking and dragging the order of the slides in the filmstrip.

To rotate an image in the slide, use Ctrl+] to rotate clockwise and Ctrl+] to rotate counterclockwise.

Configuring the Stroke Border

A stroke border adds a colored border around the entire slide (**Figure 8.2**). To add a stroke border, use the Stroke Border control. This control is located in

Guides

Shadow

Frame (bounded by the guides)

Stroke border

FIG 8.2 A stroke border makes the slide stand out better against the background.

the right panel group in the Options palette. Selecting the check box turns on the stroke border. To change the width of the border (measured in pixels), click and drag the Width slider or type a value into the field. To adjust the color of the stroke border, click the color bar to display the Color dialog box (**Figure 8.3**). Choose the color, and then either click the small "x" button in the upper-left corner or click the color bar again to close the dialog box and apply the new color.

FIG 8.3 Adjust the size and color of the border around the slide with the Stroke Border control.

If you hover the mouse pointer over the stroke border width field (but don't click), the pointer turns into a pointing finger with a double-headed arrow. Hold down the left mouse button and drag to the left to decrease the value of the field, or drag to the right to increase the value. This works for all text fields in Adobe Photoshop Lightroom.

Specifying the Shadow

Another way to make the slide stand out from the background is to add a drop shadow behind the slide. The shadow is also visible in Figure 8.2, discussed previously. To cast a shadow behind the slide, select the Cast Shadow check box and use the controls in the Cast Shadow control (**Figure 8.4**).

FIG 8.4 Use the shadow controls to adjust the look of the shadow behind the slides.

The controls enable you to do the following:

- **Opacity**. Adjusts the opacity—how much of the background shows through the shadow. Values range from 0% (invisible) to 100% (fully opaque).
- **Offset.** The distance that the shadow is offset from the slide. As the offset grows larger, more of the shadow shows. For example, **Figure 8.5** shows two different offsets. The top one is small (40 pixels), whereas the bottom one is much larger (100 pixels).
- **Radius**. The radius varies how sharp the corners are as well as feathering at the shadow edges. When set to zero, the shadow has perfectly sharp edges and corners (see the top of **Figure 8.6**). When set to a large number (see the bottom of **Figure 8.6**), the corners are rounded and the edge of the shadow is feathered.
- **Angle**. This control adjusts the angle between the slide and the shadow— in other words, the source of the "light" that creates the shadow. For example, if you set the angle to 45 degrees, the source of the light is to the lower-left, and the shadow is to the upper-right. You can adjust the shadow angle by clicking and dragging the angle knob, clicking and dragging the slider, or adjusting the value in the text field.

FIG 8.5 A small offset (at the top) looks very different from a large offset (at the bottom).

FIG 8.6 A small value of the radius (at the top) shows sharp corners and edges, whereas a large value (at the bottom) feathers the edges and rounds the corners.

Showing and Adjusting the Guides

The "guides" provide a visible border that defines the size of the slide image. Moving the guides closer to the edge of the work area increases the size of the central area (frame) in which the slide is visible. You can see the guides in Figure 8.2, discussed previously. To show the guides and adjust their positions, select the Show Guides check box and use the Show Guides control panel (Figure 8.7).

FIG 8.7 Adjust the guides with the Show Guides control panel.

To adjust the position of the guides (distance from the edge), you can either click and drag the individual guide sliders (left, right, top, and bottom) or type a value into the text field for each slider. The value for each slider is the distance (in pixels) from the edge of the work area. You can also click the guide itself and drag it to a new position.

You can either adjust the guides independently or link them together. When you link the guides, adjusting the position of one guide adjusts the position of all the linked guides to the same value. To link any of the guides, click the small square button to the right of the guide name, or click the Link All square button to link them all together at once. All linked guides move together; any unlinked guides can be adjusted independently.

Applying a Color Backdrop

Using an attractive color backdrop for your slides can really make them stand out during a show (Figure 8.8). The color backdrop actually consists of two parts: the background color and a "color wash." These can be turned off and on and controlled independently using the Background Color and Color Wash controls in the Backdrop panel (Figure 8.9).

FIG 8.8 A combination of a background color and color wash can make an attractive backdrop for your slides.

FIG 8.9 Use the Background Color and Color Wash controls to specify how the backdrop will look.

To apply a background color, simply select the Background Color check box, click the color bar and specify the color. If you don't add a color wash, the background will be all one color—the color you selected for the background color.

To apply a color wash, select the Color Wash check box. To specify the color of the color wash, click the color bar and select the color. How the color wash behaves depends on whether the color wash is used by itself or in combination with the background color.

269

Using the Color Wash by Itself

When you use the color wash by itself (deselect the Background Color check box), it begins as a light color at the starting point and gradually darkens as you move away from that point (see Figure 8.10). The starting point is controlled by the Angle control. For example, if the angle is set to 45 degrees, the starting point (lightest color) is in the upper-right corner, and the color gradually darkens as you move toward the lower left. The Opacity slider controls the initial color—the lower the opacity, the darker the starting color. At an opacity of 100%, the starting color is the specified color. At an opacity of 0%, the color wash is simply a black square.

FIG 8.10 The color wash shows various shades of a single color.

The basic background (the one you get if you shut off the background color and color wash) is black. Thus, you can think of the color wash opacity as controlling how much of the black background shows through.

Using the Color Wash with a Background Color

When you use the color wash in combination with the background color (as shown previously in Figure 8.8), the opacity controls how much of the background color is hidden by the color wash. At high values of opacity, the color wash starting point is the specified color, and the color wash color and background color are blended together across the background, with the ending point having the pure background color. As you lower the opacity value, more and more of the background shows through—less and less of the color wash color is visible.

Adding a Background Image

You can add an image as a background to all your slides and adjust the opacity of the image (Figure 8.11). To do so, select the Background Image check box and drag an image from the filmstrip to the rectangle in the Background Image controls (Figure 8.12). The Opacity slider controls how much of the background color shows through—either the default black or the combination of background color and color wash color.

Remember that the most important image on the slide is the slide image, not the background image. If you make the background image too overpowering, it takes away from the slideshow. Instead, choose a background image carefully and use a low opacity (I have found that 25% works well) so that the person viewing the slideshow sees the background image without focusing on it. In addition, choosing a dark background color (the default black works pretty well) keeps the focus away from the image.

FIG 8.11 Use a background image to set an overall theme for the slides in your slideshow.

FIG 8.12 Specify the background image and opacity with the Background Image controls.

One limitation to placing a background image is that it has to be available in the filmstrip so that you can drag it to the rectangle in the Background Image controls. If you are using the recommended technique of creating a collection for a slideshow, this means that one of the images will be the background image as well as a slide image. If you don't want this to happen, use the following steps:

1. Create the collection for your slideshow, and include the background image in the collection.

2. Switch to the Slideshow module, and add the image as a background image by dragging it to the rectangle in the Background Image control.
3. Right-click the image in the filmstrip, and choose Remove from Collection from the shortcut menu.

This removes the background image from the collection (and thus the slideshow) but leaves it available as a background image. Be sure to save the slideshow template (as discussed in the section "Saving it all as a template," presented later in this chapter).

Zooming to Fit the Frame

The section of the slide where the image is shown is known as the "frame." If you are using guides, the frame is visible as the rectangular section in the middle of the screen, as indicated in Figure 8.2, shown previously. Unless the frame has the same aspect ratio (ratio of the height to the width) as the displayed image, the image won't fill the entire frame (see the upper portion of Figure 8.13). This is

FIG 8.13 The image doesn't fill the entire frame (upper section) unless you choose to zoom to fit the frame (lower section).

especially true with portrait images (images that are taller than they are wide). However, you can force the image to fill the frame by selecting the Zoom to Fill Frame check box at the top of the Options panel on the right side of the screen. This crops (removes portions of) the image to match the aspect ratio of the frame and fill the frame (see the lower portion of Figure 8.13).

Although it is certainly nice to have the image fill the frame, there is a downside—portions of the image must be cropped to make the image fit.

To position a cropped slide within the frame, click and drag the image in the frame. This enables you to display the portion of the slide you want in the frame.

If you do choose to zoom to fill the frame, use the following steps to exercise the most control over what is removed:

1. Figure out whether most of your slides are in portrait format (taller than they are wide) or landscape format (wider than they are tall). For most people, the most prevalent format is landscape.
2. Adjust the guides and frame to match the aspect ratio of the more prevalent format.

This assumes that most of your slides will be either uncropped or cropped to the same aspect ratio (such as the original image aspect ratio). If all your slides are cropped to different aspect ratios, I recommend *not* zooming to fill frame.

3. For slides in the nonprevalent format (usually portrait), either live with the extreme cropping, or create a version of the slide in which the image is centered on a background with the same aspect ratio as the prevalent format. You'll need an image editing program (such as Photoshop Elements) to pull this off.
4. If you decide to create the new version of the slide image, import it into Lightroom and replace the original in the collection with the new version.

Adding and Editing the Identity Plate

The Identity Plate (Figure 8.14) is a special text or graphic overlay (see Adding Text to Slides Using Overlays, presented later in this chapter) that you can add to the slides.

Adding and Configuring the Identity Plate

To configure the Identity Plate, select the Identity Plate check box in the Overlays panel (Figure 8.15) and use the Identity Plate controls.

FIG 8.14 The Identity Plate provides a customizable text overlay.

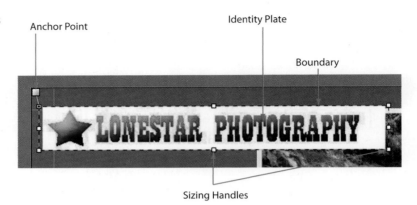

Anchor Point

Identity Plate

Boundary

Sizing Handles

FIG 8.15 Use the Identity Plate controls to configure the properties of the overlay.

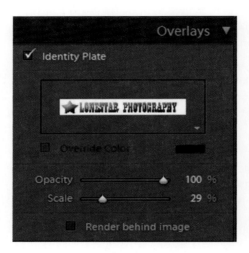

The Identity Plate controls enable you to do the following:

- **Change the color.** To override the color of the text, click the **Override Color** check box, then click the color bar (to the right of the check box), pick a color from the Color control, and click the Close (x) button. You cannot override the color if you are using a graphical identity plate.
- **Adjust the opacity**. Change the opacity of the text or graphic using the Opacity slider or text field. The opacity controls how much of the background color or image shows through the Identity Plate.
- **Change the size/scale**. To change the size of the plate, click and drag the Scale slider or enter a number in the Scale text field. You can also click the Identity Plate, then click and drag one of the sizing handles.

Setting the Scale to 100% sizes the Identity Plate to stretch completely across the slide.

- **Render behind image**. Normally, the text in the Identity Plate is displayed on top of the slide image. However, if you want the image to take precedence—hiding the text or graphic where the two overlap—select the Render behind image check box.
- **Changing the location**. You can move the Identity Plate to any place on the slide by clicking and dragging it to a new location.

Understanding the Anchor Point

When you click the Identity Plate (or any other text overlay), you'll notice a small square attached to the text boundary by a dotted line. This is called the "anchor point." As you click and drag the Identity Plate (or any other text overlay), the anchor point jumps, automatically relocating to attach itself to either a corner of the slide, the middle of the side of a slide, the corner of the image, or the middle of a side of the image. You can lock the anchor point to prevent it from moving by clicking on it. This turns it into a yellow square with a black dot in the middle.

The anchor point sets the reference between the Identity Plate (and any other text overlay) and the location of the anchor point on the screen. For example, if you set the anchor point to the upper-left corner of the image on the slide, it will move as you change images, always maintaining the same distance and angle from the upper-left corner of the image. It is usually best to anchor the Identity Plate to a corner or side of the slide, as you want it to appear in the same place on the slide. For text overlays you want to appear over the image (for example, the star rating), it is best to anchor to a corner or side of the image, so it remains in the same relative position on the image as the images change during the slideshow.

Creating a Custom Identity Plate

You can create your own version of the Identity Plate if you wish, perhaps replacing the default text with your name or the location where the photos were shot. You learned how to do this with the Lightroom Identity Plate (the one in the upper-left corner of the screen) back in Chapter 2, and building a custom Identity Plate for the slideshow works pretty much the same way.

To create and save a custom graphics Identity Plate, use the following steps:

1. Click the small arrow in the lower-right corner of the Identity Plate control to open the shortcut menu.
2. Choose Edit from the shortcut menu to display the Identity Plate Editor dialog box. You can also simply double-click the Identity Plate itself on the slide.
3. Click the Use a graphical identity plate radio button to display the graphical version of the dialog box (Figure 8.16).
4. Either click and drag an image onto the graphical area in the dialog box, or click the graphical area and pick an image from the Open dialog box.

FIG 8.16 Create a custom version of the Identity Plate in this editor dialog box.

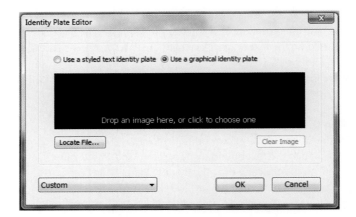

You can't click and drag an image from the filmstrip, as Lightroom won't let you.

5. Click the drop-down list in the lower-left corner, and choose Save As.
6. Fill in the name of the Identity Plate in the Save Identity Plate As dialog box, and click Save.

The maximum size of a graphical identity plate is 50 pixels high by 400 pixels wide. If you choose an image that is larger than that, it will be cut off. Note also that although the template does not show the full width of 400 pixels, the actual Identity Plate (in Lightroom) will show the full width.

To create and save a text identity plate, follow steps 1 and 2 described earlier, then continue as follows:

1. Click the Use a styled text identity plate radio button.
2. Type and edit the text in the Identity Plate.
3. Select the portion of the text to which you want to apply the changes to the font, style, and size. Use the three drop-down lists to change the font (left), style (middle), and size (right).
4. Select the portion of the text to which you want to apply changes to the color. Click the color box, and pick a color from the Color dialog box.
5. Click the drop-down list in the lower-left corner and choose Save As.
6. Fill in the name of the Identity Plate in the Save Identity Plate As dialog box, and click Save.

Adding Star Ratings to Your Slides

Adding the rating stars to your slides is simple: just select the **Rating Stars** check box. You can adjust the opacity and scale using the sliders or text fields, and choose the color by clicking the color box and picking a color from

the Color dialog box. You can also adjust the size by clicking the stars and dragging a sizing handle. By default, the stars appear in the upper-left corner of the slide (and thus may be hidden by the Identity Plate), but you can drag them anywhere you want.

Adding Text to Slides Using Overlays

You can add descriptive text to your slides using Text Overlays. Some templates even include common text overlays, such as the photo filename, date, camera, and other metadata. You turn all text overlays on and off using the Text Overlays check box. You cannot make only some text overlays visible—it's all or nothing.

Adding Text

To add text to a slide, click the Add text to slide button (ABC). Click the Custom Text button (just to the right of the Add text to slide button) to display the shortcut menu (Figure 8.17). To pick one of the items in the shortcut menu (such as Date, Equipment, Exposure, and so on), simply choose it from the list. The text is then displayed on the slide (Figure 8.18).

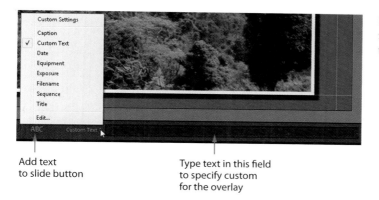

FIG 8.17 Choose an item from the shortcut menu to add that text to the screen.

Add text to slide button

Type text in this field to specify custom for the overlay

FIG 8.18 And here is what the new text might look like.

Another option is to type the text you want into the field to the right of the Custom Text pop-up list. To do so, simply click in the field and type the text, then press Enter.

If you really want to get fancy, choose Edit from the Custom Text pop-up list to open the Text Template Editor (Figure 8.19). Using this dialog box, you can build a custom text string that includes custom text as well as information about the image (metadata).

FIG 8.19 Use the Text Template Editor to create a custom text overlay.

Here is how you can build your custom text string:

- **Start with a preset**. Choose a preset from the Preset drop-down list at the top of the dialog box. This populates the text box at the top of the dialog box with the contents of that preset. For example, the Date preset places the date field into the text string in the format month, DD (day of the month), YYYY (year).

The Example line above the text box displays an example of what the text string will look like. This is not always helpful. For instance, the example of the Metering Mode field simply shows as "Pattern."

- **Add a field from the various drop-down lists**. To add a field to the example text, choose the field from one of the 10 drop-down lists in the dialog box. These lists are grouped by the type of data available in the drop-down list, such as the image name, numbering, EXIF data (metadata about the image conditions), and IPTC Data (metadata that you have provided). Selecting an item from the drop-down list places it into the text string at the location of the text cursor.

If you want to add a field that is already visible in the drop-down list, click the Insert button.

To reposition the text cursor in the text string, click between the fields, which are denoted by braces ({}).

- **Remove a field from the text string**. To remove a field, click it to highlight the entire field—the text between the braces ({}). Then press the Delete key.
- **Change an existing field**. If you want to replace a field in the text string with another field from the original drop-down list, click the field, pause, then click again to display a shortcut menu with the options from the original drop-down list (Figure 8.20). Then choose a different option.

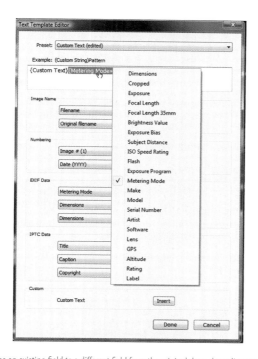

FIG 8.20 Change an existing field to a different field from the original drop-down list you picked the field from.

- **Add custom text**. You can type in any text you want by simply repositioning the text cursor between the fields and typing the text you want. This is a good way to add labels that identify the metadata or to insert spaces between the fields in the text string.

You can insert a field labeled "Custom Text" by clicking on the Custom insert button near the bottom of the dialog box. But I've never discovered a good reason to do so, because you can just click in the text string and type what you want *without* inserting a custom text field.

- **Save the settings to reuse them**. To save the contents of the Text Template Editor so you can reuse them, click the Preset drop-down list and choose Save Current Settings as New Preset. Provide the name in the New Preset dialog box, and click Create.
- **Update an existing preset**. To update the preset you are currently working with, click the Preset drop-down list and choose Update Preset "Preset Name."
- **Delete a preset**. To delete a preset, choose Delete Preset (followed by the name) from the drop-down list.

You'll know that you've modified the existing preset (and thus might want to save the changes) because the name of the preset is followed by "(edited)" in the Preset drop-down list. The Update Preset entry only appears in the drop-down list if you have edited the preset.

Moving and Sizing Text

Much like the Identity Plate, you can move a text overlay by clicking and dragging it; and each text overlay has an anchor point. You can size the text overlay by selecting it and then clicking and dragging a sizing handle. Unlike Identity Plates, however, text overlays do not have a Scale slider, so you must use the sizing handles to modify the size.

Setting the Text Attributes

Because the text overlays are text, you'd expect that you can adjust the font and face of the text—and you can by using the Text Overlays controls (Figure 8.21). To change the font, click the existing font to open a list of available fonts, and choose a new font from the list. To pick a new face (such as bold, italic, or bold italic), click the existing face to open a list of available faces and choose a new face from the list.

If the list of fonts is too long to display on the screen, click the small arrowhead at the top or bottom of the list to scroll in that direction. You can also press the key for the first letter of the font name if you know which font you want. This jumps right to the set of fonts that begin with that letter.

FIG 8.21 Change the text attributes from the Text Overlays controls.

You can also adjust the opacity using the Opacity slider or text field and change the text color by clicking the color bar and choosing a new color from the Color control.

> The Text Overlays controls are not accessible until you actually click on a text overlay.

There are two controls you can use that are not in the Text Overlays control section—the rotation controls. These are located in the tools at the bottom of the slide (Figure 8.22). To rotate the text counterclockwise, click the left bent arrow. To rotate the text clockwise, click the right bent arrow.

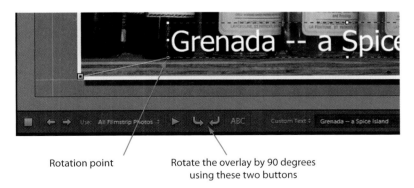

FIG 8.22 Use the controls at the bottom of the slide to rotate or change the text.

Rotation point

Rotate the overlay by 90 degrees using these two buttons

> The rotation point is the sizing handle closest to the anchor point—that is, the text box rotates around that sizing handle. The rotation point is indicated by the small black dot in the center of the sizing handle.

To change the text of an existing text overlay, click the overlay to place the text into the field at the right of the Custom Text drop-down list. Then simply edit the text, and press Enter. You cannot, however, edit the text in this field if "Custom Settings" is visible alongside the ABC button—to change that text, you must choose Edit from the Custom Settings drop-down list and change the text in the Text Template Editor dialog box.

Adding a Sound Track

You can play music with your slideshow, though the configuration options are limited: you can only use MP3 files and you can select only a single folder that holds the music. The music plays in the order that the files are listed in the folder, so if you don't like the order, you'll need to rename the files to get them into the order that you want.

Adding a number in front of the existing filename will do the trick.

To specify the music for the slideshow, use the following steps:

1. Select the Soundtrack check box in the Playback panel on the right side of the screen.
2. Click the text that reads, "Click here to choose a music folder." This opens the Browse for Folder dialog box (Figure 8.23).
3. Select the folder from the Browse for Folder dialog box, and click OK.

FIG 8.23 Use the Browse for Folder dialog box to pick a folder containing the music files you want to use.

If you have already picked a soundtrack folder, you can change it by clicking on the name of the folder, which replaces the "Click here to choose a music folder" text.

Adding Intro and Ending Slides

You can add an introductory screen to the slideshow by selecting the Intro screen check box in the Titles panel (**Figure 8.24**). The screen is rudimentary—all you can do is select the color from the color control and add the Identity Plate by selecting the Add Identity Plate check box. You can choose which Identity Plate to use by picking any of the prebuilt ones (or choosing Edit to build a new one) from the drop-down list you'll see if you click on the tiny down arrow in the lower-right corner of the Identity Plate preview.

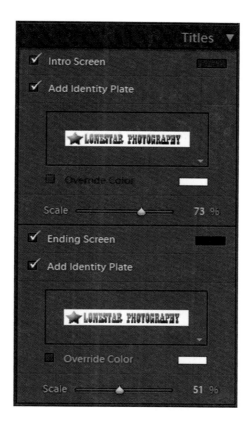

FIG 8.24 Use the controls in the Playback panel to create an intro and an ending screen.

You can add an ending screen as well by selecting the Ending Screen check box in the Titles panel. Again, all you can set is the color and whether to show the Identity Plate—though it can be a different Identity Plate from the intro screen.

Saving It All as a Template

After you've gone to all the trouble of configuring everything the way you want, you can save all the settings as a template. Any template you save appears in the Template Browser on the left side of the screen.

To add a template, use the following steps:

1. Click the + symbol in the Template Browser panel, choose Slideshow > New Template, or press Ctrl + N.
2. Type the name of the new template into the resulting New Template dialog box.
3. Choose the folder from the Folder drop-down list. The default folder (User Templates) places the new template in the User Templates section of the Template Browser. To create a new folder entry in the Template Browser, choose New Folder from the Folder drop-down list, type the folder name into the resulting New Folder dialog box, and click Create.

You can also create a new folder by right-clicking on an existing folder (such as Lightroom Templates or User Templates) or template and choosing New Folder from the shortcut menu. If you prefer to use the menus, choose Slideshow > New Template Folder or press Ctrl + Shift + N.

4. Click Create in the New Template dialog box to create the new template.

You can change a user template in a variety of ways:

- **Update the settings**. If you change your mind about an item (such as the background color or shadow settings), simply change that item on the slide. Then right-click the template you want to update, and choose Update with Current Settings from the shortcut menu.
- **Delete the template**. To delete the template, either choose Delete from the shortcut menu or click the − symbol in the Template Browser panel.
- **Delete a folder**. To delete a folder you have created, select the folder in the Template Browser, and either choose Delete Folder from the shortcut menu or click the − symbol in the Template Browser panel. You cannot delete the Lightroom Templates or User Templates folders.
- **Rename the template**. To rename the template, right-click the template, and choose Rename from the shortcut menu. Type the new name into the Rename Template dialog box, and click Ok.
- **Export the template**. If you'd like to use this template on another installation of Adobe Photoshop Lightroom, you can export it. To do so, select Export from the shortcut menu to open the Export Template dialog box. Fill in the filename (the default is the template name), navigate to the folder where you want to save the template, and click Save.

- **Import a template**. To import a template, choose Import from the shortcut menu of any user template (in either the User Templates folder or a folder you created). This opens the Import Template dialog box. Choose the template file (it's a file that ends in ".lrtemplate"), and click Open to import the template into the same folder as the template from which you chose Import.

If you want to import the template into a new folder that contains no templates, choose Import from the folder's shortcut menu. You cannot import templates into the Lightroom Templates folder.

Saving a Slideshow Collection

As mentioned at the beginning of this chapter, you can create a collection (Chapter 4) and select that collection to use the images for the slideshow. The advantage of doing so (in addition to being able to easily pick the photos to use) is that you can save the slideshow settings as a Slideshow Collection. To do so, use the following steps:

1. Click on the collection in the Collections panel to make only those images available in the Slideshow module.
2. Pick the template to use from the left panel, and make the adjustments you want to colors, text, the Identity Plate, and so on from the right panel.
3. Click the + symbol in the Collections panel, and choose Create Slideshow to open the Create Slideshow dialog box (**Figure 8.25**) and fill in the name of the Slideshow Collection.

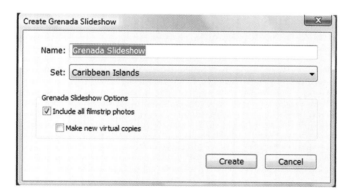

FIG 8.25 Create a Slideshow Collection that saves all your settings.

4. Choose the name of the collection set to associate the Slideshow Collection with from the Set drop-down list. By default, this will be the parent collection set for the collection, but you can change that if you wish by picking from the list.

5. Select the Include all filmstrip photos check box to include all the filmstrip photos. If you don't select this check box, no images are included in the slideshow. If you choose to include all the filmstrip photos, you can create new virtual copies by selecting the Make new virtual copies check box.

6. Click Create to display the Slideshow Collection as a child of the collection set (Figure 8.26).

Slideshow collection for the slideshow module

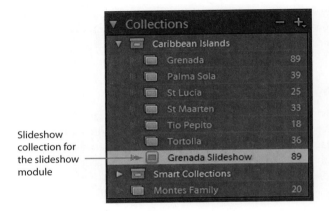

FIG 8.26 The Slideshow Settings feature saves the template and all your current settings.

If you accidentally create a Slideshow Collection with no images (or if you just no longer want the Slideshow Collection), you can delete it by choosing Delete from the Slideshow Collection's shortcut menu. Or you can click and drag images from the filmstrip to the Slideshow Collection, just as you would with any collection. Each new batch of images you drag to a Slideshow Collection appears at the beginning of the Slideshow Collection. However, as with any other type of collections you can click and drag the images in the filmstrip or in the Grid view (in the Library module) to rearrange them. In the Library module, just make sure to set the Sort list to User order.

There are a variety of ways to use a Slideshow Collection to instantly change the settings for the slideshow. Simply clicking on a Slideshow Collection (in any module except the Develop module) displays the images in the Slideshow Collection and loads the settings. If you are in any module except the Develop module, double-clicking on the Slideshow Collection in the Collections panel switches to the Slideshow module and loads the settings.

Any changes you make to the settings in the right panel group while a Slideshow Collection is selected are automatically saved to the Slideshow Collection and will be there the next time you choose the Slideshow Collection.

Saving Your Settings

There is yet another way to save your settings while you work in the Slideshow module—by using the Save Slideshow Settings and Revert Slideshow Settings items in the Slideshow menu. When you first start working on a slideshow, these menu items are grayed out, but after you change a setting, they become available. If you don't like the settings you've changed, you can revert (using Slideshow > Revert Slideshow Settings) to the last time you saved your settings (using Slideshow > Save Slideshow Settings) or, if you haven't saved your settings since then, the settings as they existed when you entered the Slideshow module.

Playing the Show

After doing all the work to set up the slideshow, the payoff comes when you can enjoy the show. You can preview it (which runs the show inside the active area) or play the slideshow in all its full-screen glory, complete with music.

Both the preview and slideshow will play in the specified order (order of slides in the filmstrip) unless you select the Random Order check box in the Playback panel. In addition, the slideshow will repeat if the Repeat check box (at the very bottom of the Playback panel) is selected. Clearing this check box causes the slideshow to play just once.

Specifying the Slide Duration

You can set the slide duration and the fade duration (the fade effect that occurs between slides) by selecting the Slide Duration check box in the Playback panel. Use the Slides slider (or text field) to set the length of time the slide is shown in seconds. Use the Fades slider (or text field) to set the length of time between slides that the fade is shown.

If you don't set the slide duration, the slides don't advance automatically—only the first slide is shown during the preview or the slideshow. This is handy for allowing you to advance the slides manually using the keyboard arrows, perhaps so you can speak about each one during the show.

Viewing the Preview

To preview your show (or play it, as described later), the first thing you need to do is decide how many of the available images you want to use in the slideshow. The Use drop-down list in the toolbar (with the slideshow controls)

specifies the photos that will play in the slideshow. The available values are as follows:

- **All filmstrip photos**. Does just what it says—includes all the photos visible in the filmstrip. However, if you select an image before playing or previewing, the show starts from the selected slide.
- **Selected photos**. Includes just the selected photos in the slideshow. Make sure to select one or more photos before starting the slideshow.
- **Flagged photos**. Includes just those photos that have been flagged as "Pick" (by pressing the P key. Photos that are either unflagged or flagged as "Rejected" (by pressing the X key) are not included in the slideshow.

The options for previewing your slideshow are also available in the Play > Content menu.

To start the preview, click the Preview button (located in the lower-right corner of the screen) or click the Preview Slideshow button, which is located in the lower-left section of the preview area (**Figure 8.27**). You can advance quickly through the slides, return to a previous slide, or stop the preview using the rest of the buttons in the lower-left corner of the preview area.

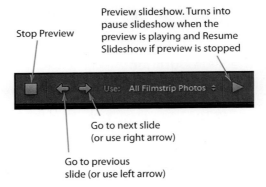

FIG 8.27 Use the Preview control buttons to start, pause, advance, and stop a preview.

You can also control the Preview using keyboard shortcuts and items in the Play menu:

- **Start the preview**. Press Alt + Enter. There is no menu item for this option; using Play > Run Slideshow (or pressing the Enter key) starts the slideshow, not the preview.
- **Stop the preview**. Choose Play > End Slideshow, or press Esc.
- **Pause the preview**. Choose Play > Pause Slideshow, or press the spacebar.
- **Restart a paused preview**. Choose Play > Resume Slideshow, or press the spacebar.

Viewing the Slideshow

There are two options for playing a slideshow, discussed in Table 8.1.

TABLE 8.1 Use these controls to run a slideshow.

Slideshow Control	What It Does
Play button	The Play button is located near the lower-right corner of the screen. Clicking it starts the slideshow. You can control the content (what is included in the slideshow) as described for the preview.
Play > Run Slideshow	Selecting this menu option (or pressing the Enter key) runs the slideshow. The options for which slides will be played are identical to pressing the Play button.

The slideshow itself fills the entire screen, so none of the menus are available. Thus, you'll need to pay particular attention to the keyboard shortcuts! Other keyboard shortcuts for controlling the slideshow are as follows:

- **End slideshow**. Press the Esc key, or click the left mouse button.
- **Go to next slide**. Press the right arrow key.
- **Go to previous slide**. Press the left arrow key.
- **Pause slideshow**. Press the spacebar.
- **Resume paused slideshow**. Press the spacebar.

You can pick and rank the slides while the slideshow is playing! Simply press the appropriate key (such as "P" for pick or "4" to give the slide a rating of four stars) while the image is being displayed during the slideshow.

Exporting the Slideshow

If you want people to be able to see your slideshow other than on the computer you built it on, you'll need to export it. You have two options: you can export your slideshow as a PDF (Adobe Acrobat) file or you can export it as a set of JPEG images. The PDF file plays the slideshow with Adobe Acrobat, but it does not support sound or music that you may have added to the slideshow. The JPEG export simply creates a set of JPEG images, which you'll need to send to a recipient—and that recipient will need an application (like Adobe Photoshop Elements) that can play the JPEG images as a slideshow.

Export as an Adobe Acrobat File

To export your slideshow as an Adobe Acrobat file, click the Export PDF button near the lower-left corner of the screen or choose Slideshow > Export PDF Slideshow (Ctrl + J) to open the Export Slideshow to PDF dialog box (Figure 8.28).

FIG 8.28 Specify the parameters for the Adobe Acrobat (PDF) file export.

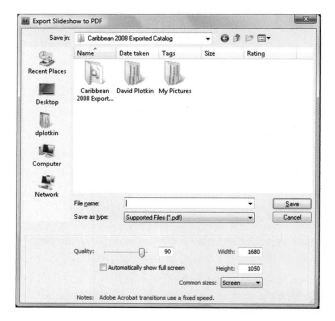

 A "PDF" file requires the Adobe Acrobat reader to play it. This is a free download from www.adobe.com.

Type in the filename, and set the following parameters in the dialog box (then click Save):

- **Quality**. Use the Quality slider or type a number (between 0 and 100) to set the quality of the exported images. This parameter essentially trades photo quality for file size—a higher quality means a larger file.
- **Width and height**. Set the width and height of the slides displayed in the exported file. You can pick from common sizes in the Common sizes drop-down list, including Screen (your current screen resolution).

 Picking 1024 × 768 is a good compromise for the screen size. Virtually all computers built since the early 1990s can manage this resolution.

- **Automatically show full screen**. Select this check box if you want the Adobe Acrobat reader to show the slideshow on the full screen, without any of the Acrobat menus and controls. Just realize that the people viewing the file must know how to control it (such as pressing Esc to stop the show) without any help from Acrobat menus.

The exported slideshow does not contain the music. Unfortunately, the show will play in silence, even if you added a soundtrack to the original in Lightroom.

You can create a slide that contains the keyboard shortcuts for Acrobat and add that slide as the first slide in your slideshow. That way, people viewing the slideshow in full screen will know how to control it. To build such a slide, you'll need a program like Photoshop Elements, which enables you to create image files containing text.

It can take a considerable amount of time to build the PDF file. You can track the progress of the task by watching the progress bar near the upper-left corner of the screen. Click the "x" at the right end of the bar to cancel the task.

Export as a Set of JPEGs

To export your slideshow as a set of JPEG files, click the Export JPEG button near the lower-left corner of the screen or choose Slideshow > Export JPEG Slideshow (Shift + Ctrl + J) to open the Export Slideshow to JPEG dialog box (**Figure 8.29**).

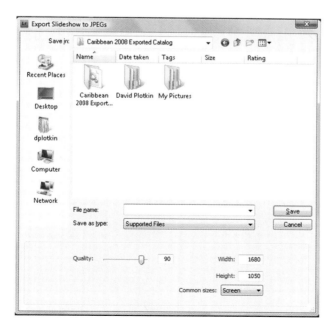

FIG 8.29 Configure the size and quality of the JPEG files in the slideshow.

Type in the filename, and set the following parameters in the dialog box (then click Save):

- **Quality**. Use the slider or type in a value between 0 and 100 to specify the quality of the JPEG file. Remember that you trade file size for quality—the higher the quality, the bigger the file.
- **Width and height**. Set the width and height of the slides displayed in the exported file. You can pick from common sizes in the Common sizes drop-down list, including Screen (your current screen resolution).

Once Lightroom has rendered the JPEG images, you'll find them all in a folder with same name as you entered in the Filename field in the dialog box. The files themselves use the filename you specified, followed by a sequence number.

Web Wizard: Creating and Posting Images on the Web

W e've discussed sharing your photos by creating a slideshow. Another way that Adobe Photoshop Lightroom enables you to share your work is via the Web. Using the Web module, you can create a standard (HTML) photo gallery or a Flash photo gallery and post the gallery on your website. A variety of templates are available to help you work efficiently.

Understanding the Web Module

The Web module, like the other Lightroom modules, divides the screen into three main areas (in addition to the filmstrip): the Preview area and Template Browser (on the left), the active area where you configure the Web pages, and the Layout panel group (on the right) where you set your options and configure the details of the site (Figure 9.1)

The active area in the middle of the screen is always "live"—that is, as you build your Web pages, you can click the links and choose photos, and the live

Configure and try out
your web pages here

Configure the type of gallery

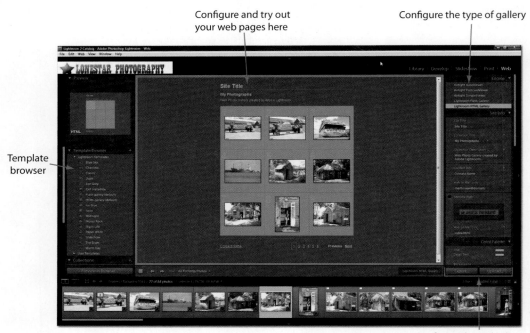

Template
browser

Configure the web photo
gallery in this area

FIG 9.1 The Web module is laid out much like the other Lightroom modules.

area will behave pretty much like a browser would. For example, if you select
a thumbnail of an image, the full image appears in the window (**Figure 9.2**). This
feature makes building your Web photo gallery very interactive.

 Click on the large version of the image or Index to return to the index
page (showing the thumbnails).

Selecting and Setting Up for the Web

To establish the basic layout and configuration of your Web photo gallery,
pick a template from the Template Browser on the left side of the screen. From
there, you can use the controls on the right side to select the type of gallery
you want to build and customize all its components.

Selecting Photo(s) for Your Site

As with the Slideshow module, you need to pick the photos you want to post
on your website. The cleanest way is to create a collection and select it before

Navigation controls

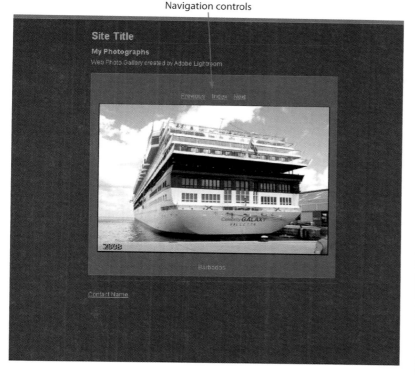

FIG 9.2 If you click a photo thumbnail, you'll see the photo, along with the navigation controls.

switching to the Web module. However, you can select photos in the filmstrip and choose Selected Photos from the Use drop-down list if you just want to create Web pages from the selected photos. To switch back to using all the available photos, choose All Filmstrip Photos from the Use list. To include just the flagged photos, choose Flagged Photos in the Use list.

You can also make these same selections from the Web > Content menu.

Choosing between Flash and HTML Galleries

Lightroom enables you to build two types of galleries: Flash galleries and HTML galleries. An HTML gallery performs the basics—showing thumbnails (which link to the larger version of the image), providing navigation controls to move between the photo pages, and displaying text labels. A person viewing the website doesn't need anything extra besides his or her browser. Another advantage is that you can open the HTML Web pages in an HTML editor and customize them further—perhaps by adding more text, logos, and links to other pages on the website.

A set of three "Airtight" galleries is listed in the gallery at the top of the right panel group of the screen. These are special cases of Flash galleries. To use one of these galleries, select the gallery you want to use and do *not* choose a template from the left panel (all of the template information is built into the gallery). After you choose an Airtight gallery, various parameters in the right panel are displayed— you fill in values just as you would with a template. The Airtight galleries are examples of third-party galleries built for Lightroom. In this case, Adobe chose to include them within Lightroom to make them easier to use. Just realize that, as with any other Flash-based gallery, you'll need to have the Flash player available and get past the various security issues (detailed later in this chapter).

A Flash website has many of these same attributes but adds dynamic special effects, such as image fades in and out, changing the thumbnail border color when you hover the mouse over it, and more. However, you don't have as much control over the size of the large images as you do with HTML, and previewing your Web pages in a browser can take quite a while as Lightroom builds everything necessary to perform that task. Also, the browser must have the appropriate Flash player plug-in installed to view the Flash gallery. If you don't have the Flash player, you'll get a warning and a link to allow you to download it. In addition, if you have the security setting set to block scripts and ActiveX controls, you'll get the warning (a yellow bar near the top of the screen in Internet Explorer).

> To allow the Flash gallery to play in Internet Explorer, click the yellow warning bar and select "Allow Blocked Content."

The available templates on the left side of the screen are designed for either HTML or Flash, and you'll need to pick a template that is suitable for the type of gallery you want to build. Most of the template names don't give you a clue as to which type of gallery they are for. However, if you hover the mouse pointer over a template name, the Preview at the top will tell you. If the preview shows "HTML" in the lower-left corner, the template is designed for HTML. If the preview shows a stylized script "f" in the lower-left corner (**Figure 9.3**), the template is designed for Flash.

FIG 9.3 The script "f" indicates that this template is designed for Flash.

If you choose to build an HTML gallery and then pick a Flash template, the gallery choice changes to Flash automatically (and vice versa).

Setting the Site Info

The text fields located in the Site Info panel on the right side of the screen enable you to customize the text that appears on photo gallery Web pages. To enter a value in each field, click the field, type in the text, and press Enter.

If you don't want a particular field to appear on the Web page, leave it blank.

The Web or Mail Link field works a little differently than the other fields in the Site Info panel. The value you enter in this field is used as a hyperlink for the contact name. What actually occurs when the contact name is clicked on depends on what you put in the Web or Mail Link field:

- **mailto:** "mailto:" followed by a valid email address. This will open the user's email program with the To: line already addressed to the specified email address. If you'd like the subject line to be populated as well, add a space and "subject = " followed by the subject line.
- **Web address**: Typing in a valid Web address (such as www.dplotkin.com) will open the specified Web page in the user's browser.

Each text label has a small arrow to the right of the field title. Click this arrow to display a drop-down list of any values you previously typed into this field for any Web presentation. To pick a value from the list, simply click on it. To clear the list, select (can you guess?) Clear list.

Adding an Identity Plate

If you wish, you can add an Identity Plate to the thumbnail pages and detail pages. Creating and editing the Identity Plate works exactly as described earlier in Chapter 8. For an HTML gallery you can add a Web or mail hyperlink to the Identity Plate by specifying the email address or Web address in the Web or Mail Link text field. If the user clicks on the Identity Plate, his or her email application (for an email address) or browser (for a Web address) will open to display the link.

The Identity Plate appears in the Site Info panel for an HTML gallery and in the Appearance panel for a Flash gallery.

Configuring the Color Palette

You have considerable control over the color palette used to render your Web pages. The color controls (located in the Color Palette panel on the right side of

the screen) vary depending on whether you are using a Flash gallery (see Table 9.1) or an HTML gallery (see Table 9.2).

Configuring the Color Palette for a Flash Gallery

TABLE 9.1 Summarizes the palette controls for a Flash gallery, as shown in **Figure 9.4**

Palette Control	Sets the Color Of
Text	Text in the main photo area, such as the photo title
Header text	Larger "header" text near the top of the screen
Menu text	Smaller "clickable" text that triggers a hyperlink or displays a menu; in Figure 9.4, this includes the contact name near the top right corner and the View menu near the top left corner
Header	The area behind the header text
Menu	The area behind the menu text
Background	Overall background color—the color of any area not overridden by other palette controls
Border	The border around the main photo area and the thumbnail area
Controls background	The area behind the controls
Controls foreground	The slideshow controls (such as those near the bottom of the screen in Figure 9.4)

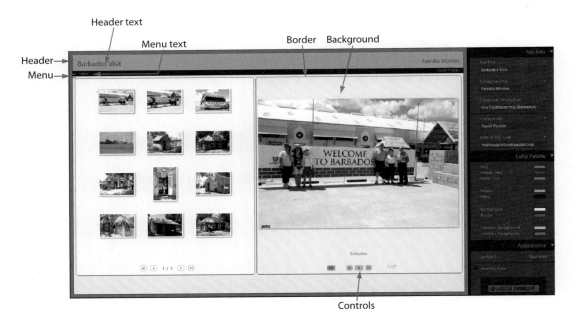

FIG 9.4 You have considerable control over the colors used in a Flash gallery.

Configuring the Color Palette for an HTML Gallery

TABLE 9.2 Summarizes the palette controls for an HTML gallery, as shown in **Figure 9.5**

Palette Control	Sets the Color Of
Text	General text, such as the site title, collection title, collection description, contact name, and the page controls near the bottom right corner on both the thumbnail page and the detail page
Detail text	The text that appears on the "detail page"—the page that appears if you click on a thumbnail and displays the larger version of the image; this text includes the page controls on the detail page, such as the Next, Previous, and Index hyperlinks (see Figure 9.6)
Background	Overall background color—the color of any area not overridden by other palette controls
Detail matte	The frame (matte) color around the larger image on the detail page (Figure 9.6)
Cells	The individual "cells," which contain the thumbnails
Rollover	The individual cells when you move the mouse over the cell; doing this changes the color to the Rollover color
Grid lines	The grid lines that separate the cells
Numbers	The numbers that appear in the individual cells; you can turn the cell numbers on by selecting the Show Cell Numbers check box in the Appearance panel

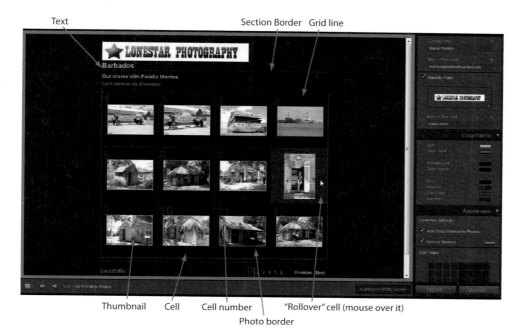

FIG 9.5 The index page(s) in an HTML photo gallery show the thumbnails.

FIG 9.6 Clicking a thumbnail takes you to the image detail page, which displays a larger version of the image.

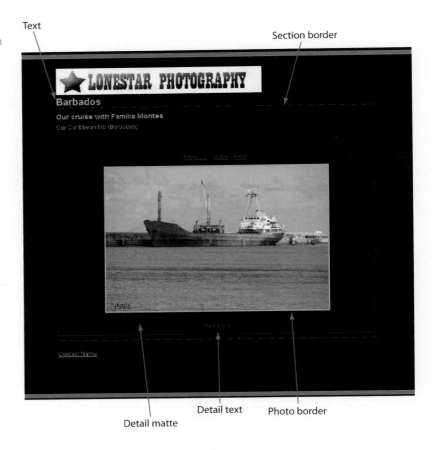

Text

Section border

Barbados

Detail text

Photo border

Detail matte

Setting the Web Page Appearance

As with the color palette, the Appearance control varies depending on whether you are building a Flash gallery or an HTML gallery.

Configuring the Appearance for a Flash Gallery

In addition to turning the Identity Plate on and off, the Appearance controls for a Flash gallery (**Figure 9.7**) enable you to change the sizes of the large image and thumbnails, as well as the layout.

To adjust the image sizes for the gallery, use the following options:

- **Large images size**. Choose a size (Extra Large, Large, Medium, or Small) from the Large Images Size drop-down list.
- **Thumbnail size**. Use the Thumbnail Images Size drop-down list to select a thumbnail size (from Extra Large to Small). Larger thumbnails (which are exported as image files) show you more information about the image before you click on it, but they take up more space on the screen and take longer to load.

FIG 9.7 Use the Appearance panel to adjust the image sizes and overall gallery layout.

The values in the Layout drop-down list make a big difference in how the Flash photo gallery is laid out. The options are as follows:

- **Scrolling**. This option places the thumbnails in a horizontal row below the larger image. Use the scroll bar below the thumbnails to scroll through them (Figure 9.8). As with all the layouts, you can use the page controls below the larger image to move through them one by one.

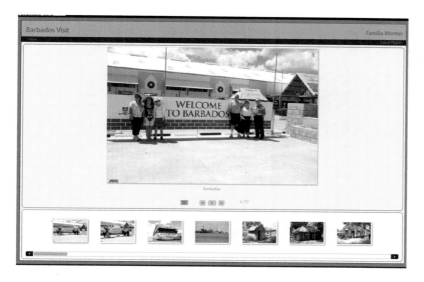

FIG 9.8 The Flash gallery Scrolling layout puts the thumbnails on the bottom.

301

- **Paginated**. Places the thumbnails in multiple columns to the left side of the larger image. No scroll bar is provided; instead, you must use the page controls below the thumbnails to view another page of thumbnails (see Figure 9.4, shown previously).
- **Left**. Places a vertical row of thumbnails to the left of the larger image. Use the scroll bar to the right of the thumbnails to scroll through them (**Figure 9.9**).

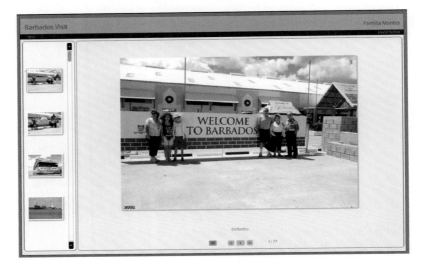

FIG 9.9 The Flash gallery Left layout puts the thumbnails to the left.

- **Slideshow only**. Displays only the larger image and controls to move through the images (**Figure 9.10**).

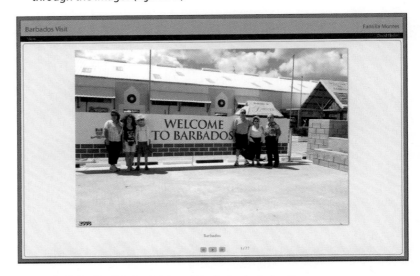

FIG 9.10 The Flash gallery Slideshow Only layout hides the thumbnails altogether.

Configuring the Appearance for an HTML Gallery

The Appearance panel (Figure 9.11) for an HTML gallery provides a set of controls to change how the Web page looks. The most powerful control is the Rows and Columns grid in the Grid Pages section. To change the number of rows and columns, hover the mouse pointer over the grid and position it so that the number of rows and columns you want is highlighted, then click. You can see the highlighted grid in Figure 9.11.

If you click here, you'll have 4 columns and 3 rows of thumbnails cells.

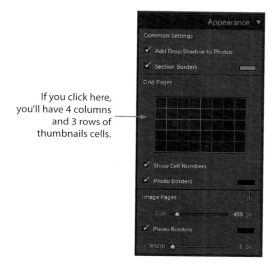

FIG 9.11 Use the Appearance panel to set the number of rows and columns, and turn on various dividers and borders.

The rest of the controls are broken up into three sections:

- **Common settings**. The common settings apply to both the thumbnail pages and the large image (Detail) pages. You can add drop shadows to photos and thumbnails by selecting the Add Drop Shadow to Photos check box. You can also enable section borders (select the Section Borders check box) and set the section border color (click the color rectangle and pick a color from the Color dialog box).
- **Grid pages**. These settings apply to the thumbnail pages. In addition to the Rows and Columns grid, you can choose to show cell numbers (select the Show Cell Numbers check box). You can also enable photo borders (select the Photo Borders check box) and set the photo borders color (click the color rectangle and pick a color from the Color dialog box). You can see these items detailed in Figure 9.5, discussed previously.
- **Image pages**. These settings apply to the pages that show the large images. To set the size of the large image in pixels, use the Size slider or the associated text field. You can turn the photo borders on for the large

images by selecting the Photo Borders check box. In addition, you can adjust the border width using the Width slider (or its associated text field) and select the photo border color by clicking the color rectangle and picking a color from the Color dialog box. You can see these detailed items in Figure 9.6, discussed previously.

Unlike a Flash gallery, you can't directly adjust the thumbnail size in an HTML gallery. The thumbnail size is set by the number of rows and columns, which sets the size of each "cell" containing a thumbnail.

Adding Image Info

The Image Info panel enables you to configure the Title and Caption fields that appear in various templates. To include the title or caption with an image, select the Title or Caption check box. To pick an item to include for the title or caption, you can either choose one of the options in the drop-down list alongside each field, or select Edit from the drop-down list to open the Text Template editor and create a custom text string, as discussed in Chapter 8.

Setting Up the Output

The Output Settings panel enables you to specify and configure items like metadata and quality. The Output Settings panel (**Figure 9.12**) also enables you to adjust the following output settings:

FIG 9.12 Use the Output Settings panel to set the size and quality of exported images.

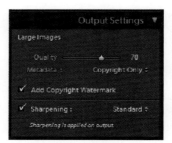

Metadata. When the image is exported to the website, you have the option of including the information about the image (called metadata) with the image. People who open the image in a viewer can see most or all of the included metadata (depending on the viewer they use). You have two options about how much of the metadata to include: just the copyright or all of the metadata. You can specify the values for the metadata in the Metadata panel of the Library module.

Large image quality. You can vary the quality of the large image between 0 and 100 using the Quality slider or the associated text field. Higher-quality images look better, but the files are larger and take longer to download.

Add copyright watermark. If you select this check box, the image is constructed with a copyright notice embedded as a faint "watermark" so it is visible to anyone viewing the image.

Sharpening. As described for the Slideshow module, you can add sharpening to your images. However, because these low-resolution Web images aren't suitable for printing, the sharpening choices are limited to the three screen options: low, standard, and high.

Saving It All as a Template

As described in Chapter 8, you can save all your selections as a template. This saves the layout, colors, and selections. The template you save is either set up for an HTML gallery or a Flash gallery, depending on the type of gallery you were using when you created and saved the template.

You might want to include the type of gallery in the template name, for example, "HTML Brightly Colored."

Saving a Web Collection

As with the Slideshow module, you can build a Web Collection to save the Web gallery settings. The Web Collection appears as a child of the specified Collection Set (if any), although it uses a different icon to distinguish it from a Slideshow Collection.

Saving Your Settings

Like the Slideshow module, the Web module has another way to save your settings while you work—Save Web Gallery Settings and Revert Web Gallery Settings items in the Web menu. They work just as described for the Slideshow module, discussed previously in Chapter 8.

Previewing and Exporting Your Photo Gallery

Although the active section in the center of the Web module gives you a pretty good idea of what the Web photo gallery will look like, the only way to really know how viewers will see it is to preview the site in your default browser. And, of course, you will need to export the finished product to a website if you want people to be able to view it on the Web.

Previewing Your Gallery in a Browser

To preview your gallery in a browser, click the Preview in Browser button or choose Web > Preview in Browser (or press Ctrl +Alt + P). This creates a set of files and Web pages locally on your hard drive and opens the first Web page in your browser (Figure 9.13). From this page you can navigate to other pages, view

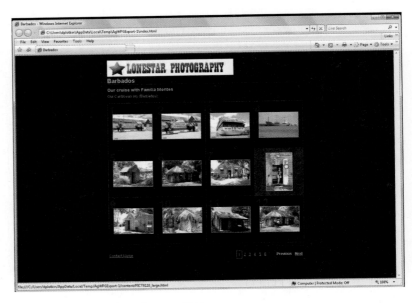

FIG 9.13 Get a good look at your gallery in your Web browser.

the larger images, and test out the photo gallery functionality before going to the trouble of uploading the gallery to your website.

It can take a while to build the preview and open it in your browser. While Lightroom is building the preview, you can watch the progress in the upper-left corner of the screen (**Figure 9.14**). The small thumbnail shows you the image that is currently being converted, and the progress bar shows you how far you have to go. If you change your mind and want to cancel the preview, click the small "x" at the right end of the progress bar.

FIG 9.14 Watch the progress toward being able to preview your gallery in this progress bar.

While viewing your HTML photo gallery, you can click on a large image to return to the thumbnail page containing that image. This works when you post the gallery on the Web too.

Exporting Your Gallery

Once you are happy with your photo gallery, you can export it to your hard drive. This enables you to view the gallery in a browser on your local machine whenever you want, without having to use the rather lengthy Preview in Browser process every time. It also enables you to modify the generated Web pages using a Web page editing program before uploading them to your website. Further, if you design your website locally on your machine with a program like NetObjects Fusion or DreamWeaver (and many others), you can import the photo gallery into the local copy of your website and then upload (publish) it from there.

To export your website, click the Export button (near the lower-right corner of the screen), choose Web > Export Web Photo Gallery, or press Ctrl + J. This opens the Save Web Gallery dialog box, where you can navigate to the folder where you want the exported files to be placed, enter a filename, and press Save. Lightroom uses the supplied filename to create a folder in which it places all the folders, Web page files, images, and support files necessary to view or publish your photo gallery. As with Preview in Browser, it can take a while to generate everything, so you can watch the progress in the progress bar at the upper-left corner of the screen.

Once the export is complete, you can view the photo gallery in your browser by navigating to the folder where you placed the files and double-clicking on the Index.html file to open it in your browser.

The "home" file for the photo gallery is always called "Index.html," and you cannot change that. It is likely that the home page for your website is *also* called Index.html. Thus, if you upload your photo gallery to your website using an FTP program, you must locate the photo gallery inside its own folder on the website. Otherwise, the page Index.html from the photo gallery will overwrite the home page of your website, which is not normally what you want.

Posting Your Photo Gallery

Of course, you probably did all this work so you can post your photos on your website and share them with the world. Lightroom enables you to do that from within the program. Doing so isn't much different from uploading other types of files to your website using your Web-building program—you just need to set up the FTP settings.

Configuring Your FTP Settings

To upload the photo gallery files to your website, you need to supply the FTP parameters. To specify them, click the entry alongside the FTP Server field in the

Output panel to display the drop-down list. Initially, this list will have only two entries: Custom Settings and Edit. Click Edit to open the FTP File Transfer dialog box (Figure 9.15). The company providing your website should have supplied you with the various parameters, so fill these into the fields in the dialog box. To save the settings as a new preset, choose Save Current Setting as New Preset from the Preset drop-down list, fill in the name of the preset in the New Preset dialog box, and click the Create button. From then on, the name of your preset will appear in the FTP Server drop-down list in the Output panel.

FIG 9.15 Fill in the FTP settings that enable files to be uploaded to your website.

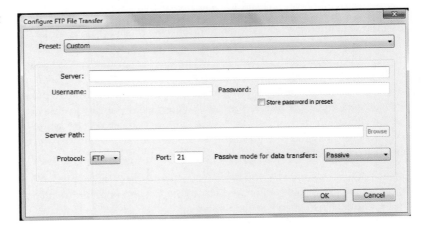

If you fill in the password and select the Store password in preset check box, you will not be prompted for your password when you upload the gallery to your website. If you do *not* select the check box, you'll be prompted for your password each time you upload a gallery.

Performing the Upload

To send your photo gallery to your website, click the Upload button. If you didn't save your password in the FTP Server preset, you'll be prompted for it. Lightroom then begins creating the website (watch the progress with the progress bar in the upper-left corner of the screen) and uploads it to your website via FTP.

Extra Stuff You Need to Do on Your Website

Once you have performed the upload, your photo gallery exists as a set of files on your website. However, people visiting your website won't know it's there! To help them find it, you need to add links to the pages on your website so that visitors can click those links and view your photo gallery. In addition, you should provide a way to return to your website's home page from the photo gallery thumbnail pages so that site visitors aren't trapped in the photo gallery.

It is crucial that you select the Put in Subfolder check box and supply the name of a subfolder. If you don't do this, the base page for your gallery (remember, it is called Index.html) will be uploaded to the main (root) directory of your website. As noted in the earlier warning, if your website home page is also called Index.html, the photo gallery will write over your website home page.

Adding Links to Your Web Pages

To add links to the photo gallery, you need to know the location of the photo gallery index pages. For both an HTML photo gallery and a Flash photo gallery, the initial view page is called Index.html, and it is located inside the subfolder you specified in the Output section of the Web module before uploading the files. For an HTML photo gallery, there is an "Index" page for each page of thumbnails inside the "content" folder (which is inside the specified subfolder). Thus, if there are four pages of thumbnails, you'll find Index.html, Index_1.html, Index_2.html, and Index_3.html. The version of Index.html located inside the content folder is identical to the version of Index.html located inside the gallery's subfolder.

The mechanism for how you add links to your Web pages depends on what Web-building software you use. But if you are already using this software to build your website, you should be familiar with it.

At a minimum, you'll want to add a link to one of the Index.html pages from your Web pages. If you have multiple photo galleries (each in their own subfolder), you might want to create a page in your website that lists them all, with each item in the list linked to an Index.html page in a photo gallery (see **Figure 9.16** to get an idea of how this might look).

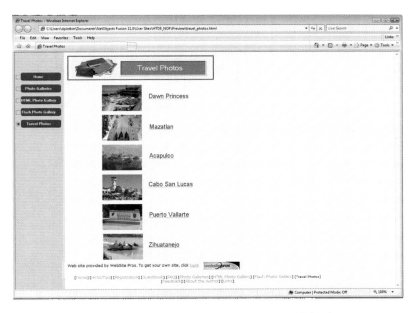

FIG 9.16 List multiple photo galleries on a page in your website to provide a quick link to them.

You can use one of the photo gallery thumbnails as the link to that gallery's Index.html page. For an HTML gallery, the thumbnails are stored in the folder content/bin/images/thumb. For a Flash gallery, the thumbnails are stored in bin/images/thumb.

Providing a Way to Return to Your Main Website

Once visitors have viewed the photo gallery pages, they should have a graceful way to return to the other pages in your website. Otherwise, they might be forced to reenter the Web address to get back to the home page. There are several ways you can implement this on your website:

- **Use frames**. If your Web software supports it, you can use frames. Frames provide (at a minimum) two areas on your website—one where you can make links always available and one where you place the content (see Figure 9.16 for an example). You can add links to the photo gallery in the "link frame" (shown on the left in Figure 9.16). And because the photo from the gallery is viewed in the content frame (just to the right of the link frame) and the link frame is always available, your site visitor can move to another page just by picking a link from the link frame.
- **Edit the photo gallery index pages**. You can use your Web editing software to add links to each index page. These links enable the site visitor to jump to another page in the website. A good example would be linking back to the page with the list of photo gallery pages, if you use one.
- **Trick Lightroom**. If you recall, Lightroom actually provides a link on each page—the "Web or Mail Link" in the Site Info panel. This link is intended to open either an email editor (mailto:) or a Web page. Simply enter the Web address (URL) that you would like the site visitor to be able to jump to (for example, the page with the list of photo galleries) in the Web or Mail Link field. Then, instead of putting a name in the Contact Info field, put in something like "Return to Photo Galleries List."

Layout and Composition

F or professional and serious amateur photographers alike, producing a quality print is the payoff for all the work done in Lightroom up until then. Whether you are printing several dozen 4 × 6 images of your vacation, producing a package of portraits for a client, or making a single large fine art print, the ultimate goal is producing a printed image that matches the one appearing on your display. The Print module provides the tools to print your image (obviously). In addition, it provides a wealth of composition and layout tools that allow you to do a variety of tasks, from printing multiple copies and sizes of a single image and making contact sheets to creating cool photocompositions like the one shown in Figure 10.1. More important, if you are like most digital photographers, when it comes to putting ink on paper you have had more than your share of disappointments making the colors in the printed photo match or appear as vivid as the image displayed on your monitor. In this chapter you will not only learn how to use the tools in the Print module to compose and print your photos but you will also discover how to troubleshoot and correct images that don't print as expected.

311

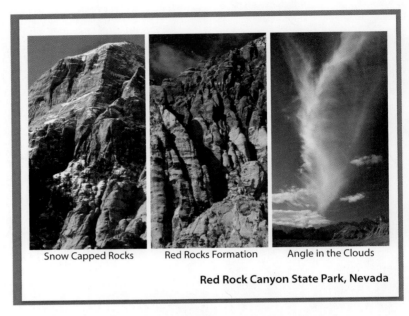

Snow Capped Rocks Red Rocks Formation Angle in the Clouds

Red Rock Canyon State Park, Nevada

FIG 10.1 The Print module can be used to create photocompositions in addition to printing photos.

One Module: Two Purposes

The Print module is functionally divided into the following two parts:

- **Composition and layout**. All of the tools needed to create contact sheets, picture packages, and photo montages. It also includes settings that let you overlay your images with text, photo information, and other print options.
- **Printing**. The Print Job pane is where you select and control the two methods of color management—Managed by Printer and Managed by Lightroom.

Your Print Module Road Map

Open the Print module by choosing Print in the Module Picker (upper-right corner) or using the keyboard shortcut Opt + Cmd + 4 (Mac) or Alt + Ctrl + 4 (PC). The major components of the workspace are shown in Figure 10.2:

Left panel group. Panes containing templates, a preview (of the currently selected template), a list of collections, and the Print Setup and Page Setup buttons.

Work area. Displays the currently selected photo(s). The currently selected template controls how the photos appear.

Right panel group. Contains controls for customizing the layout and adding text and other data when the page is printed. The print controls, including the color management, resolution, and sharpening settings, are also controlled from this panel.

Left Panel Group Work Area

Right Panel Group

Filmstrip

Toolbar

FIG 10.2 The Print Module workspace.

Filmstrip. Provides a way to select photos from within in the Print module by clicking on the photo in the filmstrip.

Toolbar. The Print toolbar was streamlined in version 2.0. Besides navigation controls when there is more than one page in the layout, the toolbar now offers a way to select photos through the **Use** toggle; clicking on it opens a list that lets the user select **All Filmstrip Photos**, **Selected Photos**, or **Flagged Photos**.

Print Module Shortcut Keys

Is your filmstrip or toolbar missing? Use shortcut keys to show and hide the filmstrip (F6) and the toolbar (T), or move your mouse to the bottom of the workspace to make the filmstrip appear.

If you are using a notebook, you may discover that the function keys on the keyboard are dedicated to notebook functions and are not recognized by Lightroom as shortcut keys. If this happens, check your notebook user guide and find out what key overrides this setting. For example, on my Macbook

Pro, holding down the FN key disables the notebook features and allows the function keys to operate normally while the FN key is held down.

For a list of often used Print Module shortcut keys, press Cmd + / (Mac) or Ctrl + / (PC), and the semitransparent listing shown in Figure 10.3 appears and remains until you click on it with the mouse.

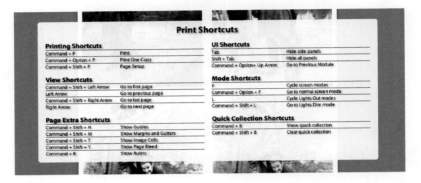

Print Shortcuts

Printing Shortcuts		UI Shortcuts	
Command + P	Print	Tab	Hide side panels
Command + Option + P	Print One Copy	Shift + Tab	Hide all panels
Command + Shift + P	Page Setup	Command + Option+ Up Arrow	Go to Previous Module
View Shortcuts		**Mode Shortcuts**	
Command + Shift + Left Arrow	Go to first page	F	Cycle screen modes
Left Arrow	Go to previous page	Command + Option + F	Go to normal screen mode
Command + Shift + Right Arrow	Go to last page	L	Cycle Lights Out modes
Right Arrow	Go to next page	Command + Shift + L	Go to Lights Dim mode
Page Extra Shortcuts		**Quick Collection Shortcuts**	
Command + Shift + H	Show Guides	Command + B	Show quick collection
Command + Shift + M	Show Margins and Gutters	Command + Shift + B	Clear quick collection
Command + Shift + T	Show Image Cells		
Command + Shift + Y	Show Page Bleed		
Command + R	Show Rulers		

FIG 10.3 The Print Module shortcut menu.

Selecting Photos to Print

The first step in the printing process begins with selecting the photo or photos to be printed. There are many ways to do this. Here is a brief list of the more common methods of selection from the Library module:

- If all of the photos are in the same folder, select that folder in the Folders panel. All of the photos in the folder will appear in the filmstrip when you open the Print module.
- In Collections, create a collection, Smart Collection or collection box. Selecting either of these folders causes all of the photos in it to appear on the filmstrip when entering the Print module.
- When printing a single photo or just a few photos, you can select the photos in the Grid view.
- If you are going to be printing a lot of photos located in multiple folders but do not need to keep a permanent collection, consider making a Quick Collection of the images that you want to print; when it comes time to print, select Quick Collection in the Catalog panel and all of the images will appear in the filmstrip.
- Lastly, you can use the new Use toggle in the toolbar, which defines the content of your print job to include All Filmstrip Photos, Selected Photos, or Flagged Photos as shown in Figure 10.4.

Regardless of the method you choose, when you open the Print module the photo(s) you selected appear on the filmstrip (if visible). The number

FIG 10.4 Clicking the Use toggle in the toolbar opens additional print selection options.

of images that appear when the Print module opens depends on the template that is currently selected. If you select more photos than the page can hold using the template, Lightroom automatically adds as many additional pages as necessary to hold them all. When eight photos were selected using a template that holds only four, Lightroom added a second page, which is shown in Figure 10.5. You can move between pages using the left and right arrow keys on your keyboard, or use the navigation arrows in the toolbar. The square button on the left side of the toolbar opens the first page.

Show first page Navigation arrows Page number and number of pages

FIG 10.5 The display of photos is determined by the template that is selected.

Understanding the Layout and Composition Tools

When you open the Print module, the selected photos appear on the page in the Work Area. How many photos and how they are arranged on the page is determined by controls located in the right panel group. The Layout engine controls which panels appear and which ones don't. The following is a list of the panels and those panels that only appear when either the Contact Sheet/ Grid or the Picture Package layout engines are selected:

- Layout engine
- Image Settings panel
- Layout panel (Contact Sheet/Grid)
- Rules, grids, and guides (Picture Package)
- Cells panel (Picture Package)
- Guides panel (Contact Sheet/Grid)
- Overlays panel

Even the two panels that are used by both layouts differ slightly in the controls that are available. Although I know this appears to be really complicated, it's not once you understand the basic concepts. But before we delve in and learn how these panels are used, we first need to take a quick look at templates.

Layout Presets: Templates

The quickest way to create a layout is by using one of the presets that are included in Lightroom. Templates contain all of the settings that control many aspects of both layout and print set-ups. This includes how the image(s) appear on the page (among other things), print settings, and more. We will learn how to import templates and use them to save custom settings later in the chapter, but for the moment let's look at some examples made from them.

Figure10.6 shows four photos that were laid out using the **2 × 2 Cells** template. Clicking the **4 Wide** template in the Template Browser in the left panel group completely changes the photo arrangement (as shown in Figure 10.7) with a single click. These templates can be customized to fit your requirements and saved, thereby allowing you to arrange photos in your own style with a single click of the mouse. Let's learn how the layout controls work.

Layout Engines

In version 2.0 there are now two layout engines. I realize that the term *engine* is the correct description, but any Texan knows an engine is that gas-guzzler under the hood of your pickup. Both layout engines are the same in that they control the placement of photo cells on the page. They differ as to how they accomplish this feat.

FIG 10.6 Four different photos laid out using the 2 × 2 Cells template.

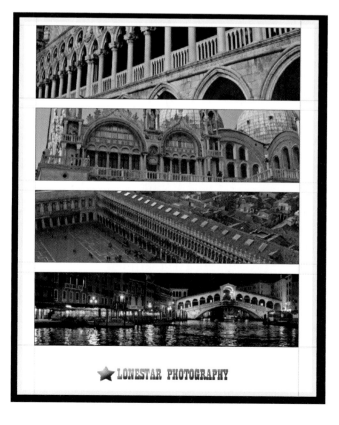

FIG 10.7 The same photos with the 4 Wide template.

- **Contact sheet/grid**. This is the original layout and is used to create contact sheets, fine art mats, cool photo montages, and just about anything you can think of that involves the placement of different photos on a page or multiple pages.
- **Picture Package**. New to version 2.0, it is familiar to Photoshop users. Its primary purpose is to allow multiple copies of a single photo to be placed on the same page(s). It differs from Grid in that each cell on the page can be resized and repositioned independently of the other cells.

Grid versus Picture Package

The major difference between the two engines is layouts made using the Grid consist of either a single cell or multiple equally sized cells. All of the cells on all of the pages are controlled by settings in the right panel group. Picture Package allows freeform placement of any number of cells, and each cell can be resized independently of one another.

Another difference between the two layouts is that Grid allows different photos to be placed on the same page, and Picture Package does not. Picture Package allows one photo per page. There can be many copies of the single photo but only one photo per page. This is because the primary purpose of Picture Package is to create multiple copies of one photo on a single page.

The templates used in Figures 10.6 and 10.7 used the Grid. Figure 10.8 shows an example of a layout that used Picture Package.

FIG 10.8 Picture Package allows different shaped cells and freeform placement, but only one photo can be used on a page.

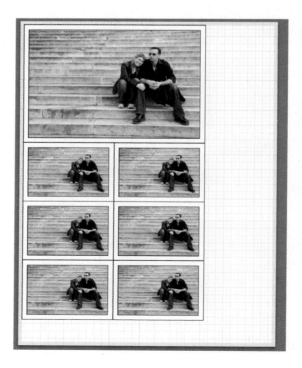

As mentioned earlier in this section, the Layout engine that is selected changes the panels that appears in the right panel group as shown in Figure 10.9.

FIG 10.9 Panel controls differ between Layout engines. The left side shows controls available with Grid, and the right side shows Picture Package.

Customizing the Layout

The basic building block of all layouts is the cell in which the photos are placed. The controls in the **Image Settings** panel determine how photos fit in the cells and the ability to create a border around each cell. The image settings affect all cells on all pages. There are two image settings that are used in both the Contact Sheet/Grid and Picture Package layout. They are **Zoom to Fill** and **Rotate to Fit**. Let's begin with Rotate to Fit.

Rotate to Fit

The photo in Figure 10.10 is a landscape-orientated (wide) photo in a portrait-orientated (tall) cell. Lightroom automatically resized the image, making it small enough so that the entire photo fits within the cell, leaving a lot of white space at the top and bottom.

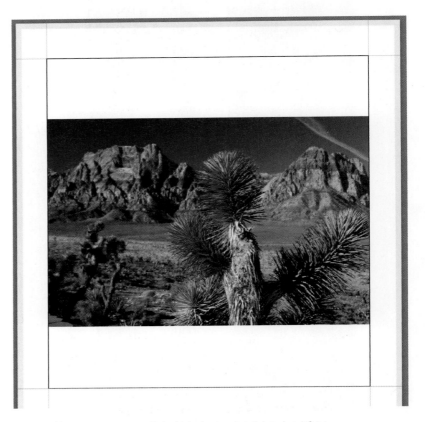

FIG 10.10 Like a square peg in a round hole, this landscape-oriented photo doesn't fit into a portrait-oriented cell.

To change the photo orientation in the cell, click on **Rotate to Fit** in the Image Settings panel. The horizontal image rotates as shown in Figure 10.11. Notice that the photo still doesn't fit the cell, so we need to learn about **Zoom to Fill**.

Using Zoom to Fill

Looking at Figure 10.11, you will notice that although the photo fits in the width dimension, it's short in height, leaving a white strip on the top and bottom. Why is that?

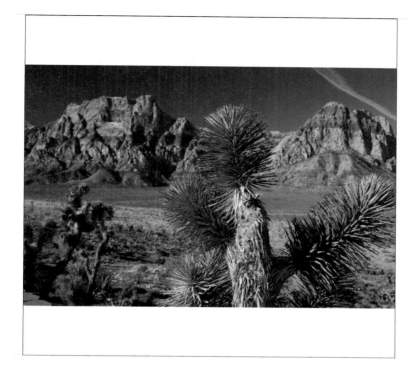

FIG 10.11 Rotate to Fit changes the photo's orientation to match that of the cell.

Unless the cell has the same aspect ratio (ratio of the height to the width) as the photo, the image won't fill the entire cell. Checking **Zoom to Fill** expands the preview image as large as necessary to make both horizontal and vertical edges of the photo touch the edge of the cell as shown in Figure 10.12.

As you can see, this is not a magic cure-all because if the aspect ratio of the photo and the aspect ratio of the cell are different (and they always are), some apparent cropping occurs. The Zoom to Fill option doesn't actually crop the photo; it only hides portions that fall outside of the cell. Like the other modules in Lightroom, nothing done in the Print module changes the original image.

Notice the cropping that has occurred on the left and right of the photo. As said earlier, nothing is lost. The part of the image that overlapped the left and right borders is hiding but not gone. By click-dragging the cursor around inside the photo cell, you can change the part of the image that is hidden by moving the image around inside the cell. The amount of the image that will not be visible is a factor of how close the original aspect ratio of your camera sensor is to the aspect ratio of the particular cell. The closer the ratios, the less cropping occurs.

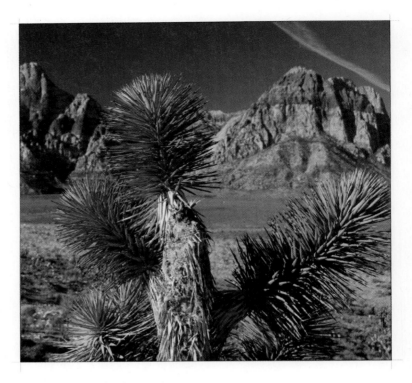

FIG 10.12 Zoom to Fill expands the photo to fill both dimensions of the cell.

The Repeat One Photo per Page (Grid) option does just that—it fills the page with the first selected photo. Because the Picture Package layout engine allows only one photo, this option is not available when Picture Package is selected.

Adding Borders to Your Photos

The Stroke border option places a border around photos on a page to make the proof sheets you are giving to a client or showing to friends more appealing. Although the operation of this feature is simple, the names used in Lightroom get a little confusing. In the Grid layout it is called **Stroke border**, but in Picture Package the same feature is called **Inner Stroke**. To avoid confusion, we'll refer to both as Stroke Border in this chapter. The other border is the **Photo border**, which is only available in Picture Package. Essentially, it is the classic white border that used to be on every photo we got back in the good old days. Although the Stroke borders can be any color you want, the Photo border is always white.

The example (Grid) shown in Figure 10.13 is a 5-point black Stroke border. The guides have been turned off to make it easier to see the borders. The example shown in Figure 10.14 used Picture Package and illustrates a 20-point Photo border and a 5-point Stroke border. The Cutline (when enabled in the Overlay panel) produces a hairline for aligning the cutting of the photos.

FIG 10.13 The Stoke border provides a border that can add punch to photo spreads.

To turn on the Stroke border, select the Stroke Border check box. You can set the width of the Stroke border in "points" (72 points are an inch) by dragging the Width slider or typing a value into the associated text field (up to 20 points). As you make the borders wider, Lightroom makes the image smaller so that it isn't cropped. The Photo border works the same way except its maximum size is 36 points.

Customizing Your Borders

If you want some other color for you border besides black, you can choose a different color by clicking on the color box, and when the Stroke Border dialog box appears (shown on a Mac in Figure 10.15), just click on a color in the palette. Here are two quick ways to select a border color to complement the colors in the photos:

- You can click and drag your cursor across the spectrum of colors in the Stroke Border dialog box. As you drag the eyedropper cursor, the border colors on the layout page change in real time.

FIG 10.14 The Photo border in Picture Package produces a white border on every photo.

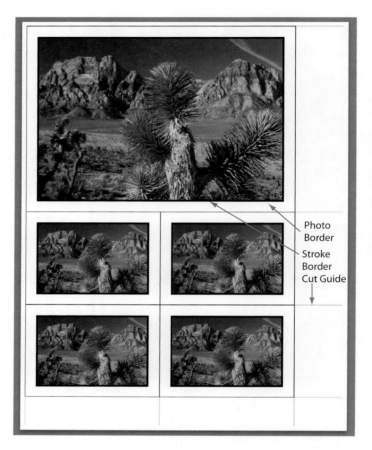

Photo Border

Stroke Border

Cut Guide

FIG 10.15 The Stroke Border dialog is used to define the color of the Stroke border.

Click here to open System color picker

Color Presets

Currently selected color

Click here to close

- If you want to pick a color that is in one of the photos, just drag the eyedropper cursor onto the page over the color in the photo that you want to use, and click it once.

Advanced Color Selection

When you define a color that you want to use again, place the cursor on one of the Color presets and hold it until the swatch in the preset changes to the color you selected. It works just like the station buttons on a car radio.

The Stroke Border dialog box has a greater color selection capability than at first appears. If you click on the current color swatch in the upper-right corner, it opens the system color picker. The dialog boxes that appear are dependent on the operating system you are using. If you dig into it, you will discover that you can create every color in the spectrum. Before you dig too deeply into this virtual box of crayons, stop and remind yourself that the purpose for being here is to pick a single color for a photo border. I strongly suggest that you pick a color and not waste a lot of time.

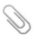

The slider on the Stroke Border option allows you to create insanely small border widths (0.2 points). If you are using a width of less than 4 points, ensure that you print at a resolution of at least 300 dpi or the resulting border may appear jagged or be barely visible to the viewer.

The Layout Panel (Grid)

With all of its sliders, the Layout panel (Figure 10.16) looks like a high-tech soundboard. As complicated as it appears at first sight, it is relatively simple to operate. The most important thing to remember is that most of the features controlled in the Layout panel will not appear on the sample page unless the Show Guides is checked in the Guides panel.

Ruler Units

Select the unit of measure to use from the Ruler Units drop-down list at the top of the Layout panel that appears when you click the double-headed arrow to the right of the current unit of measure as shown in Figure 10.17.

The unit of measure you select is used throughout the Print module. Because the sample print page in the center of the Print module is not shown in its full size (unless you have a really big monitor), it is helpful to display the rulers along the top and left edges to keep you aware of the relative sizes of the images and paper. A quick way to display rulers is the keyboard shortcut (Cmd + R/Ctrl + R).

Page Bleed

Dimensions

FIG 10.16 The Layout and Show Guides panel.

FIG 10.17 Select the units of measure.

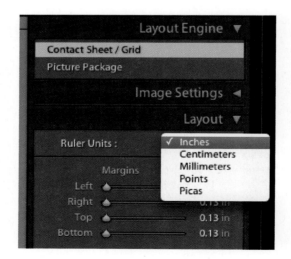

Dragging or Setting Margins for Border Control

The margins are the spaces around each image cell (the rectangle containing the image). You can adjust the margins by doing the following:

- Clicking and dragging the appropriate margin slider in the Layout panel. For example, if you drag the left margin slider to the right, the left margin widens.
- Type a value into the margin text field, located to the right of the margin slider.
- Clicking and dragging the margin in the preview area. Adjusting the margins this way displays the width of the margin as text in the margin. Adjusting the margins using the sliders does not display this measurement.

As you widen a margin, the image cell (containing the photo) may shrink to keep the correct aspect ratio for the photo. This only occurs if you do not choose the Zoom to Fill Frame check box.

Page Grid, Cell Spacing, and Cell Size

These controls are self-explanatory, so we will just highlight some important points. All of these settings interact to one degree or another. Changing one affects the others. For example, if I increase **Cell Spacing**, **Cell Size** decreases proportionally so it will fit on the page. Decreasing the number of either the rows or columns in **Page Grid** increases cell size and cell spacing. The **Keep Square** feature, when checked, forces the cells to equal height and width. Lightroom controls which dimension of the cell changes, and this is determined by what change would still allow all of the cells to fit on the page.

Layout Using the Picture Package

As mentioned earlier, the Picture Package layout engine enables you to print multiple pictures on a single sheet of paper. Thus, you can maximize the use of the paper when printing smaller photos. The idea behind Picture Package is that you want to make many copies of a single photo.

Here are some major points about how it works. The Picture Package is composed of cells that snap to the barely visible grid. As mentioned earlier in this chapter, the panels that appear in the right panel group change when a different Layout engine is selected. The **Image Settings** panel remains unchanged with the exception of the border feature discussed earlier in this chapter. The settings in the **Rulers, Grids & Guides** panel is not much different than those found in the Layout and Guides panels when in the Grid layout. There is one new item called **Grid**. When Grid is checked, a grid becomes visible on the page. Because the placement of the cells in Picture Package is freeform, this feature will cause the cells being moved around the page either to snap to the grid as you drag the cell or to snap to adjacent cells if they are dragged within proximity of a cell or a point on the grid. The snap choices are Cells, Grid, or Off.

Creating a Picture Package Layout

To use Picture Package, you can either select one of the top three templates in the Template Browser (which use the Picture Package layout engine) or click the Clear Layout button in the Cells panel (right panel group) to make one from scratch.

If you have started by clearing the layout, all you need to do to make your own custom picture package is to click the buttons in the Add to Package section of the Cells panel. They are labeled with standard photo sizes. Clicking the right side of each button opens the drop-down list of preset sizes that changes the size of each preset button. All of the standard photo sizes are on this list, but if the one you want isn't on the list, clicking Edit… at the bottom of the list opens a dialog box from which you can create your own favorite size.

Each time you click one of the buttons, a cell of that size is automatically placed on the page. Lightroom adds and auto arranges the cells in a pattern radiating from the upper-left corner of the page. If at some point you have more cells than can fit on a page, Lightroom creates another page. Look at the example shown in Figure 10.18. I kept adding photos until Lightroom created a new page. You can see the printed dimensions of each cell because the Dimensions feature is turned on in Rulers, Grid & Guides. There is a small x in a red circle in the upper-left corner that appears when the cursor is on the page. Clicking this button deletes the page.

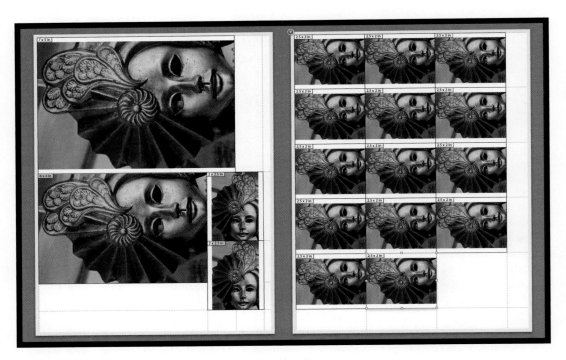

FIG 10.18 When there are too many cells to fit the page, Lightroom adds additional pages as necessary.

Customizing a Picture Package

To see how Picture Package works, let's take it for a spin using one of the photos.

1. With one image selected, select the Lightroom template (1) 4 × 6, (6) 2 × 3. The template not only changes a single image into five (Figure 10.19), it also changed all the Page Setup settings.

FIG 10.19 Selecting a Picture Package template.

2. Any of the cells on the sheet can be moved around by dragging them with a cursor or by selecting them and using the arrow keys to move them. When a cell is selected, a thin blue border appears around the selected cell. If you right-click (Ctrl + Click on the Mac), a pop-up menu appears (Figure 10.20), and you can choose to rotate the cell (in 90-degree increments) or delete it. You can also just select a cell and press the Del key. In the example, the bottom four cells were selected and deleted (Figure 10.21).

Cells can only be individually selected. There isn't an option to select several cells at a time.

3. Clicking the 4 × 6 button in the Cell section automatically adds a cell to the layout (Figure 10.22).

FIG 10.20 Right-click the cell to open cell rotate or delete options.

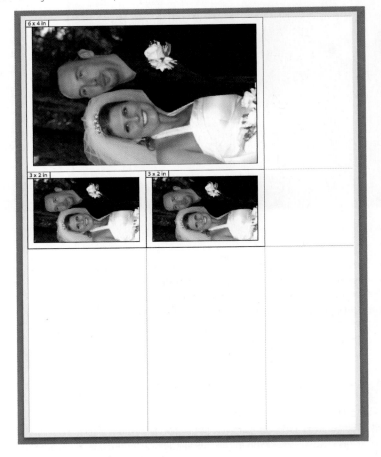

FIG 10.21 Bottom four cells were deleted.

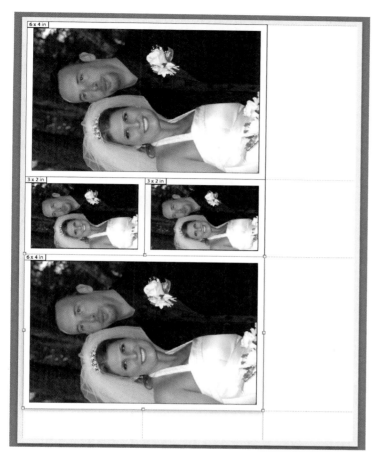

FIG 10.22 Adding a new 4 × 6 automatically arranges it in the layout.

4. Is this the only way that these photo cells can be arranged in the layout? Clicking the Auto Layout button rearranges the cells in the layout as shown in Figure 10.23. Now, it appears there is even more room.
5. Clicking the 2.5 × 3.5 button twice fits two more cells into the layout. In a few quick steps, you have created a Picture Package that gets more photos onto a single sheet (Figure 10.24).

Adding Style to Prints with Overlays

If one picture is worth a thousand words, the addition of more words to a page full of pictures may, at first glance, seem superfluous. The fact is the **Overlays** panel (Figure 10.25) provides a simple and easy way to add a professional touch to the materials you print.

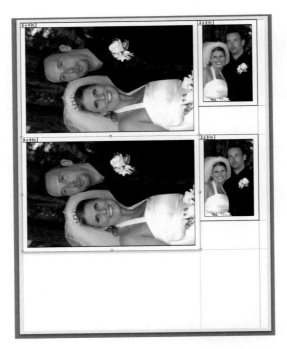

FIG 10.23 Auto Layout rearranges the cells to get the maximum use of the space.

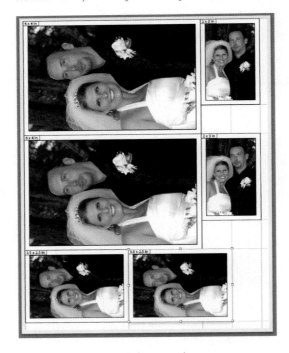

FIG 10.24 The custom Picture Package is complete.

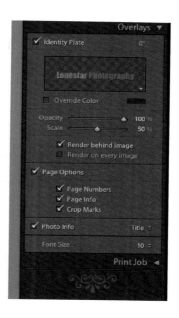

FIG 10.25 The Overlays panel.

The most common use of the Overlays panel is adding filenames to individual photos providing a quick and easy way to create a proof sheet for a client. Each photo displays whatever metadata (filename, title, captions, date, etc.) you choose to print on your photos. In the Overlay section, you will find there are several ways to add text to a printed page, using the Identity Plate, Photo Info, and Page options. Figure 10.26 shows a sample of a contact sheet created using

FIG 10.26 Sample contact sheet.

the features in Overlays. Figure 10.27 is a photocomposition using the Identity Plate for the title at the bottom of the page.

FIG 10.27 Photocomposition created using overlays.

Working with the Identity Plate

To begin with, you need to understand that the Print module has its own Identity Plate (ID Plate) that is separate from the main Identity Plate. The Print module ID Plate is unique in that it doesn't have the same dimension restriction of 60-pixel height that the main Identity Plate has. You can use either the Print module or the main ID Plate when printing.

To enable the Identity Plate feature, select the Identity Plate check box in the Overlays panel. You can make a lot of changes to the Identity Plate in the Print module without affecting the main Identity Plate that appears in the upper-left corner of your workspace.

As you discovered in Chapter 1, the Identity Plate can be text based or a graphic element. If your ID Plate is text based, from the Overlays section, you

can override the colors; if it is graphics based, the override color option is grayed out. You can choose a different Identity Plate by clicking the arrow in the lower-right corner and making a selection, and create a custom Identity Plate by selecting edit from that drop-down list. The one shown in Figure 10.28 contains a lot of custom Identity Plates I have added to mine, but yours will probably have only a custom and main Identity Plate.

FIG 10.28 From this drop-down list, you can select the Identity Plate that you want to use or open the editor.

There are several Identity Plate controls:

- **Scale**. The Scale slider adjusts the size of the Identity Plate. A faster way to resize it is to click on the ID Plate and drag the corner. As you drag it, the text/graphics in the ID Plate changes.
- **Opacity**. The Opacity slider controls the transparency of the Identity Plate. A low opacity gives a "watermark" effect that enables you to place text (such as a copyright notice) right on the image without obscuring the image too much.
- **Render behind the image**. There is no good way to explain this option. See Figure 10.29 for an example of what it looks like. Just like the name says, it puts the ID Plate under the images, so you need to make sure that there is room between the images to see the ID Plate if you intend to use this feature.
- **Render on every image**. This check box places the selected Identity Plate on the center of every image (Figure 10.30). This is a great way to add copyright information or add watermarks. If you don't select it, a single Identity Plate appears on the page.

FIG 10.29 Example of an Identity Plate rendered behind the image.

FIG 10.30 The Render on every Image feature always centers the ID Plate on the center of the image.

The Identity Plate can be placed anywhere on the image. To move it, just click on it and drag it to the spot where you want it placed, the exception being if **Render on every image** is selected. The orientation of the Identity Plate is controlled by the Rotate Identity button—located to the right of the Identity Plate check box—which provides one of four 90-degree rotation positions. There isn't a free rotation.

The quickest way to open the Identity Plate Editor is to double-click on the Identity Plate. This editor is pretty primitive, and although it is possible to do some cool stuff with it, Adobe makes you work for it. When the editor opens, the text in it is highlighted (see Figure 10.31). If the text color is white, the text is invisible when it is not highlighted, so if the text box appears empty, triple-click the text box to highlight it and see if text is present.

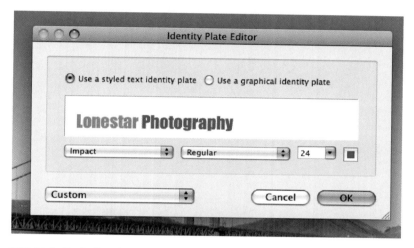

FIG 10.31 The Identity Plate editor.

Adding Photo Information

The **Page Info** feature is handy when you need to print color samples. Typically when you are printing different test prints for color correction, you end up writing the print settings on each print so when you compare the different settings you can figure out what setting produced the desired color output. With Page Info selected, the name of the printer, printer profile, and the sharpening setting used appears at the bottom of the page (Figure 10.32). The Image Print Sizes displays the printed size of the photo on the display, but it does not appear on the printed output.

You can print custom information about an image by selecting the Photo Info check box. You can use one of the presets on the drop-down list (Figure 10.33) or use the Photo Info Editor to create a combination of different fields of information. To select the information you want Photo Info to add to the print, you can select one of the presets from the drop-down list. You can also choose

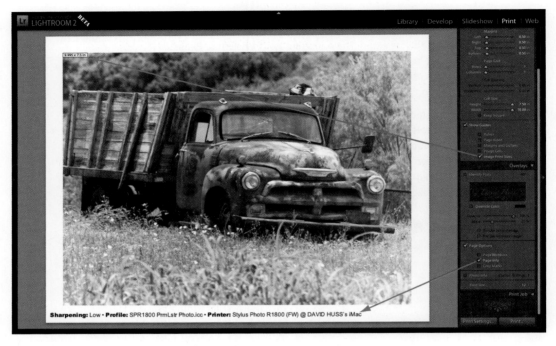

Sharpening: Low • Profile: SPR1800 PrmLstr Photo.icc • Printer: Stylus Photo R1800 (FW) @ DAVID HUSS's iMac

FIG 10.32 Page Info is very useful when producing test prints.

FIG 10.33 The Photo Info feature showing the factory presets.

the Edit option to open the Text Template Editor and construct a custom text string. You can adjust the font size using the Font Size drop-down list just below the Photo Info check box. This font control also determines the size of the items under Page Options. The Photo Info data prints below the image cell. Lightroom automatically resizes the image sufficiently to allow the text to fit.

The Photo Info feature is somewhat limited in what it can do. First, even though you can customize it to include a wealth of data, it displays selected in a single line without spaces between each field. Figure 10.34 shows the resulting mess when multiple fields are selected. Second, the user cannot add spaces to break up the data to make it more readable.

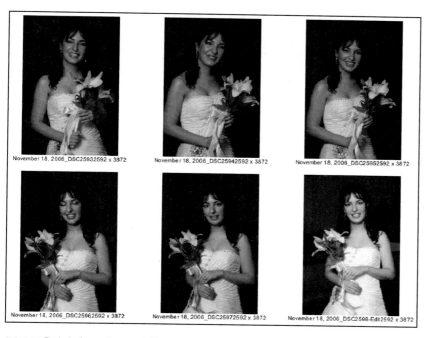

FIG 10.34 The lack of spaces between fields makes Photo Info unreadable.

Mac users have an undocumented feature that allows adding line breaks by holding the Option key when pressing the Return key. This feature is not available under Windows. An example of using Photo Info to create a caption under a photo is shown in Figure 10.35.

Making a Contact Sheet

Back in the days of film photography, it was common to create a contact sheet by laying negative strips on a sheet of photo paper and exposing it to light, then developing the photo paper normally. The result is a set of tiny prints, which are far easier to interpret than the negatives. Because the negatives are in contact with the photo paper, the result is called a contact sheet.

339

This photograph of an abandoned truck was taken in central Texas near the city of Bastrop.
The original image has color but was converted using the Aged Photo Develop setting in Lightroom 2.
Copyright 2008 Dave Huss

FIG 10.35 Mac users can add line breaks to make the Photo Info data more readable.

Contact sheets are still made today, albeit without using negatives or darkrooms. Some of us old guys and gals still call them contact sheets, but a more common term is a proof sheet. These proof sheets can be used to make a hard-copy permanent record of the photos in a collection or catalog, but the most important use is to provide a way to show clients a series of photos from which they can select the photos they want to print. To build a contact sheet in Lightroom, you can either set the number of rows and columns you want using the Rows slider and Columns slider or choose one of the contact sheet templates in the Lightroom templates list. There are two common sizes of template available: 4 × 5 (rows × columns) and 5 × 8 (Figure 10.36).

Making a Proof Sheet

The best way to understand how all of these tools work together is to use them to create a couple of real world projects. We'll begin with a typical wedding proof sheet that will be given to the couple so that they can pick the photos they want. I am aware that many photographers today give their clients a disk containing a slide show (I do as well), but the proof sheet is still a good way to present your work, and learning to make one will teach you some tricks about using the layout portion of the Print module.

In the following exercise, you will learn how to modify a template, add overlay text, and use the Identity Plate to create a professional appearing proof sheet:

1. In the Library module, select the photos that are to appear on the contact sheet. If there more than 10 photos, I recommend either using Quick

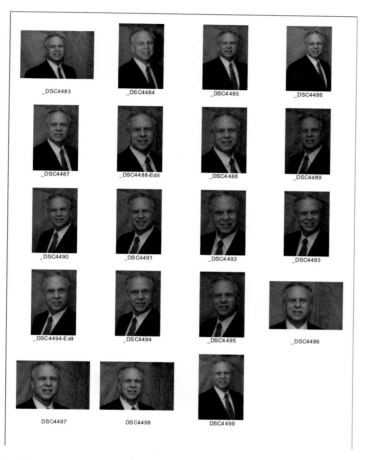

FIG 10.36 Create a contact sheet using a Contact Sheet template provided in Lightroom.

Collection or making a collection of the photos you want to put on the proof sheet. For this exercise I added 10 photos to Quick Collection.

2. Select the Print module, and choose the built-in 2 × 2 template (Figure 10.37). Because each page with the 2 × 2 template holds only four photos, when the template is selected, three pages are immediately created to accommodate all the photos. Only one page can be displayed at a time.

3. The first step is to modify the template so that each page shows six photos. Change the Rows setting of Cell Spacing from 2 to 3. The image size is reduced, and the number of pages is decreased to two. Decrease the number of photos to six by Cmd/Ctrl + clicking on each photo in the filmstrip that you want to remove (Figure 10.38). As each photo in the filmstrip is de-selected, it disappears from the page and the remaining photos on the page move around. Now that the photos that are to be

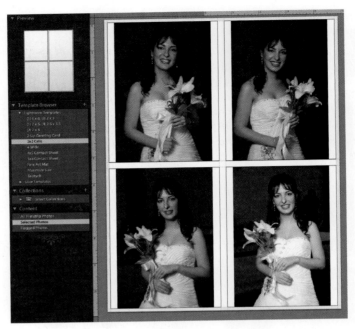

FIG 10.37 Opening Print module with the 2 × 2 template displays the first four photos.

FIG 10.38 The Changing Row setting reduces the size of the photos and the number of pages.

shown to the client are selected, I turned off the filmstrip to make the image appear larger in the workspace.

4. Next, we'll add filenames to the photos (so the clients have something they can reference) by clicking on Photo Info in the right pane and choosing Filename from the pop-up menu on the right side of the panel. Because my eyesight isn't what it used to be, I like to make the filenames a little larger. Directly below Photo Info is the Font Size from which you can change the font size within a range of 8 to 16 points (Figure 10.39). If you want to change the default typeface used for Photo Info or use a different size than the ones offered, the answer is simple—you can't. Now you have something to look forward to in the next release.

_DSC2593 _DSC2595

_DSC2598-Edit _DSC2598

_DSC2599 _DSC2600

FIG 10.39 Enable Photo Info, and change the Font Size to 16 points.

5. Looking at the screen, there is a lot of white space. Click the Print Setup button, and change the orientation of the page. Now the photos appear larger (Figure 10.40). Just a reminder—the original photos remain unaltered.

343

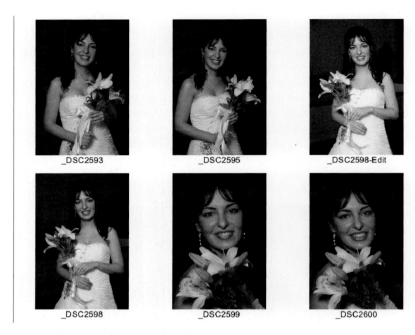

_DSC2593 _DSC2595 _DSC2598-Edit

_DSC2598 _DSC2599 _DSC2600

FIG 10.40 Changing the paper orientation allows the photos to appear larger.

6. Often you will notice a photo in the spread that you want to change. Here is how you can correct a single image. Click on the image you want to change in the filmstrip—not the edge, click on the actual photo. Open the Develop module and the photo you selected appears in Loupe view (Figure 10.41). This does not work in Quick Develop. Make the correction, open the Print module, and the image is corrected—even though the other images are selected in the Print module, when in the Develop module only the selected photo is altered.

7. At this point, you have enough for a client to use, but we want more than that. To make space at the bottom to put your company name, change the Bottom settings in the Margins panel. Change it to 0.5 inches. The photos will get smaller when you do this. It is a tradeoff between sufficient proof size and how much room to allow for your company name.

A quick way to change the margins is to grab them with the cursor and click-drag it to the desired position.

8. To add your business name, we'll use the Identity Plate we learned about in Chapter 1. Click the Identity Plate in the Overlays panel. If the orientation is not correct, you can change it by clicking on the current rotation and selecting a different one from the pop-up menu (Figure 10.42).

FIG 10.41 Individual photos can be corrected in the Develop module.

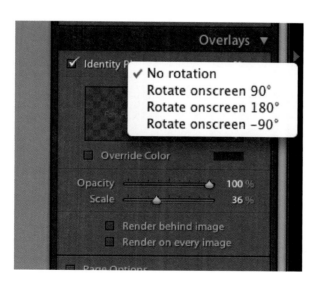

FIG 10.42 The pop-up menu controls the rotation of the Identity Plate.

9. Click and drag the Identity Plate to the bottom of the page. You can resize the Identity Plate by dragging its corners or using the Scale slider. The finished proof sheet is shown in Figure 10.43.

FIG 10.43 Completed proof sheet.

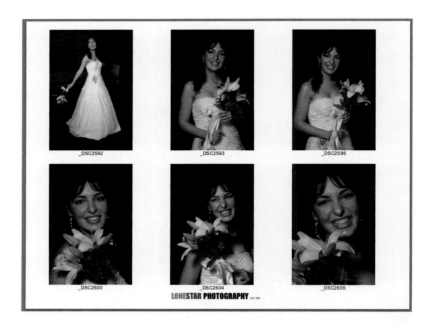

Saving It All as a Template

As with the other modules in Lightroom, you can save the Print settings in a custom template. This is especially important for the Print module, as there are a lot of settings, including the text, number of rows and columns, margins, guides, and print settings. To create a custom template, click the Add button to open the New Template dialog box (Figure 10.44). Give the template a name and save it.

FIG 10.44 Add template allows you to save all the information for reuse.

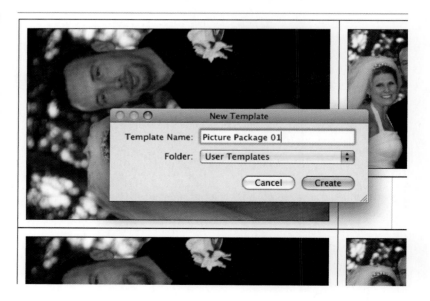

The next time you need to use this template, you only need click on it and all of the page set-up and page layout settings will revert to the template settings.

Configuring for Printing

Now that you've laid out the page and specified exactly what you want to print, you need to configure your printer to get a quality printout. This operation includes setting up color management, possibly choosing a print profile, specifying the print job parameters, configuring your printer, and printing the pages.

Using Color Management

As mentioned earlier in this chapter, printer color management can be controlled either by the printer or directly by Lightroom.

> Draft mode prints low-quality images using the thumbnails. You must de-select the Draft Mode Printing check box to be able to specify the Color Management parameters.

Controlling Color Management via the Printer

The easiest (and often accurate) way to perform color management is to allow the printer to control it. To do so, choose Managed by Printer from the Profile drop-down list in the Color Management section of the Print Job panel (Figure 10.45).

Next, you need to set the type of paper that will be used. Many HP printers automatically detect what paper is installed. Windows users can access the printer through the Properties in the Page Setup dialog box, and both Macs and Windows-based PCs can access the printer settings through the Print Settings button (both of which open the Print Setup dialog box). On a Mac, select Printer Features, select the type of paper from the Media Type drop-down list (Figure 10.46), and click the Properties button.

The last step is to ensure that the printer knows it is supposed to manage the color. How you do this is very printer specific. For example, on an HP photo printer on a Windows platform, clicking the Advanced button in the Printer Properties dialog box opens the Advanced Options dialog box. Click on the Image Color Management controls (specifically, the ICM Method drop-down list), and choose ICM Handled by Printer.

Controlling Color Management Using a Profile

If you'd rather control color management through Lightroom, you'll need to make some different choices. First of all, you'll need to pick the printer profile from the Profile drop-down list (see Figure 10.47).

CMYK and Lightroom

Many users have asked about CMYK (four-color) printing with Lightroom. If you are preparing your photos for publication, like this book, you will discover that most publishers prefer RGB images. They prefer to do their own conversion to CMYK. It is far more flexible to start with RGB images that they can take to the Web and to print.

If you must provide CMYK images, work in native RGB spaces until the colors in your photo are acceptable, and then open the image in Photoshop to soft proof for CMYK conversion, correcting any issues that arise in the conversion right there. The conversion is the very last step you do. It would be nice for Lightroom to provide soft proofing, but accurate soft proofing is complex and Adobe has wisely chosen not to insert a mediocre proofing feature just so they could say Lightroom has one. Many professional inkjet printers actually use CMYK inks or some version of CMYK, but even so, the printer still requires RGB images, not CMYK.

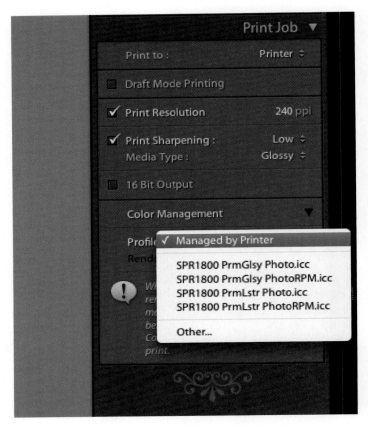

FIG 10.45 Set Color Management to Managed by Printer in the Profile drop-down list.

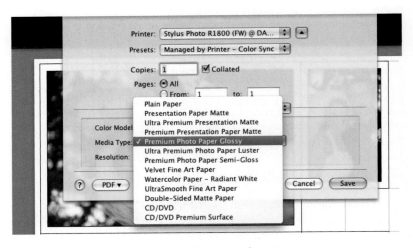

FIG 10.46 Use the Printer Features dialog box to set the paper type for printing.

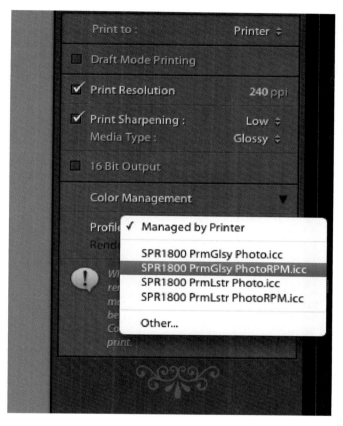

FIG 10.47 Pick a custom profile from the Profile drop-down list.

To read about how to add profiles to this list, see Using the Set Profile Dialog Box, presented later in this chapter.

Next, you'll have to turn off color management on your printer. Again, how you do this varies from printer to printer, and you'll have to consult your manual to find out how. This is very important. If you don't tell the printer not to manage color, both the software and the printer will execute color management—with unpredictable (but usually not good) results.

Using the Set Profile Dialog Box

To install custom profiles in the Profile drop-down list, click the "Other" entry in the Profile drop-down list. This opens the Set Profile dialog box (Figure 10.48). Simply click the check box alongside each profile you want to appear in the Profile drop-down list, and click OK.

Why would you want to allow Lightroom to control color management as opposed to using a printer profile? The main reason would be color accuracy, especially if you are using third-party papers. When you purchase these specialized printing supplies, you can often download and install a printer profile specially tuned for your printer from the vendor's website. To use this custom profile, you must allow Lightroom to manage your color.

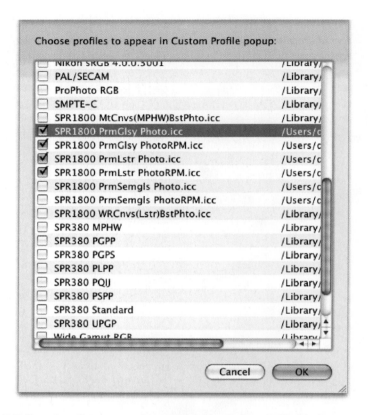

FIG 10.48 Choose the profiles you want available in Lightroom from the Choose Profiles dialog box.

Setting the Rendering Intent

A "color space" defines how well and how completely an application or a printer handles color. Lightroom uses a very large color space called "ProPhoto RGB." This color space can handle pretty much any color you can define on the screen, even highly saturated colors. However, when you want to print, your printer is not able to reproduce all the screen colors because it uses a much smaller color space. The choice of Rendering Intent (in the Print Job panel) determines how your printer will handle the colors that it can't produce (called out-of-gamut colors).

There are two choices in the Rendering Intent drop-down list: Perceptual and Relative (Figure 10.49). Which one you choose is pretty much a matter of taste, but in case you really want to understand how they differ, here it is:

- **Perceptual rendering**. Tries to preserve the visual relationships between the colors. The rendering of in-gamut colors may shift to preserve the relationships to the out-of-gamut colors. Because the out-of-gamut colors

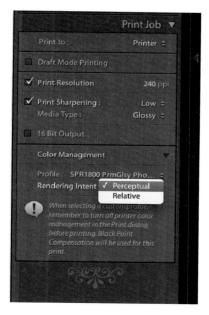

FIG 10.49 Choose the type of rendering from the Rendering Intent drop-down list.

can't be reproduced exactly, the rendering has to use the closest color it does have and change the in-gamut colors to match.

- **Relative rendering**. Reproduces all in-gamut colors and shifts the out-of-gamut colors to the closest reproducible color.

Technically, perceptual rendering works best when you have many out-of-gamut colors, and relative rendering works best when you have very few out-of-gamut colors. But because you rarely know, I find that it is best to try the two and decide which one you like best. Perhaps I am color blind, but I can rarely tell the difference.

Setting Up the Print Job

There are three settings you can choose in the Print Job panel that influence the print quality and details:

- **Draft Mode printing**. To set your printer to draft mode, select the Draft Mode Printing check box. Draft mode printing is quick but of low quality. It is a good way to get a quick printout that doesn't have to be great—perhaps a contact sheet. You must de-select Draft Mode Printing in order to enable Print Resolution and Print Sharpening.
- **Print resolution**. You can set the print resolution of the image by selecting the Print Resolution check box and specifying a number (in ppi—pixels per inch). This is handy when you have a high-resolution image because printing at more than 300 ppi simply slows down the printer without

increasing the quality of the printed output. By specifying a number between about 220 ppi and 360 ppi, you'll not only get a good quality image, but you'll avoid some of the anomalies (like color banding) that sometimes occur when the image resolution is very high.

- If you are printing to an Epson printer, change the resolution to 360. This is the best setting for the print engine used by Epson. For non-Epson printers, a setting of 240 (the default setting) will work very well.

The Print Resolution has nothing to do with the *printer* resolution. Printers often offer very high resolution printing, such as 1440 dpi (dots per inch) or higher. The *printer* resolution is a measure of the printer's ability to place tiny dots on the paper to create smooth colors. The *print* resolution measures the actual pixels per inch of the image. For example, if I have an image that measures 2400 pixels wide by 3000 pixels high and I want to print that image at 4 × 5 (inches), the resolution will be about 600 ppi. Some printers (especially snapshot printers), will actually produce poorer results than they would at 300 ppi. Thus, you can tell Lightroom to scale the image and output at 300 ppi, and you'll actually get better results.

- **Print sharpening**. If you don't sharpen an image when printing, details may come out a little soft. Thus, sharpening is usually a good idea. When the Print Sharpening feature is selected, the sharpening is applied to the image sent to the printer. The image in Lightroom is unaffected. This means that you cannot see the effect of the sharpening in the preview. You set the amount of sharpening by selecting the Print Sharpening check box and picking a value (low, standard, or high) from the drop-down list. This feature produces a very soft amount of sharpening, even when you select a high setting.
- **16-bit output**. This is a new feature in Lightroom. The advantage of 16-bit printing is that it can produce a greater dynamic range in the printed output. This assumes that the printer can accept 16-bit output. It should be pointed out that not all printers can accept 16-bit output. Another point is that just because you are printing using 16-bit output doesn't mean that the quality will improve.

Setting Up for Printing (Printer Dependent)

Every printer has a unique set-up dialog box, and each one is a little different. The last step before printing is to make sure that all the properties are set appropriately. These may include the paper and color management (discussed previously), printing resolution, scaling of the image, layout, paper source, and even automatic adjustments such as brightness and color saturation (depending on your printer).

Lightroom Controlled Color Management

To make the best possible prints, you need to use Lightroom to manage the printer color. This method uses ICC profiles that are made for specific papers for your printer that you need to download from either the printer or the paper manufacturer's Web page. Not all printers have profiles. Typically, profiles are only offered for high-end consumer and professional printers. So if you bought a photo printer that only costs $60, odds are that you will not find a profile and should print using printer-managed color.

1. The first step is to download and install the profiles for the printer and paper you are using. For example, Epson provides, free of charge, four different ICC color profiles for my 1800 model. Why four? Because Epson makes four different paper types for use on this printer: glossy, matte, fine art, and canvas. What if you want to use a paper made by a different manufacturer? You can go to that manufacturer's website and download an ICC profile that matches its paper with your specific printer. If you are using a printer that is several years old, consider buying a new printer. It is a far better thing to buy a new printer than to curse the fact that the manufacturer doesn't upgrade the ICC profiles for its older printers.
2. Now that the profiles are installed, your next step is to click on the profile. If this is your first time, your choices will be Managed by Printer and Other.

FIG 10.50 Printer Web page provides the latest printer profiles.

Click on Other to see the profiles available. Is the profile box blank? Most likely you have downloaded but did not install the profiles. When you see the list of profiles, click on the ones that you want to appear in the Color Management area of the Print Job panel, and click OK.

3. Now the profiles you chose appear in the Color management area. Select the profile that matches the printer and the media that you are using for the print job.

4. The last step is to choose the Rendering Intent. The two choices are Relative and Perceptual. Rather than provide a technical definition, here are some generally accepted guidelines. For images that do not have large areas of bright saturated colors, choose Relative. If you are printing fine art photos on matte paper or printing images with lots of dark colors, consider Perceptual.

5. Click the Print button. The most important step is to ensure that the printer's color management feature is turned off. If you leave it on, both Lightroom and the printer will attempt to do color management, and the usual symptom is a light magenta cast on the finished print.

After you have printed the image or images, compare a printed sample with what is on the display. Do they look alike? Not to burst your bubble, but they won't. Why? The pixels in the image on the display transmit light. The pixels on the printed photo reflect light. The appearance of the image on the display and the printed image can get pretty close, but they will never be the same. So what happens when the printed output doesn't look anything like the image on the screen? The following section describes some common printing problems and their solutions.

Troubleshooting Printing Problems

This section describes some of the more common printing problems with Lightroom:

- **Magenta color cast**. If your printed output has a magenta color cast, there is a good chance that you are attempting to print using Lightroom-controlled color management while the printer's color management option is still turned on.
- **Print is too dark**. This is a common problem with Lightroom. The overall brightness of the image appears OK when viewed on a display, but it is too dark when printed. This often occurs when the brightness of the display makes the displayed image appear lighter than it really is. The solution is to look at the histogram in the Develop module and make sure it isn't shifted too far to the left. If it is, the best tool to correct this is the Brightness slider in the Develop module.

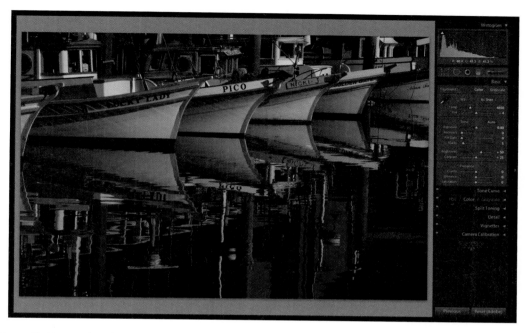

FIG 10.51 The histogram shows the image is a little underexposed even though the image appears to be well illuminated.

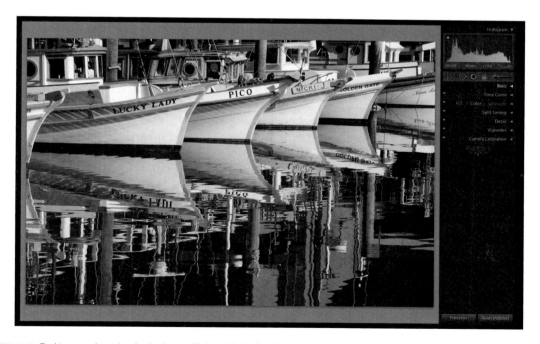

FIG 10.52 The histogram shows that the distribution of light and dark will produce an image that isn't too dark even though the preview appears slightly washed out.

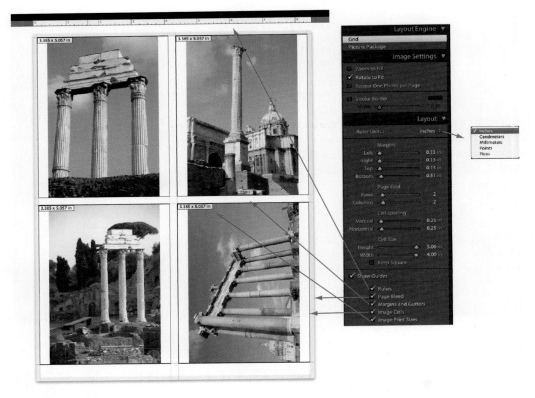

FIG 10.53 The rulers and guides provide layout information.

There are various other guides (Figure 10.53) that can help you do your print layout:

- **Page bleed**. Some printers can't print all the way to the edge of the paper. If your printer doesn't support borderless printing or if it does but you are not using borderless paper, the Page Bleed guide shows the unprintable area on the page. This is helpful for making sure your picture doesn't get cut off at the edges. The Page Bleed guides are hard to see—they are the very light gray strips around the edges of the page.
- **Margins and gutters**. These guides show the margins around the edges of the "image cell" (rectangular area that contains the image). You can adjust the margins as described later in this chapter.
- **Image cells**. These guides show the rectangular area that contains the image, known as the image cell. It doesn't provide any more information than the margins and gutters—it just draws a darker rectangle around the interior of the margins.
- **Image print sizes**. This guide displays text for the image size in the upper-left corner of the image. This information only appears on the display; it does not print.

Lightroom Printing Fundamentals

Lightroom offers two methods for printing images: printer-managed printing (default) and Lightroom-managed printing. When using printer management, Lightroom sends the printer a tagged file, which it uses to define how the printed colors will appear on the paper. The printer manages all of the colors. In application (Lightroom)-managed printing, you select a printer profile (designated by printer type and paper type and provided by the printer or paper manufacturer) before printing. When it comes time to print, Lightroom controls all aspects of the color management. This is the best choice for accurate color prints assuming you do not forget to turn off the color management option on your printer.

Which method is best? First, don't be too quick to dismiss the printer-managed color option. Printers have come a long way in the past few years, and testing has demonstrated that allowing the printer to manage the color can produce good results. If you are not sure which is best for you, I recommend that you print a few printer-managed photos to see if it works for you.

Print Setup

Regardless of which method you choose, color managed by the printer or by Lightroom, the process begins the same way. Even though the Print module

FIG 10.54 Selected photo orientation is incorrect.

can print a lot of images in a single batch, for the first attempt, let's look at what it takes to print a single photo:

1. In the Library or Develop module, select the photo or photos you want to print. In the Print module, you can also select photos from the filmstrip.
2. How the image appears in the Print module depends on what template (in the left panel) is selected. The example shown in Figure 10.54 used the Maximum Size template. If the photo rotation appears incorrect, you will notice there are no rotation arrows in the toolbar of the Print module. Don't worry. We'll fix it in the next step.

If you leave the Rotate to fit option in Image Settings checked, the image will always have the correct orientation for the page regardless of the Page Setup setting.

3. Click the Page Setup button (lower right), and from the dialog box (Figure 10.55) select the printer, size of paper, and correct orientation (portrait or landscape) you will use. You can also choose File > Page Setup (or press Cmd + Shift + P/ Ctrl + Shift + P). Make sure you select the printer you are using first. It controls what paper size choices are available to you. You cannot pick the type of media you are using in this dialog box. There is also an option to scale the image. I recommend leaving it at 100%. If you need to resize the image, the best way is to jump back to the Layout panel in the Develop module.

FIG 10.55 Page Setup feature (Mac).

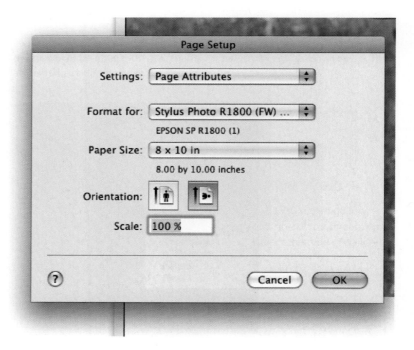

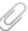

Windows users can access the selected printer's properties by choosing the printer from the Name drop-down list and clicking the Properties button in the Page Setup dialog box. Mac users don't have a Properties button and must take the more scenic route to their Print Settings by closing the Print Setup and using the Print Settings button.

4. After completing Page Setup, go to the Print Job panel in the right panel and check the settings in it (Figure 10.56). If Draft Mode Printing is selected, all other options are grayed out and Lightroom uses the thumbnail as a print source. The resulting photo prints fast but is relatively ugly because of the low resolution of the thumbnail. The Print Resolution has a default setting of 240 dpi. This setting makes an acceptable print on most printers, but if you're using an Epson printer, Epson recommends using a setting of 360 dpi. Don't use a resolution any higher than 400 dpi. It will increase the print time and consume more ink without improvement in the printed output. If you are printing an image larger than 8 × 10 inches, a general rule of thumb is that larger images can get by on lower resolution settings.

FIG 10.56 Print Job panel.

5. Print Sharpening is a feature that confuses some users. It has three settings: low, medium, and high (Figure 10.57). What causes confusion is that when the setting is changed, nothing appears to have changed in the photo being previewed in the work area. That is because nothing has changed. Print Sharpening is applied to the image file that is sent to the printer, and the original image is unchanged. Which Sharpening setting should you use? It is a mild, albeit good, sharpening algorithm that you can use the high setting on nearly every photo without blowing out the edges of objects in the photo. If you are printing portraits of people, you may not want to apply any sharpening as it brings out wrinkles and blemishes.

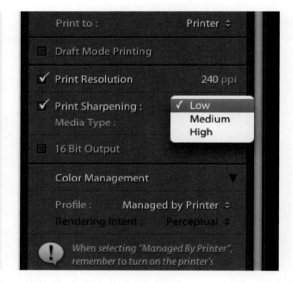

FIG 10.57 Print Sharpening has three settings, which are applied to the image that Lightroom sends to the printer.

6. Finally, you don't need to go through this set-up every time you want to print a photo. Once you have the print settings the way you want either in general or for a specific project, click the Print Settings… button, click the arrow button on Presets, and from the drop-down list you can save your current settings as a preset. Later you can open the preset immediately with a single mouse click in the Page Setup dialog box. You can also manage your presets from the same list.

Index